INTERVIEWS WITH AMERICAN ARTISTS

DAVID SYLVESTER

INTERVIEWS

WITH AMERICAN

ARTISTS

Yale University Press
New Haven and London

First published in 2001 by Chatto and Windus.

Printed in the United States of America by Edwards Brothers Inc.

ISBN 0-300-09204-0 (cloth : alk. paper)

Library of Congress control number: 2001096192

The paper in this book meets the guidelines for permanence and durability of the
Committee on Production Guidelines for Book Longevity of the
Council on Library Resources.

10 9 8 7 6 5 4 3 2 1

For Andrew Forge

CONTENTS

PREFACE

This book consists of edited versions of interviews recorded on audiotape with twenty-one American artists, the eldest born in 1900, the youngest in 1955.

All but five of the interviews were commissioned by the BBC between 1960 and 1967 and edited for broadcasting on the Third Programme. The book therefore owes its life to that institution and to one of its bravest talks producers, Leonie Cohn, who persuaded her superiors that lengthy interviews with American artists were of serious interest to a British audience and who was also mainly responsible for editing the broadcast versions. In a couple of cases, the interviews that were commissioned were not as long as they might advantageously have been.

The fact that the book includes interviews with a high proportion of the leading American artists of the period will probably provoke the question why doesn't it include more of them. One reason is that some artists are unwilling to be interviewed (among them, ironically, the Abstract Expressionist painter whom I probably knew best). Another is that I have never solicited interviews with artists I didn't already happen to know. A third is that there have been artists whom I have known well and whose work I have greatly admired but about whom I had a feeling that my questions and their answers wouldn't connect.

The texts published here are in three categories editorially. Eight are reprints or virtual reprints of previously published texts. Four are new versions of published interviews made from the original transcripts. Nine have not previously been published in any form.

Fixing the sequence for the contents was problematical. Should the interviews be in chronological order? Should the artists be in chronological order? Or should the sequence have some sort of art historical sense? Having decided in favour of the latter, I am much indebted to Lynne Cooke for proposing the solution I have adopted and also for her counsel regarding the selection. I am also grateful to Angelica Rudenstine and Irving Sandler for their advice.

I owe a very special debt to Nicola Del Roscio for his indispensable guidance and collaboration in the editing of the interview with Cy

PREFACE

Twombly and my thanks to Craig Houser of the Guggenheim Museum, New York, for his help with the interview with Jeff Koons.

The book has demanded skilful secretarial work for which I have to thank Helen Hobbs, Eileen Smith and Naomi Sylvester.

DAVID SMITH

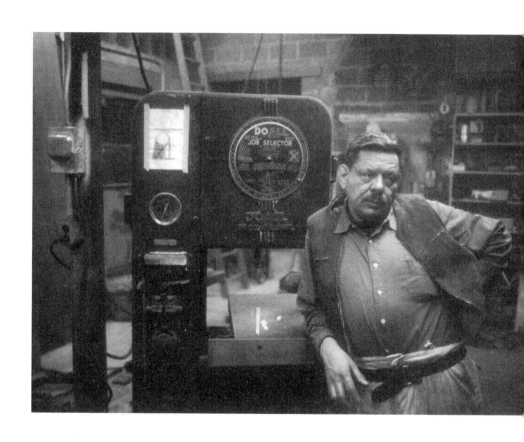

Recorded March 1960 in New York City. The version edited for broadcasting by the BBC was first published in *Living Arts*, April 1964. The present version has been edited from the transcript.

David Smith inside the Terminal Iron Works, Bolton Landing, New York, 1962. Photograph by Dan Budnik.

DAVID SMITH 1960

DAVID SYLVESTER *Did you find that being a close friend of the Abstract Expressionist painters was helpful to your work as a sculptor?*

DAVID SMITH We talked about other things usually, but we did spring from the same roots and we had so much in common and our parentage was so much the same that like brothers we didn't need to talk about the art, any more than I need to talk about nature. Well, Pollock, de Kooning, practically everybody I can think of who is around fifty now – sort of arrived artists – all came from the Depression time and all came from the bond of the WPA, the Works Progress Administration. It was a government employment of artists and somewhat of a defensive thing. We made very little more by working than people drew for not working, in unemployed relief. We drew maybe five or six dollars a week more for working, which was very nice because, for the first time collectively we belonged somewhere.

And this gave you a stimulus?

Well, we belonged to society that way. It gave us unity, it gave us friendship and it gave us a collective defensiveness. And it was the first time we ever had recognition from our own government that we existed.

Do you still feel that you belong in that way?

Times have changed.

Do you still get any government patronage?

Not that I know of. There are a few of our more traditional men who have had monument patronage, or they design a coin or something like that, but there is no patronage generally speaking and there is not even recognition. The Federal government, when they send over exhibitions of American art to other countries, often start with buffaloes and Indians.

When a few of the contemporary men were put in these exhibitions, by demand of museums and just general recognition here, some of the senators raised such a fuss about it that it was slightly embarrassing. Now if I'm invited to any of these Federal things, I don't choose to take part in them because I just don't like to be distressed.

There wasn't much help at first for you and your friends from private collectors here, was there?

Private collectors were quite few and far between. But there is another thing the WPA did: it stimulated the interest in art. You see, while some artists were employed, don't forget there were a lot of teachers and there were art historians and there were critics and all people related to the arts. They were related to us and to the connection between the painter and the sculptor and the people. There were many public classes, adult painting classes, adult sculpture classes and WPA exhibitions that travelled throughout the country and went to places where art had never been shown before. They went to union halls and schools and places like that. There was an interest stimulated in people by their response to it, and also by a desire to do it. You know, amateur response: it's a sort of groundwork for professional collectors. Most collectors can paint or draw to a degree and so, therefore, seem to recognise the artists who are full-time artists quicker.

So really, government help in the thirties had a lot to do with creating the climate which produced this thing post-war, although there hasn't been help post-war.

Yes. I think reasons are very hard to find, and reasons are never one thing, they are a hundred things, but I can't think of one thing that stimulated the response of the public better than the WPA educational projects did. Nor do I know anything that kept so many artists alive during the thirties than the WPA. There was nothing else.

A lot of the work that was being done in the thirties by painters who are now abstract was figurative work – often a form of Social Realism, connected to Diego Rivera and so on – was it not?

The great body of work at that time was a form of Social Realism, which did relate to Rivera, but not in our case. We were kind of expatriates right in our own country – even in the Village in New York. I mean, we were expatriates there even, in a certain way, but there were a lot of die-hards here – men like Glarner and Diller and Reinhardt. Many of these men, who were what were called non-objectivists, went right through the thirties firmly convinced of their own stand. There were many of us, not too many, that came from fathers or grandfathers who were Cubist. We came, not very directly, you see – we came through the French magazines *Transition* and *Cahiers d'Art*. We came through both of those magazines and we came through men like Stuart Davis and Jean Xceron and John Graham and men like that who more or less went back and forth between Paris and here and told us what was going on in Europe.

You yourself were abstract before a lot of the painters of your generation, weren't you?

I have been essentially an abstract sculptor.

You were in Europe yourself for some time in the late thirties?

'35 and '36.

In what way do you think this affected your development? I mean, the others weren't actually in Europe as you were for a long period, were they? They mostly got it through the magazines, didn't they?

Most of us tried to go to Europe if we could. Most of us did. I don't remember whether Jackson did or not. Of course, de Kooning had come from Europe and Gorky had come from Europe, Graham was a Russian and he'd come from Europe; Stuart Davis had gone to Europe earlier and more or less had been a part of Cubism.

How do you feel it affected your development, going there at that moment?

It was very important. Most of all it was one of the greatest points of my own liberation mentally. You see, before, in the early part of the thirties,

5

we all were looking for a kind of Utopian position or at least a position where somebody liked our work. In the early thirties, none of us, like Pollock or Gorky or de Kooning, none of us could show our work any place. Nobody wanted to show it; and it seemed that the solution was to be expatriates. Most of the men a little older than we were had sought a solution in expatriatism – all the way from Majorca to Paris itself. And the one thing that I learned – in '35 and '36 I was in England and Russia and Greece and France and places like that – and the one thing that I realised was that I belonged here. My materials were here and my thoughts were here and my work was here, and whatever I could do had to be done here. I certainly gave up any idea of ever being an expatriate, so I laid into my work very hard. That must have been in the minds of other men, otherwise there wouldn't be so many of us here now. We're growing by thousands; there are thousands more painters and sculptors in this country. Why, nobody knows. It's not particularly profitable but it's just a feeling in the air and a kind of liberty and a right, now.

It's often said that one of the reasons why American art built up after the war was that it was stimulated by European artists who came here from Paris in the early 1940s and stayed here during the war.

That is part of the scene and it is important. It has been very rewarding to us to have men like Lipchitz and Mondrian and Gabo become Americans and live here with us. That is good, and it's been very nice. We have met them and we have found that they were humans like we were, they were not gods and they were fine artists, and so we know more about the world now.

In the thirties, of course, a lot of the more or less Social Realist work being done then was involved in a sort of social commitment. I believe you were exceptional in having strong left-wing commitment but working abstract.

I have strong social feelings. I do now. And about the only time I was ever able to express them in my work was when I made a series of medallions which were against the perils or evils of war, against inhuman things. They were called *Medals for Dishonor*. When I was in the British Museum in London in 1936, I bought a series of postcards which were

made during the First World War, and they were war medallions of the Germans. And that and Sumerian cylinder seals that I had been studying in Greece and intaglio carving impelled me to do that series of medallions which took me three years. I first had to learn how to carve in reverse in order to make these. It was about the only thing I have ever done which contributed my work to a social protest. I don't feel that I have to protest with my work. Whatever society I belong to must take me for my ability as far as I can go with it. My effort is to drive to the fullest extent those few talents that were given me, and propaganda is not necessarily my forte.

I talk about your being abstract but in fact a lot of your forms seem to me to be referential to nature; I mean, in these big, stainless steel things, I see a lot of them as personnages. *Are they at all this for you?*

They don't start that way. But how can a man live off of his planet? How on earth can he know anything that he hasn't seen or doesn't exist in his own world? Even his visions have to be made up of the forms and the world that he knows. He can't go off this planet with visions, no matter how they're put together, and he naturally uses his proportion and his objectivity. He can't get away from it. There is no such thing as truly abstract or non-objective; man always has to work from his life. Everything that he knows and sees is in his consciousness even if it's an object that he's never seen before, it all must have tangible relationships and it was also made by a man, so it's going to have the world of that man in it and it's going to have, somewhere in it, his image too – or his relationship to that image.

And you, you have no preconceptions about which way the thing is going to go?

I try not to have. I try to approach each thing without following the pattern that I made with the other one. They can begin with any idea. They can begin with a found object; they can begin with no object; they can begin sometimes even when I'm sweeping the floor and I stumble and kick a few parts that happen to be thrown into an alignment that sets me off on thinking. It sets off a vision of how it would finish if it all had

that kind of accidental beauty to it. They go that way, they go any way.

How would you analyse the difference between your work and its intentions and the Cubist constructions by González and Picasso of which it's a continuation?

Well, there is one thing. Going to school at the time that I went to school, I didn't read French, so when I had a copy of *Cahiers d'Art* I didn't know what it was about; I learned from the pictures, just the same as if I were a child in a certain sense. I learned the world from seeing before I ever learned the world from words. So my world was the Dutch movement de Stijl, it was Russian Constructivism, it was Cubism, it was even Surrealism; all of these things, even German Expressionism, even Monet. They all fitted in to me; they were all so new and so wonderful; they all came to me at one time practically. The historians hadn't drawn the lines yet as to which was which and where at which particular time. And my heritage was all those things simultaneously, so I am all those things, I hope, with a very strong intellectual regard for Cubism and an admiration for it, because it was great at a particular time. It was both painting and sculpture. It was a great point of liberation in both painting and sculpture, and especially sculpture.

I tend to think that in Europe the successors to the great pioneers are more doctrinaire in attitude, that your attitude is more eclectic, more free. And I wonder whether this freedom isn't very much a part of the vitality of post-war American art and whether it isn't shared by people like de Kooning and Pollock. Do you think that they too have just taken what they wanted quite freely from earlier modern art?

I think so. Gorky didn't read French and I don't think de Kooning read French either. We were all together at a particular time in our early days and we were sort of expatriates. We drank coffee together in cafeterias – and when I say we drank coffee, it was usually one cup because few of us could afford more than one five-cent cup of coffee in those days, plus a cookie maybe. And all we did was walk around and talk sometimes, but mostly we worked; and we each sort of took according to what we wanted. You must remember that, when we all met here in New York, I

had come from Indiana and I had only seen a sculpture a couple of years before that, or a painting. Gorky came into Providence and de Kooning came into New York. I think they all had a little bit more knowing of museums and art than I did before, and they were both Europeans in a sense, and I think all Europeans know more about art than people from Indiana do. I don't think I had seen a museum out in Indiana or Ohio, other than some very, very dark picture with sheep in it that was in the public library. But as far as anything I ever knew about art, I didn't know until I came to New York.

But you'd wanted to produce art before?

Oh, I wanted to be a painter when I came.

And you did paint for some years?

I painted for some years. I've never given it up. Even if I'm having trouble with the sculpture, I always paint my troubles out.

What was it that made you turn from painting to sculpture suddenly?

I think it was seeing Picasso's iron sculpture in a *Cahiers d'Art* around 1930. Seeing iron and factory materials used as a way of producing art was quite a revelation. And since I had worked in factories and had known iron and metal working since I had been very young, it came to me that it should be. I had also seen iron work by the Russian Constructivists, Rodchenko, Malevich, Tatlin. I'd seen reproductions, sometimes in German magazines. It was a revelation in a way. Later on, I learned that González had done the welding for Picasso on those works of around 1930, but I didn't know it at the time, and if it had said so in the article, it was in French and I wouldn't have known it anyhow.

It could be important, going back to what we were talking about before, that you and the others were seeing the works in reproduction and you weren't reading the text. Maybe this is why you were able to use them so freely?

Yes, and I also like the idea that we have no history – that we have no art

history and we pay no attention to art historians and that we're free from the connoisseurs and the minds of museums and collectors and everybody else. We are very independent here; we're indigenous and independent and we have no authorities. We were all pretty raw, I think.

Were you at all influenced in your use of sheet metal and so on by Calder?

No. I knew metal working before I knew Calder, and Calder is one of our great men and he is earlier by a few years than any of the rest of us. Calder had worked in Paris quite a bit in the early days, though he did go to school here in New York at the Art Students' League.

Your previous knowledge of working in metal, then, came from working in a factory?

Yes. After my first year in college I had worked on the assembly line in the Studebaker plants up in Indiana and I had enrolled at Notre Dame University, or I had matriculated, but the courses weren't what I chose, so I went back to the factory and worked the year out and then came East, and finally wound up at the Art Students' League. And that's where I studied in a rather traditional way for the first year, and then in the second year I studied with a man named Jan Matulka, who had had his schooling in Munich and was somewhat of a Cubist and Expressionist, and the world sort of started revealing itself there and for some reason I belonged there and no place else.

Have you ever had any temptations to work in traditional materials – carving or modelling?

Oh, I do both. I model in wax and make bronzes that way and I carve sometimes. Some of my early work was carved. I don't choose to close out any method, approach or material, and I draw figures and things like that at times.

Do you ever do it from nature?

Sure, sure. As a matter of study and a matter of balance. I draw a great

deal, because sculpture is such hard work. If I put in ten or twelve hours a day, it's hard labour; you know, it's sort of dirty work in my profession. I like to take a bath and change my clothes and spend the rest of the day drawing.

You do it all yourself, don't you? I mean, you could now afford studio assistants.

Well, I can't use studio assistants any more than Mondrian could have used assistants to paint in solid areas, or any more than de Kooning or any of my friends can use somebody else to put their backgrounds in, even though they might be pure white. They still don't want the marks of another hand on their own work. Now, that is twentieth-century too – that is defensive in a certain way because it's contradictory to this age. We are among the few people left who are making the object from start to finish.

You never feel it would be conceivable for you to make a model and have an assistant make it on a big scale?

I don't even make copies. If I make a cast sculpture, I make *one* and all the marks are mine. I don't approve of copies and I don't make and produce copies for the sake of making more money.

And this, of course, connects you very closely to the painters of your generation, doesn't it? This to and fro between the artist and the material makes you very closely linked with Pollock and de Kooning.

Well, we were all friends and I talk with painters and I belong with painters in a sense, and all my early friends were painters because we studied together. And I never conceived of myself as anything other than a painter. Some of the greatest contributions of sculpture to the twentieth century are by painters. Had it not been for painters, sculpture would be in a very sorry position.

One of the things you've been telling me is that the New York School is held together much more by personal friendship than by common doctrines.

There is no unity or organisation or even aesthetic unity, but we do have a very strong bond in our defence, but we also are strongest in our own individual identity. Our effort, I think, is all shooting off in independent directions. And the artists themselves will not admit to the existence of the New York School. They won't admit to any classification, and most of those painters known as Abstract Expressionists are the first to say they are not.

But there are surely some key basic attitudes in common. You said in a recent statement that you want 'to approach each work with new order each time'. Now, this aim would seem to be an aim that is common to you, to Pollock, to de Kooning, to Kline. This surely is something you share?

I think we do. Maybe each man would define it in a slightly different way, but I think we agree somewhere close to that statement. However, we are all so obstinate that we would not agree to the other man's terminology. You see, we are all so independent in that way. Yet we collectively are kind of brothers in a particular way. But most of all we work from our own identity. We have the strength of having identity now. You see, we have all lived two-thirds of our lives. We have had little patronage. We have survived against conflict. We also know that strength comes from conflict. So who can hurt us now? I mean, we're on our own. Patronage? Nobody can tempt us with anything. We all have our own identities by this time and we're going to go with them as far as we can go.

Now that a lot of you have become extremely successful and are getting big prices, is this going to make things more difficult?

Absolutely not. Absolutely not. It hasn't hurt one of our men. Oh, maybe we drink a bottle more per week or per month than we ever did, but even a lot of our men do not sell when they don't feel like selling and if they've sold enough, they say: 'Well, that's enough for this year; I'll sell next year.' They don't even want money other than for a few of the nice things. When they do get a little sum of money, it goes into a better studio, more paint and bigger canvases, maybe a new suit of clothes, maybe a party for other artists. A few of us have cars; I still stick with a truck which I've always had. But a lot of the artists have no cars. Five different men that I

know that have made a little better livelihood recently have gotten out of a cold-water flat and gone into a nice, big, long studio. Some of them are painting pictures twenty-six foot long, ten foot high. Well, that's a wonderful point of liberation now. If they had any mercenary reasons for such a thing, you would lose it there because you could never in the world sell a picture twenty-six foot long and ten foot high. It doesn't fit any place, it's nobody's royal command, it has absolutely no functional need any place. But it's their desire to do it and it's a statement of freedom against having painted little pictures so long in a little studio, and it's a statement of liberty.

If you knew an architect whom you found sympathetic, would you like to see some of your work placed in architectural settings, outside buildings, inside the large entrance halls of buildings?

I would like to see it, certainly. But I'm working on quite a large size – you know, my work is running from nine to fifteen feet high. Right now, I have a very modest acceptance and rather modest sales and I am surviving without architects, and if they choose to use my work as it stands I would be delighted to sell it to them and have them use it. But I do not think that I will change my point of view to meet theirs. I have no natural affinity to modern architecture. I can't afford to live in any of these buildings. They're not part of my world. My sculpture is part of my world: it's part of my everyday living; it reflects my studio, my house, my trees, the nature of the world I live in. The world that painters and sculptors live in has walk-up places with cracks and you look out the windows and see chimney-tops. We just don't belong to the architects' world. And I don't think any of us can sort of make the old-fashioned royal bow to suit their needs. Liberty of our position is the greatest thing we've got.

LOUISE NEVELSON

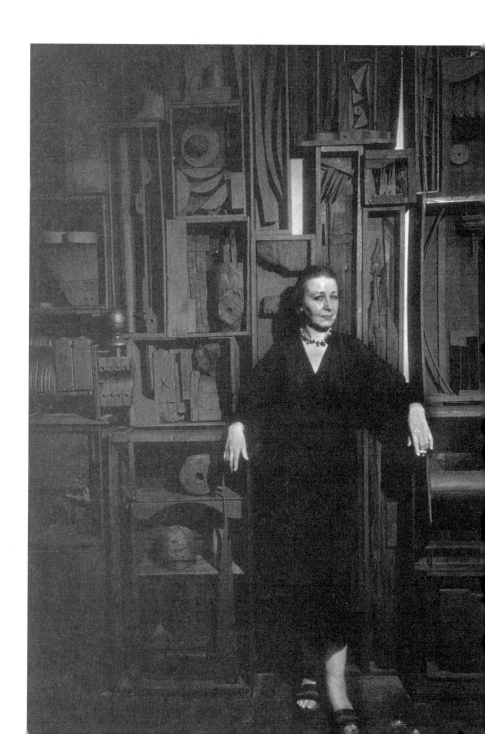

Recorded November 1963 in London. The version edited for broadcasting by the BBC remains unpublished. The present version has been edited from the transcript.

Louise Nevelson with *Cathedral I*, Grand Central Moderns, New York, 1958. Photograph by Dan Budnik.

LOUISE NEVELSON 1963

DAVID SYLVESTER *Are all the parts of the assemblages ready-made or do you carve some of them?*

LOUISE NEVELSON None of them are carved, but they're not all ready-made either. I always have a big house; the house I'm living in now was a private sanatorium: it had seventeen rooms and four baths, and, having all that space, I have a lot of wood. Some pieces of wood I've had as long as several years, and I haven't found the place to put them, and then all of a sudden you get a brainstorm and you use all of it. So I wouldn't say that I carved any of them. Or that I can use all of them. You are creating as you go along, and the nature of what you are doing tells you what wood you want.

How do you add to the supply of wood?

Well, I can walk anywhere in New York City, and that's really the way I started. In the big wall in the Museum of Modern Art there are different kinds of boxes: litter boxes, fruit boxes, fish boxes, all sorts. In the morning you walk and you find all sorts of things.

The boxes themselves, then, are ready-made?

They were ready-made at first, but not now. That is the difference.

So you now have them made to your specifications. By the way, where do you find the bits of driftwood?

I pick them up at the wharf and at beaches and wherever I go. You're usually driving and you pick them up and put them in the car. Then I have friends that are artists and knowing what I want also pick them up. If they deliver things to my house and I can't use them, I lay them aside. But it's a very interesting thing that you never know exactly what will be useful.

LOUISE NEVELSON

So far as actually working on the individual pieces is concerned, apart from assembling them, it's simply a matter of sawing up parts of them?

Well, sometimes you don't like a particular edge and you file it. And yes, you cut some. But I happen to really have a good eye, and I've never measured a thing in my life and either it fits or it doesn't, but usually it does.

When you begin one of these works is it with an idea for a single box or do you see a whole composition of several boxes before you begin? How much do you visualise?

I must say I never see a single box. Actually, a wall that doesn't have at least forty or sixty boxes doesn't interest me, because there's something about energy and the accumulation and the repetition that has something to do with my consciousness.

And when you have framed an idea of the character of a wall, you go on looking among the things to find suitable pieces?

Yes. Or it can be the other way round. Something may be delivered to the house that will set me off and that sets off the pattern. It isn't always myself superimposing. Some people feel very much that they have to impose everything; I play with my material and I permit it to superimpose on me. There is the surprise, you see, and I certainly welcome that.

When you're working on a wall, are you working on the contents of several of the boxes simultaneously or do you finish one box and go on to another box?

Yes, more or less, yes.

When you've finished all the boxes for a wall, do you find that you've got the number of boxes you began with or do you find suddenly that you've got to add another six boxes?

That happens both ways.

And when you've reached the end of a wall, do you then find that, in view of the effect of the parts within the whole, you go back and change certain of the boxes?

No, I certainly do not.

But do you juggle the positions of the boxes?

Yes.

And when you see the wall set up in a gallery do you sometimes still feel that you want to go on making changes or do you feel content that each box is in its right place?

Well, that's a very good question, because with the last wall I put up, which was a little circular, I found that certain surfaces were more hidden in cupboards than others and felt for the first time rather contented, because in the final analysis it's like painting a surface painting and therefore you wouldn't want too many open spaces in one spot and too many closed, so your division is really like painting a canvas.

How important are the titles for you? And when do you give them?

Well, I think for one thing my whole kind of thinking is in this direction, so it isn't searching for a title at all. My titles are sort of like a lasso; they're thrown into space.

The works, of course, vary in character, in poetic character. To what extent do you feel aware in building up one of the walls of its having a specific mood? Do you think about this at all or not?

Well, let me say this. Maybe I'm going to vary that question but come back to it. I never think that I'm making art; that would offend my kind of thinking. You see, I'm not making art, and we've had different discussions with artists and they said, 'Why don't you use white here and red here and this and that?' And I always say, 'Well, I'm not making art.' Then you might return and say, 'Well, then, what *are* you doing?' and

somewhere I can't quite answer it, but I hope that my work transcends making anything and I hope that there is a communication. It doesn't have to be sweet, it doesn't have to be not sweet, but it has to be valid.

And can you say what the validity of it consists in?

I think in the structure. We're not unaware of our heritage, on all levels. In other words, we're aware of art and its principles in the past. We're aware of architecture that stands, and of music. They all have their principles, their rules, or they wouldn't stand. And even when some of our very modern composers strike out, they are really striking out with a hope of finding a new order. And certainly I feel utterly in sympathy with that. I feel it has to be valid. Something has to stand, because we're still on two feet.

People looking at your work are very aware of its poetic quality, its mysterious quality. Your work gets likened to Emily Dickinson or to Marianne Moore. I don't know whether those comparisons make sense to you.

They certainly do.

To what extent in making the work do you allow yourself to be aware of these qualities?

First I am aware of the formal need for what really constitutes the work. But then I also feel that the very nature of one's nature has something to do with it, so if your nature is, let us assume, poetic, naturally it's going to be projected into it.

It seems to me that these still-life objects take on certain organic meanings when you start putting them together, that they acquire potency as images – say, of parts of the body or of flowers.

No, they're not to do with the human body or flowers; they're to do with themselves, as they are. I see if they are valid and right and I don't have to superimpose another thing.

20

1963

So there is nothing of a sort of Surrealist thinking about the ambiguity of certain forms?

Not in my thinking.

Where did you first get the idea of making these boxes and walls? What led up to them?

Way back in 1941 and '43 I had shows in New York with the Nierendorf Gallery and the Norlyst Gallery – the second was about the circus – and already I introduced this concept, you see. And already I used different materials: for example, mirrors, broken mirrors on wood, screwed on. And I also used electric lights for eyes, used sand, used glass marbles and different things. It still was a little bit radical and so, while it was liked and I got very nice reviews and everything, it wasn't established. I was using things that people have used later, yet it never dawned on me not to do it. They seemed like art to me, and they seemed right to me, and they seemed healthy. When I saw a great big beautiful beam that was being thrown out, it seemed healthy and wonderful. It made me healthy to just identify myself with it. And I didn't have to ask anyone, I just began using it. I had moved downtown, where artists lived, and I didn't have materials and I saw these. I've always been a very active person and I began using them and loved them: they seemed right for me. In the first place, my father was a builder and before that dealt in lumber; and second, so did my grandfather. And somehow it seemed natural. I don't think I was very analytical even. It seemed right and I identified. It was like a swimmer. You dive in and there you are.

What made you turn as you did from painting to sculpture?

Well, the only reason anyway that I went into painting is that I had certain time and the only time that I had was to go into painting. In other words, when I came to New York, say I had the mornings, well there are teachers, teaching painting, and it seemed right. It didn't matter what I would do, because I've always painted and from childhood I'd always drawn and always done etchings. But then I wanted a better definition of myself, and sculpture, while it had its limitations, also had its freedom.

Why do you say sculpture gave you greater freedom than painting?

Well, because it freed me, it limited me and freed me, with, say the cube, say the cone. It simplified and gave substance to me, and for instance, I was brought up in the country, in Maine, and I was overwhelmed as a child with too many trees, the forest and all. And, after I began to study painting, I could go back to the country and, since I recognised the light and the shade and the movement – in other words, things coming in front, and things coming in back – I wasn't overwhelmed because I had order. And that order has been sustaining me ever since. You see, now, for instance, in my sculpture – if you want to call it sculpture – I usually paint my work. I have different studios for different colours. I have a black studio, a white studio, a gold studio, so that my mind doesn't get confused. Because, when I go into the black studio, I don't put them together and then paint them, not at all. I sort of tint them and then use them, so that it won't confuse me, because if I used them in the raw, then painted them, they would have different dimensions and different textures. And that is for me a secret, and I've heard other artists and sculptors say: 'Why do you take so much time to dip these things, like a tie-dye? That's wood. You can put them together?' Well you can't and get the result you want.

Do you find sometimes that you're brought to a stop when working on a wall, because the sort of pieces that you want aren't there in the house, and that you have to wait until you find them?

Yes, that happens too, because, say, for instance, pieces of a certain size belong to a certain size box. And, if you don't have them, then you just can't do anything about it, because if you use smaller pieces it isn't quite right. But on the other hand, you see, there are a lot of leeways, because I've used boxes within boxes. There are so many ways, and when you're acquainted with these things, you can use them not necessarily in one way. You might break up a form or break up a box to get a certain texture or a rugged edge.

Do you feel that you have any sort of prejudices about the kind of furniture that you incorporate?

When I use a hat form or a toilet seat, once I am working on the translation they are no longer furniture, they are no longer what they were, and I would be embarrassed to think they were. They're no longer that at all and I choose them because they seem right.

So you want to detach these things from their particular associations, their origin, just as you don't want them to have overtones of the kind that Surrealists are interested in. You want them to become as absolute as possible? It's a very formal approach and you want the poetry to come of its own.

Exactly. Without any superimposition.

And you were saying that you tint the pieces before you put them together, so the particular colour is part of the concept from the start: there's no question of wondering whether the colour of a particular wall might be changed.

I have never changed any colour. I think that the material somehow cries out for the colour. There are certain forms that seem right for a certain colour. That's the way it has to be and it is that.

ADOLPH GOTTLIEB

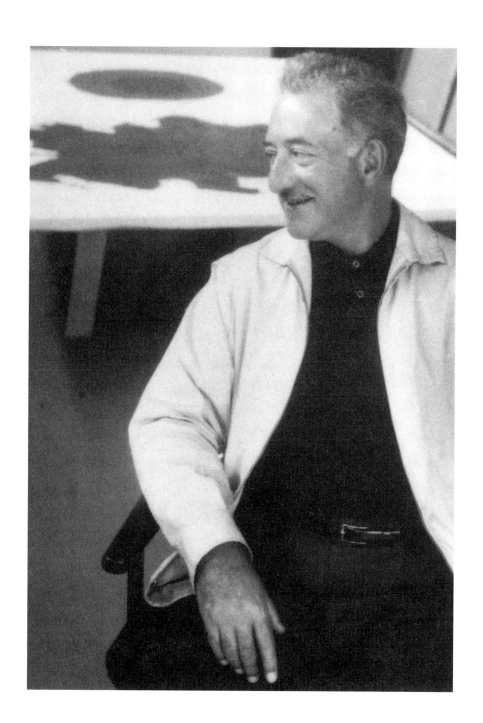

Recorded March 1960 in New York City. The version edited for broadcasting by the BBC was first published in *Living Arts*, June 1963. It is reprinted here with minor changes.

Adolph Gottlieb at East Hampton studio, c.1960.

ADOLPH GOTTLIEB 1960

DAVID SYLVESTER *One of the things that puzzles me about the New York School of painting is that it isn't exactly a movement. I mean normally with a movement one person's paintings aren't entirely distinguishable from others. You can confuse a Cubist Braque with a Cubist Picasso; you can confuse a Monet and a Sisley. But you can't mistake a Pollock for a Rothko. And yet we talk about the New York School as if it was more than just a generation of painters working in a particular place; we talk as if there were certain common aims. And I wish you could define what it is, if anything, that holds these painters together in spite of their entire differences of style.*

ADOLPH GOTTLIEB We have to keep in mind that what is called the New York School has been in existence since the early forties, a period of approximately fifteen years, and if you were to examine the work of the Cubist group fifteen years after the inception of Cubism, I think you would find that painters like Braque and Picasso, and others who were related to some extent with Cubism – like Matisse and Derain – ultimately, all these painters seem very different. This is not to say that the American painters of the New York group had a programme such as the Cubists had, or that any of them worked as closely as Braque and Picasso; however, I think it is very significant that recently I was at the home of Thomas Hess and he had a painting hanging there and I said to my wife, 'Is that one of my paintings?' And she said, 'Well, it looks like one of yours from around 1942.' But then, we realised that it wasn't one of mine but one of Baziotes's paintings. I don't mean to imply that I was influenced by Baziotes or he was influenced by me, but at that time, 1942, the differences in our painting may have seemed very great, but now the difference is not so great, apparently. For example, in the early forties Rothko and I decided to paint a certain subject matter. Perhaps if we saw some of those early paintings now which shared the same subject matter, they might not seem so different as they did at the time. However, at no point was there ever any sort of a doctrine or a programme or anything that would make a School – a conscious common denominator that made all the paintings have a relationship. I think it was simply a

situation in which all of the painters were at that time; they were trying to break away from certain things. There were also certain destructive impulses.

What in particular did you feel you were trying to destroy?

I felt that what it was necessary for me to destroy was the concept of what constituted a good painting at that time – in other words, the standard which existed, the measuring rod with which paintings were judged. And I felt that it was necessary to destroy this for myself because I felt that it didn't apply to anything that I was interested in. I thought the standards were false.

You are thinking of people like Benton, are you?

Yes. It was the standard that had been established by people like Benton and others of the American scene and Social Realist group of painters, and I think that these people established a pattern of what was considered to be good, upright, American painting of that time. Actually it was on its last legs. It was apparent that it had nothing more to offer, but this was a standard that existed in America at that time. Of course, people in the art world did have a high regard for French painting too, but it was felt that American art could exist independently of the international art of Europe and specifically Paris. So therefore I felt that it was a chauvinistic movement and rather ill-founded. It was parochial, regional. It did not represent the future of art at all.

You were reacting against two things simultaneously. On the one hand against the parochialism of the American social scene painters, and on the other hand, of the French idea of the well-made picture.

The French idea of the well-made picture was not so clean-cut as it appears to be today. Whereas today the French seem to have an idea of the well-made picture which to me represents the cuisine type of painting – well-cooked painting with a delicious sauce – during the forties I didn't think of French painting in that sense. I thought of painting, not as specifically French, but as European. Picasso was just as much a Spaniard

as a Frenchman. He represented French painting in a sense, true, but nevertheless painters like Picasso and Braque and Matisse and so on represented not only French painting but painting that functioned on an international level. It wasn't specifically French to me. It was the good painting of my time. And this was a standard that I could very much respect. And in addition to that, the standards were not only set by individuals but also in terms of movements such as the Cubist movement, the Surrealist movement and so forth. And these movements seemed to me, as an American, from the distance at which I viewed them, perhaps more organised and planned than they actually were.

The distances at which you viewed them in spite of the fact that you'd previously worked in Europe?

I hadn't really worked in Europe. I was in Europe when I was merely a boy. I was about eighteen and just beginning to become interested in painting, and then I went for a short trip in 1935 and I didn't work. I just looked while I was there. But I think more significant, perhaps, was the fact that during the war many of the Surrealists came to America and we were able to see them as just other human beings like ourselves and not as mythical characters who had superhuman capacities and talents. I think that there was a feeling after meeting them personally that, well, if these men can have these great achievements, there is hope for us. Prior to that we had accepted a colonial status and felt we could never equal the art which was produced in Europe.

What is it that you felt had to be done: to do something different, or to go further? Did you have any clear idea of what needed to be done?

I didn't have a clear idea. I was merely groping. I think I had a feeling that it was necessary for me as an individual to find my own identity and establish my own values and find sort of a new honesty, and be able to make some sort of a statement and stand on my own feet with that statement; and that it wasn't even necessary, perhaps, to make art for me but merely to make a statement with paint, because that was the only way that I could express myself. And if I could make some such statement which was an authentic statement on my part, perhaps this would become art.

Of course, you and your friends succeeded in reconciling a great many tendencies in European art of the first half of the century and using it with extraordinary freedom. I mean Miró and Picasso, Mondrian, perhaps something of Expressionism, a lot of Surrealism. You seemed to manage to use all this in quite a free and uninhibited way and to take what you needed from it. Can you explain how this happened? Because European artists of the same time, European artists of your generation, were in rather a mess after all that had been done by Picasso and Matisse, and yet you here seemed to get out of this mess.

The only possible explanation I have for it is that the situation was very desperate and everything seemed hopeless and we had nothing to lose, so that in a sense we were like people condemned to life imprisonment who make a dash for freedom. Nothing could have been worse than the situation in which we were, so we tried desperate things. We revolted in a way against everything, all of the standards; we didn't accept any standards. We were like the people who are nothing but chess players or tennis bums and who refuse to do anything useful. And we felt that we were willing to go all our lives and do this despised kind of painting without any hope of success. That was the way it was, and we accepted that; and most of us refused to assume the normal responsibilities of a respectable citizen. It wasn't completely reasoned out, it was simply something that we all felt a compulsion about and we just had no alternative.

One gets the sense even now, in a remarkable way, that here you are all successful and yet you're still mostly friendly, which is a bit of a miracle among painters, I must say. And one gets this sense of a strong allegiance and a strong sort of corporate spirit. It must have existed then and been more important then than it is now. You said you had no programme but was there a lot of theoretical discussion?

We had certain common assumptions. We hung around together and we also talked a lot about painting. The one thing we did agree upon was that a certain group of painters respected each other's work and I think that the same group of painters still respect each other's work; and I think that's why we have been able to remain friendly. Even though we may

disagree on specific works or have certain reservations about the other man's point of view, we nevertheless respect his talent and his integrity. That is why a particular group has more or less gone through this period of approximately fifteen years as a group.

But there must have been several things that you agreed on. What were they at the time? How did they change later?

For example, Rothko and I temporarily came to an agreement on the question of subject matter; if we were to do something which could develop in some direction other than the accepted directions of that time, it would be necessary to use different subjects to begin with and, around 1942, we embarked on a series of paintings that attempted to use mythological subject matter, preferably from Greek mythology. I did a series of paintings on the theme of Oedipus and Rothko did a series of paintings on other Greek themes. Now this is not to say that we were very absorbed in mythology, although at that time a great many writers, more than painters, were absorbed in the idea of myth in relation to art. However, it seemed that if one wanted to get away from such things as the American scene or Social Realism and perhaps Cubism, this offered a possibility of a way out, and the hope was that given a subject matter that was different, perhaps some new approach to painting, a technical approach, might also develop. And as it turned out, such a new approach did develop. At least, it was a different approach than either of us could have arrived at if we hadn't taken a radical departure with respect to subject matter. Well, eventually, of course, we did not remain loyal to the idea of using mythology and ancient fables as subjects because it immediately became apparent that, if you are dealing with the Oedipus myth, you're involved with Freud, Surrealism, etc.

Your recent paintings, of course, are freest of all of symbols: this very simple statement of two forms one above the other. And yet, on the other hand, it might be said, perhaps stupidly, that there are symbolic suggestions in the relation between these forms – male and female perhaps, or earth and sky, or anything like that. Is there anything of this for you in your recent paintings, or is it just a question of relating two forms on a canvas – which is, I suppose, the most difficult of all pictorial problems?

31

ADOLPH GOTTLIEB

Well, when I'm painting, of course the problem for me is to relate the two forms, and that is the problem with which I have been involved for the last several years. Obviously when I'm finished with a painting and I look at it, I am then a spectator and I can to a certain extent see it the way some other spectator will see it. I can see that everyone will have some associations. Now, if I were to feel strongly that there shouldn't be any associations, I could then revise my paintings and eliminate anything that would suggest some association, whether it is earth and sky, male or female, or some notion of celestial bodies or Sputniks. However, I don't feel strongly about that, I have no impulse to take a doctrinaire position, let us say, in favour of what we call a non-objective sort of painting.

These relations between two forms often have a strong feeling-tone. They may be related in one painting in a violent way, in another in a friendly way and another in a rather sexual way. Are you aware of this while you are actually painting?

Oh no, I'm not aware of it at all. When I'm painting I'm completely preoccupied with the technical problems. Furthermore, before I even start to paint I have to get myself charged, and this is something which I can only feel in a vague way. When I feel that I'm fully charged and ready to let go on the canvas, I'm not in a position to analyse and view myself in an objective way. I have to let my feelings go and it's only afterwards that I become aware of what my feelings really were. And for me this is one of the fascinations and great experiences of painting – that I become aware of myself and that in the process of painting I become more aware as a person.

In other words, it's painting towards self-discovery, not painting as a means of self-expression?

I think that's very true.

Coming to New York for the first time, I've had feelings in many ways that the painting of the New York School is as much rooted in the New York landscape and the kind of movement and pattern of New York as Impressionist painting is rooted in Argenteuil or Renaissance painting is

rooted in Tuscany. And certainly de Kooning has told me how much his painting owes to motifs taken from New York. Are you yourself conscious in your own painting of owing something to New York life? Do you think that the geographic qualities of New York have made you paint in a different way from what you might have been painting had you been on the West Coast or in the Middle West or in Europe? Are you conscious of any such thing?

Definitely I am. When I was in Paris last spring, my original plan was to go for four months and to paint there, and a number of people urged me to stay. They wanted to see what would happen, how my painting would change. But I felt strongly after being there less than a month that it was necessary for me to come back to New York, because I feel a certain rhythm in New York which I didn't feel in Paris. Everything about life in Paris is conducive to a lowered state of energy. It has a sedative effect, it is seductive. I had a tendency to become like everyone I saw in Paris – to become preoccupied with the excellence of food and drink. In New York, which is barbarous along those lines, I don't mind the poorer quality of material life: our food, which is much worse, and our hard liquor which is not as refined. I think that, aside from those things, there is a tempo in the life of New York which is exhilarating and I feel that this gets into one's painting.

You feel it is the pulse of the city rather than the look?

It's the pulse, not the look. I'm not involved with the external appearance of the city; it's the vibrations.

BARNETT NEWMAN

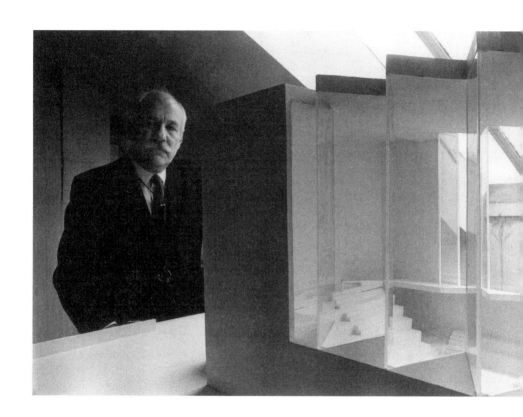

Recorded April 1965 in New York City. The version edited for broadcasting by the BBC was first published in the *Listener*, 10 August 1972. The present version has been edited from the transcript.

Barnett Newman at Treitel-Gratz Foundry, c.1965. Photograph by Ugo Mulas.

BARNETT NEWMAN 1965

DAVID SYLVESTER *When was it that you first did a painting with one or two simple lines, horizontal or vertical, across the surface?*

BARNETT NEWMAN I would say that it began in '46–'47. In those years, whenever I did a painting with one or two elements in it, it did always have a sense of an atmospheric background, I suppose – with the exception of a painting which I called *Euclidean Abyss*, where the background is black and has some white coming through, but there's no true atmosphere; and where I move to the edge, a yellow edge with a corner in it. For me it's a historic painting in terms of my own history, because there for the first time I moved to the edge, and the edge becomes lighter than the central section. Ostensibly it should have ended where the dark part ends, but I moved further to the actual edge of the canvas, and I felt that I'd moved to the edge but hadn't fallen off. But the painting where I had only the one symmetrical line in the centre of the canvas – with no atmosphere – I did in 1948 on my birthday. Later I gave it the title *Onement*.

What led you to such an extreme kind of form?

I don't paint in terms of preconceived systems, and what happened there was that I'd done this painting and stopped in order to find out what I had done, and I actually lived with that painting for almost a year trying to understand it. I realised that I'd made a statement which was affecting me and which was, I suppose, the beginning of my present life, because from then on I had to give up any relation to nature, as seen. That doesn't mean that I think my things are mathematical or removed from life. By 'nature' I mean something very specific. I think that some abstractions – for example, Kandinsky's – are really nature paintings. The triangles and the spheres or circles could be bottles. They could be trees, or buildings. I think that in *Euclidean Abyss* and *Onement* I removed myself from nature. But I did not remove myself from life. And I think I got myself involved in what I began to realise was the true thing in relation to life for

me, which in a sense was my life; and it became more personal.

In what way did that simple vertical give you this feeling that it related to your life? In a symbolic way? In a moral way?

Not in a moralistic way but in a moral way, in that it raised questions for me of the nature of myself in relation to the painting itself as an object, to the whole enterprise of painting as an activity. The problem of painting as a thing or as a window or as a vision of the world or as a living thing, and the moral crisis, I think, moved around the . . . It's hard to re-create the emotional equivalents of fifteen years back.

One thing does seem clear, I think. Up to then abstract painting seemed to present two distinct alternatives – the one using geometric forms and the one using free forms, biomorphic forms. Then you came along choosing neither alternative. A line that might have been straight was curved.

I don't think of it as a line, I think of it as a colour area that activates and gives life to the entire area of the painting. It's not a stylistic device, it's something that for me is more real. It permitted me to see myself and have a sense of my own reality. And that sense brings me to a deeper relation to the problem of nature. What we are actually trying to do is to say something that really is a metaphysical act, a metaphysical preoccupation in words, and it's not only difficult to talk about painting, but it's even more difficult to formulate an emotional complex which is tied up with a metaphysical experience, but I don't like to get involved really too deeply in these things, because they're hard to talk about without producing the impression that I'm involved in mysticism, which I'm not.

Let's consider the paintings with the narrow lines. You don't think of this vertical as a line; you think of it as a narrow band of colour. This, I take it, means that among other things you don't think of it as a line traversing a field but as a field between two other fields.

Yes. A field that brings to life the other fields, just as the other fields bring life to this so-called line. I think of line as a thing that involves certain

possibilities. It acts as a contour and moves in relation to a shape; it also acts as something that divides space. Also one has to remember that, in relation to the problem of line, an artist can only make, or a human can only make, two kinds of line: he can make a straight line or he can make a curved line. It's possible to combine those things, and you get a sort of a zigzag or you get a combination of lines that create a sense of a shape. But to me there is a difference between a shape and a form, between a shape and a confrontation of an area. To verbalise and articulate what I think the line did to me, what *Onement* made me realise, is that I was confronted for the first time, I suppose, really with the thing that I did, whereas up until that moment I was able to remove myself from the act of painting, or from the painting itself. The painting was something that I was making, whereas somehow for the first time with this painting, the painting itself had a life of its own in a way that I don't think the others did, as much. I think that the paintings that I did before this have a sense of life, but the thing I feel in relation to these paintings is that they are more removed, or most removed, from the problem of association with biomorphic or abstract shapes or any other kind of thing. I feel that I brought in a new way of seeing which could not have happened if I hadn't brought in a new way of drawing. I would like to make clear that I did not begin my old work or my newer work on the basis of a theoretical position, in relation to a way of drawing, a way of painting, a way of doing anything. I was fundamentally against all dogmatic positions. Having in my youth been an anarchist, a philosophical anarchist, I was against all dogmatic positions and I suppose that one way of describing my own feelings in relation to *Onement* is that it fortified me in this attitude towards life. It was a non-dogmatic painting, if that explains it. I don't really say you have to paint a painting by putting all of it in the centre. I don't really say there has to be a certain way, a certain size, that it has to be clean at the edges. I really don't know in that sense how to make a painting. I was once asked in the written symposium run by Tiger's Eye why I paint and I said: 'I paint so I'll have something to look at.' And sometimes I said: 'I write so I'll have something to read.'

One thing that I am involved in about painting is that the painting should give man a sense of place: that he knows he's there, so he's aware of himself. In that sense he relates to me when I made the painting because in that sense I was there. And one of the nicest things that

anybody ever said about my work is when you yourself said that standing in front of my paintings you had a sense of your own scale. This is what I think you meant, and this is what I have tried to do: that the onlooker in front of my painting knows that he's there. To me, the sense of place not only has a mystery but has that sense of metaphysical fact.

I certainly do get a sense, which is quite extraordinary, of just that. Perhaps it is metaphysical because I find it very difficult to explain. In some odd way, the relations on the canvas between, say, two vertical areas of black in relation to an area of white give me a curious sense of having some rightness of placing in relation to my own possible gestures.

I hope that my painting has the impact of giving someone, as it did me, the feeling of his own totality, of his own separateness, of his own individuality, and at the same time of his connection to others, who are also separate. And this problem of our being involved in the sense of self which also moves in relation to other selves . . . The disdain for the self is something I don't quite understand. I think you can only feel others if you have some sense of your own being.

I think that one does get the feeling in front of your paintings of valuing one's own being, a certain sense of exhilaration in one's own being. One also has a sense of the otherness of the painting which is a separate presence from oneself. Obviously, people find cause for resentment in the fact that there are entities in the world other than themselves, and they need to accept the otherness of others.

Yes.

The experience of your painting would certainly seem to me to be an analogy of this, though I find it very difficult to explain, and I suspect that you find it difficult to explain.

I was just going to say that if you find it difficult to explain, I find it even more difficult to explain. I remember an incident during my first show, in 1950, where a friend of mine, a painter, got terribly upset and had tears in his eyes and began to abuse me. And I said: 'What's the trouble?' He

said: 'You called me names, you made me aware of myself.' I said: 'Well, take it easy. I mean, everything is going to be all right.'

Why do you give some of your paintings titles such as Adam?

In titles I try to evoke the emotional complex that I was under: for example, with one of the paintings, which I call *Vir Heroicus Sublimis*, that man can be or is sublime in his relation to his sense of being aware. I give paintings titles actually because I think they have some meaning. I try in the title to create a metaphor that will in some way correspond to what I think is the feeling and the meaning.

Does your sense of the feeling in a particular work come to you while painting it or after you're finished?

The verbalised title comes after I've finished. The test of the title naturally has to do with what I felt I was expressing at the time.

And while working on a painting are you conscious of developing that expression of a particular feeling?

When one becomes totally absorbed in the painting, the painting has a relation to one which is extremely complicated and, I think, quite profound. It would be impossible if I were in the middle of a painting for anybody to say: 'Well, what do you think of it? What do you call it?' At the same time, as the painting progresses and as it's finished, I do have a relation to it which in some way gives me the clue to its title. In other words, I'm not involved in formal exercises, so it's not a question of only giving it a title that is a handle for others to use. I think that the painting itself confronts me as a very particular thing, and I try to give it a title which for me evokes the emotional content, and I hope is a clue to others. But I do think that the paintings should have their impact in terms of their emotion without the title. I'm not illustrating an emotion. The problem of a painting is physical and metaphysical, the same as I think life is physical and metaphysical. It's no different, really, from one's feeling in relation to meeting another person. One has a reaction to the person physically; also I do believe that there's a metaphysical thing in the

fact that people meet and see each other, and if a meeting of people is meaningful it affects both their lives. And to be able to say what really affects both their lives, as we are trying to do here, is extremely difficult.

But you are *saying that the kind of sense of life which you feel in a painting is of the same order?*

Yes. Otherwise we would be creating either fetishes or images or objects.

WILLEM DE KOONING

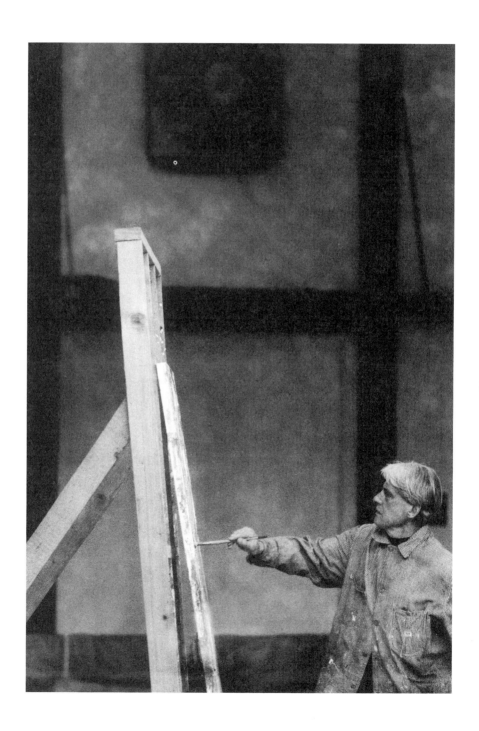

Recorded March 1960 in New York City. A monologue assembled from excerpts and entitled 'Content is a Glimpse' was first published in *Location*, Spring 1963. The version edited for broadcasting by the BBC is published here, with minor changes, for the first time.

Willem de Kooning painting in his new studio, The Springs, New York, 1964. Photograph by Dan Budnik.

WILLEM DE KOONING 1960

DAVID SYLVESTER *Your position must be unique among the painters of the so-called New York School in that you're the only one of the leading painters who was neither born here nor came here as a child nor came here as a refugee. That is to say, you came here by your own choice, when you were about twenty, twenty-one.*

WILLEM DE KOONING Twenty-one years old.

Most people leaving Holland would have gone and stayed in Paris, and you chose to come here. Did you have any desire to go to Paris?

Not particularly, no. In those days when we went to the Academy, doing painting, decorating, you know, making a living, the young artists, they were not interested in painting *per se*. You used to call that, you know, good for men with beards. And the idea of a palette with colours on it, was rather silly. At that time, we were influenced by the de Stijl group. The idea of being a modern person wasn't really being an artist in the sense of being a painter. And so it wasn't really so illogical to come to America. And also, being young, I really didn't understand the nature of painting. I really intended to become an applied artist. I mean it was more logical to be a designer or a commercial artist. I didn't intend to be really a painter. That came later.

When did that come?

Well, first of all I didn't expect that there were any artists here. We never heard in Holland in those days that there were artists in America. There was still that feeling like that was the place where an individual could get places and become well off, if you work hard; art was naturally in Europe. But very soon when I was here for about six months or a year I found out that there were a lot of artists here too. There was a Greenwich Village; there was a whole tradition of painting and poetry; I just didn't know about it, and it must have directed me back to the interests I had when I

was fourteen, fifteen, sixteen years old. I must have got an idea when you're about nineteen and twenty that you really want to go up in the world and you don't mind giving up art. I was here only about three days and I got a job in Hoboken as a house painter. I made nine dollars a day, which was quite a large salary, and after being around four or five months doing that, I started looking for a job doing applied art work. I made some samples and I was hired immediately. I didn't even ask them the salary because I thought if I made a few dollars a day as a house painter, I would make at least twenty dollars a day being an artist, you know. And then in the end of two weeks, the man gave me twenty-five dollars and I was so astonished I asked him if that was a day's pay and he says, no, that's for the whole week. And I immediately quit and then went back to house painting. So it took quite a while for me to make that shift from being a Sunday painter, you know, working most of the time and painting once in a while, until I was able to paint longer periods and take odd jobs here and there on the side.

About when did this begin to happen?

I really don't know. It was a gradual development but it was really more of a psychological attitude. In other words, the amount of painting and amount of working would be equivalent to one another more or less. It was just an attitude that it was better to say, no, I'm an artist, I have to do something on the side to make a living. Do you see what I mean? So I styled myself as an artist and it was very difficult. But it was a much better state of mind.

When the Depression came were you involved in the WPA?

Oh yes. When the Depression came, I got in the WPA. Of course that went over a period of quite some years on and off, and then I met all kinds of other painters and sculptors and writers and poets and architects, and all in the same boat because America never really cared much for people who do those kind of things. I was on the project probably a year or a year and a half, and that really made it stick, this attitude, you know, because the amount of money we made on the project was rather fair, you know. In the Depression days one could live

modestly and nicely. And so I felt, well, I have to just keep doing that. The decision to take was, was it worth it that I should put all my eggs in one basket, that kind of basket of art. I didn't know if I really was competent enough, if I felt it enough.

Did you make contact with people like Pollock at that time?

No, they came later. They were younger men. I was in it lots before them, you know. No, the one I really met was Arshile Gorky.

You met him when?

I met him in 1929. Of course, I met a lot of artists, but then I met Gorky. Well, I had some training in Holland, quite a training, you know, the Academy. And then I met Gorky, who didn't have that at all, he came from no place. He came here when he was sixteen, from Tiflis, in Georgia, with an Armenian upbringing. And for some mysterious reason, he knew lots more about painting, and art, he just knew it by nature – things I was supposed to know and feel and understand – he really did it better. He had an extraordinary gift for hitting the nail on the head, very remarkable, so I immediately attached myself to him and we became very good friends. It was nice to be foreigners meeting in some new place. Of course, New York is really like a Byzantine city – it is really very natural too. I mean, it is probably one of the reasons why I came myself, without knowing. When I was a child I was very much interested in America; it was like a romantic . . . you know, cowboys and Indians. Even the shield, the kind of medieval shield they have, with the stars on top and the stripes on the bottom, like it was almost the heraldic period of the Crusaders, isn't it, the eagle – and as a child I used to be absolutely fascinated with this image.

Are you conscious of your sort of European formation?

No, I'm not conscious of it at all.

You're not?

Now that is all over. It's not so much that I'm an American; I'm a New Yorker. You know, I think we have gone back to the cities and I feel much more in common with an artist in London, or Paris. It is a certain burden this American-ness, a sense of . . . I know if you come from a small nation, you don't have that. When I went to the Academy and I was drawing from the nude, I was making the drawing, not Holland, do you see what I mean? It was getting a little bit of a bore. I feel sometimes as an artist must feel, like a baseball player or something. Members of a team writing American history. Do you know what I mean? I mean . . . got all the respect, and somehow the artist . . . I think it is kind of nice that at least part of the public is proud that they have their own sports and things like that – and why not their own art? I think it's wonderful that you know where you came from – I mean, you know, if you are American you are an American.

When you started to paint the Women, *you were doing something much more overtly figurative than any of the other Abstract Expressionists had been doing?*

Yes.

This must have made you feel you were out on a limb?

Yes, they attacked me for that, certain artists and critics. But I felt this was their problem, not mine. I don't really feel like a non-objective painter at all. I just visited in San Francisco and Diebenkorn and Bischoff and fellows like that who paint now, they feel they have to go *back* to the figure, and that word 'figure' becomes such a ridiculous omen. In a way, if you pick up some paint with your brush and make somebody's nose with it, this is rather ridiculous when you think of it, theoretically or philosophically. It's really absurd to make an image, like a human image, with paint today, when you think about it, since we have this problem of doing or not doing it. But then all of a sudden it was even more absurd not to do it. So I fear that I'll have to follow my desires.

So it was a simple desire, then, doing the Women? *It wasn't a moral decision, it wasn't a theoretical decision; it was just a desire?*

1960

Yes. It had to do with the female painted through all the ages, all those idols. And maybe I was stuck to a certain extent, that I couldn't go on, and it did one thing for me: it eliminated composition, arrangement, relationships, light – I mean all this silly talk about light, colour and form. Because there was this thing I wanted to get hold of. I put it in the centre of the canvas, you know, because there was no reason to put it a bit on the side – do you see what I mean? So I thought I might as well stick to the idea that it's got two eyes, a nose and mouth and neck. So I go to the anatomy and I felt myself almost getting flustered. I really could never get hold of it. I mean, it kind of almost petered out. I never could complete it and, when I think of it now, it wasn't such a bright idea. But, well, I don't think artists have particularly bright ideas. Matisse's *Women in Blue*, *Woman in a Red Blouse*, or something, you know – what an idea this is! Or the Cubists. When you think about it now, it is so silly to look at an object from many angles. It's very silly. It's good that they got those ideas because it is enough for some of them to become good artists.

And why do you think it especially silly to paint the Women?

It is a thing in art that has been done over and over, the idol, the Venus, the nude. You know Rembrandt wanted to paint an old man, a wrinkled old guy – that was painting to him. He got an idea about painting, he thought he wanted to paint this guy with the wrinkles, you know what I mean? No, the artists are in the state of a belated Age of Reason. They want to get hold of things, like Mondrian. He was a fantastic artist, but now when we read his ideas and his idea of neo-plasticism, pure plasticity, it's kind of silly, I think. I mean, not for him, but I think one could spend one's life having this desire to be in and outside at the same time. He could see a future life and a future city – not like me, who am absolutely not interested in seeing the future city. I'm perfectly happy to be alive now.

Were you troubled while you were actually painting them by the absurdity of doing this thing again which had been done so many times before?

Oh yes. It became compulsive in the sense of not being able to get hold of it and the idea that it really is very funny, you know, to get stuck with a

49

woman's knees, for instance. You say, what the hell am I going to do with that now, you know what I mean, it's really ridiculous, and it may be that it fascinates me, that it isn't supposed to be done. I knew there were a lot of people, they paint a figure because they feel it ought to be done, because since they're a human being themselves, they feel they ought to make another one, a substitute. I haven't got that interest at all. I really think it's sort of silly to do it. But, like I said before, at the moment you take this attitude, it's just as silly not to do it. One has to have one's own convictions. I don't have those things like, I imagine, Mark Rothko.

But, when you were painting them, you said you found the problem of having to deal with a very specific subject stopped you from having to worry about aesthetic problems in the painting. It stopped you from having to think too much about problems of picture-making.

Well, yes, but in another way it became a problem of picture-making, because the very fact that it had a word connected with it – 'figure of a woman' – made it more precise. Perhaps I am more of a novelist than a poet. I don't know; but I always like the word in painting, you know.

You like the word in painting?

In painting, yes. I like the word in painting.

You mean, you like the forms to be identifiable?

Well, they ought to have an emotion of a concrete experience. I mean, like I am very happy to see that grass is green – you see what I mean? Like at one time, it was very daring to make a figure red or blue. I think now it is just as daring to make it flesh-coloured. I found that out for myself. Content, if you want to say, is a glimpse of something, an encounter, you know, like a flash – it's very tiny, very tiny, content. When I was painting those figures, I was thinking about Gertrude Stein, like they were ladies of Gertrude Stein. Like one of them would say: how do you like me? Then I could sustain this thing all the time because it could change all the time. She could almost go upside down, or not be there, or come back again; she could be any size. Do you understand? Because this content could

50

take care of almost anything that could happen, you know; and I still have it now from some fleeting thing – like when one passes something, you know, and it makes an impression.

But the impact? You weren't concerned to get a particular kind of drama or a particular kind of feeling?

No. I look at them now: they look vociferous and ferocious, and I think it had to do with the idea of the idol, you know, the oracle, and above all the hilariousness of it. I do think that if I don't look upon life that way, I won't know how to keep on being around.

So there was no question of any sort of attempt to make a comment on the age?

No. Oh, it maybe turned out that way, and maybe subconsciously when I'm doing it. But I couldn't be that corny.

It has been said that to some extent these paintings have a relation to current popular mythology. You remember Tom Hess's phrase, 'a Michelangelo Sibyl who has read Moon Mullins'. Were you conscious of this in painting them?

A little, yes.

In one of the first studies you collaged in a mouth cut out of an ad.

Yes. That helped me. I cut out a lot of mouths. First of all, I felt everything ought to have a mouth. Maybe it was like a pun, you know what I mean, but maybe it's even sexual, or whatever it is, I don't know. But anyhow I used to cut out a lot of mouths and then I painted those figures and then I put the mouth more or less in the place where it was supposed to be. It always turned out to be very beautiful and it helped me immensely to have this real thing. I don't know why I did it with the mouth. Maybe the grin. It's rather like the Mesopotamian idols, you know. They always stand up straight looking to the sky with this smile, like they were just astonished about the forces of nature, you feel – not about problems they had with one another. That I was very conscious of;

and it was something to hang on to.

Because the mouth always stayed pretty well the same.

I wouldn't know what to do with the rest, you know, with the hands maybe, or some gesture. And then in the end I failed, you see, but it didn't bother me because I'd in the end give it up, and I felt it was really an accomplishment. I took the attitude that I was going to succeed and I also knew that this was just an illusion.

Do you feel that the paintings are failures?

I never was interested, you know, how to make a good painting. For many years I was not interested in making a good painting, you know, like you could say: now this is really a good painting or a perfect work. I didn't want to pin it down at all. I was interested in that before, but I found out it was not my nature.

That's one of the big differences, isn't it, between post-war and pre-war thinking: that we now accept imperfection and we no longer have Flaubert as an ideal but rather Dostoyevsky.

Yes.

You just threw it out and let it go and you knew it was imperfect.

Yes, and I have worked on it probably just as long as they did. Not with the idea of perfection but to see how far one could go, you know – but not with the idea of really doing it.

But always with the aim of trying to get this impact on to the canvas?

Yes. Anxiousness and dedication to fright maybe, or ecstasy, you know, like *The Divine Comedy*. To be like a performer; to see how long you can stay on the stage, with that imaginary audience.

The pictures done since the Women, *are they all landscapes? A lot of them*

are just called Painting *or* Untitled, *aren't they? But they are not, in any case, non-objective; or are they in some cases?*

No, they're emotions, most of them, the later ones. Most of them are landscapes and highways and sensations of that, outside the city. With the feeling of going to the city or coming from it, you know. In other words, I'm not a pastoral character, you know, I'm not a – how do you say that? – 'country dumpling'. I am here and I like it in New York City, but I love to go out in a car. I'm crazy about weekend drives even if I drive in the middle of the week. I'm just crazy about going over the roads and highways and . . .

In those landscapes, is it the sensation at times of things seen while you are in movement?

Well, in *Merritt Parkway* I was doing that, but that came almost incidentally in the sense that I love to be on those highways. And they are really not very pretty, but the big embankments and the shoulders of the roads and the curves are flawless – the lawning of it, the grass. This I don't particularly like, or dislike, but I wholly approve of it. Like the signs. Most people want to take those signs away – and it would break my heart. You know, all those different big billboards. There are places in Connecticut and New England where they are not allowed to put those signs, I think, and that's nice too, but I love those grotesque signs. I mean, I am not undertaking any social . . . I'm no lover of the new; it's a personal thing.

But in the parkway pictures you really wanted to convey the sensation of something seen from a moving car?

Well, I didn't intend to do that but, when I was working on this picture, this thing came to me: it's just like the Merritt Parkway.

So you didn't intend to paint the Merritt Parkway.

No, but I'm there in those kind of places.

So in these paintings what sort of an idea do you begin with?

I don't think I set out to do anything. But I find, because of modern painting, that things which couldn't be seen in terms of painting, things you couldn't paint . . . it's not that you paint them but it is the connection. I imagine that Cézanne, when he painted a ginger pot and apples and ordinary everyday wine bottles, must have been very grotesque in his day, because a still life was something set up of beautiful things. It may be very difficult, for instance, to put a Rheingold bottled beer on the table and a couple of glasses and a package of Lucky Strike. I mean, you know, there are certain things you cannot paint at a particular time, and it takes a certain attitude how to see those things, in terms of art. You feel those things personally and, inasmuch as I should set out to paint Merritt Parkway years ago, it seems I must have liked it so much I must have subconsciously found a way of setting it down on paper, on canvas. It could be that. I'm not sure.

The idea of what is possible, this works itself out for you in the act of painting?

Yes.

Not before you begin to paint?

No. Well, now I can make some highways, maybe. Well, now I can set out to do it and maybe it will be a painting of something else. Because, if you know the measure of something, for yourself . . . There's no absolute measure that you can identify yourself. You can find the size of something. You say, now, that's just this length, and immediately with that length you can paint, well, a cat maybe. If you understand one thing, you can use it for something else. Well, that is the way I work. I get hold of a certain kind of area or measure or size and then I can use it. I mean, I have an attitude. I have to have an attitude.

And this isn't merely something that you recognise after the picture is finished? This thing becomes conscious for you while you are in the course of painting a picture?

I feel now, if I think of it, it will come out in the painting. In other words, if I want to make the whole painting look like a puddle, you know, like a lot of puddles, for instance – maybe the end of the day, when everything is very light but not in sunlight necessarily – and so, if you have this image of this puddle and if I really think about it, it will come out in the painting.

And do you think about it?

Yes. I would, yes. That doesn't mean that people notice a puddle but I know when I succeed in it the painting would have this.

Does it matter to you whether other people see?

No, I don't mind.

It's sufficient that other people should get the painting as a configuration of forms.

Yes. They can interpret it their ways. I mean, it is all right.

But in taking the picture to a conclusion and finishing a picture, are you conscious, as you were with the Women, *of making it correspond with the impact of its subject or do you simply work it out in terms of itself as an internal harmony?*

Well, I said before, I never intended to succeed with it, but the emotion must be there.

It's not merely to make it work within itself?

No. Not for the sake of painting or art, you know; because then I wouldn't be able to paint.

So there is always a desire to make the painting correspond with a remembered experience?

A lot of it, yes. More like that now. I get freer. I feel I am getting more myself in the sense of I have all my forces. I hope so, anyhow. I have this sort of feeling that I am all there now and, you know, it's not even thinking in terms of one's limitations, because they have to come naturally. I think whatever you have, you can do wonders with it, if you accept them. And I feel with the help of all the other artists around me doing all these different things, I wouldn't know how to pin it down. But I have a bigger feeling now of freedom. I am more convinced, you know, of picking up the paint and the brush and drumming it out.

May I ask you this question again that I asked you before about the point of departure? Is it a simple desire, say, to paint a green picture or to paint a blue picture? Do you begin with the idea of using a particular colour or a particular shape on the canvas?

No. I make a little mystique for myself there. Since I have no preference or so-called sense of colour, you know, I could take almost anything that could be some accident of a previous painting. Or I set out to make a series. There are pictures where I take a colour, some arbitrary colour I took from some place. Well, this is grey, maybe, and I mix the colour for that, and then I find out when I am through with getting the colour the way I want it to be that I had six other colours in it to get that colour. And then I take those six colours and I use them also with this colour. Now, that's silly, isn't it? But I figure: why not? You know, the paint manufacturers are so incredible nowadays that you go to a store, it is too vast, there is too much of everything. You can probably buy I don't know how many different shades and pigments and qualities, and it is a burden. So I hope to limit myself and enlarge slowly. It is probably like, you know, I imagine a composer does a variation on a certain theme. But it isn't technical. It isn't just like found because, if I am interested in this puddle, I'm not going to find it in any place.

So it's only when you've been working on the picture for a certain amount of time that you begin to see what the picture is going to refer to?

Not always. Sometimes I set out with that idea, but most of the time when I do that, I find something else. I have this measure, you see, so it's

no contradiction really. All these things are already in art and, if you can, even if you go to the Academy or go to students and you really can do it and you get the point and you can . . . Well, you know how to draw a basket, you see. I know I got somewhere that Rubens said for students not to draw from life, to draw from all the casts of the great classic works and you really get the measure of them. You really know what to do. And then you put in your own dimples. Isn't that marvellous? You see. Now, of course, we don't do that. You've developed a little culture for yourself, like yoghurt; as long as you keep something of the original microbes, the original thing in it, it will grow out. So I had this original – like most artists have – this little sensation, so I don't have to worry about getting stuck, you see?

And what makes you feel that a painting is finished? When do you leave a picture alone?

Well, I always have a miserable time over it. But it is getting better now.

But what is the criterion by which you know you can stop the painting?

Oh, I really . . . I just stop, you know. I sometimes get rather hysterical and because of that I find sometimes a terrific picture. As a matter of fact that's probably the real thing but I couldn't set out to do that, you know. I set out even keeping that in mind that this thing will be a flop in all probability and, you know, it sometimes turns out very good.

But for you the coming off of a thing involves a correspondence with an experience outside painting, does it?

Yes. Yes. Oh yes. Well, that's painting to me.

FRANZ KLINE

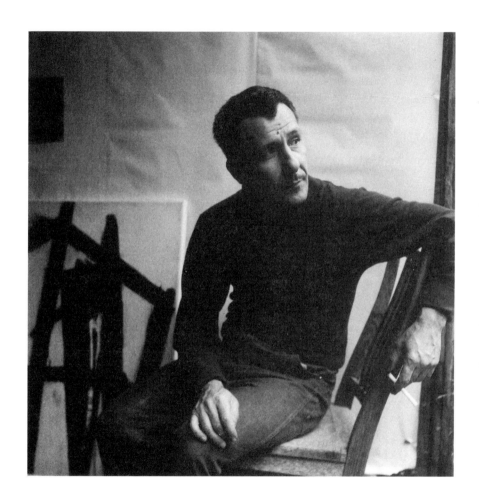

Recorded March 1960 in New York City. The version edited for broadcasting by the BBC was first published in *Living Arts*, Spring 1963. It is reprinted here with minor changes.

Franz Kline, photograph by Hans Namuth, 1954.

FRANZ KLINE 1960

FRANZ KLINE It wasn't a question of deciding to do a black-and-white painting. I think there was a time when the original forms that finally came out in black and white were in colour and then as time went on I painted them out and made them black and white. And then, when they got that way, I just liked them, you know. I mean there was that marvellous twenty-minute experience of thinking, well, all my life has been wasted but this is marvellous – that sort of thing.

DAVID SYLVESTER *During the time that you were producing only black-and-white paintings, were you ever using colour and then painting over it with black?*

No, they started off that way. I didn't have a particularly strong desire to use colour, say, in the lights or darks of a black-and-white painting, although what happened is that accidentally they look that way. Sometimes a black, because of the quantity of it or the mass or the volume, looks as though it may be a blue-black, as if there were blue mixed in with the black, or as though it were a brown-black or a red-black. No, I didn't have any idea of mixing up different kinds of blacks. As a matter of fact, I just used any black that I could get hold of.

And the whites the same way?

The whites the same way. The whites, of course, turned yellow, and many people call your attention to that, you know; they want white to stay white for ever. It doesn't bother me whether it does or not. It's still white compared to the black.

It's still white compared to the black.

But I've noticed something with other artists who do use the whole range of forms of colours and black – in Albers, for instance, who experiments with yellow, red, blue, the whole scale. Of course I love his colour

paintings, but when I see a black-and-white such as *The Homage to a Black and White Square*, I like that best, you know. I think it has something to do with deciding just exactly what you really like best. You can say, well, of course, I love this and that and so on. There's always that wonderful element of doubt. I like the black painters really, even if they did work in colour.

Who are the black painters?

Well, Velázquez is a black painter and he, of course, was probably one of the few great colourists. And also Tintoretto, and Rembrandt . . .

Is Goya a black painter?

Goya, yes.

Is it the case that you have been very much consciously concerned with equalising the black and white on the canvas to make them part of the surface?

No, no. When that finally came across me, it was through reading somebody talking about it that way. People have written on that, when they've brought in that everything is the same, brought in a little of Zen, and space, and the infinite illusion of form in space. No, I don't think about it that way. I mean, I don't think about it either as calligraphy or infinite space. Coming from the tradition of painting the areas which, I think, came to its reality here through the work of Mondrian – in other words, everything was equally painted – I don't mean that it's equalised, but I mean the white or the space is painted, it's not . . .

Black on white?

That's right. In other words, calligraphy is simply the art of writing.

A black form on a white ground?

Yes. You don't make the letter 'C' and then fill the white in the circle.

When people describe forms of painting in the calligraphic sense they really mean the linear, inscribing a drawing and so on. No, I didn't have this feeling that painting was the equalisation of the proportions of black or the design of black against a form of white; but, in a lot of cases, apparently it does look that way. I rather imagine as people have come from the tradition of looking at drawing, they look at the lines, until you go to art school and then some drawing teacher tells you to look at the white spaces in it; but I didn't think about the black-and-white paintings as coming that way. I thought about it in a certain sense of the awkwardness of 'not-balance', the tentative reality of lack of balance in it. The unknown reason why a form would be there and look just like that and not meaning anything particularly, would, in some haphazard way, be related to something else that you didn't plan either. You see?

And you have never, at any time, really attempted to sort of clinch the black and white.

No, I don't like to manipulate the paint in any way in which it doesn't normally happen. In other words, I wouldn't paint an area to make texture, you see? And I wouldn't decide to scumble an area to make it more interesting to meet another area which isn't interesting enough. I love the idea of the thing happening that way and through the painting of it, the form of the black or the white come about in exactly that way, plastically.

But there is no sort of preconception as to what the thing ought to be?

No. Except – except paint never seems to behave the same. Even the same paint doesn't, you know. In other words, if you use the same white or black or red, through the use of it, it never seems to be the same. It doesn't dry the same. It doesn't stay there and look at you the same way. Other things seem to affect it. There seems to be something that you can do so much with paint and after that you start murdering it. There are moments or periods when it would be wonderful to plan something and do it and have the thing only do what you planned to do, and then, there are other times when the destruction of those planned things becomes interesting to you. So then, it becomes a question of destroying – of

destroying the planned form; it's like an escape, it's something to do; something to begin the situation. You yourself, you don't decide, but if you want to paint you have to find out some way to start this thing off, whether it's painting it out or putting it in, and so on.

But what about stopping it? I mean, when you decide that you're going to leave a painting alone, can you in any way rationalise or explain what it is about it that satisfies you?

It can at times become like the immediate experience of beginning it; in other words, I can begin a painting if I decide it would be nice to have a large triangle come up and meet something that goes across like this. Now, on other occasions, I can think the whole thing through. The triangle needs an area that goes this way and then at the top something falls down and hits about here and then goes over there. So I try and rid my mind of anything else and attack it immediately from that complete situation. Other times, I can begin it with just the triangle meeting a large form that goes over that way, and when I do it, it doesn't seem like anything. When this series of relationships that go on in the painting relate – I don't particularly know what they relate to – but the relationship of those forms, I, in some way, try to form them in the original conception of what I rather imagined they would look like. Well then, at times, it's a question of maybe making them more than that. You see what I mean. It'd be a question of, say, eliminating the top or the bottom. Well, I can go through and destroy the whole painting completely without even going back to this original situation of a triangle and a long line, which seems to appear somewhere else in the painting. When it appears the way I originally thought it should, boy! then it's wonderful.

But it seems to you to relate?

Yes. But it's not an illusionistic thing. It just seems as though there are forms in some experience in your life that have an excitement for you. I remember years ago in Spurrier's class; he, being an illustrator, the idea was to take a subject or a story and do something about this thing so that when somebody picked up a magazine, they looked at the illustration and

they thought, 'Terrific, I'll read that.' The particular subject that we were to handle had to with a scene in the railway station in the first war, with soldiers, and the engine coming into a French village. Well then, I knew exactly, not exactly what an engine looked like but there was something to draw, you know. I mean that was completely different from someone saying: 'A girl sat on the divan and said, "Henry, I love you, darling".' Those sort of forms in your experience do, in some way not dominate, but they become the things that you are involved with. I don't mean that squares become windows; after all, squares become heads, they become everything, you know. I don't mean it in that sense. A curved line or a rhythmical relationship do have, in some way, some psychological bearing, not only on the person who looks at them after they've been conceived but also they do have a lot to do with the creative being who is involved with wondering just how exciting it can be. And then, of course, the elimination and agitation and the simplification come in through the many varied experiences that go on just through the experience of painting. The painting itself has something to do with it, rather than thinking about it just being the fact that you like to do a heavy palette knife painting. In other words, you try out some way in which things do meet your excitement about doing them. Even if you can't do them very well, there is something terrific about the tenacity of the form that won't allow you to do it.

How do you want your pictures to be read? Are they to be read as referring to something outside themselves? Do you mind whether they are? Do you mind whether they're not?

No, I don't mind whether they are or whether they're not. No, if someone says, 'that looks like a bridge', it doesn't bother me really. A lot of them do.

And at what point in doing them are you aware that they might look like a bridge?

Well, I like bridges.

So you might be aware quite early on?

Yes, but then I – just because things look like bridges, I mean . . .
Naturally, if you title them something associated with that, then when
someone looks at it in the literary sense, he says, 'he's a bridge painter',
you know.

*And do you ever encourage an image along? Consciously? Do you ever nurse
it?*

No, no. There are forms that are figurative to me, and if they develop into
a figurative image that's – it's all right if they do. I don't have the feeling
that something has to be completely non-associative as far as a figure
form is concerned.

*But do you have a feeling that they have to be associative either? I mean the
way that de Kooning in his outdoor paintings in the last two years wants
them, really wants them, to correspond to experiences of parkways and . . .
You don't think in those terms.*

I think that if you use long lines, they become – what could they be? The
only thing they could be is either highways or architecture or bridges.

*If somebody were to say to you that they felt that one of the excitements of
your painting was this kind of sense of city life that it has . . .*

Oh, I like that because I like the city better than I do the country.

*But would that seem to you to be an irrelevant or a relevant response to your
paintings?*

No, that's all right. After all I've lived here – I've lived in New York for
twenty years. Years ago, when I went out with a paintbox, I painted from
roof-tops and I painted from studio windows; so, the last recollection I
have of objective painting has been in the city, you see.

*What about the titles of your paintings? Do you title them yourself or are
they titled by Sidney Janis?*

66

I title them myself – I can always think of about four titles. After that, they become 'Girl with Red Rose' or something like that, or they become a descriptive thing about the painting; so Sidney, who does have this remarkable way in which he can say 'Bridge' or 'Foursquare' or 'Black' . . . I don't think about it that way. As a matter of fact in a lot of cases I really don't know what to call them but I have painted many pictures that were untitled or even called by numbers, you see, or just called by the colours or the tone.

Are you conscious of particular paintings having particular feeling-tones? Particular emotional content? That some of them might be, say, angry; that one of them might be cheerful, that some of them might be sad?

Yes.

You do feel them that way?

Yes.

Is this important for you?

Yes. As a matter of fact it is nice to paint a happy picture after a sad one. I think that there is a kind of loneliness in a lot of them which I don't think about as the fact that I'm lonely and therefore I paint lonely pictures, but I like kind of lonely things anyhow; so if the forms express that to me, there is a certain excitement that I have about that. Any composition – you know, the overall reality of that does have something to do with it; the impending forms of something do maybe have a brooding quality, whereas in other forms they would be called or considered happier.

Are you aware of these qualities when you are actually painting or only after you have finished the painting?

No, I'm aware of them as I paint. I don't mean that I retain those. What I try to do is to create the painting so that the overall thing has that particular emotion; not particularly just the forms in it.

But you do try to retain a certain emotion in the overall thing?

Yes.

An emotion you might be able to name while you are painting it?

Yes, at times, yes.

That you might do something in a painting because you wanted to preserve a particular brooding quality?

Yes, I think it has to do with the movement, even though it can be static. In other words, there's a particular static or heavy form that can have a look to it, an experience translated through the form; so then it does have a mood. And when that is there, well then it becomes a painting whereas all the other pictures that have far more interesting shapes and so on, don't become that to me.

So if there was one sort of criterion for you, the success of a painting that you were doing, would it be this, that it conveyed a particular mood?

Yes, that could be one of the aspects of it. I mean, there are other paintings that become irrevocable . . . in other words, there couldn't be a thing either added or taken away.

A lot has been made of this thing of spontaneity in Abstract Expressionism, but you make a lot of use of preliminary drawing in your painting.

I rather feel that painting is a form of drawing and the painting that I like has a form of drawing to it. I don't see how it could be disassociated from the nature of drawing. As to whether you rush up to the canvas and knock yourself out right away or you use something . . . I find that in many cases a drawing has been the subject of the painting – that would be a preliminary stage to that particular painting. I've taken drawings I like, but I've also worked with drawings that I didn't think very good.

When you decide to use a drawing for a painting, are you interested in that

drawing because it already seems to contain a certain mood?

Sometimes, yes.

And in what happens in the painting does this mood often become transformed?

Yes, quite often it does. The painting can develop into something that is not at all related to the drawing and have no particular mood about it at all. It's just a cool kind of reality that has a series of involvements within it; and the pure excitement of those things happening within this form is enough for that particular painting. The other thing is that it depends apparently on the scale of things. When I started first to work large, what I thought was large then – in other words, six by eight feet was a pretty large canvas then—

What – about 1950?

That's right. So a friend of mine let me borrow some money from him and we wound up buying eleven yards of canvas for forty dollars, and that was an awful lot of canvas. Most artists wouldn't use up that in their life. So then the situation came of previous years of not having canvas; then there was that excitement about painting over old paintings and using the things underneath that rather kidded you along, you know, and there was a nice texture, and the whole thing became another process of painting. Well, after having purchased this eleven yards of canvas something like seven feet high, I thought it would be rather nice to treat it just as paper, stop worrying about this Belgian canvas. So, in the procedures of working large, I still had that grief, you know, about wasting all this material, so at that time I did a lot of drawings on the telephone book. I could go through the whole telephone book in one night. And then, instead of looking at them critically the next day, I just put them away, forgot about them. And then as time went on, say a month or two later, or even three months later, I'd go back through these so-called drawings, and then they formed in some way the beginning of something that I could work on six by eight feet.

FRANZ KLINE

Do you still work in this way?

I go on doing that but I also paint without a smaller sketch to start with. A lot of the paintings have developed through painting out other paintings and then, in some way, I can use some reference maybe from part of another drawing, that maybe I had done three years ago, or something like that. I look around nervously for some situation to set this thing off again. It might become then a process of over-painting and under-painting to a certain extent.

You might use several drawings in doing a painting?

Yes.

Have you been using the drawings in the colour paintings you've done recently?

No. I get a particular sense of mass or scale from my own drawings. My drawings don't change, you know. Some of them become more or less similar and then they become rather boring to me. Then, over say a period of hours or a day, I'd see something in another drawing that probably doesn't have that same familiarity which hooked up to a previous experience in a painting before that, you see. So then I am not able to translate that particular form into a colour. I think the colour – use of colour – obviously works against it. The pictures that developed with colour, I didn't particularly want to use or add colour to black and white and I guess it was just the experience of being rather bored with looking at a lot of black-and-white paintings. And every now and then I have the feeling it would be marvellous just to do a large area in yellow or red or something like that. But of course I fail most of the time. But not always. Sometimes it is a red or yellow or blue area in the painting. I think that the things that I did develop in colour were the ones that worried me most, you know, in the last exhibition, and that wasn't because of the colour particularly or that I had an attitude about colour. I think it was just a question of the feelings of the paintings.

You work on the paintings for a long time?

Well, no, not necessarily. I like to do them right away, you know, and when they come off and I'm done with them, they're marvellous. But I can't do it all the time, of course.

Do you ever find you can work with a painting over a long period and it comes off? Or do you find that if it doesn't come off fairly quickly, it doesn't come off at all?

Some of the pictures I work on a long time and they look as if I've knocked them out, you know, and there are other pictures that come off right away. The immediacy can be accomplished in a picture that's been worked on for a long time just as well as if it's been done rapidly, you see. But I don't find that any of these things prove anything really.

When you're using a drawing to make a painting do you ever find the painting is really very close to the drawing?

No. What I find is that if the painting is better than the drawing, then it eliminates the drawing. You see what I mean? Then you have two of them – a small one and a large one.

ROBERT MOTHERWELL

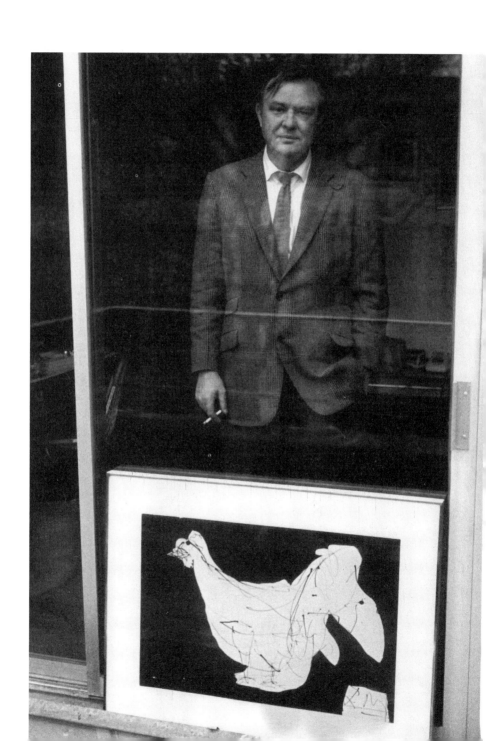

Recorded March 1960 in New York City. The version edited for broadcasting by the BBC was re-edited by the artist and first published in *Metro*, December 1962. His version is reprinted here.

Robert Motherwell at his residence, East 94th Street, New York, 1964. Photograph by Dan Budnik.

ROBERT MOTHERWELL 1960

DAVID SYLVESTER *How clear an idea do you have before you start to paint of what the painting is going to be like?*

ROBERT MOTHERWELL Usually not much. More simply, I begin from an impulse, an intense and irrational desire that takes you over, prompting you to start moving. And from experience, with some knowledge of what moves oneself, I think it's not altogether arbitrary what one begins with. I mean, I think that any painter would instinctively begin with forms, colours, spatial areas, kinds of format, that in general have been more sympathetic to him than others have been. But certainly implicit partially is the feeling, not that 'I'm going to paint something I know' but 'through the act of painting I'm going to find out exactly how I feel, both generally and about whatever is specific'.

In which case, the term 'action painting' has got quite a lot of validity for you, among others?

It depends on what emphasis the word 'action' is given. If it's given the emphasis that a painting is an activity – yes. If it's given the emphasis that it's like a cowboy with a six-shooter that goes bang, bang, or is a gesture – then, no.

You don't, for example, have any idea before you start a painting whether the forms are going to be packed fairly tight or whether it's going to be rather open and spacious, so to speak?

In my case, I find a blank canvas so beautiful that to work immediately, in relation to how beautiful the canvas is as such, is inhibiting and, for me, demands *too much too quickly*; so that my tendency is to get the canvas 'dirty', so to speak, in one way or another, and then, so to speak, 'work in reverse' and try to bring it back to an equivalent of the original clarity and perfection of the canvas that one began on.

At what point do you feel a painting is finished – if this is a question to which one can give a verbal answer?

I think, when your feeling is completed. (It was a big issue with American painters ten years ago.) I think it's really a question of the completeness of the feeling. One would think, well, that's relatively simple, when you've done what you're going to do, that's that. But actually all artists are haunted, much as one tries to get away from it, by *a priori* conceptions to take over one's mind and drive one too far, or not allow one to go far enough. And, I think for myself, and I believe for most of the painters I know, judging the exact critical moment when everything that is necessary is there and nothing more is there, is one of the most difficult and crucial steps in the act of painting.

When you've finished the painting, do you attribute to it any verbalisable feeling? I mean that a particular painting is violent, that a painting is sexual, that a painting is serene, and so on?

Sometimes. And if people ask me things about a painting, sometimes I can say something; sometimes other people say something (though rarely) that strikes me, 'yes, that's absolutely true'. *The process of painting is a series of moral decisions about the aesthetic.* I mean, when one's actually painting, the brush runs rapidly or slowly and such and such an area appears with such and such edges, and one thinks, 'no, I don't like that black with that blue, or this spacing between these two forms is not adequate'. But, in the end, unless this is done only on the basis of taste, which is to say, on the basis of the merely aesthetic . . . there must be something further that one has recourse to, in relation to making one's judgement. And I think what this is, is really ultimately moral. That no sharp edges, or too tough a version of reality, or inert lumpy paint is too insensible, are morally rooted judgements. Or, there's no air in this picture, and human life requires air to suck in and be put out, in order to be. I know it sounds somewhat absurd being an artist and a Western aesthete, in a sense, to insist on the moral, and I certainly don't mean it in a puritanical sense: but I really think art is basically a moral enterprise. And that the artistry, if you want to put it that way, is the beauty and completeness with which a moral position is asserted. But the very nature

of this beauty is dependent on the moral position. I think a great deal
that's happening between America and Europe now – I'm speaking now
of younger artists – is our implacable insistence here on moral values,
which I think is slowly disappearing among younger artists in Europe,
who paint mainly with taste. And I don't mean this in a superior or self-
righteous or any holier than thou ways, but almost primitively, as a kind
of animal thirst for something solidly real. It's directed to what one really
feels and not to what one prefers to feel, or thinks one feels.

So that painting becomes a clarification of what really are one's attitudes?

Yes, one learns a lot from it.

A way of discovering what one is?

The essence of this particular historical moment is the problem of
identity; traditionally, American literature is full of it. It's an American
problem. Or perhaps, it is a problem for everybody; but it's extremely
sharp here. For example, four years ago or so, I was in Germany as a
'guest' artist, and saw a great deal of Germany. There was the problem
of rebuilding Germany: in the case of Nuremberg (or of Renaissance
cities), it was a real moral issue as to whether one should replace, say,
Nuremberg with modern buildings, and forget that it had been a
medieval city, or try to reconstruct it in a medieval fashion. And the
various Germans I spoke to were passionately on one side or another. I
think most Germans who thought about it at all were really involved in
the problem. City councils were, architects were. A really passionate
debate, in the most concrete terms. It so happens that I prefer, in many
respects, past architecture to present architecture. But I would have been
in favour of building in a modern way. Nevertheless, it struck me, in that
context, that the issue of 'modern' art or 'modern' architecture was
concrete in Europe, real, with all kinds of political, social, economic
implications. For us here in America it's more nebulous, more vague, in
the same way much more ultimately extreme. Here we are conditioned to
welcome the new. It's not the choice of what's going to happen to the
economy, or what religious implications there are, or whether one's
taking basically a reactionary or radical stand, for such positions here are

fluid, tend to merge with each other, tend to change. But much, much more, to use a metaphor, as though one had to decide at the Last Judgement under what guise one had chosen to commit oneself in relation to one's own being and psyche and soul. It sounds romantic the way I put it (though I personally believe that one of the interesting things about America is that it's further into the future as a whole civilisation than other countries, and consequently, though perhaps inadequately and in a very ragged way, is here and there facing things that all men sooner or later are to face, if there's ultimately to be a civilisation of real individuals.) . . . Tribal customs are less strong here. That puts much more pressure on any given individual in relation to what his identity is going to be. He has to choose, alone. I can't emphasise how strongly in relation to what I personally know about Europe, how much more – though we're supposed to be the great conformists – how much more, at least in this kind of an enterprise, one's on one's own. And now, without being romantic, there's a terrible human price to pay for it. I mean, one has to be a 'hero' in a way, or not exist at all, given such conditions. There's not a society to pick us up and incorporate us, though we've been very lucky in certain social and economic ways – for reasons that really have nothing to do with painting, but with the ambitions of the audience.

So, the painting – the kind of painting that you do – though abstract, is in some way a metaphor of an attitude to reality, of a feeling about reality?

Mmm, yes, painting is exactly a metaphor for reality. I do think there are references. I think the so-called 'abstractness' of modern art is not that it is about abstract things, but that it's an art really in the tradition of French Symbolist poetry, which is to say, an art that refuses to spell everything out. It's a kind of shorthand, where a great deal is simply assumed . . .

But to what extent are you aware of such references, specific references, while painting a painting?

From moment to moment, probably only a few . . . I think there's always mainly a sense of overall meaning. That is, of, quite simply, one's life, of that one exists. That one's existence in some way makes sense, even if one

doesn't know exactly all the connections. I mean that's the act of faith. That one's being *is* meaningful. Consciously one knows snatches of it. From one moment to another moment in working on a painting, certainly I don't have total clarity. Very few people I know do. But it's not merely a specific painting that one's working on. It's also that one's whole life work is continually consummated in one's mind. And to some extent, the works of other people. So that, except when one's asleep (and maybe even in one's dreams), one is constantly reflecting, contemplating, shifting, having flashes of clarity and so on. So that I wouldn't say at all that I start a canvas, and then finish it, and when the time comes, send it to one of my dealers to be sold. But that it's maybe like the farmers' year, where there's storms, and there's spring and there's summer, and you don't know whether certain things are going to come up or not. Certain things come up much better than you had expected, and vice versa. But looking at the whole year, a year later, you can think, yes, 1959 was a very good year, or, no, 1959 was a year when I was stopped, blocked, confused. But nevertheless, each particular work for me is a specific moment or a specific embodiment of a large, overall enterprise.

You were talking before about the moment-to-moment awareness of meanings in painting. This kind of lack of preconceptions of what the painting ought to be, in terms of figuration or non-figuration, the absence of orthodoxy here, seems to me to be one of the great strengths of painting of your generation; it doesn't seem to have got caught up in all the theoretical arguments that French artists have, I think, been tied down by in recent years. Have you got any explanation of how this came about, or how your generation of painters got this freedom from orthodoxy?

I suppose that America is less socialised than other countries. By this I mean that tribal habits, ideas, marked-out relations with the community, whether they're for the community or against the community, are much more blurry here. So that it becomes not a question of whether one is a 'Parisian-style' painter, or whether one is an 'abstract' painter or whether one loves the Renaissance – in a sense there are no criteria, except authenticity of expression. It's almost as though every American painter were subject to some kind of aspiration that no rationalisation, no programme could deal with, when the end's simply what's there has to

give forth, and there is no criterion except, 'yes, that is really what gave forth', and not an idea of what, for example, ought to have been given forth. I know very few painters who really enjoy painting, because of the self-imposed pressure to be 'real'. At the same time American painting is a rather remarkable enterprise: if one goes without *a priori* aesthetic and socially moral preconceptions about our culture, it's possible that one can go off the track altogether. But it's also possible that one could reach a series of images that are more truthful, in relation to what really goes on in beings, than the kind of conspiracy, almost, that tribal customs and culture lead one to, making one feel that one ought to feel things that one really doesn't. I think some of the French dramatists (such as Ionesco) are beginning to be on the same track that we're on. It's also, I think, bad for a painter to think too much historically, because, when one looks at a phenomenon from the perspective of world culture, it seems relatively insignificant (interesting as it may be), and certainly, in order to make something moving, one has to feel that it's terribly significant. In that sense, to be on an aesthetic island, without the pressure of history on our backs, is an advantage. But it's also an advantage that can become very easily licensed; and does, I think, in the hands of people who are not essentially ethical by nature.

To ask you a terminological question. What about 'Abstract Expressionism'?

Well, I think that's an historical question of minor importance. Before 1940 there was relatively little abstract art in America. Most of it was relatively geometric versions of Cubism, or of Mondrian and de Stijl, or of Arp reliefs, and the like. So that when our painting first appeared, the critics at once realised that to describe it as 'abstract' would be misleading in relation to what then was understood to be abstract, which was something precise, exact, geometrical, hard-edged. In America, the word (I suppose taken from Germany) for something highly emotional is 'expressionist', and some critic, either in the *New Yorker* or the *New York Times* . . .

I think it was Robert M. Coates in the New Yorker.

. . . then called it Abstract Expressionism, meaning that this was a very

emotional art, but an abstract one.

But with the difference that, I think, with, say the 'expressionist abstraction', as Barr called it, of Kandinsky, there's a preordained intention to convey a particular feeling-tone or emotion, of which there is none in your kind of painting.

I agree. I might add that I've never met an American artist in my milieu speaking about German Expressionism with admiration. With the exception of Gorky, I've never heard one of my colleagues speak about Kandinsky with any genuine interest.

It's interesting that they should speak of Mondrian with such enthusiasm, is it not?

Well, Mondrian is absolute, and is pure, and those are real aspirations of our art. When I say 'pure', I don't mean clean. I don't think Mondrian himself did; I knew him when he was here during the war. He went to an exhibition by the Surrealist, Tanguy, and was asked what he thought, and he said he would like Tanguy's pictures better if they were dirtier, that for him they were too clean. And it seemed like a paradox . . . I don't think it was. I think he meant that when they were too 'clean' they were essentially lifeless, statuesque, unrevised. As for me, I must say, Mondrian's painting is intensely rhythmic, warm, passionate – restricted as the means ostensibly seem to be.

It was this apparent paradox by which the so-called Abstract Expressionists, meaning you and others, are really far more sympathetic towards Mondrian than towards Kandinsky. The Mondrian thing seems paradoxical only in relation to the Mondrian that people interpreted in the thirties as a rather cold and static artist. Maybe it's only more recently that we've realised about the blinking that takes place at the intersection of the lines, of shuttling back and forth and so on, that Mondrian becomes in some ways a more dynamic artist than Kandinsky.

Mondrian certainly is to me the more intense artist, though I don't know of another Abstract Expressionist interested in him. Certainly one of the

things that is valued here is intensity of expression. But it's understood, I think, among the painters I most respect, in the way that Matisse conceives of intensity, which is to say, that you do not make an intense picture in showing a dramatic gesture. Rather, it's the means themselves that create the intensity. Mondrian was in accord with this. In that sense, I think even the early Kandinsky, whom I rather like, is less intense.

In other words, you're saying that, in spite of the romanticism which you yourself attribute to the aims, your own aims and those of your friends, there really is an obsession with the architectural qualities of the work?

Absolutely. I think another of the aspirations came from the Surrealists being here during the war. I mean, the official definition of Surrealism is to make a work automatically without *a priori* aesthetic or moral conditions, which is exactly what we do. At the same time Surrealism was an assault, with a few exceptions – Giacometti, Arp and Miró – on the 'purity' of painting. I mean, on making painting – means themselves speak, without reliance on literature; and that second insistence of Surrealism, Americans really rejected. So that historically, though it has very little visual resemblance to either, Abstract Expressionism is in part, I think, a fusion of certain Surrealist means, above all plastic 'automatism' with the Cubists' insistence that the picture speak as a picture in strictly pictorial language.

I would say that our painting tends to be 'metaphysical' (I say 'metaphysical' in quotes) rather than naturalistic. I think most painters in Europe and the Orient in recent times have relied very heavily on nature, either on the human body or on landscape, no matter how much they may be finally transformed. With most of us, I think, they are really not a point of departure, but much more 'ideal images', in the way that perspective, though it may have been empirically derived from nature, is essentially an ideal way of reconstructing it. A 'construct', in Bertrand Russell's sense. A construct has a kind of logic of its own and when it's beautifully used, you really don't care whether nature behaves that way or not. There's something about the absolute internal order of it that is profoundly moving and certainly something unique to human beings, that kind of thing. At least I feel that way, quite absolutely. I can and

sometimes do employ human 'figures' or fishes or birds or a wall. But they're used in the employment of something else which does not derive from them. And that's why I can use them or not, as I please. They're never dominant.

PHILIP GUSTON

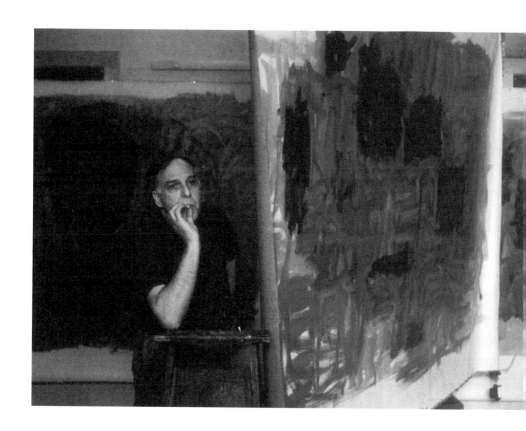

Recorded March 1960 in New York City. If a version was edited for broadcasting by the BBC it remains unpublished. The present version has been edited from the transcript.

Philip Guston in his Woodstock, New York, studio, 1964. Photograph by Dan Budnik.

PHILIP GUSTON 1960

PHILIP GUSTON We were talking yesterday at the studio about the picture plane, and to me there's some mysterious element about the plane. I can't rationalise it, I can't talk about it, but I know there's an existence on this imaginary plane which holds almost all the fascination of painting for me. As a matter of fact, I think the true image only comes out when it exists on this imaginary plane. But in schools you hear everyone talk about the picture plane as a first principle. And in beginning design class, it's still laboured to death. Yet I think it's one of the most mysterious and complex things to understand. I'm convinced that it's almost a key and yet I can't talk about it; nor do I think it can be talked about. There's something very frustrating, necessary and puzzling about this metaphysical plane that painting exists on. And I think that, when it's either eliminated or not maintained intensely, I get lost in it. This plane exists in the other arts, anyway. Think of the poetic plane and the theatre plane. And it has to do with matter. It has to do with the very matter that the thing is done in.

DAVID SYLVESTER *The matter giving a certain resistance so that we don't go straight through it to the idea?*

Exactly. In other words, without this resistance you would just vanish into either meaning or clarity, and who wants to vanish into clarity or meaning?

But apart from this thing of the picture plane, most great paintings have this duality between the forms of the surface and the forms in depth.

Exactly.

There's a tendency in a lot of recent American paintings not to want to get this depth.

I think that de Kooning works in depth, and it might be one reason

why he's never felt the need to enlarge.

I was going to say that you and de Kooning both seem to work in depth while preserving the plane.

I would say so, I would say so.

And is this a matter of instinct or a matter of wanting to? Well, that's a silly question . . .

But, of course, you know, it's terrible to rationalise about painting because you know that, while you're creating it, you can have all sorts of things in your mind consciously that you want to do and that really won't be done. You won't be finished until the most unexpected and surprising things happen. I find I can't compose a picture any more. I suppose I've been thinking about painting structures for many years, but I find that I know less and less about composing and yet, when the thing comes off in this old and new way at the same time, weeks later, I get it, and it arrives at a unity that I never could have predicted and foreseen or planned. And yet this is a problem that we all have dealt with.

How much of a developed idea do you begin a picture with?

Well, I always begin with some kind of . . . Well, I work on only one painting at a time. It goes on for weeks, sometimes months, and scraping and putting it on and scraping, as you know, and it's as if I have to save myself on that one work. And then, when it's done, God knows how, it always seems impossible to paint another picture. Utterly impossible. And when it's done, life seems wonderful again and you feel marvellous.

How long does this last?

It lasts about a week; two weeks would be the limit. I start paying attention to my family and go to parties, and I think life is terrific. And then this thing starts again, and when I start again I think I have found a way and I really like that last picture which has become such a friend. But then later it becomes a terrifying enemy because I really want to do it

again. I think, well, I'm a painter, I can certainly make a picture now and . . . This has been going on for years with me and I . . . I'll start with the same elements and why not? Other painters have made variations on paintings. It goes on like that, optimistically, for a week, and then it starts to break down again. And I always start with a kind of ideal picture in mind.

Has it got a colour, this ideal picture?

Oh, it has some kind of a marvellous structure. It has to do with a dream about painting, you know, I'd really like to make a real great painting and I just can't do it. It really breaks down after a while and I find bit by bit, you know, I find myself getting dumber. Really, I don't know. Perhaps it's all these parties I've been going to recently, but right now I don't know what to say about painting. It always remains the most puzzling, enigmatic thing. But when this thing happens, this very peculiar and particular thing does finally happen, in other words, when you have these few lucid moments . . . I mean you could be a carpenter. I'd say that in a month I'm a carpenter for almost thirty days and then I have three hours, four hours, when the thing happens and I wish I didn't have to be putting those planks together – putting this colour on top of that colour and structuring to my own increasing boredom.

Do you find that the conclusion of the pictures often comes quite quickly?

Yes, the last stages, very certainly. I always know when it's going to happen too. I know the day, the day you take the phone off the hook. It's when you've played all your cards, all your dice, clever tricks.

When you get towards the end, do you actually foresee what it's going to look like?

No.

You still have to find out?

I still have to find out. But I know when this happens. I mean, it's when I

don't back up any more to look; I don't put something down and pull out a cigarette and look. Someone said to me the other night something interesting. I was talking to a foreign painter I know and we were talking about 'how do you know when you've finished?', which is a very interesting problem. Actually it is the key to all things, when is a painting finished? And last week I had finished a painting; you saw it yesterday. I had worked around the clock for three or four days and nights; I think I got one night's sleep. I kept on and on and on. That's how I usually work and this friend said that she'd read somewhere that Hemingway had said that he leaves his workshop when something has happened in his work that promises him something to do the next day. And I thought, 'Oh, my God, I feel just the opposite.' And yet I know that feeling. In the past I would stop when something happened on the canvas and I would think, 'Oh yeah, tomorrow I'll work on that.' But that's like promising yourself a goodie for the next day. I think it's very adolescent. I like the early Hemingway books, but I find I can't do that. It's an immediate thing, it's a crucial moment. It's somehow a feeling of all your forces, all your feelings, somehow come together and it's got to be unloaded right then. I mean, there's no cookies for the next day at all. There is no next day.

And when it's going, you really can stay there? You don't have to get away from the canvas and see how the picture looks?

I don't even know that I'm doing it at that time. It's a peculiar moment to talk about. The mind being as devious as it is, you could see the whole thing as a kind of moral test, I think. And you know exactly and precisely when you're kidding yourself. It's a thirty-secondth of an inch but you know, the narrower it gets, the more devious it gets. We all know that. I mean, writers are like that. Actually, painting is exactly parallel to life. I mean, you know when you're really making love and when you're not really making love, or any emotional involvement. Did you ever listen to someone talk on a platform or in conversation when you knew that he was only telling you a story and your mind wandered? But when you always really listen is when they are not hearing themselves tell the story. Well, that's creation. That's all it's about. And anyone who can see can see it in a painting. Don't you think so? It's only the very object of painting to get to that point, and I don't think it has anything to do with

spontaneity either. And if it is freedom, it's a very peculiar kind of freedom. It's the kind of freedom that's weighed down with a lot of baggage, but it's a very necessary kind of freedom because . . .

. . . it must be achieved.

It must be achieved. Yes, but only under certain conditions.

*Well, I mean, the carpentry, as you call it, is the necessary preparation to –
to put it rather pretentiously – the dark night of the soul.*

I know I've thought so too. I think that's a kind of necessary rationalisation. Would you be as interested in seeing men fly, unattached and free, as you would be in seeing a man with, I don't know, two hundred pounds of cement strapped on to him and let's see him get two inches off the ground. I think creation is something like that. It's not imagination and it's not freedom and it's not spontaneity. I think it's a more human experience than that. I mean it can be tragic; it can be joyful; it's compounded of so many elements and increasingly I almost think I don't want to analyse it any more, think about it. And yet, when this thing has happened . . . Right now, for the last few days, I've been thinking, now what in the hell happened those three days and nights I worked around the clock? What pictures did I scrape out? And then I remember the pictures I scraped out. So that I keep tracing what it is that happened. You somehow propel yourself or are propelled into a kind of open-eyed sleep or a sleep where you are acting. I don't think you can worry yourself into this state, I think you just become that. Perhaps that's what the painting represents. Actually, one of the real problems that always bothers me is sustaining a feeling. I mean, when I look at Poussin now, well, I think that's the most incredible thing to maintain the feeling for a year, however long it took Poussin, I'm telling you, to paint this vast structure. But perhaps that is not given to us now. I don't know.

Perhaps we can only make sort of fragmentary statements?

I don't know. Actually, all modern art puzzles me. I don't understand it, I really don't. I don't know whether it's fragmentary. I have a sickening

nostalgia for this other state of sustaining a feeling for months, being able to construct and build a picture. Well, Mondrian, I think, did that, of course. He was almost one of the last artists to do that. I wish I could get there.

Going back to this other thing of creating depth in a painting. Now, when you convey a sense of space, there tends to be, whether you like it or not, a tendency for figuration to come in. I mean, the creation of depth is very much involved with the whole concept of figurative painting.

Of course.

I'd like to know what you feel about this whole problem of figuration. Do you want your painting to have references?

Absolutely. You know in the forties I was very involved with figuration. I painted a whole series of children's pictures, all sorts of props and so on; they were always imaginary. I don't think I ever really painted very much from life, although I have done several portraits. But these pictures were imaginary, and even though I used scenes, houses and figures and tables, chairs, wooden floors, things, instruments, there too I wanted to get to a point where the burden of things didn't exist and something else came through. You use things; the idea is, of course, to eliminate things. And just as, fifteen or eighteen years ago, I stretched out to get that – put it in and took it out – to get that look in that kid's eye and the way his mouth was open or wasn't – I mean a very particular kind of look – I'd do the same now. In other words, I can't find any freedom in abstract painting. I'm just as stuck with locations, a few areas of colour in relation to some kind of totality that I want, as I was before. And so the problem of figuration is somehow irrelevant to me. I think some of the best painting done in New York today is figuration but it's not recognised as such.

Could you give an example?

Well, I think of my pictures as a kind of figuration. Obviously they don't look like people sitting in chairs or walking down the streets, but I think that they are saturated with . . . I think every good painter here in New

York really paints a self-portrait. I think a painter has two choices: he paints the world or himself. And I think the best painting that's done here is when he paints himself and by himself, I mean himself in this environment, in this total situation.

What about figuration in a more literal sense?

I try.

You do?

Yes, and I think there's a psychological problem involved here. I've tried and I really want to, but I don't think it's possible. I can't. Perhaps another generation can.

When you say you tried . . .

By that I mean the isolation of the single image which is what figuration means. Is that what you're talking about?

Yes.

You mean like a Rembrandt?

Yes.

The self-portraits of Rembrandt?

Or de Kooning's Women.

Yes, but when you look at . . . I was in Washington the other day and looked at that late self-portrait by Rembrandt. Honest to God, I didn't know what I kept looking at; finally, I didn't know what it was. I mean, next to it was a Van Dyck and you said: yes, there's a portrait; but, if the Van Dyck is a figure, well what is the Rembrandt? Actually something very peculiar goes on there. There's an El Greco head which is reputed to be a self-portrait. I don't know whether it is or not, but it's a terrific head:

the beard and collar, the flesh and the bone, seem to be in some kind of constant movement. Whereas the Rembrandt seems to be so dense; you feel that, if you peeled off a piece of forehead or eye, you know, as if you'd opened up this little trap door, there'd be a millennium of teeming stuff going on. I don't know what it is, finally. You know, Van Dyck gives some idea of a man, some idea of a portrait. You know the more you think about these things, the less the things appear as they are supposed to appear. In those great Rembrandts there's an ambiguity of paint being image and image being paint which is very mysterious.

Do you ever get a simple desire to paint an apple?

Oh sure. Certainly.

And what happens?

I do it too.

With an apple in front of you or from memory of an apple?

Memory of an apple. What's interesting is that a couple of years ago a group of younger painters started to paint figures and still life – and I think you had something like that going on in England. And a lot of reviewers talked about going back to nature and all kind of business but, of course, it really meant going back to Cézanne and early Matisse and Corot. In other words, it's almost as if there were no innocence about their work at all. If they paint an apple from an apple why not paint the Crucifixion?

What happens if you try to paint an apple?

Well, you've got Chardin; you've got Cézanne on your mind and you've got everybody else on your mind.

These get in the way? They come between you and the apple?

I'm interrupting here, but I wouldn't paint an apple. What I really would like to do would be to paint a face.

1960

Do you ever start with a face?

Oh yes.

And what happens?

Well, it's very hard to contain it. Now, these are dangerous waters. Because actually I hope sometime to get to the point where I'll have the courage to paint my face. But it is very confusing because sometimes I think that's really what I *am* doing, in a more total way. And at other times I doubt that. I am in constant doubt about this whole thing. We're talking about something which I wake up with and go to bed with every day, and I don't know exactly how to talk about it. What I really want to do, it seems, is to paint a single form in the middle of the canvas. I mean, one of the most powerful impulses is simply to make . . . That's all a painter is, an image maker, is he not? And one would be a fool, some kind of fool, to want to paint a picture. The most powerful instinct is to paint a single form in its continuity, which is after all what a face is. This happens constantly on a picture. I remember last year I became so nervous about what I was doing that I finally reduced it down to the can on the palette with brushes in it. Well, that's real, that can with brushes. And I painted the can with brushes sticking in it, and I couldn't tolerate it. I couldn't face it. It was as if it didn't contain enough of my thoughts or feelings about it.

Was this because it became other people's clichés? Or something different?

Something different. I don't know what the something different was.

Was it that the form on the canvas wasn't the outcome of your experience of working on the canvas but only some kind of sign?

Something like that. That's right. It became signs. Exactly. Now, I think you've hit it. It seemed to become signs and symbols and I don't like signs.

You wanted the actual experience of the thing?

95

That's right. Yes. Therefore the whole thing got broken up and finally I got involved in a more expansive, extended experience there, as far as I can figure out.

Did anything come of the picture? Or did you destroy it?

I destroyed it.

But is it conceivable that a picture which might begin like this and might go through this process nevertheless was a picture you completed?

Yes, but it wouldn't hold.

All the same, might all this experience go into a picture that you preserved?

And still have that single object, you mean? Yes, well of course, I see it that way. I see later that, as I look at my own pictures, they are to me – I don't know what they can be to anyone else – a kind of record of this journey. So that I see where I started with certain things – you might say objects – and then they became dissolved and then somehow the whole field becomes the reality. There's something very fascinating to me about the idea of painting a single object because it . . . I mean, why won't it hold? I've got about twenty thoughts mixing and merging in my head. Just give me a moment.

Well, I'll put it this way, I remember once, years ago in London at the waxworks – I've always been fascinated by waxworks, like everyone else . . . But, you know, there's something of waxworks in art; you know what I mean? It's a very valuable ingredient there. In Madame Tussaud's museum, with these life-size portraits of Gandhi and President Roosevelt and so on, you are in a state of ambivalence there. That is, if you regard it as art, they are too much like real life. If you regard them as real life, they're after all, an effigy, an art. You don't know where you are. Of course, the frustration is that I would really like to go up and shake hands with Gandhi and feel his warm hand and talk to him, but, you see, he won't talk; his heart doesn't beat. And yet I'm convinced that part of the fascination in visual art and visual representation is its impurity. I think that part of the strange fascination about a Raphael, for example, or a

Piero, is the kind of frozen . . . It's not aesthetic, you know. I mean, we've all been mistrained: aesthetics, composition and all that stuff. But if one really keeps looking at this effigy, which is, of course, highly formalised and schematised, it involves the erotic very much. It's almost real but it isn't. Of course, a lot of lousy art is built on this premise. I mean a lot of lousy art is waxworks, of course.

So there's the frustrating ambiguity of the waxworks and the frustrating ambiguity of the Rembrandt.

Believe me, you've got me a little wrong. I maintain that the frustration is an important, almost crucial, ingredient. I think that the best painting involves frustration. The point about the late Rembrandt is not that it's satisfying but on the contrary that it is disturbing and frustrating. Because really what he's done is to eliminate any plane – anything between that image and you. The Van Dyck hasn't. It says: I'm a painting. The Rembrandt says: I am not a painting, I am a real man. But he is not a real man either. What is it, then, that you're looking at?

HELEN FRANKENTHALER

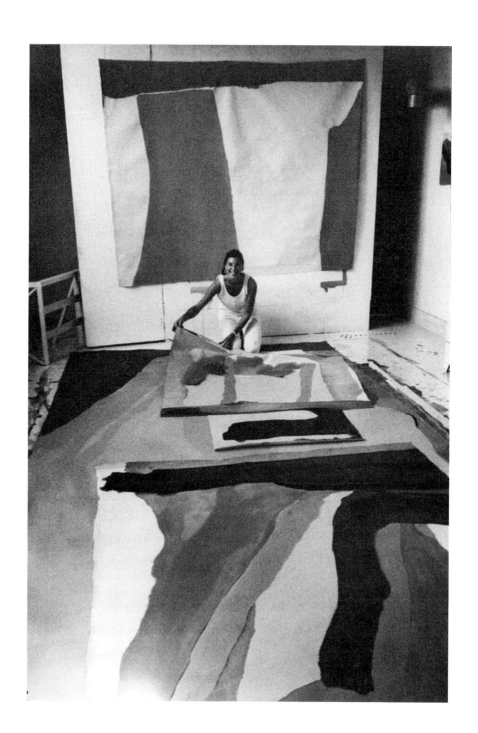

Recorded December 1961 in London. The version edited for broadcasting by the BBC remains unpublished. The present version has been edited, with the interviewee's participation, from the transcript.

Helen Frankenthaler in the studio at Provincetown, 1968. Photograph by Alexander Liebermann.

HELEN FRANKENTHALER 1961

DAVID SYLVESTER *How clear an idea do you have when you begin?*

HELEN FRANKENTHALER I often have a very clear idea of what I'm going to do when I start a picture. I don't always get the result I want. Sometimes I might think I want to do a picture ten feet by ten which has no paint in certain areas that might go out to the edges and is primarily in two colours and has some kind of imagery, perhaps some symbolic theme, and in which I want to repeat a shape four times. (I'm just making this up as an example.) Sometimes, once I've started the picture, I can stick with that idea. And sometimes something else creeps in and my hand and mind go ahead of it or to the side of that idea, and something else happens. But usually I start out with a notion of what I'm about, and what I want to do. I mean, it doesn't just happen.

And this can become very much modified in the course of painting?

It varies. Sometimes I see it come off the way I want it to, sometimes I'm surprised and pleased, sometimes I'm puzzled and I leave it alone, sometimes it looks terrible and I scrap it.

You rarely use a brush to put paint on, do you? Do you splash? Do you dribble?

I usually use paint straight out of a can or a jar, and then use rags or brushes to form the so-called accident into my aesthetic.

Do you use a can with a hole in the bottom?

No. Pouring it. Or throwing it.

Which leaves a good deal of room for accident?

I usually put the painting on the floor but then move it to the wall, or

turn it around, so that I'm working both on the floor and on the wall. Occasionally, I might toss paint out of a pail or use a finger or my hand. It depends on my mood and what I think the picture cries out for.

I take it your paint is fairly thin.

It used to be, more than it is now. For seven or eight years I used nothing but unsized canvas, and then I used turpentine and tube pigments and sometimes enamel, and that produced a very thin stain. But now I'm much more involved in getting a harder edge rather than a blotted edge or a bleeding edge, and I want a surface that is sized and primed, and I find the paint – while it can still get into a pool – is thicker and more compact.

To what extent would a change of mind be determined by some accident you hadn't anticipated and to what extent would a change of mind be determined by a gratuitous decision to take another direction?

First of all, I think most of my accidents are predetermined accidents. In other words, I might want a blob of blue that is two feet square: now, when I toss or spill a blue on the canvas at the chosen spot it might turn out to be an S-shape that is not two feet square, and I have something else, and I either proceed from that or form that S-shape into a square or I feel, no, I can't work with that. I reject the picture. Or I leave it to dry. Then I might come back to it in a few weeks or months. But I am more apt to work with it and take it from there. I think that a really good picture looks as if it all happened at once, an immediate image. When a picture looks laboured and overworked, you can read in it: 'She did this, and then she did that, then she did that.' There is something in it that has nothing to do with beautiful art. No matter how much work the artist puts into a surface, it should not look dead and laboured. It might take years of laboured efforts and discards to produce a really beautiful motion that is synchronised with your head and heart, and therefore it can look as if it were suddenly born.

Do you find that working on a big scale makes it more difficult – because of the larger area of canvas to control – to get this effect of immediacy?

I've never thought about that. No, it's more difficult in that there are more steps to take, but, as far as the mind and feelings go, it is no more difficult. In other words, if I did a painting the size of a packet of cigarettes it would take a lot of effort to know where to paint dark and where to put the charcoal lines, and one must start putting down the most important ones, as one would in a large picture. One doesn't know exactly what one wants to do, or what the end result will be, but I think if you're really involved in it you're unaware of getting from one corner to the other.

Why is it important to you to work in this way?

I think that I can say that I really yield more often when it's large. Which doesn't mean that all the big paintings are all the best paintings, but that the paintings I like the most of my own happen to be big.

Do you know why this is?

Not altogether. However, one reason is that a lot of what makes a large abstract picture work has as much to do with the surface as it does with spatial perspective. Light on the surface as well as in depth is somewhat what I mean.

When you talk about doing what you mean, does this mean that you have an idea of a definite feeling-tone for your paintings? Do your paintings have a definite character for you? Do particular paintings mean something in terms of, say, gaiety or loneliness?

I think anybody looking at my pictures would not say this is a gloomy picture or this is a picture about loneliness or this is definitely a landscape or this is two figures in a room, but it's much more the symbol or the atmosphere of those things. I'd guess I'm not involved in hardened design balance but of drawing in a way that has some meaning.

To what extent when you're working are you aware of a meaning in the work, and do you try to develop any meaning which you see in it or do you let it happen? Or do you not become aware of a meaning till afterwards?

Both. And the real logic comes, and that is very rare, when your thoughts and your feelings about it are worked together.

Something's got to determine, while you're working, your idea of what you're driving towards. At some time in the course of doing a painting does some criterion take over of how the painting has got to be in order to be right for you?

Yes.

Now, what would that criterion be?

Well, to be specific, I might think I would like to do four red shapes that are all the same size but each is slightly different. And then I'd like to do a blue shape that's the same size as a red one, with the idea that all these things can be the same size. But each has a different meaning and a different space in relation to what's next to it. Now, that's an idea, and an idea does not make a beautiful painting. So as this progresses as I paint, I become more and more involved in the drawing, the colour, the work, the size of the canvas, and not that idea – although it's that idea that got me going – so that, if it is successful, I'd throw out everything but the actual painting of it. But something of that original idea transcends it, and hopefully gives the picture that much more meaning.

You've used the word 'beautiful' more than once. This means that you're primarily concerned in working to achieve something which seems to be beautiful rather than that it should be expressive.

Well, I think anything beautiful *is* expressive.

But you're concerned with form rather than with content. The point is that when you say that if a thing is beautiful it is expressive, it means that you let the content look after itself.

Yes, yes.

'Beautiful' is a word that has become in our time unfashionable. I happen to

like it myself, but it is certainly unfashionable, largely, I suppose, because we haven't got any accepted canon of beauty. You nevertheless seem to have quite a clear idea of what seems to you to be beautiful. What are the sources, do you think, of this idea?

I think when I say 'beautiful' I mean something moving to someone who really knows. Now, that's an infuriating thing to say, because most people would say: how dare you, who says you know and I don't know? Or that you can see and I can't see? So that I sound very dogmatic, because if you use the word 'beautiful', you also use words like 'good', 'bad', 'right', 'wrong' – though I wouldn't say 'ugly' was the opposite of ' beautiful', since many clumsy pictures can be beautiful pictures. Dead unfelt pictures are not beautiful, don't work. If you have seen enough and know enough and your feelings are open enough to allow yourself to be moved or puzzled – there are relatively few people like this – you just know that this sends you, this is beautiful – the way you can see a roomful of Rembrandts and three might be masterpieces, and you know they are, and next to, say Franz Hals, they can make Hals look of less quality. Now, you can't prove it. You just know it. And you become a snob about it. Or you try to be very polite about it, quiet, without expressed opinion.

Although one can certainly say that your paintings are evocative, although they are not self-sufficient aesthetically, in a way that, say, an Albers is, for you the solution is a formal solution; it's not a solution in terms of poetic imagery.

Yes, I agree. In the end it is much more formal than the other. But, you know, sometimes people look at my pictures and they say oh how lyrical, or how witty, and, depending on who says it and what the picture is, sometimes I really get wild with rage and sometimes I feel, absolutely, that's right.

JOHN CAGE

Since this interview was to deal with Cage's work as a whole, the English composer Richard Smalley joined us in this recording, made December 1966 in London. The version edited for broadcasting by the BBC remains unpublished. The present version has been edited from the transcript. A second, much shorter, interview by the author alone was recorded in July 1987 in London and extracts from this were first published in an essay, 'Points in Space', in *Dancers on a Plane: Cage, Cunningham, Johns*, London (Anthony d'Offay Gallery) 1989.

John Cage at rehearsal with the Merce Cunningham Dance Company, Fondation Maeght, 1966, photograph by Herve Gloaguen.

JOHN CAGE 1966

ROGER SMALLEY *You studied for quite a time with Schoenberg. What do you think you learned from him in retrospect, as opposed to what you learned from him day-to-day at the time?*

JOHN CAGE Well, the first thing that I learned from him, something which I don't think I any longer use, was the understanding of structure. I remember one day when we were walking towards a building, he said that he wanted to convey in a book the notion of harmony as structure. As far as I understand it he was talking about tonality and the means, the tonal means, for dividing the whole into parts and making those parts clear and so forth, and that he wanted to emphasise this notion – which would have been welcome certainly in a study of harmony, because conventional harmony, as Varèse agreed with me once, is something that anybody who is bright enough could learn in twenty minutes.

True.

There is nothing there really to study that you couldn't learn in twenty minutes. And then taking another ten minutes you could add all of modern harmony to the classical theory.

This is taking harmony on its own as divorced from its function in any musical structure.

However, as I explained to Schoenberg when I was still studying with him, I had no feeling for harmony, nor tonality, nor any of those things. But you see he conveyed to me what was underlying his interest in harmony: namely an interest in structure. So that when I began to compose using noises, which couldn't possibly make use of tonal structure, I still carried over that notion of structure and the necessity for it, and I made rhythmic structures.

Based on dance.

109

No. No. Never around things. Never around sounds. Never around
movements in space or anything like that but rather on the space when
nothing is in it, and that space is the space of time. And I made a
structure that was what I called macrocosmic. That is to say, it was
divided in such a way that the large parts had the same proportion as
each one of them had small parts within it. So that if we have one
hundred measures it could be divided into ten groups of ten each. In that
way you could divide the ten large sections into, say, two, three and five,
because the total was a square root number, you could divide each ten
measures into two measures, three measures, five measures. You then
had, as it were, a city – that is to say a structure in which you could do
anything. You could either make that structure noticeable, you could
emphasise it, or you could, so to speak, make it unnoticeable. Or you
could do, as Schoenberg wanted tonal structures to do, you could start
out by making it clear. Then you could work, as it were, against it, and
you could continue with what he called 'far-reaching' actions or
variations in such a way that the activity within the structure became
such that the structure dissolved.

Yes. But to take a specific example, the two percussion movements of Amores
are a good example of this kind of structure.

No. They are not.

They are not?

They are not. They are quite different. It may be that the first, the one
with fingers on tom-toms in a pod rattle, is. I haven't looked at it
recently, but what I was concerned with in that piece was not so much
structure as method. Method I consider as being a different thing from
structure. Method for me is the note-to-note procedure. It's like going
from one letter to the next in a word, or from one word to the next in a
sentence. It's almost like, well, twelve-tone music, serialisation, that is for
me a method. Whereas the structure is a division of the whole into its
parts. Now I produced in that second part of the *Amores* a method which
controlled the number of icti within each measure, and that was indeed
serial. It was a serialisation of numbers and I think it can be very easily

analysed to discover what the original series of numbers was.

Yes, it can be.

Now, the third piece in that group *Amores*, which is for wood-blocks, was written before I had any notion of structure. I had only a notion of method, but a very curious one, which, strangely enough, relates to Boulez's work of the late forties. Namely, the cellular. He claims that it arose also in Webern, but I was unaware of Webern's work at the time, so that I wrote the piece and had fifteen years to go before I met Boulez, so that that piece has static cellules which are repeated and succeed one another in terms of a rather short serial notion which was taken as being cyclical – that is to say, the end connecting with the beginning. Well, that's true of most twelve-tone music. It had no division of parts.

It had no division of parts, but would it also be true to say that it's anti-developmental?

I think all of my music has been.

You see, I'm trying to establish some connection between these pieces in which, although there are fixed structures with sounds in them, the positions of the sounds within them are decided by you. Later on, of course, you began to use chance means.

And indeterminate means, yes.

To decide whether the events occurred still within this tonal structure. So you would say that the pieces even of the earlier period were still anti-developmental as a whole?

I think so. When I was still very uncertain of my work and wanted to hear what somebody who had worked longer in the field of music thought of it, I would naturally seek out a person whom I respected, send my work to him and ask for criticism. At the time that I wrote that Trio for Wood-blocks in the *Amores*, I wrote also some pieces for two flutes. I sent those pieces for flute, which were very much like that Trio for Wood-blocks –

that is to say, fixed things which Schoenberg would have called a motif. And he would have thought of them as things ready to be varied, whereas I was thinking of them as tiny little blocks, you see, which could simply, by means of juxtaposition, produce a piece of music. And I used for their juxtaposition, as I've said, a serial means. But the series didn't have twelve elements in it. I also equated with those cellules, as Boulez did later – what would it be called in the Bauhaus, the negative of it, the thing that you have something and then you have its absence? – virtual space. So that I used silence of the same length as the cellule as being able to represent it. And Boulez did this too. At any rate, I sent this piece off to Adolf Weiss, with whom I had studied, and that was why I respected him, because I knew him as a teacher, and I wanted some reassurance about my compositions. He sent them back: the original manuscript is all covered in the margins explaining where things had gone wrong. Now, what had gone wrong from his point of view was that the thing didn't proceed. It didn't get anywhere. It no sooner began, I remember one of his remarks states, than it stops. And there is no reason to expect, he says, after that stop that the piece of music is still living. Therefore, if I was going to make music more traditionally, I should learn not to have those silences. I should learn how to connect one thing with another so that it couldn't get apart. Isn't that interesting?

But your primary interest when you were actually writing these pieces was not specifically in the exploitation of silence and the deliberate stopping?

I was in fact continuing by the means which I have described. I was continuing my work of composition, and by not having something happening it seemed to me that the whole thing was continuing. The fact that there were no sounds didn't seem to me to stop the continuity. Nor was it a pause because I wasn't talking . . .

DAVID SYLVESTER *Yes, there's an interesting use of silence in the Mozart G Minor String Quintet.*

ROGER SMALLEY *I was just going to mention that David and I heard that this morning, the slow movement of the Mozart G Minor String Quintet played by the Griller Quartet. The quality of the performance in continuing*

through the silences and these isolated fragments of melody seem to be
beautifully connected.

DAVID SYLVESTER *And there's a very conscious use of silences in*
Mozart's writing in that movement, isn't there?

Yes.

Is your concept of the use of silence relatively different from Webern's?

Well, it arose without my being aware of Webern. It was Lou Harrison
who wrote a criticism in the *New York Herald Tribune* of a piece of mine
called *The Perilous Night* which came shortly after *Amores*. About two
years later. He said that he was struck by the resemblance between this
music and that of Webern, whose work I did not yet know. I then
became, because of that remark in the press, interested to hear work of
Webern and pleasantly enough that was possible shortly in New York,
and I remember sitting on the edge of my seat, bolt upright, struck by
those five short pieces, you know, in that String Quartet, Opus 5. And
then later when I was teaching and I was aware that bright students
already in the late forties had no interest in either harmony or
counterpoint and I was searching for a means to introduce the effects of
discipline. And I did this by requiring my students to copy out by hand
the first movement of the Opus 21 of Webern, The Symphony, and then
with coloured pencils and so forth to analyse the work in such a way that
they could explain every note in it to me. I would not do that any longer,
because Webern's work no longer has any urgency for us. The silence that
made me sit on the edge of my seat and the whole nature of the music
that was so lively for me in the early forties no longer is. Are you not
familiar with those concerts of modern music beginning with Webern,
and the resemblance of that to concerts of older music beginning with
Bach, say, or before Bach? Webern performs in other words the function
of making everybody feel that things are not dangerous – that they are,
indeed, classified.

ROGER SMALLEY *If you did take that score of the Webern Symphony and*
draw in the crayons in different colours, it would look very pretty. It does

look very pretty. Has the notion of a score as an art object been very important to you? I know your scores have been exhibited to be looked at, simply to be looked at.

It's simply a by-product. It's not part of an intention.

It's not part of an intention as, say, it is in Bussotti, some of whose pieces were originally art.

Right. Well this is an after-effect of my own work. When I brought my solo for piano in the concert for piano and orchestra to Darmstadt, it started a whole wave of graphic notation in Europe.

You feel they were misunderstanding your intentions?

Not at all, they were taking off in terms of their own intelligence from a point which struck them as opening up a field of possibilities. But in moving into that area they were not following me, they were rather having their own experiences. It never occurred to me to make something graphic in order that it would be graphic. It only occurred to me to make something graphic in order to bring about other sound possibilities than could be brought about with conventional notation.

DAVID SYLVESTER *In one of your stories you talk about Schoenberg's pointing out the eraser on his pencil and saying 'this end is more important than the other', and you go on to say things which clearly show that you are out of sympathy, rather strongly out of sympathy, with that remark of Schoenberg's. And I take it that you might also feel that Webern was a composer who used his eraser too much.*

He must have. He must have.

What's wrong with the eraser?

It means, does it not, that an action has been made, that it has been decided that is not an action which one wishes to keep, and so it is removed by means of the eraser? Not like the way of painting that we

know of from the Far East, where the material upon which one is painting is of such value that one dare not make an action that requires erasure. So one prepares himself in advance before he makes a mark. He knows when he is making it that he is going to keep it. The possibility of erasing has nothing to do with that kind of activity.

Right. This is an important moral principle for you, isn't it? In your essay on Jasper Johns you say: 'There are various ways to improve one's chess game. One is to take back a move when it becomes clear that it was a bad one. Another is to accept the consequences, devastating as they are.'

Right.

And that Johns is an artist . . .

. . . who accepts the consequences.

This seems to me a marvellous characterisation of Johns as an artist and it's obviously something which you feel is morally a very important point in Johns's favour.

Oh yes. Absolutely.

And this presumably is an important principle for yourself in your own practice.

It's also an extremely useful principle in all the circumstances of our lives.

It's a principle of generosity: is that what it is?

Yes, and it leads towards enjoyment, experience, and all these things, and away from the things we know about through Freud – which brought about inability eventually to act at all. Guilt, shame, conscience.

ROGER SMALLEY *It's an act of faith in your material, then?*

Okay, it's also an act of faith in yourself. Now, that means that it's an act

115

of faith in life because there is nothing in the world other than people and things. Now, if we can get ourselves to the point that many of us are when you can identify, for instance, as Rilke was able to identify with the tree, or Suzuki in a lecture was able to identify with the pencil . . . Then, if we can think, as we may so easily now through our technologies, of the possibility, not of just reincarnation as we pick it up from the Orient, but as an actual transformation by means of our techniques, say things that we see into things that we hear . . . Or of my appearing or your appearing in many places at once and even transformed through visual modulating means into other things that look like yourself, then we need in such a world, and it is the world we're living in – we need faith in all of those things. That is to say, faith in non-sentient beings – sounds, rocks, trees, pencils, etc. And faith in living beings – animals, plants, people.

So then.

And a faith that isn't selfish, a faith that has no boundaries.

So the traditional concepts of a composer making sketches and making drafts and working out *a piece as opposed to working* on *a piece is totally alien to you?*

Well, you'll be surprised it isn't. Much that I say would make it appear that I'm foolish, you know, but I'm really not. I'm just as capable of making a sketch as the next person. All of this will be made manifest in a publication this year, in collaboration with Joan Miró, where there will be gravures of his and all the stages of a composition of mine, including a final manuscript in Duchamp fashion, that is to say not omitting anything that was connected with the work and with what led towards the end. I wanted it all there – and then finally lithographs, I believe with colour, and his part that is a response to his feeling about my composition, plus a text of mine about our having met. So you will see there that I'm capable of sketches.

DAVID SYLVESTER *The painter of course erases by painting another layer over what he's painting. He doesn't entirely get rid of what is there before, and somehow the virtue of what is there before comes through in a*

mysterious way. But he is erasing. Presumably in the same way, it's not the eraser that you're objecting to, it's Schoenberg's notion that the eraser is more important than the pencil.

I might put it this way, that I'm not objecting to exploration.

ROGER SMALLEY *You're objecting to rejection? The total rejection . . .*

Yes, look at what I'm doing. You see, I'm keeping all of those sketches, exactly as Duchamp did. I think his example is the one that impresses me. He didn't throw anything away. He wasn't ashamed. Finally, what I'm objecting to is those things I mentioned, guilt, shame and conscience, in the desire to appear good rather than bad. Now, if in the course of making a work you make as I do sketches, discarding some, you see the processes of a mind that it went through in order to, at the last minute, do something which didn't call then for anything else to be done after that was done.

Yes.

It of course *does* call for something else, but it's not what we call '*that piece*', it calls for the next piece.

DAVID SYLVESTER *In the introduction to the catalogue of your works, you're really saying the same when you said that you haven't included in the catalogue certain works which you thought were of inferior quality. And in the next sentence that you have kept the manuscripts.*

Right.

You don't believe in covering up the traces of what one has done?

No. At the same time that I love that Chinese story about the animal in winter who slept in a tree and brought his feet up off the ground so that if the snow fell his traces would be covered. Also I was just thinking that we could take an opposite tack in this conversation and say that I prefer the eraser to the pencil, because in a sense each work that I do is an

erasure of all the previous work, is it not?

Do you think of it as that?

Well it's at least not that, hopefully.

I think you're erasing with the pencil end.

Yes, you're quite right. Oh, that's lovely, I like that.

But actually I think that there is a point here with regards to the eraser. One of the reasons for the importance of the eraser for Schoenberg, and, if you like, Webern, I take it, was the desire to make the thing concentrated and pithy. Obviously, especially in the case of Webern, to make the utterance as short as possible. Would I be right in saying that your own works have been growing longer? Most of your early works were pretty short, one minute, three minutes, five minutes, six minutes, most of them, and lately they've been growing longer, and obviously this is a result of a conscious decision on your part?

I think our time sense has changed, or that we have changed it. We're all familiar now, so familiar with 'space-time'. A time which is not a time but is space. With all these pieces that I've written in recent years, they can be quite long, hours long. All of them can also be just a few seconds long.

They don't have to be played for any particular length. This is part of the principle of indeterminacy.

ROGER SMALLEY *But would you prefer them to be longer than shorter?*

No. No. It doesn't make any difference to me. I wish to be, as it were, useful and practical, so that if, say, there was an occasion when one wanted two seconds of music, one could, say, take *Atlas Eclipticalis* and play it for two seconds; it's unlikely because it takes too long to set the thing up. You could set up, however, one part of it very easily and quickly and do it for two seconds. Because I conceive that a long work which has many parts can be expressed by any one of its parts or any number of its parts for any length of time. For instance, you yourself can be so

expressed. You could be expressed by entering a room not completely, but just say with one hand, or with a hair of your head and you could maintain that expression for either a long time or for a short time. When you started this part of the conversation I found that I was thinking about the difference between prose and poetry. I was thinking that Webern particularly suggests poetry and the eraser is perhaps necessary in writing a poem, and that this activity on my part suggests perhaps a big book that does not need to be read.

DAVID SYLVESTER *And also that can bore you for long passages at a time but still leave a mark.*

Right, and you could read it for instance for any length of time. You could, in other words, have it around, pick it up, put it down, or you could settle down and read it for several hours. And you could, as in the case of *Finnegans Wake*, read it without understanding anything for a long time, and then suddenly you could understand something.

ROGER SMALLEY *But all that you are saying now seems to presuppose that the longer the piece goes on the more chance you have of getting something out of it.*

I must confess that I very much enjoy our current ability to listen to things for a long time and I notice this becoming a general practice in society.

DAVID SYLVESTER *Epic films?*

Epic films and the Warhol films that go on and on and on, where virtually nothing happens, or the music of Lamotte Young which goes on for hours and nothing seems much to happen. And large audiences enjoy it.

ROGER SMALLEY *I was going to mention that because it seems that Lamotte Young, although his compositions could like yours be short or long, would* much *prefer them to be long. In fact, it's only after the first half hour or so that aural things begin to happen to you. You don't feel your*

pieces are in the same category?

No, because Lamotte is focusing one's attention, whereas I'm not focusing it.

You don't make any distinction between a kind or type of musical material or form which might be different if one was to write a piece an hour long, or the length of the Wagner opera than it would be if you were going to write a Chopin Prelude.

Well, if you look over *all* my work then I have to say yes, I do make such a distinction, but that my recent work has all been such that it has this indeterminate quality with respect to certainly its length. I tend, given the practicality of it in social terms, to make it long. I like, for instance, to start a piece without the audience's knowing that it has started. That can be done in several ways. And to conclude it without their knowing that it has stopped. That appeals to me very much, and was accomplished actually, for the beginning at least, if not the end, at St Paul de Vence this summer. We began playing an hour before the concert began. People were already there, because it's up on the top of the hill in the Giacometti garden of the Fondation Maeght, and the reason people didn't think anything was happening was because the spaces without activity were so long. We had taken the percussion parts of *Atlas Eclipticalis*, three of us, Gordon Mumma, David Tudor and I, and rather than giving four minutes, six minutes, or eight minutes to a single system of the notation as I had done previously, we gave, I believe, one hour to each system. And this was due to my faith that that would be a thing to do. And so we began at seven-thirty; the audience were, as I say, some there and some not. At about eight-thirty, of course, when the lights came up and the dance began, they knew that something was happening. Then some of them must have known that what they had been hearing before had also been a performance, but they had not paid attention to it.

DAVID SYLVESTER *At the performance in London of* How to improve the world, *you said afterwards to some of the remonstrators that it can be given as a lecture but, as you said, people ought to be glad that you can do more than one thing. On that occasion you did not give it as a lecture but*

you gave it as a kind of musical performance in which, as you said, your voice speaking the words was the source of the musical performance created by the electronic machinery, which made noises come through. A lot of people left before the end and there was slow clapping. People were obviously bored and exasperated. They were actually looking at the sheaf of papers in your hand and seeing you get near the end, thinking 'good, it's near the end' and then when you got to the end of that sheaf, you rather annoyed them by picking up another lot and starting on that. I think you were probably conscious that you were doing that, but ...

That's my wicked laugh by the way.

Some people who did find the thing interesting nevertheless said: 'Why did it have to go on so long? The point could have been made in ten minutes.'

Why are people so stingy about their time?

Yes.

Why are they so ungenerous? What in heaven's name is so valuable about thirty minutes or forty-five minutes? Or an hour and a half?

I think that you want people to give something. Isn't that it?

I assume – and I think by assuming it, I invite it – I assume generosity, on my part and their part.

You quote this saying somewhere: 'If something bores you after two minutes, listen for four, if it bores you after four minutes, listen for eight ...'

Yes, and I consider that generosity can be expressed in at least two ways, that is to say, by giving or by receiving.

Now, in point of fact it's at the heart of your whole doctrine, is it not, the idea of the spectator's participation in the work, of active participation, that he is not passive but he has to supply something, he has to interpret, he has to select?

But active at the point where he has disciplined himself, not at the point where he has not disciplined himself.

But you are asking him to give something?

Give in terms of the person who is disciplined to giving.

But the giving of time, you feel, is a part of that which has to be given?

Well, if something that is being given takes time, then its receiving must take an equal time. We don't know, we don't know, do we, when we get into situations how much time it's going to take. We ought, through our discipline – that's why I'm harping on it – we ought to be able to endure things for a short time or a long time or middling times. I can give an instance of endurance, I'm sure we all can. It was in Japan and, knowing of my involvement with Zen Buddhism, I was taken along with all the dancers too. I was taken after a rather strenuous day of tourism to a temple between Kyoto and Nara in the country, that had no heat, of course – it was a cold night – to be present at a very special service, the service where the student rushes up in the course of the service and is given a question to which he must reply immediately, you know, a very unusual service. And so they thought, since it was being given and we were there, we should all hear it. Well, in the first place we had to sit for about an hour and a half in icy cold waiting for this thing to begin, and then the service itself lasted for something like four hours, and we were quite exhausted, and then we had to continue from there. I don't regret having done it and I noticed that most of the dancers and the people in the company also were able to endure that really difficult situation.

ROGER SMALLEY *This sense of generosity especially applies to your performers, doesn't it? I mean you were generous enough to give them music where they could make a variety of actions at any time.*

Yes.

So you expect them to be generous enough, I presume, to discipline themselves to decide the best *sound that they could produce at any particular*

point and then produce it as well as they could.

I wouldn't say the best sound. I would say to make certain that what they do do is done in the spirit of the piece which itself is indeterminate and admits of many sounds. You see, I'm averse to all these actions that lead towards placing emphasis on the things that happen in the course of a process. What interests me far more than anything that happens is the fact of how it would be if nothing were happening. Now, I want the things that happen to not erase the spirit that was already there without anything happening. Now, this thing that I mean when I say not anything happening is what I call silence, that is to say, a state of affairs free of intention, because we always have sounds, for instance. Therefore we don't have any silence available in the world. We're in a world of sounds. We *call* it silence, when we don't feel a direct connection with the intentions that produce the sounds. We say that it's quiet, when, due to our non-intention, there don't seem to us to be many sounds. When there seem to us to be many, we say that it's noisy. But there is no real essential difference between a noisy silence and a quiet silence. The thing that runs through from the quietness to the noise is the state of non-intention, and it is this state that interests me. Therefore, I don't go along when you say the making of the best sound, you see.

I mean by that the most appropriate sound.

Well, then, I agree, that is to say, appropriate in the sense of being appropriate to silence.

DAVID SYLVESTER *You reiterated the importance of the spectators and the listeners being disciplined. What exactly do you mean by that?*

Free of intention.

This whole point about duration also related to your story of when you were taking a class and you played on the gramophone some Buddhist music which was simply a monotonously repetitive cymbal, and after fifteen minutes a woman cried out that she couldn't stand any more of it, and you stopped the gramophone playing, and a man complained that he was just

beginning to find the thing interesting. Obviously you are concerned that if the thing goes on longer one's attention may improve, one's ear would sharpen itself to what was going on.

Exactly, so that if one began such a listening period in a state of non-discipline, one could move into a state of discipline, simply by remaining in the room and being subjected to this activity which eventually one finds interesting.

And what you're really saying is that, by submitting oneself to listening for a very long time, one does discipline oneself, one does learn attentiveness, one does learn to focus, which is what the whole thing is about, I take it?

Exactly.

But there is a totally other way. I mean it seems to me that Webern's way is, by the very pithiness of it, by the extreme concentratedness of it, that you know that the thing is not going to go on for long. So you achieve from the very start an intense effort of concentration. And I'm not sure that this is a way that doesn't to me personally make more sense, because, assuming you're using a gramophone, you have the possibility of hearing the thing again and again but each time listening with intense concentration, because you know it isn't going to go on for long. Webern does create a situation of that concentration, does he not?

He did for me. He no longer does. He might for another now still, and he might two hundred years hence have that usefulness for another person. It's just that it doesn't work for me any longer in that way. It just sounds like art, that's all.

In a sense, what you're doing is to revert to an earlier period, because Webern in a way belongs to the reaction against the nineteenth century; well, it belongs very much to that. You're really reverting to the Wagner–Bruckner–Mahler tradition of making a vast structure, creating a whole world surrounding the listener, a world which he learns to inhabit, within which he learned to recognise leitmotifs, in which he learns to recognise variations, but in a sense, it's a reversion to a second half of the

nineteenth century attitude to the spectator.

I'm entertained by what you say, but I would hope that it was not true. Now, why would I hope that it's not true? It's because I connect those works of Mahler, Bruckner and Wagner and so forth with the industrial business. They're big machines. I'm not making a machine. I'm making something far more like weather. I'm making a nothingness. It strikes me as being aerial, whereas all those works that you just referred to strike me as being heavy, having to be on the earth. When I arranged in New York the eighteen-hour and forty-minute performance of Satie's *Vexations*, the piece which was repeated eight hundred and forty times, my closest friends, who ordinarily would come to any concert that I would arrange, failed to turn up. Why? Because they had read in the newspapers that this thing was going to happen which they felt they could not understand, even though they didn't attend. In fact, when I arranged the concert I did it as a responsible action to a composer who was dead, of course, but whose work had never been performed, and I thought that just as a matter of the responsibility of one composer for another, I should do it, that that was reason enough, and I thought it'll just be this thing like what I think a Warhol film is, you see, just going over and over. Not at all. The *Vexations* of Satie I would be willing to equate in terms of experience with any religious work of any culture, any of the Bach Passions and so forth and so on. I'm sure of this. Now, I noticed that my feelings were not different from the other people who were involved in the performance. We used some twelve pianists, and I had altered my sleeping habits and so forth, previous to being engaged in the performance, and I had to alter them back to normal again afterwards, so that this fact at that performance was a physical change in my life, and I remember, after it was all over, going home at noon and sleeping for a long time. When I woke up after that sleep, the world was really new. I remember Philip Corner, another composer, coming down after about the tenth time he'd played for twenty minutes, looking absolutely transformed. He said, it's fantastic, this work.

ROGER SMALLEY *So do you see music at all related to ritual, a ritualistic act?*

Well that one was, and I imagine now a music in the future which would be quite ritualistic. It would be simply by means of technology, a revelation of sound, even where we don't expect that it exists. For instance, in an area with an audience, the arrangement of such things that this table for instance, around which we're sitting, is made experiential as sound, without striking it. It is, we know, in a state of vibration. It *is* therefore making a sound, but we don't yet know what that sound is. Now if we could, and I think it would be ritualistic, if we could, simply make it audible. I had the experience, for instance, of making myself audible not by speaking, but simply by being in an echo chamber.

DAVID SYLVESTER *You said to a questioner, a hostile questioner who said why should I sit here and listen to unintelligible nonsense, you said because it could be important to you, and he said why, and you answered, because it's important to you in your life or something like that, and he protested. Then you went on to say something about, you put it very politely, 'If I may say so, our intolerable world.' What are the features of our world which you find* particularly *intolerable and which you think that the disciplines of the kind of art that you're involved in can help to cure?*

In my mind what you've just said, you know, calls up two different directions. My concern for the irrational, and my belief that it is important to us in our lives, is akin to the use of the koan in Zen Buddhism. That is to say, we are so accustomed and so safe in the use of our observation of relationships and our rational faculties that in Buddhism it was long known that we needed to leap out of that and the discipline by which they made that leap take place was by asking a question which could not be answered rationally. Now they discovered that, when the mind was able to change so that it was able to live not just in the rational world but wholly, and in a world including irrationality, then one is, as they said, enlightened. Now, in connection with the thought of Marshall McLuhan we know that we live in a period of the extension of the mind outside of us, in the sense that the wheel was an extension of the power that we have in our legs to move. So we now with our electronics have extended our central nervous system not only around the globe but out into space. This then gives us the responsibility to see enlightenment, not in terms of individual attainment, but in terms

of social attainment, so that at that point we *must* say that the world, as we see it now, is intolerable. Do you follow? Now on the individual level, now as ever and for ever more, it will be possible to see each day as excellent, '*Nichi nichi, kore ko nichi*', but in social terms, in terms of the extension of our minds outside of this which is our present situation, we must see the necessity for the training and disciplines of all of the creation such that life in this intolerable situation will work. Now, I needn't, need I, point out intolerable things going on nowadays? They're too evident. We know them without even mentioning them. Our heads are full of them. We must make the world so that those things don't take place. This divisiveness of intention and purpose, and competition in the world between the nations. The wars, the dog eat dog, the piggishness, is utterly intolerable. And we must see – I don't know how to say it in Japanese, I must learn – but it would be 'Each day is a miserable day' as long as, for instance, as *one* person is hungry, as *one* person is unjustifiably killed, etc., etc., etc. Is that not true?

Very true.

ROGER SMALLEY *But how does art help?*

I may be wrong but I think art's work is done. I could be right in terms of my own work, with respect to it. I must be wrong certainly with regard to other people's work, with respect to it, but as far as I'm concerned twentieth-century art has done a very very good job. What job? To open people's eyes, to open people's ears. What better thing could have been done. We must turn our attention now, I think, to other things and those things are social.

So you must logically give up composing?

No, no, let's not be logical. We're living in this rational irrational situation. I can perfectly well do something illogical. I can do something unnecessary. I can fulfil invitations, I can invite myself to do something frivolous. I can be grand at one moment and idiotic the next. There's no reason why I shouldn't. I might even from time to time need a little entertainment! But I was talking with Jasper Johns not so long ago and

we got talking along these lines and he said that he could imagine a world without any art in it and that he saw no reason for thinking that it would not be a better world than the one we're living in. And for that to come from an artist who more than any other of the artists in New York has reasserted the values of painting – not as an interdisciplinary activity but as just plain painting – and an artist whose last painting – the one I saw before I set out on this tour – he was so pleased to see that when he had finished it there was nothing but paint on the canvas! There are so many people who find his work, you know, not so urgent for them because he is so painterly, so devoted to painting. For *him* to say there's no need for art or that it might be better not to have any, he really knows. Sometimes people ask me what is the goal of technology; I say we really need a technology that will be so excellent that when we have it we don't even know it's there. In a sense – and I see this recurring in all fields now, this statement recurring – the proper goal, I don't like the word goal but let's use it. The proper goal of each activity is its obviation. Wouldn't this be a lovely goal now for politics, for economics?

So you advocate a return of the condition of art that perhaps it was in the Renaissance when it existed but people weren't so aware of it? They banqueted in halls and they were surrounded by great paintings and they listened to music but they talked while the music was on. Do you see this as a future position of art, perhaps?

I see it as the present one actually. It began for me, I mean this experience began for me, in Washington. David Tudor and I were performing my *Variations 6*. While we were performing people who were seated around the performing area – but they themselves were surrounded by the loudspeakers – which gave the result of the sound, you know, and it was in the Pan American Union. First those left who found the whole thing insupportable. Then those who were interested stayed but began moving around the room and conversing. And those who were most interested came close to see what we were doing and shortly began talking with us while we were performing, sometimes relevantly and sometimes irrelevantly. Now, in *Variations 4*, in the case of the performance in Hollywood about two years ago, some people came up to me while I was performing (it was in an art gallery) and I was unwilling to talk to them

because I thought I was performing, and when they talked to me I didn't reply or if I did, I think I did to one person who was quite insistent, I simply said, 'Don't you see that I'm busy?' Whereas in the case of *Variations 6*, this whole need to be busy had dropped away. The work was being done, which brings us back to that haiku poem *Taking a Nap*: 'I till the field taking a nap, I pound the rice taking a nap.' I pound the rice. That is to say, by doing nothing, everything gets done.

DAVID SYLVESTER *This is true and false.*

I think we have to say yes to what you just said. Yes, it is true and false, but it's very true.

ROBERT RAUSCHENBERG

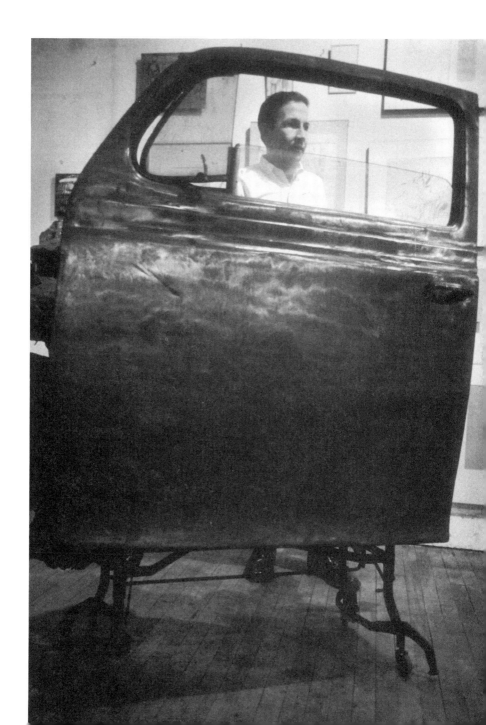

Recorded in two sessions in August 1964 in London when the artist was there with the Merce Cunningham Dance Company. The version edited for broadcasting by the BBC remains unpublished. The present version has been edited from the transcript.

Robert Rauschenberg with work in progress, New York, 1964. Photograph by Dan Budnik.

ROBERT RAUSCHENBERG 1964

DAVID SYLVESTER *I had my first sight ever of Merce Cunningham and Co. only the other night. The first dance on the programme,* Suite, *produced a surprisingly familiar image. It brought to mind the Giacometti sculpture called* La Place *showing five very separate figures in a street.*

ROBERT RAUSCHENBERG I know it's been compared to that in the use of space; people sometimes see some similarity there. I know that Merce is a great admirer of Giacometti.

Well, about Giacometti's attenuated figures in general, they often give me a strange sensation that I've had in watching a few of the greatest dancers: that they can somehow seem to be containing the volume of their body within its actual contour. Do you know what I mean?

Yes, Yes. And that figure activates the entire space.

Exactly. One dancer I've seen do this is Ulanova.

Yes, I've seen her in a ridiculous role of a blind woman and I just wanted to weep while I saw her manipulate all the empty space on an enormous stage. I think Martha Graham earlier did it. But Merce can do it, and he tried to get that into the relationship of the people on the stage, and one of the things he worked the hardest on at rehearsal was the respacing of the dance.

Well, Giacometti can activate space in that way more than any other sculptor I can think of.

Oh yes, oh yes. But it also has to happen with great paintings. The canvas itself has to be recognised as having as much presence before one begins to paint as it does afterwards. So that you can kill the space by doing one of either two things. One is insisting on a central focus and another is to paint in such a way that you have it in mind to direct the spectator's eye.

In my own work I would like any time I'm finished with a picture for it to look complete, but not in the sense of 'complete' meaning 'filled'. I mean space is not to be just filled, it's to be dealt with. And I think the space in a room is brought into the painting by some sense of openness. Now, you can put an awful lot into a picture if you keep in mind that this painting could actually be a little larger but it isn't, so that the edge of the canvas is just a stopping, a termination of activity that's been going on – which is something that anyone can see. I mean, that's a fact, it's not an aesthetic.

I take it that this is one reason why you introduce real things that project beyond the canvas. And I'd like to ask you whether, when you bring in some found object, there's any problem for you in the relation between its physical being and the associations it brings with it.

Using something that's more familiar some place else its identity has to remain the same. But somehow the context should be able to free it or open it up to thinking about it differently but at all costs avoiding some kind of surrealistic placement. In Surrealism, where the use of foreign materials is to make illogical juxtapositions of subjects, even though a single conscious point may not be being made there's always the implication that the thing is unnatural. And I think it's terribly difficult always to complete the cycle again where you began with a glass of water and you reduce it to the fact that it's this big, it's this high, that it might topple over, that it evaporates, that it has to be refilled, that it picks up reflections, that it has to stand in a certain position to remain filled, plus all the psychological implications of a glass of water. And in most cases my manipulation of the psychological is to try to avoid the ones that I know about. I had trouble in one painting, a silk-screen painting. I was silk-screening a glass of water and I put it over green and the whole painting had to change to destroy the look of poison, which is just simply an association that one has with a glass of green liquid. But, having made a decision which is taking something out of its natural existence or its natural environment and putting it some place else, you have to work until, when you have finished the painting, the glass of water looks as reasonable there as it would any place else you might have it.

Whereas a Surrealist would want it to look surprising.

Right. And another problem arose from using a brick. It was a painter's problem even though it was a brick instead of a particular colour that I was having to deal with. A brick is heavy and most comfortably it would lie, but when it was down unfixed or fixed on something that clearly would hold it, support it, it tended to look less like a brick because it looked like an architectural form of this particular colour made out of this particular material. And the only way that I was able to, at that time, let it look as brick as possible was to suspend it. It seems to me that a weight hanging gets very close to a surrealistic attitude, but it wasn't. The brick was not Dada even. The brick was most commonly itself and gave the most with its material, like what it furnished as a shape, as a colour, as a volume, by being suspended. In other words, you don't just work obviously to create something that gives one the sense of ordinariness. I think it's a very sophisticated process that takes place in order to finally get back to a kind of natural or straightforward presentation of what you're doing.

In the painting called Allegory *there's a large piece of crumpled tin that goes from the top to the bottom of the canvas.*

It was a result of bulldozers' work in tearing down a building in the neighbourhood. I uncrumpled it as much as I could and I found that activity very interesting. It's like unwrapping something. And the form kept changing. And so I pulled it out with the use of enormous hammers and crowbars and things to the dimension of the painting that I was working on. I felt that, even though it was perfectly clear that it was a mass of crumpled tin, its history was built into it, it was filled with the sand of the place that it was found in, it was no longer that smooth sheet that it had been – and it had been many years since it hadn't been that. And I was amazed that it created the illusion of something much lighter, much more fragile, than what it was. And I found a dichotomy of fact. The tin was so lively I had trouble getting it on to the surface because it kept looking like something added, because it looked very light and almost as though it could blow away, or as though it was the result of a wind instead of a bulldozer. And the way I solved that was by putting it on a mirror which could let it extend as far behind the picture as it protruded. And it just sat there without my having to doctor it up,

change its form, forcing it, either by colour or by putting another piece of the same kind of metal or the same colour as it was some place else, to be tied in academically. Nearly everything around us that we have any control of is based on how well things work together. I mean, one furnishes a room with what fits into that room nicely, on what goes together, and I think it is an enormous influence on us. And the thing that's so exciting about art is that it doesn't have to get along.

Why was the painting entitled Allegory?

I think the painting is in four sections; it may be only three . . .

It's three, one of them much wider than the others.

Each section had its own independence more obviously than in some other paintings that I'd done, so that one could bridge the separations by calling it *Allegory*, which can be a series of events, and in this case they relate because I simply had fastened them together. Also the implication of *Allegory* is that it's large. I enjoy titling paintings very much because it's a very dangerous thing to do. Introducing another colour or another piece of material or another image does relatively change the relationships – if you add something that's blue all of a sudden that relates to everything else that is blue or blueish – but I don't think as much so as the one word that one uses to refer to the entire picture. And it's always difficult to pick a title that looks as though it works with that painting but not to the point that it explains it.

Do you always title them after you've finished or do you ever title them while you're still working on them?

Sometimes I think of a good word that interests me.

And you find that influences the way you work on the picture subsequently?

Yes. I for a long time tried to do a picture called *Buffalo*. I only tried I think twice and one time the picture ended up being called something else. And the picture that I did call *Buffalo*, I could see that that was right

when I was about three-quarters of the way through.

Have you ever found that giving a thing a title while you were working on it made it go wrong?

No more so than any other ideas I might have while I'm working. Sometimes I think I can use ideas of any sort as an excuse to begin working. And when I'm just working organically, without a lot of problematic considerations, well that's ideal. And when I do stop and I start thinking problematically about the painting, any image or idea of composition that I can have that will get me back across the room working again is a good one. In the sense that once I get there I can know that it's not about knowing that I have to do that. Sometimes I still know that's what I'm doing, and I do something else. It sounds so simple-minded but it happens quite often that I think what the painting needs is a little red right over there and by the time I get the red on the brush and get back to the picture I can't remember where I thought it was to go. But there I am with red and there's the picture and I put it down. And then that's much more interesting for me than sort of building a picture as one might build anything. I prefer the attitude of the picture just evolving rather than working towards some kind of conclusion. I think the largest consideration is that you don't let any single element actually dominate the picture. So that nothing becomes subservient.

When you start a combine painting, does the first idea tend to be a rough idea of its overall look?

Oh, never.

Or the desire to associate two elements or three elements?

The latter possibly but very rarely. Most often what happens is that I get some canvases and I usually stretch a variety of sizes and shapes and then there may be something that I wonder if I could get that into a painting. And the whole thing begins around one thing rather than a kind of dualistic relationship of two things.

For example, what did Allegory *begin with?*

I think it began with that's how much unsized canvas I had left and that dictated the size of the picture. And after I had begun the painting – which is in three or four sections, I'm not sure – I felt that I'd like for it to be a little larger. And that's where the panel comes in which is the piece of metal. And I couldn't say why I wanted it to be larger or I just felt like working on something bigger than the canvas was, and that's happened before. There's a picture called *Winter Pool* that has a ladder in the middle of it separating the actual two canvases. It wasn't that I wanted to do a picture with a ladder, even though that may look like the most arbitrary element in it. It was just something about feeling restricted with the size that I had made for myself. And yet literally I had no more room to paint on when I put the ladder in between, but it was a larger painting. I haven't examined this, I don't know if it's so or not, but I think what might happen is that I go through periods of liking a lot of paint, and big brushes as opposed to another period where I get very involved in the relationship, say, of a ruled pencil line as colour.

Do you usually, then, begin with marks rather than with ready-made objects?

No, I can begin from any part. Sometimes when I can't get started I just simply draw a line all the way across the canvas. And then my activity is doing something in relationship to that line, but very simple-mindedly like working above it or below it or on it, or in some cases to do something to cover up that line. But I think any of these excuses is to get started and is just an aesthetic as an extremely recognised noble intention.

The foreign elements introduced: if one can generalise, are they more often than not things you've already got lying around the studio or things that you are looking for while you're working on the thing?

Most often they are things that are just around. Or something that is found in some cases maybe while I am walking home from being out. I find night a very good time to focus, or weekends, because you're not so

distracted as the streets just aren't so full and there's time to see other things other than people or crowds. Sometimes you just see directions like the people are coming this way and the cars are going that way when it's very busy. Like in *Allegory* that piece of tin you mentioned: it was practically folded up so that I could carry it. And I knew that there was lots of tin there. And so I simply took that. I imagine that that was already in the studio. I very rarely see something and say: 'Oh that's exactly what I need for such and such a painting.' So that sometimes I have a sense that I just need something else: I need more and in a case like that I'll just simply go out and walk around the block.

I take it that you would never want somebody looking at a painting of yours to know exactly why you used a certain element, what your attitude was to it.

Right. While I actually try to work with things that my attitude isn't clear about, there is another awkward technical problem. That is that when I finish a painting, particularly with the collages and constructions, most people assume that it's about using anything. Now, one can use anything. But I have certain limitations, and at a particular time have enormous bias about particular objects. Nostalgia is constantly a problem because the most available materials have more or less been discarded. The fact that they are old or have been thrown out usually implies that they've been used. But I'm not involved in that fact that they have been used, except in the way that it physically appears in that object. But that's an association one has to constantly be on guard about. So that I might use a glass of water in a painting but I would hesitate to use a glass of wine.

Because it's too particular?

The associations tend to funnel inwards.

It would be quite different using a glass of wine if you were a Frenchman?

Right. People used to send me all kinds of things thinking I might use them, but they were too interesting in themselves and their beauty was a strain on their function. So I more often just used the things that were in

my own immediate vicinity. They'd be tearing down a building one day, they would be putting one up the next. The telephone company would be working one day, the water people would be working another. And they all make their own particular kind of artist's equipment. So that the piece which I'm working on when the telephone people are out tunnelling new lines would be made up of something quite different on another day when the kerb was being widened.

But you were able to use a bottle of Coke, which in your environment is as natural as a glass of water.

Yes. And there was even a problem, for that painting was damaged in Venice. And something that is common in one locale becomes exotic in another – just a working hazard. The European Coke bottle is white instead of green, and it was very difficult to find green Coke bottles. And a great number of Cokes had to be consumed in order to finally come up with enough green ones. But there's the difference. But I like that too. Say that will force someone who wouldn't naturally be drinking Coke to have to because they are concerned with the painting; they'd have to go out and start drinking Coke in Venice in order to try to find a green Coke bottle. I like it that it seems to me to be an extension over my interests in doing the picture. When a painting with a goat in it was exhibited some place in Europe, someone sat on it to have their picture taken. And it broke one of the front legs. It was such a serious break that with my kind of at-home craftsmanship I was unable to reinforce that leg enough without changing the whole picture. And it wasn't a Museum of Modern Art or Metropolitan restorer I had to call; I had to call the Natural History Museum and get one of their best taxidermists over.

You have several works in progress simultaneously, do you, normally?

Well, with the silk-screening I do. I've worked on as many as I think eight paintings at one time. But before I didn't used to be able to do that: I didn't like the divided focus. But it may have been that at that time it was more difficult for me to focus. But now I like it very much. I get hung up on one painting. But then I just move to the next one. It's like if you had a house and you didn't like house-cleaning, if you decided this room was

1964

too messy for the way you were feeling at that time, you might find it comforting some other time and you just walk to the next one. So that way you don't get involved with your work problematically. It takes the same amount of time to do eight as it does to do one. Usually . . . well, let's pick a number like five. If I'm working on five paintings at once – because eight is exceptional – it's difficult just physically to be able to see out of the corner of your eye that many paintings, if you work the size I generally work. I like living in the same place that I paint. I like to live with the paintings. Nothing like in a big romantic sense, but that they are there while I'm doing other things. That's why I'd be working on one painting and I might just simply look up from making a pot of coffee and all of a sudden I would know exactly what to do and go over and start working. I work better that way than sitting down and staring at the picture and trying to figure out what it needs. I try that, but then I don't force it. I don't really get very disturbed about that. I don't because I'm familiar with this other thing that can happen. And when I work on more than one painting at a time now I find the look that you give a picture and the sort of relaxed awareness that you have of that painting in its present condition while you're working on another painting is very very sort of refreshing. And action tends to just flow more naturally. It's like trying to remember someone's name. The harder you try to think about it, the more difficult it is. Or if you think of a name that's very much like, well then you're just lost until you forget the whole thing.

I find it very interesting that you don't begin with dualistic ideas – you know, wanting to associate two particular things. And I think it's a thing which one might have supposed happened.

But I think one can rationalise any kind of relationship between two things that way.

Do you have to stop yourself doing this?

Yes, I do.

You do get a temptation to do it?

Absolutely, yes. Because that's another thing about our training, about seeing the similarities, the superficial relationships between things, that those similarities are the ones we already know. I think paintings do have a limited life anyway. I think they more and more become the way we remember them. And when that happens the painting is dead.

JASPER JOHNS

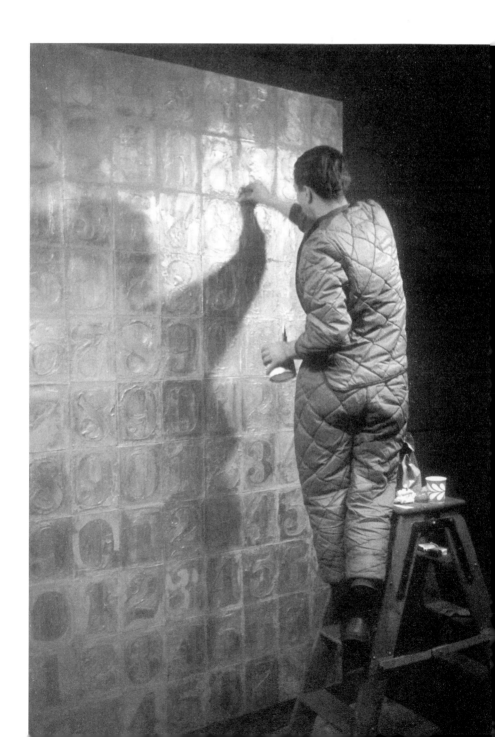

Recorded April 1965 at Edisto Beach, South Carolina. Excerpts from the version edited for broadcasting by the BBC were first published in *Jasper Johns Drawings*, London (Serpentine Gallery) 1974. The present version has been edited from the transcript.

Jasper Johns at work during a winter heating crisis in New York, 1964. Photograph by Dan Budnik.

JASPER JOHNS 1965

DAVID SYLVESTER *You began with monolithic images such as a flag or a target or a numeral and then extended this use of given forms into all-over compositions by constructing grids with a numeral or a letter in each frame. You've gone on employing those strategies but at the same time you've developed the use of increasingly free kinds of composition.*

JASPER JOHNS In the flags and targets and things of that sort there was a rigid image which determined certain simple divisions in the painting, and the painting tended to be a very clear object, filled by one image. It seemed to me that if an image filling a space could make an object, then something which was less of an image filling a space could make an object. In the *Flag on Orange Field* I left space around the image, and gradually I tried to eliminate the image completely. I wanted not to have a clear method of beginning. I wanted not to have to measure precisely elements which were going to make up the picture before making up the picture. I wanted to have less steady lines that I had to follow, less steady references, as in the flag you have a straight line or a star, and somehow, however well you make a line that is not straight, or you make a star that is not symmetrical, you always have to suggest that static thing as a reference. So that when you begin looking you have the opportunity to see whether or not the line is straight, whether or not the star is symmetrical, and of course in my work it never is, or it tends not to be. A straight line was not straight, and it seemed reasonable to operate with that idea.

Was there anything other than an instinct of what seemed right on the canvas that told you what to do? Did you measure what you were painting against anything outside the painting?

Well, occasionally I have images in my head, like, say, falling apart. Nothing more than that.

Well, that is quite a lot.

145

Yes.

Will there be an attempt to make what was on the canvas be like, say, the process of falling apart?

Yes, there would be that image at any rate in my mind. But the painting itself is always rather static.

When you were painting Disappearance II *did you have an image of disappearance?*

No. I had an operational idea of that which involved folding canvas. The first *Disappearance* was involved with the idea of putting more into a painting than the painting could hold, and what this involved was to take a piece of canvas larger than the canvas on which I was working, and to fold the large piece of canvas so that it would fit into the smaller area, and then to paint. Then the painting beyond it was of my own sensibility or whatever. No laws governed it.

What about Out the Window? *Did you have an image relating to a window?*

My sister was visiting me when I lived down in Wall Street. Across the street was a parking lot, which during the week was filled with cars. And on Saturdays and Sundays the parking lot was quite empty; three sides of it were very high with bare walls. And my sister, who didn't know my work, and who certainly didn't care very much about my work, was looking at my paintings and she went over to the window and looked at the parking lot and she turned and said it looks as if you paint what you see out of the window. I thought that if she looked out of the window and saw nothing and looked at my painting and saw nothing, that was a marvellous relationship between the painting and whatever she saw. Her idea was to negate the painting by saying it was like what was out of the window, which was nothing, where to me out of the window there was a great deal to look at. And I made that the title of the painting. Then after that I did another painting which is also called *Out the Window*. And I suppose I did that because it followed somewhat the other painting: the

canvas was divided into three horizontal areas, each one with a colour name in large type, in large letters, 'red yellow blue'.

And when you did the painting with a similar configuration called By the Sea?

I was by the sea, I was down here at Edisto, and it was one of the first paintings I did down here. And it seemed to me that my painting had developed, had changed, I suppose because of the light. During that painting I was working at many different times of the day – at four o'clock in the morning, pre-sunrise, by electric light and, since one side of my studio is always screened, as the sun comes up the light comes in, and at a certain moment one turns off the electric light and works only by daylight, and then as darkness comes, one is able to turn on the electric light again, and one needs to, and it seemed to me that the colour relationships had changed from what they had been previously in my painting. And I called it *By the Sea.*

Do most of your titles come only after you have finished the painting?

Most of those paintings I've made I've named after they have been painted. With the targets and flags, there is no concern about names; I was simply painting what they were.

Sometimes you get different ideas for names while you are working on a painting?

Many times, because I like the business of naming a painting, and frequently I've begun to think about a title before I've done the painting.

If you have a change of mind while you are painting as to what the title might be, do you find that that change of title influences the way you go on with the painting?

No, I don't think so. Sometimes I change the title because it seems to me the painting has changed.

JASPER JOHNS

What is the role of the titles?

Well, Duchamp said it was an extra colour. He felt that about his own paintings. For me the title is simply a sort of suggestive pleasure. It is also a way of identifying paintings, of being able to refer to a painting and know that it is one painting rather than another.

But you give it more thought than is necessary for that, don't you?

I don't see that need require a lot of thought.

You wouldn't leave it to your dealers to name them, would you, as some painters do?

Some of my paintings have been misnamed by my dealers. I have a drawing which is called *Broken Target* and which I never called *Broken Target*, I called it *Target*, but the drawing has in itself got a broken quality which made it easily referred to and so on.

Now, there are cases, obviously, where you have named the piece quite meaningfully, as when you called the two beer cans Painted Bronze.

Yes. I wanted to call them what they were. They were referred to generally as *Two Beer Cans*, and they are not two beer cans, they are two ale cans. So I thought to confuse the situation more and also to make it clearer to call it *Painted Bronze*.

So this was a case in which the title was an extra colour. It was decidedly informative and not simply a name.

I thought it was informative, and that it made it clear that it was not beer cans, but was strictly bronze. It avoided the problem of beer cans as opposed to ale cans.

But it was a way in a sense of telling the spectator how to look at things.

It was that: it was also a way of making it look freer, less a

148

representation of two cans. Yes.

I'd like to revert to Out the Window.

The painting began by its being divided into three sections. In the upper section I put in large letters the red, in the middle section I printed in large letters the word yellow, and in the bottom section I printed blue. And then I proceeded to paint it in broken brush strokes, and broken areas of colour, in a way that looked foreign, and broke the three divisions and broke the lettering.

So the idea there was to put certain clear-cut configurations, namely divisions and letters, and then begin to break them up.

Well, that was what was done. I don't remember that was the idea of what to do. I don't know that the idea exists other than that that is what was done. I don't know that I had such an idea. I know I thought to divide the canvas into three sections, I printed these words in and I proceeded to paint. The way I painted, I had had no idea to paint it in that way.

The idea then is often no more than a certain way to divide the canvas possibly with the introduction of certain elements? The idea is often no more than that?

Yes.

So the idea that you begin with is very often, or perhaps generally, no more than those elements of which the painting itself is to be made?

It is a way to begin a painting, but during the painting many things can happen. The elements which you use to begin the painting can be reinforced, can be made almost a subject matter, or can be obliterated. Usually they are both partly reinforced and partly obliterated.

So what the painting is is the result of the process of working with the marks that you make upon the layout you begin with.

Which resolves those marks. Like making marks within marks and over marks.

Except that the form you begin with is usually conventional. And the marks with which you work are personal.

I suppose so. Yes.

Now, the ones you begin with. Are they very deliberately conventional? Such as the strictest division of a canvas by straight lines? Or the use of accepted signs, printed forms of lettering? Or accepted designs such as flags or maps?

One's first divisions of the first marks or the first thinking tends to reinforce the idea that the canvas is an object, either by mathematical divisions on or within a particular area. Or by relating to some conventional object from the environment, such as a big letter.

Do you think of the letter as an object from the environment?

Yes. It's not a written letter. This time it is not made by handwriting, it is a conventional form.

But you think of it as a letter taken from the environment and as a kind of standard form of letter. You think of it as a letter much as that which might appear, say, on somebody's front door?

Well it's not my letter.

No, but it could be that a letter was an ideal form, a sign which belonged to no particular place or time, or it could be that a letter was a letter such as one might see in a certain kind of context.

I can't make the distinction between those two.

Well, the letters of the alphabet have a long history, and one may look at a large number of fives and one might see a five which clearly belonged to Germany between the wars, a five that was Art Nouveau, a five

that was eighteenth-century.

Well I try to avoid that kind of particular quality.

In other words, it is not so much the environmental aspect of the letter that interests you, it's more its permanent aspect. An ideal form.

I don't know whether it's an aspect which implies permanence or ideal form. I tend to think of it as not involving personality. I tend to think of the choice I make as that the letter should have no characteristics of a personality having made it. Then it seems to me to be open and generally useful as a letter, rather than only useful in a particular situation. I try to pick something which seems to me typical, undistinguished by its peculiar or aesthetic design qualities. And to pick something which doesn't force you to focus upon its originality in terms of design. So, if you want to call that ideal, perhaps that's ideal. Perhaps for someone else the conception of the ideal would be something more peculiar, or more studied, more shaped.

I mean the universal rather than a particular.

I mean I pick it, and I pick what I want and that's what I pick. It seems to me that I tend to pick something which has characteristics which for me suggest the ordinary. It would not occur to me that the ordinary was someone's conception of the ideal. The ideal seems to me to suggest a different kind of precision.

Have you ever asked yourself why you are attracted to numbers and letters?

I don't know whether this is why I am attracted – that it is the logical extension of the earlier images which I used.

Do you know why you were attracted to them?

They seemed to me preformed, conventional, depersonalised, factual, exterior elements.

JASPER JOHNS

Why are you anxious to use as your starting point these depersonalised elements?

I am interested in things which suggest the world rather than suggest the personality. I'm interested in things which suggest things which *are*, rather than in judgements. The most conventional thing, the most ordinary thing – it seems to me that those things can be dealt with without having to judge them, they seem to me to exist as clear facts, not involving aesthetic hierarchy.

If you were to begin with a common object such as a bottle or a loaf of bread, something again which has a conventional and recognisable form – I suppose the nearest you've come to that was in using a wire clothes hanger – this would be another way of dealing with something impersonal and external and factual and working upon it, reinforcing it and obliterating it. But you prefer to begin with, say, numbers, letters, flags, geometric divisions on the canvas? I take it that this is a matter of instinctive preference rather than doctrine?

Oh certainly, but instinct tends to become doctrine. But the thing certainly has not been reasoned in this way before beginning. They have simply been begun. And one also thinks of things as having a certain quality and in time these qualities change. The flag for instance, one thinks it has forty-eight stars, and, suddenly, it has fifty stars; it is no longer of any great interest. The Coke bottle, which seemed like a most ordinary untransformable object in our society, suddenly some years ago appeared quart-sized: the small bottle suddenly had been enlarged to make a very large bottle, which looked most peculiar except that the top of the bottle remained the same size – they used the same cap on it. The flashlight: I had a particular idea in my mind what a flashlight looked like; I hadn't really handled a flashlight since, I guess, I was a child, and I had this image of a flashlight in my head, and I wanted to go and buy one as a model. I looked for a week for what I thought looked like an ordinary flashlight, and I found all kinds of flashlights with red plastic shields, wings on the sides, all kinds of things, and I finally found one that I wanted. And it made me very suspect of my idea, because it was so difficult to find this thing I had thought was so common. And about that

old ale can which I thought was very standard and unchanging, not very long ago they changed the design of that.

Well, I think when you were talking about the flashlight that is exactly what I meant by the ideal. The flashlight that you wanted was an ideal flashlight, like the ideal number that I was talking about. It hadn't got particular excrescences, it was a kind of universal flashlight, and like an ideal flashlight it was in reality particularly elusive.

Yes, it turns out that actually the choice is quite personal and is not really based on one's observations at all.

The ideal is an abstraction from a number of separate flashlights, and in reality it was very difficult to find an example that conforms precisely with the general idea.

I don't like to think of it in that way, but you are probably right.

Would it be true to say that when you're making paintings or drawings or prints, when you're working on the flat, you tend to refer to flat motifs, such as numbers and letters and flags and targets, rather than to three-dimensional objects, such as the flashlights and ale cans that appear in your sculptures?

Generally. But that is not entirely true. There are plaster casts of objects attached to paintings.

Three-dimensional objects to represent three-dimensional objects.

I don't generally worry too much. I find a way to do it which comes directly from a process. For instance, in one painting I wanted to use a skull, and I tried many things. I tried pirates' flags and death's-heads and such things, and nothing worked. Because most of these things seemed to have been made by one person and there didn't seem to be a standard form. My solution finally was to buy a skull, and to put paint on the skull and then to rub paint off the skull and to get an impression of this skull. It is a painting that suggests a skull without my ever having to draw it. Or

represent it. I mean I represented it by letting it represent itself simply by doing something.

Making a projection. One of the few still-life objects in your pictures is the wire clothes hanger.

It is the most conventional hanger in this country.

But it's interesting that when you do a picture of a tangible object, it's an object that has virtually no volume, no substance, unlike the objects dealt with in the sculptures.

Yes, the sculptures involve much greater representation, actually, than the paintings. There is no doubt about this. Using solid objects is an extension of painting. I don't represent them but I make use of them.

When you begin a painting or drawing with a rigid and factual image, do you work on it with some degree of intention or do you simply paint round it, over it, across it, and see what happens?

I work with the image enough in mind to allow someone examining the work – and in working I am the one examining the work – always to be able to find it. I work with any image so that perhaps from painting to painting of, say, similar images a different focus is required to find it. But I don't think there is ever any doubt that it is there.

But are you aware of any end to which you were directed while working on it?

I may be imitating something I heard somebody else say, but I think I work until my energy runs out on that particular thing. I then have no more energy to give to it, and then I stop.

And then you stop.

But by the time a painting is finished, it has usually got quite boring to look at for me.

But is it finished because you get bored or do you sometimes finish before you get bored?

I think I usually get bored before I finish, having no other suggestions to make in the painting, no more energy to rearrange things, no more energy to see it differently, and then I think the painting is the way it is.

Is what you are doing in working on it investigating the possibilities of the different ways in which the elements you began with can be seen and not seen and half seen?

That is certainly part of it. But I wouldn't say that is *it*, but it is certainly part of it. My idea is this, I think. You do something in a painting, and you see it. Now, the idea of 'thing' or 'it' can be subjected to great alterations, so that we look in a certain direction and we see one thing; we look in another way and we see another thing. So that what we call 'thing' becomes very elusive and very flexible, and it involves the arrangement of elements before us, and it also involves the arrangement of our senses at the time of encountering this thing. It involves the way we focus, what we are willing to accept as being there. In the process of working on a painting, all of these things interest me. I tend, while setting one thing up, to move away from it to another possibility within the painting, I believe. At least, that would be an ambition of mine; whether it is an accomplishment I don't know. And the process of my working involves this indirect unanchored way of looking at what I am doing.

Obviously each new move is determined by what is already on the canvas; what else is it determined by?

By what is not on the canvas.

But there are a great number of possibilities of what might go on the canvas.

That is true, but one's thinking, just the process of thinking, excludes many possibilities. And the process of looking excludes many possibilities, because from moment to moment as we look we see what we see; at another moment in looking we might see differently. At any

one moment one cannot see all the possibilities. And one proceeds as one proceeds, one does something and then one does something else.

But the marks you make are not made automatically?

But how *are* they made?

That is what I would like to know. Are you conscious of the different ways in which you are making them?

At times, yes. At times I am conscious of making a mark with some directional idea which I've got from the painting. Sometimes I am conscious of making a mark to alter what seems to me the primary concern of the painting, to force it to be different, to strengthen, to weaken, in purely academic terms. At times I will attempt to do something which seems quite uncalled for in the painting, so that the work won't proceed so logically from where it is, but will go somewhere else. At a certain moment a configuration of marks on the canvas may suggest one type of organisation or one type of academic idea or one type of emotional idea or whatever. And at that moment one may decide to do two things: to strengthen it, by proceeding to do everything you can to reinforce it, or to deny it, by introducing an element which is not called for in that situation, and then to proceed from there, towards a greater complexity.

So you are aware that the painting has taken on a certain dominant emotional idea?

Emotional or visual or technical. One's awareness can be focused on any kind of idea. I guess it's an idea; it is a suggestion.

You are conscious that the painting might have a certain mood?

Certainly.

Is it often a mood that you intended it to have in the first place or one that has simply evolved?

I think in my paintings it has evolved, because I'm not interested in any particular mood. Mentally my preferences would be the mood of keeping your eyes open and looking, without any focusing, without any constricted viewpoint. I think paintings by the time they are finished tend to take on a particular characteristic. That is one of the reasons they are finished, because everything has gone in that direction, and there is no recovery. The energy, the logic, everything which you do takes a form in working. The energy tends to run out, the form tends to be accomplished or finalised. Then either it is what one intended – or what one is willing to settle for – or one has been involved in a process which has gone in a way that perhaps one did not intend, but has been done so thoroughly that there is no recovery from that situation. You have to leave that situation as itself, and then proceed with something else, begin again, begin a new work.

And you want the finished painting to embody a sense of the experience of looking?

Yes.

Of looking in general or of looking at the particular elements which are introduced into the painting?

I want the painting to be a thing which can be looked at. I don't know whether one wants anything other than to just work and stop work.

Do you have a very clear idea of what you don't want to do?

Yes, and that is a lot to have.

Is the result perhaps that which is left when you have found out for yourself what you don't want to do?

Well, the result is what is left when you have done what you have done and when you don't do any more. I think one's attitude towards the result, the way you are introducing it now, is about *judging* what you have done, which one will tend to do, but it's not very interesting. The most

interesting judgement about painting that I make is the way I proceed after it. Not always. But one of the possibilities is that you do something which allows you to do something the next time that you would not have been able to have done the last time. Another is reaching a kind of illusion of perfection – either visual perfection or intellectual perfection or emotional perfection or perfection of energy.

But what would be the criterion of that perfection?

I think the standards which one happens to have, whatever they happen to be. I mean, one says something is beautiful; and then someone else says something is more beautiful, and someone says something is big, and then someone else says something is bigger.

But that is not the same as perfection.

Well, it can be a perfection of that element. For me it is very interesting to be able to make a large painting, because I tend to work in a certain size, and it is always interesting to me when I decide to break that so as to work in a different size. And that to me is a sense of accomplishment, that is to say, it breaks my habits if I do it. Generally, when I make a large painting it's for some subjective reason which is different from deciding to make a painting of a different size. Or when I make a small painting it's for the same kind of thing. I don't like to make miniature paintings and I frequently do it, but every time I make one I say 'I'll never make another one', and I constantly have some impulse to do it. I'm using 'perfection' in a very curious way, I suppose. But nevertheless, if the interest is to make a small painting and then one makes one, and judges it, one may take pleasure in its qualities; the pleasure one might take may be based purely on its size.

And when you make a large painting?

The same thing applies. One goes about one's business and does what one has to do and one's energy runs out and then one looks at it as an object; it's no longer part of one's life process. At that moment, none of us being purely anything, you become involved with looking, judging, etc. I don't

think it's a purposeful thing to make something to be looked at, but I think the perception of the object is through looking and through thinking. And I think any meaning we give to it comes through our looking at it.

And what of the objects you began with?

The empty canvas?

The empty canvas and the motif, if you like, such as the letters, the flag or whatever.

I think it's just a way of beginning.

In other words, the painting is not about the elements from which you have begun?

No more than it is about the elements which enter it at any moment. Say, the painting of a flag is always about a flag, but it is no more about a flag than it is about a brush stroke or about a colour or about the physicality of the paint, I think.

But the process which is recorded as it were in the finished object – this process has an analogy to certain processes outside painting?

You said it.

I'm asking you.

Well, it has this analogy. You do one thing and then you do another thing. If you mean that it pictures your idea of a process that is elsewhere, I think that's more questionable. I think that at times one has the idea that that is true, and I think at times one has the idea that that is not true. Whatever idea one has it's always susceptible to doubt, and to the possibility that something else has been or might be introduced into that arrangement which would alter it. What I think this means is that, say in a painting, the processes involved in the painting are of greater certainty

and of, I believe, greater meaning than the referential aspects of the painting. I think the processes involved in the painting in themselves mean as much or more than any reference value that the painting has.

And what would their meaning be?

Visual intellectual activity, perhaps; 'recreation'.

I don't in looking at your painting have the sense that I can pin down references, but I feel there are references there, and that these are what give the paintings their intensity and their sense that something important is happening or has happened. Is it possible that what has happened in the painting can be analogous to certain processes outside painting, for example, on the one hand, psychological processes, such as concentrating either one's vision or one's mind on something, attention wandering, returning, the process of clarifying, of losing, of remembering or of recalling, of clarifying again? Or that again there might be an analogy to certain processes in nature, such as disintegration and reintegration, the idea of something falling apart, the idea of something being held together?

I think that it is quite possible that the painting can suggest those things. I think that as a painter one cannot set out to suggest those things, that when you begin to work with the idea of suggesting, say, a particular psychological state of affairs, you have eliminated so much from the process of painting that you make an artificial statement, which is, I think, not desirable. I think one has to work with everything and accept the kind of statement which results as unavoidable, or as a helpless situation. I think that most art which begins to make a statement fails to make a statement because the methods used are too schematic or too artificial. I think that one wants from painting a sense of life. The final suggestion, the final gesture, the final statement has to be not a deliberate statement but a helpless statement. It has to be what you can't avoid saying, not what you set out to say. I don't know. I like the idea of very clear-headed procedure. I like the idea of being able to do what you intend to do. But I think that sort of language aspect of painting is not deliberate, it is not contained in our lives. I think it is our lives, you have to settle for that, and I think you even have to encourage it. I think the

other becomes academic and not useful to us.

So that it really is by letting the painting and the process of painting have a life of its own and not wanting to tamper with it that it might be in some way a counterpart of life itself.

One is tampering with it by doing it. But to make choices in doing it for reasons of gaining an effect is to eliminate the life which is at work. I think it ought to end up more as a more total configuration, or a more generally applicable one, I think one ought at least to attempt that. I think one ought to use everything one can use, all of the energy should be wasted in painting it, so that one hasn't the reserve of energy which is able to use this thing. One shouldn't really know what to do with it, because it should match what one is already, it shouldn't be just what one likes.

So that the vitality of the painting is that it is in some way a kind of self-portrait?

I thought you were going to say that. No, I don't think it is a representation, I think it is a use of one's energy – or that is what interests me. I don't think it interests me that it's a picture of oneself. Of course it is in a way. But I don't know that the value of the painting in any work is that it is a self-portrait. No, I don't think that is it. I think the conception of the self-portrait is that one sees oneself as separate from things, and that one is able to make an image of oneself, but I think that is already making energy particular and cutting oneself off from one's life. So I don't think that that's what gives it its life. What finally gives the thing its life is 'life'. But I was just speaking of the process of making. I think one has to do everything that one can think to do; and one has to use everything one has to use, but, more particularly than that, I'm saying that I don't think one should simply cut off a part of one's energy and apply it for a certain result and then be delighted that one gets the result. If what one wants to do is to make a picture of something, one should be able to make a picture out of it. If one wants to accomplish a certain thing, and one knows what that thing is, one should simply set out and do it. And I think the more interesting paintings are paintings which are

made in a more open way. Because the paintings should use up everything. I don't think one should imagine one is making something which is useful to oneself.

In other words, painting is an activity, not a means for producing finished objects?

I think finished objects are produced as by-products of an activity. And I think the objects are frequently entertaining and I think one will have a sense that they are meaningful – frequently, but I don't think that's the point. It is difficult to be on two sides at once, to be on the side of making and on the side of looking at someone's work. Because one does do both, but I think probably one changes one's values when one does it.

The value of the activity, I take it, is that it provides you with a vehicle with which to bring all your energy to bear on something?

Perhaps also there is an element of uselessness in the activity, perhaps it's very self-indulgent. I don't know, but there is something quite marvellous about the uselessness of this activity.

A lot has been said about the sort of semantic paradoxes that are presented in your work.

Yes.

How conscious are you of presenting them?

Occasionally very conscious. Generally my work deals in very simple-minded paradoxes. I don't think they are particularly original but they interest me.

I suspect that you don't ever work in order to illustrate a paradox in the way that artists like Duchamp and Magritte do?

I don't think one works to illustrate a paradox, but also I am not certain that either of those two artists does; I think that one's thinking simply

comes to one in a form, and it's manifest in the work in this form.

When, for example, you write 'red yellow blue' across three areas of grey, is it your intention that this should present a striking contradiction?

Fortunately one does take pleasure in one's work occasionally. I didn't see that I accomplished anything by doing it, but it interested me to do it; it amused me as a possibility. I had worked for a long time with red, yellow and blue, the colours. I was usually restricted to geometric areas, very well-defined. When the painting was moving away from such well-defined areas, the idea occurred to me of using the colour names instead of the colours which I had been using. One takes it lightly, such a decision or such an idea. But one is able to take it lightly because one takes it so seriously that one is amused that something quite serious occurs to one quite clearly, and that is always amusing – that something gains this kind of clarity. In those paintings where colour names are used many times, the stencilled words were the only kind of objective thing in the painting for me – the fact that they were made by stencils, with conventionalised lettering. All the brushmarking, other than paint put on through stencils, was arbitrary, and had to do with my arm moving. I liked it that the words had a meaning. I liked it that the letters had a concrete characteristic. I liked it that those objects appeared in the context of this arbitrary suggestive painting. I liked it that the meaning of the words either denied or coincided in the coloured paintings, or reaffirmed the actual experience of the colour sensation. Those paintings to me were an accomplishment in ambiguity that previous paintings had not reached. I'm talking as the viewer again.

There always seems to be this constant of an opposition between this personal handling, the marks, the free marks, with which you proceed to deal with what you began with, and the impersonal conventional elements with which you begin.

Yes.

The result is always tension between these two. In the paintings the whole design of which is a conventional design or a variation upon it such as the

flags and the maps, you can confine your operations to a smaller area than in the paintings which have a free composition where the received elements are a smaller part of the whole. You persist in doing both kinds of painting. Or do you feel a temptation to move away from the maps and the flags and never to do more of them?

Well, I always feel temptation to move away from whatever I'm doing and never do any more of it. But one goes on working and one frequently uses elements that one has used before.

So you alternate between doing things that are quite unforeseen, and reverting to what you've done before. And you carry out commissions, making new variants on things you've done before.

Yes.

You obviously have no economic need to do this, since you can sell another kind of painting just as easily as the work you do on commission.

We don't know that yet, if the work hasn't been made, if it's an unforeseen variety.

Well, you have a fair chance, let's say. I take it your motive is not purely economic. What is it that you enjoy, then, about doing another version for a commission?

Well, I don't always enjoy it. I frequently do paintings which I don't enjoy doing. I think pleasure is not the prime reason for painting.

Have you any preference among your own paintings?

I have some preference for about four particular paintings. I tend to prefer paintings which I associate with accomplishment or a change.

You frequently incorporate into your paintings pieces of reality, such as spoons and forks or casts of body parts. Has it ever occurred to you to make an illusionistic representation of a spoon or fork rather than to

attach a spoon or fork by wire?

I've done schematic drawings of such things, generally, in opposition to the actual thing or in the same visual range. Sometimes I've done sketches; they are usually working sketches or descriptive sketches.

But all the same, when you are actually making a painting you prefer to incorporate the real thing or a part of the real thing rather than represent it?

That's my tendency, yes, so far.

Do you know why?

No, but I can make up a reason. I think my thinking is perhaps dependent on real things and is not very sophisticated abstract thinking. I think I'm not willing to accept the representation of a thing as being the real thing, and I am frequently unwilling to work with the representation of the thing as standing for the real thing. I like what I see to be real, or to be my ideal of what is real. And I think I have a kind of resentment against illusion when I can recognise it. Also, a large part of my work has been involved with the painting as object, as a real thing in itself. And in the face of that 'tragedy', so far my general development has moved in the direction of using real things as painting. I find it more interesting to use a real fork as painting than it is to use painting as a real fork. This probably has some sort of spatial implications, but I don't know exactly what they are.

It doesn't have a meaning for you, as it did for, say, Schwitters, that the real fork is something that has been actually used and handled?

I don't think so, I don't think that has any value for me, the patina of wear and the sentimental associations; that something has been attached to someone doesn't interest me very much. I tend to dislike that, actually. I think the object itself is a somewhat dubious concept. I think one is ready to accept the illusionistic painting as an object and it is of no great interest that an illusion has been made. I think the object itself is perhaps in greater doubt than the illusion of an object. I don't mean as illusion

but as object. I think one is ready to accept illusionistic painting, the illusionistic representation of an object, one is ready to accept as an object – I don't mean the illusion but I mean the conception of the work – one is ready to take that as an object. I think one is now able to question the object itself, whether it has any real body or any real use – what we call reality, I guess. I think one wonders if one couldn't simply shift one's focus a bit in looking at a thing, and have the object be somewhere else, not be there at all. I think it is questionable now whether the object is the dish, or whether it is a section of the dish and part of the table. And I think now that our main conception of an object is that it will hold something.

What about your sculptures, which do seem to affirm the existence of objects? Or do they question it?

I think some of them question it, I suppose, in a schematic way by having a kind of painterly surface. I mean that the actual variation in the surface puts the object in doubt. Some of them are more painterly than some of the paintings are, I think. I think the concern for surface in some of the objects tends to make you focus in such a way that the object itself is lost sight of and that you are concerned with variation of visual or tactile experience rather than with form in space, whereas I think some of the paintings suggest that they are forms in space more readily than that they are 'windows'.

That they are forms in space – these flat canvases or, rather, not quite flat canvases but canvases the sides of which are inches thick?

Many of my paintings reveal that. In many of my paintings one has a sense that there is a back side to them too. The first one was the painting called *Grey Canvas*, where one canvas is literally turned to another and a large part of the surface is taken up with the rear of the canvas instead of the front.

And Disappearance II – *is that the same sort of idea?*

I think so.

166

1965

Here the idea of disappearance, the disappearance of a part of the canvas, relates to the notion that a painted canvas is more of an object than it is a representation, like a window.

Yes. I think most of my paintings, well, certainly the earlier paintings, suggest that. For instance, in the big *Target with Plaster Casts*, I was concerned with actual things being used in the painting and also the edge of the painting, which has a great thickness, and has also been worked upon: the entire sides have been collaged. And at that time I was very much concerned with the actual fact of a painting being an object, whatever you did to it, rather than making a statement on the front of it. I always wanted to be reminded that the canvas was there, and one is reminded in one's studio because one constantly has these things to drag out: you turn it one way and you don't see it, so you turn it in another way and you do see it.

Is this perhaps why you make very little attempt to give any guidance as to how your paintings are to be interpreted but go to great pains to restore your paintings physically when they have been damaged? That is to say, as objects you want them to be what you want them to be, but as to the meaning anybody wants to put upon them, that is no concern of yours.

I like that very much. It's a very nice interpretation.

You were talking about the object quality given by thickness in the support. What of thickness in the paint?

Usually I apply paint rather heavily at least in spots, and it seems to me that these areas of paint which have a certain thickness take on a three-dimensional objective quality. It seems to me it is simply an extension of that recognition to get to the point where you use an object in the painting in the same way as you use the paint in the painting. All of these smaller areas within the canvas relate to the original situation of having the canvas be an object. The canvas is object, the paint is object, and object is object. Once the canvas can be taken to have any kind of spatial meaning, then an object can be taken to have that meaning within the canvas.

167

The marks stand as traces of where the brush moved. They also create a sense of flatness, of depth, of flatness contradicting depth and so on.

That is a possibility.

A possibility which generally occurs with you?

Which perhaps occurs with me. I think one is nevertheless conscious of the paint as paint – as fact as well as spatial suggestion.

Certainly, but are you also conscious of the total texture of the paint as having a total general reference to something else? To be specific, do you feel that paint is in some way an embodiment of your sensation of reality? What is the relation between what is in the painting and what you see when you look about you?

The relation is that there is always something to see and anywhere one looks one sees something.

What is the difference between seeing when you look about you and seeing when you look at a painting?

At its best there is no difference.

So that the painting is then in some way a crystallisation or a trapping of the sensation you have when you look about you?

Perhaps, but I wouldn't want to push that idea. I think one likes to think there is no difference between the experience of looking at a work of art and looking at not a work of art. There probably is some difference, but I don't know what it is. In the work of art there is probably a more directed sense of seeing, but that is questionable too because one can face a work and not have that sense. One can face the work and have that sense of emptiness like what my sister had, of nothingness, when in fact there is a great deal to be seen. One can look at a wall and have a similar experience of nothing of interest or one can find great interest in looking at an area of wall, or at anything.

Are you trying to invest the canvas and the paint with a life that makes the sensation of looking at it resemble the sensation of looking at reality? Is that what you are saying?

Well, that has perhaps been said, but I wouldn't like to exaggerate that idea, that the painting is a language which is separated from one's general experience.

But the paint is more than the result of your making certain marks and arriving at an order which sometimes satisfies you?

What is it the result of if it is not that?

Well, it is that, but is that all it is?

Well, all it is is whatever you are willing to say, all it is is whatever you say it is; however you can use it, that's what it is. I think the experience of looking at painting involves putting the paint to use, taking the painting as something which exists. Then, what one sees, one tends to suppose was intended by the artist. I don't know that that is so. I think one works and makes what one makes and then one looks at it and sees what one sees and I think that the picture isn't preformed, I think it is formed as it is made. And might be anything. I think it resembles life in that in any, say, ten-year period in one's life anything one may intend might be something quite different by the time the time is up – that one may not do what one had in mind, and certainly one would do much more than one had in mind. But once one has spent that time, then one can make some statement about it – but that is a different experience from the experience of spending the time. And I think the experience of looking at a painting is different from the experience of planning a painting or of painting a painting, and I think the statements one makes about finished work are different from the statements one can make about the experience of making it.

Again and again you return to the way in which something is posited and then contradicted or departed from, so that you are constantly interested in the way in which intention and improvisation work together, in rather the

same way as you are interested in how the conventional material you begin with, say the map, the letters or figures, is contradicted, reaffirmed, modified, submerged, clarified, within the process of painting. In other words, it seems to me that your constant preoccupation is the interplay between affirmation and denial, expectation and fulfilment, the degree in which things happen as one would expect and the degree in which they happen as one would not expect.

Well, intention involves such a small fragment of our consciousness and of our mind and of our life. I think a painting should include more experience than simply intended statement. I personally would like to keep the painting in a state of shunning statement, so that one is left with fact that one can experience individually as one pleases. That is, not to focus the attention in one way. But to leave the situation as a kind of actual thing, so that the experience of it is variable.

In other words, if your painting says something that could be pinned down, what it says is that nothing can be pinned down.

I don't like saying that it says that. I would like it to be that.

CY TWOMBLY

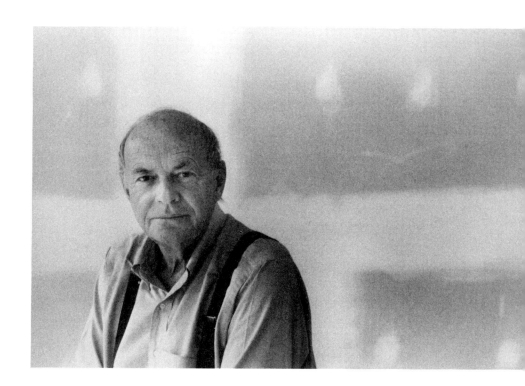

Recorded June 2000 in London. Edited for publication here.

Cy Twombly in his studio, Lexington, Virginia, 1994. Photograph by
W. Patrick Hinely.

CY TWOMBLY 2000

CY TWOMBLY I'm southern and Italy is southern. Actually, it wasn't all that scholarly, my reason for going to Rome. I liked the life. That came first. And the background of architecture, which is one of my many passions, a great background. And, you know, I went to Rome in the fifties, which was a whole other world from what it is now. It's not the same city. In a sense, the life is totally different. It had more space, you could see it and you could enjoy it. Now you just plough through just trying to get to where you're trying to go with the least stress. It's wall to wall. If I went to Rome now, I wouldn't spend two days. But when I went I was in paradise.

Probably even more than architecture I'd be drawn to landscape. That's my first love, landscape.

DAVID SYLVESTER *And what sorts of landscape especially?*

All kinds of landscape, if it's not cluttered up and vandalised. Yesterday we went out to Blenheim, and I love that flatness and the trees. I like all kinds. And where I'm from, the central valley of Virginia, is not one of the most exciting landscapes in the world, but it's one of the most beautiful. It's very beautiful because it has everything. It has mountains, there are streams, there are fields, beautiful trees. And architecture sits very well in it.

And I've always lived in the south of Italy, because it's more excitable. It's volcanic. The land affects people naturally, that's part of the characteristics, for me, of a people, in a sense. Say, if you lived in the Sahara or you lived in Naples or you lived in the Alps, all these things create a main condition, besides poverty, the states of poverty. Do you think so? Maybe it's that a lot of people aren't particularly attracted to nature. A lot of people have no knowledge of plants, trees, botany and things. I knew a poet who was totally ignorant about botany. And I said: you can't be a poet without knowing any botany or plants and things like that; it's impossible, that's the first thing you should know.

CY TWOMBLY

I think the landscape that has moved me most is the Greek.

Yes, you see, that's so strong.

I like the hardness of it. But I was also very moved by India, the enormous breadth of it and the light of it, the expanse.

The expanse is so beautiful, and then the river goes off in the distance like the music; there's a vast bucolic space to it, on and on. But India is one of the most fascinating countries because in half an hour you can be totally in another world – physically, culturally and everything. Architecture can change, the people can change and the landscape first of all in any direction. In America you have to go long distances to see any change in anything. Well, I have a nostalgia now for northern Europe at this time of the year when there are the white nights in Russia. I love to go to St Petersburg during the white nights at the end of June. The Russians are really nostalgic for nature. They have a love of the land. Every time you see a book on Leningrad or anything there's architecture, but a third of it is always going to be the gardens and the nature and the flowers. Anywhere there's a grave of a poet or a painter there's always fresh flowers put. Pushkin. I like that; it's probably nineteenth-century but it has a wonderful kind of sentiment to it.

I've found when you get old you must return to certain things in the beginning, or things you have a sentiment for or something. Because your life closes up in so many ways or doesn't become as flexible or exciting or whatever you want to call it. You tend to be nostalgic. And I think about my boats. It's more complicated than that, but also it's going out and also there's a lot of references to crossing over. But the thing of the Nile boat in *Winter's Passage: Luxor* was about the wonderful thing, the lazy thing, of being two or three months in Luxor by the river. It was just that, it explains a winter passage. From a certain point to the other side: it's like the Greek boat that ferries you over to the other world. That sculpture didn't have it. But sometimes the large painting in Houston does have it. It's a passage through everything.

And I am very happy to have the boat motif because, when I grew up, in summer with my parents we were always in Massachusetts, and I was always by the sea. You know, sometimes little boys love cars, but I had a

particular passion for boats, and now I live by the sea. For sure, it *is* a passage, but it's also very fascinating for lots of things. When you get interested in something you can find out a lot about things. You might meet people who are interested in one subject or another, like they collect palms. I've found people from all over the world who were fanatical about palms, which you wouldn't know unless you were interested in palms. And the sea: because, if you've noticed, the sea is white three quarters of the time, just white – early morning. Only in the fall does it get blue, because the haze is gone. The Mediterranean, at least – the Atlantic is brown – is always just white, white, white. And then, even when the sun comes up, it becomes a lighter white. Only in the fall is the Mediterranean this beautiful blue colour, as in Greece. Not because I paint it white; I'd have painted it white even if it wasn't, but I am always happy that I might have. It's something that has other consciousness behind it.

When you were young, were the boats that especially interested you river boats or sea-going boats?

They were fishing boats usually, because I was always down at Gloucester where the Portuguese had the fishing boats off the Grand Banks. But there are millions of inlets, all of New England is inlets; it's not a straight coast, it's thousands of miles of inlets. They're always full of boats, row boats, sail boats, every kind of boat.

When you did the very large painting which you talked about before and which you finally called Say goodbye, Catullus, to the shores of Asia Minor, *did you have the idea when you were working on it, or quite early in working on it, that it was about this thing of passage?*

No, no, I don't think it had. There were certain areas that were always there. I wanted to use Burton's *Anatomy of Melancholy*, which is just everything, and I got very excited about it. I got different copies; I got a second edition, because I like to have the material that's as close as possible to when it was done: you're absorbing a kind of instinct or something. And then work went on so long and never got anywhere too much. It was hanging in a big room in Rome, two side panels on one

wall; it's four metres tall and sixteen metres long. Then I decided I had to call it after a Keats poem and I liked it. Sometimes I like a title to give me impetus or a direction or a feel for the way it should go. Sometimes it changes. Because it had already taken five or six years – not working for three of them – I thought it had taken so long, it was languid and I wanted to call it *On the Mists of Idleness*. I think it's the title of a poem; it might be a line.

I don't remember that there's a Keats poem with that title, but I could be wrong or perhaps it's a line or a phrase. But actually I suspect that it's your own conflation of two different lines of his: 'Season of mists and mellow fruitfulness' and 'The blissful cloud of summer-indolence'.

Well, the painting went on and finally it was painted and, because I had to pass by it every day, I took it down. And then on that wall the original windows were reopened so that there was no place ever to hang it. And when they did my gallery in Houston, I thought I'd just send it back to America and maybe in one of the warehouses I could finish it. Then I went to Virginia and a friend of mind had a warehouse just near my house and I said, 'Oh, let's ship the painting to Lexington and all the paint', and I did it there, all sort of one winter. And so all the images of boats, they're like prehistoric things, and there's a beautiful Celtic boat with lots of oars. That had started a couple of years before. I had already read Catullus, and the image came that is one of the really beautiful lines. I very much like Catullus and you can just visualise his brother by reading that line. You know the line: 'Say goodbye, Catullus, to the shores of Asia Minor.' It's so beautiful. Just all that part of the world I love. The sound of 'Asia Minor' is really like a rush to me, like a fantastic ideal. In most paintings I never even have titles. But in certain ones I really have to have them.

And the title comes while you're working?

No, just sometimes. Always before this something happens, like those early paintings – *Criticism* and *Free Wheeler* and all those all-over paintings. Jasper Johns and Bob Rauschenberg were there. We were going to show the work and we made a list and then gave the titles

to the different paintings.

But after they already existed?

The paintings existed. But when I did *The Four Seasons* I was planning to do *The Four Seasons*. And I wanted specifically each season to be distinct.

But were you saying before that sometimes, while you're working on a painting, a title comes and then that title influences how you go on with the painting. Did you say that just now or did I misunderstand you?

No, in the large painting it changed, but actually I didn't have an idea of which one of the three titles it would be until at Houston I decided on *Catullus*. Everything is very flexible; it is with me and very quick in changing. Although I must say I have a certain order in my mind, but as far as painting goes there's enormous – probably more than with a lot of people – freedom. Because I have to get in a state of mind. And that's why I've slowed down.

Before, I used to smoke and look, because smoking is very conducive to stimulating the mind. Finally I had to stop because it was overstimulating my lungs. I sort of work off and on and I usually paint eight hours and I never eat. And I might have some wine to stimulate a free passage of thought. And I used to have always music playing. What is that painting of mine in Philadelphia? Is it *Fifty Days in Iliam*? It's very strange, no one has ever mentioned it. Have you ever seen it? Well, it's one of a large group of paintings. It's called *Fifty Days in Iliam*: I spelt it I-L-I-A-M, which is not correct. It's U-M. But I wanted that, I wanted the A for Achilles; I always think of A as Achilles. I wanted the A there and no one ever wrote and told me that I had misspelt Ilium. I'm saying anyone in America.

So what did they do, just change the title or leave it?

No, they still called it *Iliam*, but no one ever noticed that.

They may have noticed it but been too polite to say because they thought you were making a mistake.

177

Or no one cares. But *Iliam* was for the A in Achilles, because I did that *Vengeance of Achilles* with the A shape. Also it's the Achilles thing and the shape of the A has a phallic aggression – more like a rocket. It's pointed. The *Vengeance of Achilles* is very aggressive. My whole energy will work, and instruments and things will have a very definite male thrust. The male thing *is* the phallus, and what way to describe the symbol for a man than the phallus, no? Also it comes into the boat. I always make a direction that's pointed: it goes out and it's difficult to use sometimes, because it goes one way, from left to right, but it deals with subject matter that probably has a certain sensuality. The female is usually the heart or a soft shape, and certainly very painterly. There's a lot of tactile paint in those . . . you know which ones? Some of them got very heavy, like the last of the series called *Ferragosto*. It really gets heavy because paint is a certain thing. I don't have a dislike for it, but those paintings, for instance, were done in August in terrific heat in Rome. All my things, every one of them, show a certain agitation. And I have a certain kind of knowledge of things. And there are certain elements that I use. This double image like the brown paint, it's verbal. There's a Jungian example of a small child. It's based on the use of words, how you affect the child.

 The child is in the bathroom and the father gets very anxious. So he goes to the door and says 'What are you making?' and she says 'Four horses and a carriage'. She was making a sculpture. Because children have that. It's a sort of infantile thing, painting. Paint in a sense is a certain infantile thing. I mean in the handling. I start out using a brush but then I can't take the time because the idea doesn't correspond, it gets stuck when the brush goes out of paint in a certain length of time. So I have to go back and by then I might have lost the rest of it. So I take my hand and I do it. Or I have those wonderful things that came in later: paintsticks. Because the pencil also breaks if the canvas is too rough. So I had to find things that I could use, like my hands or the paintsticks. I can carry through the impetus till it stops. It's continual. I mean, I'm talking about specifics, the heavy kind. And also, when I talked about the Jungian thing . . . I use earth things and certain human things as symbols for earth – like it might be excrement but it's earth. And I did those charts, big palettes . . . two or three paintings with palettes and all of the colours – pink, flesh, brown, red for blood. And I think with most painters you can think and it can change very fast, the impetus of what something is. It's

instinctive in a certain kind of painting, not as if you were painting an object or special things, but it's like coming through the nervous system. It's like a nervous system. It's not described, it's happening. The feeling is going on with the task. The line is the feeling, from a soft thing, a dreamy thing, to something hard, something arid, something lonely, something ending, something beginning. It's like I'm experiencing something frightening, I'm experiencing the thing and I have to be at that state because I'm also going.

I don't know how to handle it. Pollock, when you see him working . . . To me, Pollock is the height of American painting. It's very lyrical. Gorky, who is very passionate, can copy a drawing or take a drawing and copy it exactly as a painting, and Miró can too, it's amazing. Miró can do a drawing to paint and that's another training in a sense. So there's a certain mannerism that comes in both of them, and probably everything becomes obvious in time. But I don't have that. The line is illustrated or the colour. I'm sure it has great feeling when they're doing it, but it's more towards defining something. It has a certain clarity because it's a complex thing. I'm a painter and my whole balance is not having to think about *things*. So all I think about is painting. It's the instinct for the placement where all that happens. I don't have to think about it. Like installing that sculpture show in Basel: I didn't have to think. So I don't think of composition; I don't think of colour here and there. Sometimes I alter something after. So all I could think is the rush. This is in certain things and even up to now, like *The Four Seasons*, those are pretty emotionally done paintings. And I have a hard time now because I can't get mentally ill. I usually have to go to bed for a couple of days. Physically I can't handle it, and I can't build myself. You know, my mind goes blank. It's totally blank. I cannot sit and make an image. I cannot make a picture unless everything is working. It's like a state.

Like a state. Ecstatic?

Ecstatic, exactly. I'm usually in a very good humour, except that I can be a little violent if it's going bad. If I'm making a mess I get a little sadistic with the paint, but usually I'm enjoying myself. It's more like I'm having an experience than making a picture. So I've never had anyone around. I never have. People are different, but I have to really be with no

interference. And it takes me hours. Painting a picture is a very short thing if it goes well, but the sitting and thinking . . . I usually go off on stories that have nothing to do with the painting, and sometimes I sit in the opposite room to where I work. If I can get a good hot story going I can paint better, but sometimes I'm not thinking about the painting, I'm thinking about the subject. Lots of times I'll sit in another room and then I might just go in. It takes a lot of freedom. I'm working for two years on a subject now: ten paintings, and that can carry on for two years. I worked last summer and I started this summer and with just the simplest motif I just can't seem to do it. And everything slowed down. The sculptures: I don't know, because I like the singularity of them. And I might be able to do sculptures, but the painting is less and less.

Going back, which word is more accurate, 'ecstasy' or 'trance'?

That I don't know. If you're a saint, maybe 'ecstasy'. Well, you know, trance and ecstasy are slightly different. Ecstasy is a little more overt; trance is more passive, more dreamy, and so you're lost; whereas with ecstasy all kinds of images can come in – fireworks, Jesus and what have you.

So 'trance' was wrong; 'ecstasy' was better?

Probably better just to say 'excitable'.

Well, 'rush' was pretty good.

'Rush.' But that is such a contemporary word. I think that's even in a young culture, driving fast in a car or jumping off those bridges and things. It's a rush I guess. But 'rush' to me is too focused. Whereas it's the instinct and the motion and the whole all together. And it functions in different directions. It's not the focus. It goes beyond. It's something else where everything runs together. If you're in that state all the time you'd be dizzy, you'd fall down.

And the sculpture is more tranquil?

It's a whole other state. And it's a building thing. Whereas the painting is more fusing – fusing of ideas, fusing of feelings, fusing projected on atmosphere.

FRANK STELLA

Recorded December 1965 in New York City. The version edited for broadcasting by the BBC remains unpublished. The present version has been edited from the transcript.

Frank Stella conversing with Ellsworth Kelly, MOMA, New York, 1967. Photograph by Dan Budnik.

FRANK STELLA 1965

DAVID SYLVESTER *I'd like to ask you about your titles, which are often romantic and picturesque, perhaps improbably so. They're often place names like* Pagosa Springs *and* Zambesi; *some allude to a contemporary artist, as in* Jasper's Dilemma; *some are called by people's names, such as* Luis Miguel Dominguin; *some have Spanish titles which sound like inscriptions, like* De La Nada Vida a la Nada Muerte. *How do they come about, the titles?*

FRANK STELLA The titles are usually ideas or things I've come across that actually interest me, and the titles are in part rather closely related to the work in some kind of way. If I find a series of things that I might read about or a series of places that I've been to, if I like the names enough, if they strike me enough, I jot them down or something, and then as I'm working or as I'm thinking about working, and say my working drawing is done, I try to match them up. But sometimes I have the drawings of visual ideas before, and then I wait a while and find titles that seem to fit. But I like to feel that they're not arbitrary identifications, and I feel some involvement actually with the names.

Does this mean that by the time you're working on a painting you usually have a title?

Yes. In every case since the series. The design of the series is so far ahead usually of its actual execution, by the time I get around to painting them I almost always have – in fact, have always had – titles for them. The only thing that happens is sometimes titles get switched around a little bit, but that's all, after they're painted.

Do you expect other people to see the point of the titles usually, or are they a purely private concern?

No, I don't feel that there's any reason for people to get the point. I think that they suffice as identification, and that's good enough. But for me

sometimes some of the titles seem to have an expressive quality and that in their sound or the way they look maybe people will see something in it if they want to.

Could you even give an example of the way in which a title would affect the form of a painting?

Yes. For example, all of the copper paintings are based on place names in the mountains in the south-western part of Colorado: Pagosa Springs, Creede, Sawatch, Telluride. Telluride Park is a mining town in Colorado, and the shape of the painting happens to be a T and that's just one word I would naturally match up with the T. And again the fact that they're metallic, the most metallic paintings that I did, the copper ones, because there's a separation between the copper powder and the vehicle that carries it – it doesn't really mix very well – and there's a kind of heavy residue of metallic powder on top, so it's natural and easy that the mining towns and the paintings which are most heavily metallic should go together. There's a title, *Creede*, spelt with an E on the end, and a lot of people have misspelled it or misinterpreted the painting as Creed, meaning some form of belief, but it's actually a town in Colorado and the distinguishing thing about it is that it's a small mining town backed up against a sheer blank wall of rock, and the painting is a right-angled or L-shaped painting which is, again, backed up against itself. So there are those kind of relations. And one last example: there are a lot of paintings which have *Valparaiso* as a title, and that's based on Whistler's painting of ships in the harbour of Valparaiso which is also called *Crepuscule in Flesh Colour and Green*. Actually I cut it out of a magazine and the basic trapezoidal shapes of the sails started kicking me off as an idea: the *Valparaiso* and the trapezoids made up a series of Vs. So it just happened to fit. And it was a nice way to use green and flesh colour, green and reds, in the series. So some of them fit in that way, some don't fit as well as that.

Speaking of series, do you invariably work in series now?

Since I started the black paintings in 1959 I've always worked in series. Before that the paintings weren't specifically in series but they were pretty

closely related. Just before, in '58 say, when I was a student in school, they weren't series at all. They were one painting after another and mostly, you know, they jumped around a lot like student paintings do. But once I got started on something when I came to New York, then it started to break down into series.

When you do a series, would you ideally, if it were possible, like the series to be preserved as such and always be shown as a whole or would you, indeed, have a contrary feeling?

I don't have any real strong feeling about it. The only feeling that I have about it is that I always like for the first time after they're immediately finished to show the series together, because they were meant to be shown at least once like that. What happens to it after that I don't care. I've had only one or two series that have never been shown together, and those are actually series that I thought weren't so hot anyway, so I didn't really care. But if I have something I feel really strong about, say, for example, the copper paintings, I wanted them to be shown together, and there were a lot of circumstances at the time which made it hard to show them together. For example, Leo Castelli wasn't anxious to show them together, and nobody was very happy about this series to begin with. But I was kind of obstinate about it and insisted and held out and sort of finagled until they finally did get shown as a series. If I want them to be shown as a series I usually do it at once.

When you do a series do you work on several paintings at a time?

I usually work on a series together, but usually in sequence. I start on one and work sort of down the line like a kind of production line. I usually, though, set up the whole series. In other words, I have all the stretchers made or, at least, mostly made before I start, and then I stretch them up and then I work consecutively down the series.

You work from drawings.

I make drawings beforehand, but to just see what the organisation of the paintings is going to be and to work out the series. But mainly the

drawings are made in order that I can make a scale drawing from them to give to the man who makes my stretchers so that they can be built in the beginning. I tend to make the scale drawings for myself.

And do you look at the drawings while you're doing the paintings?

No, because the drawings are so simple and mostly monochromatic that I can remember what I'm supposed to do. Like, for example, on the L-shape I know how to draw the lines because the intervals are the same. It's the same number of inches through every stripe and I just have to stripe the series in pencil for guidelines and then that's it. In some cases, where the colours were complicated, I had to make myself a little sheet to remember the sequence of the colours. But that's all.

When you do a series are all the paintings usually decided before you start to paint the series or do you find that in the course of painting ideas occur for further ones?

In the beginning, the series were pretty complete. There were still a lot of series that have had one or two paintings which I wasn't sure about and which could even now still be executed. But after enough time goes by, I usually don't go back and do them. But in some cases, and it's happened more recently, I've had series which weren't so coherent: I did maybe, say, three or four, and then two or three months later came back to do two or three additions to that series. One series that I did is open-ended because there are two more that I definitely want to do. I don't know if I will get back to them, but there was a size problem and I haven't been able to get the materials together to do them yet. But they are two that I feel I really want to do and will eventually do.

You were talking about the stripes being exactly the same width. What led you to the decision you made at a certain point that the stripes needed to be, for your purpose, the same width?

Well, the original decision came about simply because of the size of the brush that I used on the black paintings. That was the result of the brush being used flatly. And it came out to about a little under three inches, and

so I liked the way that looked and it seemed to suit my purpose and so from then on I used a very arbitrary size but which could be handled by a brush of two-and-three-quarter inches. And for a long time, in fact, until now, I've found no reason to vary it.

What do you mean when you say 'an arbitrary size'?

Well, for example, I use two-and-three-quarter inches, but I could have used three, and I think if they'd been consistent enough they would have been all right. I could have used maybe a two-and-five-eighths, but two-and-three-quarters was the one that I got into the habit of using, partly because it related to the width of the wood I was using to make the stretcher frames, which turned out to be wood that's called one-by-three. And when it's milled down it actually comes out to about two-and-three-quarter inches on the side. So I decided that for the sake of consistency I would make the width of the stripes – since they came out very close to that anyway – two-and-three-quarter inches.

And because you want the width of the stretcher to be part of the experience of the painting?

I don't want the size of it to be part of the experience of the stretcher. The reason that I had the width is an accident. It was an easy, cheap way to make stretchers, ending with one-by-three, but I liked the effect that it gave of lifting the painting up off the wall, giving it a sense of, like, shadow around the edges, so that it seemed to me to make you more conscious of the surface of the painting. And so I've always kept my stretchers wide since then.

But it would be just the same to you if you were working on board and the board were pushed out by pegs to keep it away from the wall surface? This would be just as satisfactory for you?

Well, it should be, but I don't think I would like the way it looks: I wouldn't like looking behind it; I like it to be closed off. Really what I want is the effect of when you see it dead on, that it has a sense of being a separate surface from the wall, doesn't lie too close to the wall.

It's not of positive importance to you that, when you see the painting diagonally as you're walking round an exhibition, you see the sides of the stretcher?

No. That's a circumstance of walking around to the side of any painting and it's not supposed to mean anything special.

Now, you continue to use the same two-and-three-quarter inch stripe regardless of the size of the canvas.

Right. But the size of the canvas is determined by the drawing and by the use of that interval. In other words, if they're not out of scale and they're all scaled to that proportion, to that width of the stripe, the final size of the painting is in some way determined by that module.

Why do you want to use a module?

Again, I had no strong feeling. It's something that I started with when I had the whole series of black paintings which were done with a sort of rough by-hand module. And then, when I started to get into things like shaping the canvas, the module seemed to be helpful and a way of keeping the format sort of organised and coherent. To not use the module would have meant to make a whole lot of decisions and the paintings would have essentially been different kinds of paintings that were more relational, more complicated, that I wasn't interested in doing at the time.

You wanted to narrow the area of decision?

Yes. I think that that's one of the main things that the paintings are about.

And the narrowing of colour?

Well, colour again . . . It's hard to explain. My paintings are essentially monochromatic, but I've never had a strong feeling that I was doing monochrome paintings because, while I only use one colour, they're not

really monochromatic because there's always the ground showing
through. So I would describe what I would do as, say, an all-orange
painting, but actually it's orange and white, orange and canvas-ground
colour, whatever colour that turned out – and the ground colour does
tend to vary naturally a little bit with whichever the main colour is. And
then I did do multi-coloured paintings too, but I never had strong
feelings about making – like Ken Noland does – expressive colour
paintings. I always used colour in sort of like you might use it as, say, for
colour-coating. It's just to tell you what colour the area is. It's like: this is
the brown colour, this is the blue colour, and this is that. I did think a lot
about the colour in the sense that the colour or the quality of the colour is
supposed to be right for the shape or the design of the canvas. For
example, I really feel that the copper colour is right for the copper
paintings. And I feel strongly that the aluminium colour is right for the
kind of design that I put on the aluminium paintings. I don't think that
you could reverse them. I mean, obviously the aluminium paintings
painted in copper would look wrong and the copper couldn't carry those
big expansive fields or areas and the aluminium paint would be too
fragile to carry the severely arbitrary shapes of the copper paintings.

*Now, in the shapes which began in the black paintings as a shape within
the canvas and then became a shaped canvas, there's usually a sense of
symmetry which is either complete or slightly modified – either a completely
symmetrical shape or, say, an L in which you feel the possibility that it might
be completed with another L to make a U, like one of the other paintings in
the series. How did this preoccupation with symmetry arise? Was it a
conscious decision that to work symmetrically or in relation to symmetry
would be interesting, or is it merely a matter of being obsessed with
symmetry and so far working in that way because it just interests you
to do so?*

Oh, I don't think that I was ever obsessed with it. It just happened. Once I
got into it, once I had made certain basic decisions which resulted in the
black paintings, there didn't seem to be any point in trying to fight it. It
seemed to me that the symmetrical format gave me what I wanted, and so
I simply followed them where they led, and I used a lot of symmetrical
formats and a lot of variations on symmetrical formats. Symmetrical

organisations force me into some kind of situations in the shaped canvases which are not exactly asymmetrical but which have to do with forces and weights and balances, but at the same time regulated in such a way that they're not what I would commonly call relational. In other words, I think of them as symmetrical in the sense that, while they're strung out or possibly asymmetrically balanced, the weights and the units are all the same, so you have a kind of symmetry even when you have odd numbers. There always seems to be at least a sort of bilateral symmetry in all of my work. There's always a middle point and there's always a reference point which all of the parts relate to. And they're balanced, sort of simply and sort of conventionally, without being relational. There's no background or foreground. Each piece is a kind of unit, but it locks together into what I think is a basically stable or symmetrical situation – in the way that, say, a Z – whether or not you think that's a symmetrical figure – has opposing forces but they lock together into a kind of stability.

You want the paintings to have a suggestion of possible instability?

I like to feel that they have. I wasn't preoccupied with that in the beginning. In the beginning I was happy to have total stability, total symmetrical organisation. But lately I've wanted to have some sense of, not so much movement as direction and a little bit of a sense of force, a little bit of some kind of necessity of the parts relating to and forcing themselves into situations. They are a little bit dynamic at the same time being totally stable – these most recent things made up of a series of interlocking Vs.

Returning to the earlier narrowing down of the field of decision, I presume that this came out of a sense of necessity you had in relation to an existing artistic situation.

Well, I think that it does relate to the situation that I came into, which was obviously late developing Abstract Expressionism. It was also, you know, simply very personal on the level of being a student. I mean, just on the level of my own paintings that I was doing at the time, in the late fifties, I just felt, looking at what I did, that more and more the decisions I was forcing myself into were just unsatisfactory. They weren't good

paintings and I would have to ask myself outright if I could make better decisions like this – would they be better paintings? – and the only answer I could really give myself was: yes, they could be better paintings. But I couldn't see any alternative to making good decisions in the way that other painters before me had made good decisions. So that I could make a good Motherwell decision or a good Hans Hofmann decision or a good de Kooning decision or a good Kline decision or something: they had ways of dealing with the kind of painting that they were doing. But I couldn't see how I could possibly accept all of their painterly assumptions, structural and colour-wise and organisational, and still be able to make them have anything really to say. And then I began to think too that it might be necessary also for me to have something different to say to begin with. And then it was really largely on the basis of simple unsatisfactory decisions that I made in my what I call student or just my beginning paintings. And the way I began to deal with the unsatisfactory decisions that I had made led to the paintings that I did, which led to a kind of closed system, a kind of modular organisation, a kind of dependence on symmetricality.

Concerning your work as a whole, do you feel – as many severe abstract artists before you have done, such as Mondrian and Malevich – that the paintings have some meaning beyond their formal qualities?

I don't think that they do. The whole question of what kind of meaning a painting can have is really too difficult for me to deal with and also something that I'm really not interested in. The only thing I'd like to say about Mondrian and Malevich is – as I see my paintings now and I think I saw them then – they're strangely not related in any way. And it seems that the simplest way to see my paintings is in the way I can't help seeing them even now – that they're just very simply extremely closely related to Abstract Expressionism. It seems to me that their weight and the whole feel of them and the whole way you would have to experience them is sort of the way you would have to experience the American painting of the late fifties. That's how they look to me even now.

Except that there aren't the very visible traces of personal handling.

Well, that's not true. If you look at the black paintings there's a lot of sense of hand in them, and they're, say, close to Rothko in their kind of vibration, in the fuzziness of the edges and everything.

Yes, I'm sorry. Even so there's not that almost wilful affirmation of personal handling.

No. One thing you can say about my paint-handling, and this was very deliberate, was that it's pedestrian in the sense that it's closely related to, say, a house-painting technique. I wanted to be able to put the paint down as directly as possible. To put the paint down in a heavy-handed or a kind of pedestrian way is very different, say, from the painting of, for example, Ellsworth Kelly or any other kind of hard-edge paint put down flatly and blankly. I wouldn't be able to paint a big area as well or as flatly or as cleanly as, say, someone like Kelly and I wouldn't be interested in even trying to do that. And that's one of the reasons why, for example, we have this space in between the stripes so that the paint can just go down and the edges sort of fall where they may, and I don't have great problems about brushing on the paint because I simply brush it back on one stripe, which is a lot different from when you're painting a big area and you want to get it flat and have to do a lot of good brushwork to brush it out correctly. And I kind of reduced that to a minimum for myself because I just wanted the paint to be applied as simply as possible. And I think that this is certainly and obviously a kind of reaction to Abstract Expressionist or to, anyway, very painterly paint-handling.

And a reaction to the idea of fine art?

Not necessarily. I mean, partly I think it's a reaction to the sort of preciousness of fine art and fine art technique. But, for example, it was never my ambition to make – though it may come out that way, or people may say it that way – to make non-fine art or to make, say – something we don't actually have – a truly pedestrian art. Is there something half way between handicraft and fine art which is common-man or pedestrian art or something like that? I mean, I think that my things have to fall or stand as fine art; they are fine art and I'm not interested in denying that. I don't think that, for example, there's any

rules about what technique makes something fine art or not. It isn't a way of putting the paint on the canvas that guarantees or that even gives you the information to tell you that this is fine art.

But is the heavy-handedness meant to say something?

Mostly it says something about me or about the way I just feel about things. Every art has some kind of personal touch or some kind of personality. It's the kind of person I am in some kind of way. And that heavy-handedness just seemed to suit me. And in a way it was sort of relaxing at the time anyway, to just be able to step up and paint it and not always watch what the brush was doing or be involved in tracing the gesture of your arm. It's kind of deliberately, I think, anti-drawing. Because at that time Abstract Expressionism seemed to me to be in a real conflict about drawing, a really unresolved position about drawing. Everybody was sort of drawing with their paintbrush and what they were doing was sort of outlining or giving you depth or indicating things with a drawn line. It was like they really wanted to do a lot of charcoal drawing and then paint over it or show you some of the charcoal, but they realised that they had to do it with just paint and just a brush, and in some ways the brush wasn't suited to do the things that drawing was supposed to do. And so just worrying about that a little bit I think I wanted to eliminate this sense of drawing. The only drawing that was in my paintings was explicit, and that was laid as a pencil line which was a guideline and that was it. The rest was paint.

Very broadly speaking, Abstract Expressionism has a tendency to be both surrealistic and passionate, and one would suppose that your paintings were not at all surrealistic and were rather cool.

You can't say that they're passionate but, on the other hand, this depends how you want to describe passion. You can have degrees of passion, it seems to me, and the most flamboyant exhibitions of passion aren't necessarily the most passionate. But as to the Surrealist thing, I think you're entirely accurate there. Not liking Surrealism was very strong. I mean, I saw that Abstract Expressionism – as I think everybody saw at the time – how heavily it leaned on Surrealist ideas and how it organically

developed out of America's idea about Surrealism, and I thought that that was the weakest part of the under-structure of Abstract Expressionism. And I just didn't like it, because it was sort of European. It was something that they had to lean on, something that I thought it was time to be dropped completely, and I sort of had a kind of responsibility in painting that came after the Abstract Expressionists to deal with this Surrealist thing once and for all and eliminate it.

Who do you feel your main influences have been? Newman, for example? Ken Noland?

I'd like to say that Barney influenced me but the only thing I can say about it is that Barney's show was in the spring of '59 and that was the first time I ever saw any of his work, and by then I was already way into what I was doing. I think that the shows at French and Company of Noland and Louis and Gottlieb all had an influence on me. It was an influence in terms of quality. I saw that it was necessary for my paintings to deal with that level of quality – to get up to that, at least get close to it. So that sort of coloured my thinking about painting. I don't know how to describe what kind of influence they've had on me, but I think that mostly I've been influenced by what I thought were implicit ideas in other people's paintings, which is, again, something hard to describe. I might, say, be influenced by what I think I see or saw in Mondrian and Matisse and Malevich too – those big sort of general influences. It seems that some ideas, some ways of thinking about things, are crucial and that you have to deal with them.

On the other hand, there is that thing we talked about before, that with Mondrian and Malevich – and one could add Newman – there is always that metaphysical preoccupation, that sense of the transcendental.

Well, the only thing I can say about that is that I just honestly don't understand it, and it was never an issue for me. The only issue as I saw it, or the only thing that kept me going, was basically the issue of quality. It seemed to me that things have to be what I would consider good paintings. Or in other words the paintings would have to have a kind of quality. The best I can say in the way of describing it is that it has what

you call visual presence – I mean, something that you feel in front of the painting. It convinces you, something like that. And as for the transcendental or metaphysical things, I just simply don't understand them, and I'm honestly not interested in them. It seems to be something that was almost a generation thing. I can't think of any artist in my generation or any artists that I really know that are working right now that could be interested in that either or even understand it. It seems it's something that's sort of gone by or passed by on the level of ideas. Maybe it's not such a good thing, but the ideas now are much more simply technical or simply pedestrian, simply involved in the making of the actual object. That's about all I can think about.

Can you see a significance in this? I mean, I'm asking you to be your own art historian, if you like. Why is it that your generation has got this determined concentration on technical qualities in this way?

Well, I think, say, Mondrian to Barney Newman raise some structural and spatial and what I would call surface issues – I mean, the quality of the painting on the surface – which you can't ignore any more. I mean, if we look back at their paintings and see what their basic ideas were, what they were trying to do, and then we see it would have to be seen in a certain kind of consistency, say, in paint-handling or in structuring or organisation, I think there's nothing we can do but try to deal with those things. It's like that's what they left us to do, in a way, and if we succeed in, say, solving most of those problems or dealing successfully with them, then the generations that follow us will maybe go back to the sort of transcendental or some other kind of ideas. They will see that their responsibility or what's left to them is to add something more.
They'll say: Yes, their paintings were formally correct or interesting or something, but they lacked a certain this, that and the other. And then they will try to deal as best they can with providing that this, that and the other that was lacking in our work.

To me, your painting seems to have considerable content, but I would find it quite impossible to try and say in what it consisted.

I wouldn't be able to describe any content, if it has any. I mean, what I

want it to have is a certain kind of obvious visual directness and presence and I think that I would be unhappy if the effect was so dry or so sterile that it just seemed to go dead. I mean, I think that in order for it to be convincing visually it has to have a certain amount of some kind of inherent substance, and I think that that comes in the degree of commitment, in the degree of the success of the structure, in paint-handling, in the technical things. I mean, I think, if it's worked through enough, it becomes convincing. If they go dead then – and I hope that I'll be able to see it – then I'll try to do something about it.

With a lot of abstract art, even of a very austere kind, the artist often has the feeling that it nevertheless relates to certain experiences of reality.

I would need an example of what you're talking about.

Mondrian would be an example. When Mondrian called a painting New York City *or* Trafalgar Square *he really meant that that painting gave sensations in being looked at analogous to sensations he had felt in those places.*

I don't have a direct sort of correspondence or correlation like that. I think I explained a little bit that the titles are about as close as I get to the things that I see. A thing that I can see in a lot of my paintings is that they seem obviously to relate to a kind of urban situation almost or urban landscape, and there's something about my paintings and the way that they're done which just seems to relate to city life. I don't know how to explain it, and a lot has specifically some of the quality of New York or something. In other words, they don't look to me, for example, like Detroit paintings or Venice paintings or Istanbul paintings or something. There's something about them that has that New York quality or something. I don't know that that's a good idea; in the beginning I couldn't avoid it and I don't even try to avoid it now, but I think that that could be limiting in a way. And maybe it's something that's good: I would like to have it. Maybe, say, for example, Ken Noland doesn't have that, and he has a kind of slightly more autonomous field to his paintings. They're not so place-oriented, they're a little bit more pure art than my paintings are, or higher art or whatever you want to call it. I mean, my

paintings seem to me a little too close to the ground. I'd like them to be a little bit more neutral, but I don't know. I don't think that my personality or my whole sort of personality organisation is such that I could ever get to be like that. My paintings always seem to be tacked to something or heavy in some kind of way.

CLAES OLDENBURG

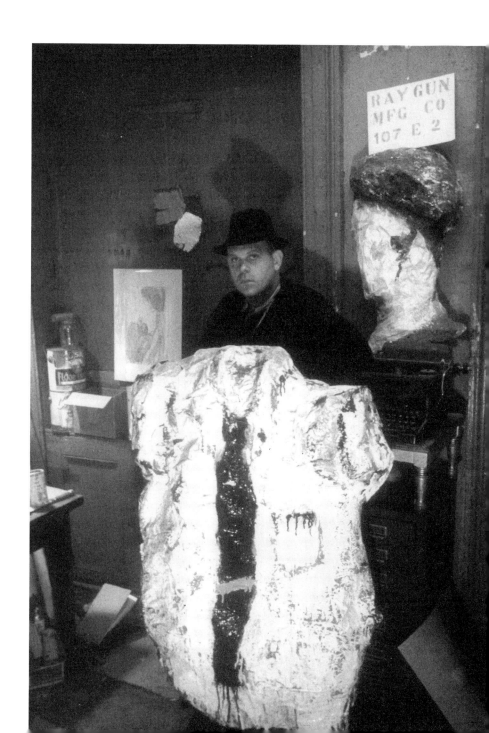

Recorded May 1965 in New York City. The version edited for broadcasting by the BBC remains unpublished. The present version has been edited from the transcript.

Claes Oldenburg inside the 'Ray Gun' studio, New York, 1965. Photograph by Dan Budnik.

CLAES OLDENBURG 1965

DAVID SYLVESTER *Do you consider yourself an entirely American artist, as if you weren't of Swedish parentage?*

CLAES OLDENBURG Yes, I think I'm an American artist. I mean, I have a certain memory and I've been brought up in a home where there was a lot of influence from Europe; I'm interested in Europe; I'm very interested in the European influence on America, and this directs, say, the place I live in New York, the Lower East Side, where there are more ethnic groups, you know, brought together. But in my work I consider myself entirely an American artist.

I'd like to ask you a very simple question about your development, which is how you reached the point of making the painted sculptures of food and other common objects.

I started to make a certain kind of object at the end of 1960 and the technique was that I used a cloth dipped in plaster placed on a chicken-wire frame and when that dried I painted it with enamel. The original impetus came from the signs and the billboards and also the objects in windows that I encountered while walking to my studio, so that it was a very natural kind of thing. I was very influenced by the coloured taxi-cabs, for example, which I used to watch while I was working at Cooper Union Museum, located in a place where a lot of traffic comes together, and I wanted a surface on my painting that was as metallic and as uncompromising as the paint on the taxi-cabs or the paint on the billboards. And to do this I looked around for a line of industrial enamel that was very bright and brilliant, and I found a line called 'Frisco' which I bought in a small store in Avenue C and used it without mixing the paint at all, just used it straight so that the contrast was very violent, just as in the signs and taxi-cabs. At the same time, the plaster surface created a certain amount of subjectivity because the paintings weren't flat, they were irregular, and, depending on where you stood in relation to the paintings, that resulted in valleys and you knew there would be

difficulties for the eye which you don't find in the average sign board.

These were paintings not sculptures?

Well, I consider them paintings. I mean, the vision I had was of colour and space, that is to say, three-dimensional colour.

But what were you doing before this?

Well, before this there was a period when I pretty much of necessity used materials I found on the streets in New York. There's always a lot of debris, paper and burlap and wood, and I used this because I could get it easily and I could construct my images out of it; I retained the original coloration. And these were shown in a show. I titled the whole thing *Street*, for these were street images.

Did these street images include figures?

Figures? Yes, well, if you look at the street landscape, especially round the Bowery, the people tend to become part of the landscape. Most of the time they're lying down flat. It's a devastated area where the people become the equivalents of, say, a rag on the street or something. They don't stand out as people do normally, they just become part of the landscape. So my street had automobiles, it had people and it had sort of objects you find on the street and sort of linear patterns you find on the street all together without any differentiation. It really wasn't a figure concept, it was more of a landscape concept in which the figures played the part of objects or landscape.

And in fact you hadn't been working many years when you started doing the signs?

I hadn't been *visible* for many years, shall we say. I had been working for about ten years, preparing myself in many ways. But you know how it is. All of a sudden you arrive with something which makes you visible.

Had you done any art school training?

1965

I did go to the Art Institute of Chicago off and on. Most of all I tried to digest traditions by myself, mostly doing a lot of drawings that I did in solitude for a period of about five or six years thinking about what art could be or should be at this time. And this was a pretty private thing; I just worked away on my own. I made hundreds and hundreds of drawings in that period, many of which were destroyed because they weren't quite clear enough.

Drawings of objects and figures?

Yes, figures and objects. In 1958 I thought I might solve the whole problem of the figure, you know. Then I studied the figure tradition, but it was a dead end for this time.

What artists of the past interested you then?

Almost everybody.

Which artists of the past interest you now?

Well, I think I'm more interested in contemporaries now, I think I've forgotten all about the artists of the past. I mean, they're in my work but I've forgotten about them.

You don't go to museums of Old Masters or antiquities?

No, I haven't been to a museum for a long time, and that's a good sign, I think.

And you don't look at reproductions?

I have a lot of reproductions, but I haven't looked at them for about four years. I'm self-sufficient; I get my inspiration now from my experience.

But, of course, the experience includes the past experience of existing images – I mean, beyond the signs and billboards?

205

CLAES OLDENBURG

Oh sure, sure, and I did study anything that could conceivably be considered art, anything that was graphically created. I was very fond, as most artists are, of the drawings of the so-called insane and children's drawings and, well, anything that's written or drawn, and trying to discover what it was that was art. I think that art doesn't differ very much through the centuries. I think there's a possibility that you can sense the universal. Like those street sculptures I did were very much influenced by a strong sensation of African sculpture, and I felt that that wasn't really out of place on the streets of New York.

And then you made the colours in space; and did the food follow from that?

Yes it did, because the food really wasn't a question of subject matter, it was a question of metaphor, of finding in my experience the force of the sensation of colour that I wanted to project, and when I went up and down Second Avenue and looked at the gigantic pastries, they seemed to be created as much for aesthetic pleasure of a sort as to be eaten, and in fact sometimes more for aesthetic pleasure.

I always think about cake that it never tastes as good as it looks.

Now, that's especially true in America.

About gigantic pastries, I've often wondered whether your inspiration for a sculpture of a hamburger or of an ice cream cone or of a slice of cake was an actual hamburger or ice cream cone or slice of cake or whether it was blown-up advertising representations of those things?

Oh well, it was mixed sometimes. In the beginning I started by tearing fragments out of advertisements and reproducing these fragments from the advertisements. These were translated mostly into reliefs or deep reliefs, and the step beyond was to find the three-dimensional objects. And, of course, that is better seen in an actual object. But I still rely a great deal on the representations. If I come to a city I first of all buy all the newspapers to see how they represent the objects in a place. And I work a great deal from the picture of the object that I assume people are carrying around in their minds, somewhere between the

206

1965

actual thing and the representation of it.

In an ice cream shop you've ice cream cones that you buy inside the shop, but you might have standing outside the shop an enormous representation of an ice cream cone.

That's right. Well, the scale is terribly important when you're making a piece, but the scale in reality doesn't bother me. I find that I regard a very big thing the same way as I regard a small thing. But I'm always very excited when I see the large representation of a small object because that takes it into the realm of sculpture or painting or something like what I do, but my piece is independent of the source. I make my own rules.

But do you think that those common man-made objects which you choose to represent tend to be objects which have already been represented in popular imagery?

Well, I prefer that because I like to work with something that seems to me both anonymous and universal – an accepted image. I suppose when you invent something like an ice cream cone or a machine, it goes through several states until it begins to look the way people want it to look, since most things are created in the image of man. And after this has settled for a while you get a traditional form, and I would really prefer to work with a traditional typical form. It's a more settled image. I don't think I would be drawn to a bizarre image. Say somebody invented a new ice cream cone; I think I would be more drawn to a traditional one. And if I am imitating industrial form I usually go back to a period when I think it's reached a sort of formal summary of what people wanted before it entered a sort of Baroque stage. For example, an outboard motor now looks very different than what it did in the '30s or '40s, and it's a little hard to make out what the motor is from the forms that it has now, but in the old days it was very square and simple and very clear what it was. I try to find a most typical form of my subject, but this also occurs in the actual object. I mean, the representation of the cone doesn't differ that much from the actual cone, so you have a living cone that people eat that's already tradition. It's a very clear image, and I always seek those images like the hamburger and the hot dog, things that have really

taken form. I'm not drawn to untypical images.

And, although you have done bananas, you're generally not drawn to objects which are not man-made?

They must be man-made: I've used a banana very few times; one time I can remember I used it in a lunch box, but there the whole container had the setup of the lunch box. It was very typical, I think. Every morning there are millions and millions of lunch boxes made up in the same way, and if you look on TV they always make up the lunch boxes the same way and I imagine the housewife watches TV and is affected by that. There's a concept of a lunch box which includes a banana, so . . .

So that none of your still-life sculptures is of a straight piece of nature?

I love nature but in my work I'm concerned with what man has made of nature. My subject is really the relation of man and nature or what man has done to nature. Because I'm confined to city images, really, and I never go out to the country and sketch and, although I did once, I found that it wasn't quite on the mark.

In the same way you've made images of typewriters and vacuum cleaners and so forth.

Yes, what I like best is the store window, the hardware store – and the street, a home, where all the objects in the landscape are man-made objects, where the rug is the equivalent of the grass and so on. And I'm especially interested when you have artificial landscapes made in nature, swimming pools, for example, as in California. And any kind of architectural attempt to impose man's image or man's will on nature. That's my subject.

When you deal with these things, you make their identity very clear and simple. At the same time, as one looks at your images of them, they seem full of metaphors. To what extent are you conscious of such metaphors, to what extent do they happen in spite of yourself?

1965

I'm conscious of wanting to create my own metaphor. I'm torn between the desire to reproduce things as they are because they're strong and the necessity as an artist of having to use metaphor. And so each object that I make tends to fall somewhere between the two or I tend to invent some kind of dislocation in the object, usually by substitution of material or by some sort of contrast which takes the object away from the original. I know there are many artists who simply use the actual thing, but it's not enough for me; I have too much tradition in me, you see, to do that. So that my work tends to be a kind of a compromise or going either way. So, if I make a telephone, for example, I make the telephone out of a yielding material like vinyl plastic so that it can be pushed around, so that I as an artist can exercise my subjectivity. But I'm very concerned with making that subjectivity available to everyone, so that the man who owns my telephone can also push it around. So that it's not a question of my imposing my will on the object too much; it's a question of realising the presence of subjectivity and letting everyone push it around. Always my objects allow change and for their rearrangement, and I don't intrude on other people's rearrangements even if I don't approve of them sometimes. So there's got to be some way of getting myself into and getting other people into the representation. You see, I'm not satisfied with just using or re-creating an actual thing; I have to make substitutions with metaphors, and that's what makes the work lean in the direction of poetry.

For example, in your sculptures of the soft typewriter where the space bar has fallen out of place and lies there flat like a spatula, and all the keys are fallen down and lie there in a sort of heap of counters spread across, now, this to me has an extraordinary sense of collapse which is no longer anything to do with any experience one can have of a typewriter. The whole sculpture becomes a kind of metaphor for collapse, for disintegration, for the idea of a rigid object that's fallen apart, in an extremely pathetic way. Now, obviously you were conscious that, in making the soft typewriter whose keys have fallen down, you were doing something very fundamental to the concept of the typewriter. But did you actually have a sense of what that meant?

I never thought of the typewriter as having a sense of the pathetic. I think what I worked with is a contrast of form. If something is hard I'm very

simply led to believe that it could be soft. Or if something is soft, I want it to be hard. And I don't think so much of the interpretation of this. It's just a natural possibility. I'm concerned more with forces and states of matter rather than the emotions attached to the particular piece. If you want pathos from my typewriter, you can get it. But that's how nature is. The sun goes down and really all that's happening is the sun going down. But a lot of people are standing around feeling very sad the sun is going down.

If one sees that soft typewriter with its collapsed keys as a pathetic image, you think that's sentimentality?

I think so, yes. I would say this. That, recognising the reality of emotion, you know, the presence of emotion, I wouldn't put it down. Whatever people want or need to see, I think that's good. The thing could be pathetic one day and not pathetic the other day. I'm not making any rules as to how the thing should be received, you know. The thing that interests me most is that you've set up a series of natural possibilities. And, well, I'm subject to sentiment too – I mean very much subject to sentiment. Of course, some days I can see it in that way, but that's not good discipline when you're making it, you know. I think there's two kinds of poetry. I think that the type of poetry that a painter or a sculptor uses is not like the type of poetry a writer uses. And I always use writers' terms to talk about my work. I speak of natural poetry or a poetry of resemblances and states. It's very simple poetry; it's a fact one thing resembles another. And that you can use that to make all kinds of jokes or transformations. It's an exercise of fantasy, a metamorphosis of the object. Metaphor is probably the wrong word for it, because it's really a word out of poetry.

Let us say you get this dislocation of the natural state of a thing, say, a hard object turned into a soft object. This is one thing. Now, another thing is the sort of thing that Arp does where he creates a form that establishes a likeness between unlike things. Now, I don't know if these sort of things follow inevitably from dislocating the customary state of an object. They can in some cases. But I wonder to what extent you're conscious, in making these transformations of familiar objects, of establishing likenesses with other familiar objects.

Well, it's much less programmatic than that and it's much more playful. I have a few simple forms, such as the right angle, which I use over and over again in variations. Like I use the right angle in a pistol and it would occur in other objects, for example, there's that *USA Flag* you saw the picture of. Now, the American flag is not a whole American flag, it's a fragment. But if you turn it upside down you'll see the right-angle form again. And a form like that tends to repeat itself and I will be able to say to myself that a pistol equals the American flag. You know, it's a playful thing. In the absence of any systematised imagery for the artist I've invented my own world of playful images, and these are always surprising me too. When I was planning a happening to take place in a swimming pool, I was making a drawing of the rectangular swimming pool and the diving board, and I found that this was nothing but my *Good Humor Bar*, the chocolate and ice cream bar with the wooden tail, turned in on itself. So that gives me a sense of certainty in a playful way. And it's to set up a system of resemblances that don't make logical sense but which give me the feeling of a system of imagery within which I can work. And, if I reach the end of the precipice and don't know where to go, I can fall back on this system of imagery.

How do you distinguish – because I have a feeling there is a distinction which I can't quite put my finger on – between what you're doing in this kind of playful invention and what artists like Arp and Klee have done – and to some extent other Surrealists.

Well, it's hard to answer. I don't know enough about their approach to things perhaps to be able to say. I have the feeling that mine is more concerned simply with the appearances of things rather than the meaning attached to things. If I found a resemblance between things, I wouldn't make very much of it. I would only be concerned with the form. I think Klee always made a great deal of rational matter out of the resemblances of things. I may be wrong. I certainly wouldn't say or support any of the resemblances with writing. I would just let them happen, because I have the feeling that nature is very simple and I have the feeling that everything really looks like everything else. If we could get our eyes adjusted we'd find that the whole world was very simple, whereas it appears very complicated. I always look for an extremely simple form in whatever I see

and try to find another simple form that looks like it. And it's to cope with the environment, I suppose, to get it down to a workable condition, because I suppose what an artist wants is that the world should arrange itself so that he can pick and choose and see what it's all about.

I see that with you it's very important that, whatever else a thing might be, it has to be clearly one thing.

Absolutely. It's got to be. In order to be what I want it to be it has to always reverberate back to the original image and be a normal simple thing or a typical well-located thing – and usually something out of my own experience and experience of the people around me. So I have this prejudice towards naturalism or what have you, you know, where I really want the thing to be located in a particular time and place. And I'm always very happy when the poetry disappears and people see it as the thing itself. And the action between the metamorphosis and the original object interests me very much – this kind of tension between the two.

I take it that your dislocations are totally different from Dalí's when he does a soft watch folded over a branch of a tree.

I don't think it's like that because, after all, my landscape is very realistic and his landscape is . . . well, he indulges himself. I don't. If I find myself going too far into my fantasy I pull myself back. And with me, it always goes back to simple experience like riding the subway, and what I try to do is use my landscape, my own landscape, and try to avoid as much as possible imaginary landscapes. Another way to say it would be that I tried to make the real landscape imaginary. And I certainly wouldn't put any such far-fetched things as soft watches falling over trees in my landscape. And that, I suppose, brings up the whole problem of Surrealism and the distinction between what I and many other artists do and surrealistic ideas. I think in general the American artist is very much more located and very much more practical, very much less romantic, than a Surrealist and has had no problem of the schism between his everyday life and his dreams. I find that they just sort of coalesce. And my dreams are very everyday.

1965

Suddenly I'm reminded of what Léger used to say to me in the late 1940s when he came back from America. When he was there he'd done these paintings of things which he found at the edge of the city, where the city became the country; you know, sort of vacant lots with rubbish left around. And they were sort of fantastic, but they'd be fantastic things which had happened; there was no real break between the fantasy and the reality. Because Léger found this thing in America it might easily be specifically a part of the American experience.

I think it lives here. Yes, I think it does.

Is it because of this very high degree of cultivation in America of imagery? Is it because the whole environment is so packed with imagery?

Yes, I think so. I think in the first place it's a newer country where people don't have so much rubble to clear, you know, to build what they want to have. And the emphasis here is so much on the artificial environment of the city that . . . They have an entirely different situation from Europe. I spent some time in Paris and it's hard to see what you could do in Paris. I mean the city has been determined for so long and it doesn't suit the imagery of the present. And here you have a constant translation of the images into actuality everywhere.

Going back to Dalí's soft watch, what's the difference between his soft watch and your soft typewriter? Is it simply the fact that your typewriter is an isolated and compact object and the Dalí soft watch is folded over something? I think it's not just that. You said that you think the soft watch is improbable. Why is it more improbable than the soft typewriter?

Well, I don't think Dalí is interested in watches; I think he's interested in the watch as a symbol. And I am interested in watches. I've never made a soft watch, but it's conceivable, you know. I have a rubber watch which I got from a firm in Chicago that I like very much, which I can press and squeeze. But I think that's the difference. Dalí doesn't care for watches, you know, as themselves. I think if he did care for watches he would care for a very expensive watch with diamonds in it or something. He wouldn't care for an ordinary watch made up in Connecticut.

CLAES OLDENBURG

He is interested in the things as symbols and not interested in them as objects.

As objects, right. And the transformations that I impose on them are very systematic, so as to preserve their objectiveness and their references always to a natural condition, an objective condition. As I say, a non-pathetic, a non-symbolic, development of the original object to a form that will stand as art.

When you say 'a form that will stand as art' I think in a way this leads to what is the most interesting question of all about your work, and that is this obsession with softness. In almost all the sculpture of almost all civilisations – and above all in the sculpture from the past that Modernism has prized – hardness, a suggestion of hardness in the form, is almost a primary criterion of good sculpture. The form is intended to be hard and taut, not slack. You make a very strong point of making soft form. And obviously you do this because you want to do it. But is there also an intention to prove it can be done?

Well, I think it's an intention to prove that sculpture is not limited. Why should sculpture be limited? Take a very general notion of sculpture, and if a thing is one thing why shouldn't it be its opposite? Why shouldn't there be soft sculpture? I mean, if you're interested in form rather than in sculpture as some narrow idea of what sculpture can be, why shouldn't there be soft form as well as hard? We're going back to the time when I used to make things out of what I picked up in the street. There is another notion that's not allowed in sculpture, that sculpture can be perishable or made of perishable materials. But there again I would like to make it out of perishable materials, and why not? And maybe I did the wrong thing, but I wanted to do it and why shouldn't I do it? I don't know, this probably goes back to some religious concept of sculpture: it should last, it should endure, and so on. But I think of sculpture in general as form and space or mass and space and that allows me to include anything as sculpture – allows me to go on, for example, to think of chairs as sculpture, or bottles or bathtubs or sinks or anything. Because what I finally arrived at after thinking about it was that everything is possible if you have the desire to see form. I found that a great many

people objected to the fact that my sculptures were soft, you know. I think it must be some sort of sexual thing. Perhaps sculpture is involved with erections and so on. Sculpture has always had a kind of a masculine quality and painting has always been regarded as a softer art. But, having no problems about, say, if one thing is painting or sculpture, all my pieces have been somewhere in between. I've simply gone on the way I felt like going on. But it has stirred up a lot of questions.

It seems to me that your work is revolutionary to an extraordinary degree in the sense that you have managed to upset a concept of sculpture that has been dominant in practically all the world's sculpture. It's not surprising that it's stirred up a lot of questions.

I think that sculpture is a much more traditional form than painting.

But, you know, even in painting, surely, while it's true that painting is the softer art, it's generally been considered that a quality of tautness in the form is a desirable quality. Form in painting is not supposed to be slack even though it's possibly a softer art. So I don't think that, when you say you're working somewhere between sculpture and painting, that isn't enough to explain how radical you are.

As I said, I did study tradition as much as I could in my way, but I reached a point finally where I relied on my own experience, and this experience had a lot to do with my sense of myself as a physical object, and I felt that it was natural for a sculptor or painter to create a body image of himself. Or to try to find the image of himself that was true as a body in space. And I spoke of all the different ways that an artist can establish certainty, I mean by his own arbitrary imagery and so on. Well, one of the things that he can refer to is his own body. I find when I'm written up in papers people very often compare my work to myself; I suppose they're trying to insult me. But it seems to me a very logical thing. I don't think I'm drawn very much as a body image to rigid sculpture. I am drawn to something which is more like me, more soft and flabby. That's one part of it. The other part of it is that intellectually I like change and I don't like permanent things. Just as I would make a sculpture out of a piece of paper I would also make a sculpture out of

some form that could be altered. And these are simply things that I felt about myself. I was trying to translate my own experience into the sculpture. And as I said I wasn't really trying to work within the traditional notion of sculpture. Most of the pieces are my body images, like the telephone. In that case it could be set beside a torso, the traditional torso without arms and legs and head, and could make a sort of equivalent with the torso, but mine would be modern and it would also be pushable, alterable. So that there is a sense of that tradition of sculpture in the thing, and the tradition is altered by my own sensations of myself at this time and in this space. I didn't set out to upset sculptural values. I simply set out to project myself into the form and material.

You didn't set out to upset sculptural values, but in fact you did upset sculptural values by refusing to accept a kind of censorship . . .

Right.

. . . which had previously existed.

Another thing is that there are a lot of very fine new materials which were never available before. There's a sort of silicone thing that comes out like rubber, and you can cast very fine things with it. And if I had the means and the time I would cast something like a Greek sculpture in the silicone rubber and that would mean that it would sway in the wind, which would interest me very much. I would like that. I like anything that is subject to change and subject to nature and subject to conditions.

You're saying, of course, that the choice of the material for a work very much affects its form, as in most sculpture.

The material is very important. When I went to California last year to make my show, I didn't know what to do with myself because all my ordinary sources of supply were changed. I mean, normally I live in New York and I went to a new place to dislocate myself and then one day I found a remnant store and it sold remnants of vinyl plastic. A club or something would make up a special material which you couldn't buy anywhere else and they would have, say, ten yards left over and they

216

would sell it to the store. So I made a practice of going in there every week and seeing what had arrived, and many times the material that had arrived suggested the piece to be made. I got a very strange green kind of sticky plastic which made a great impression on me and resulted in a series of beans that I had made.

The beans were a non-man-made subject for a change.

Well, as I originally conceived them they were inside a box marked 'Birds Eye'. And they are quite cultivated beans. They're chopped off beans, you know. The impress of man is very strongly on them.

So this breaking down of the prejudice that sculpture ought to be hard is partly the consequence of working in materials in which soft forms look right where they tend to look wrong in stone or bronze.

It really begins when Bernini made things look soft and he pulled it off.

He made them look soft and hard at the same time. I mean, his curls of hair look like curls of hair but also look like stone, terribly like stone.

I admire him very much, but there isn't very much you could do with vinyl if you made up your mind to use it; the logical thing was certainly not to make something hard of it. It's always hard to separate all the motives but it certainly is very true that, if you make up your mind to deal with materials that occur in everyday life, you're going to get certain forms. Vinyl goes to upholstery – that's how it starts – and if you think of an upholstered object then you're right away with a soft sculpture. I used Formica. Formica went right away to a very hard subject – to the furniture that I made.

And that furniture looks very hard furniture.

Very hard. Just as the vinyl looks very soft, the furniture looks very hard.

But then, of course, there are all these games that you play with expectations with regard to material. I wish you would say something about that in

regard to Bedroom Ensemble – *I mean, the bed with the zebra-skin upholstery and the amazing leopard-skin coat. Presumably you could have used either a real leopard-skin coat or an imitation leopard-skin that was plausible. In point of fact you used an imitation that was very implausible. And this in a way is where the magic lies. But how did you make these choices of material?*

Well, the thing is that I always have in my mind a kind of reference to tradition, such as the conventional painting being a rectangle and so on. So the conventional sculpture is somewhat rigid and, if I can find a material that suggest the rigidity of the conventional form and also changes it, I'm very happy, very happy. And the leopard coat did that. I didn't want to make a real leopard coat, and so this leopard coat by being stiff and improbable lies just enough outside to please me. There again the material came along. I happened to find this rather rich material, rigid plastic. I think a real leopard coat would not have been as interesting as the one I found, which is sort of very paintedly elaborate. It's used a great deal for bath stools and so on. I really conceived it as a kind of cut-out or broken painting, and that's why the rigidity was interesting to me.

What you're insisting on is that a sculptor can be capable of making both taut sculpture and slack sculpture which is living form.

It places much more responsibility on the artist who deals with slack form. I mean, he really has to prove himself, you know. Most of my slack form, if it's set up the right way, you can see that the basis for it is a very rigid basis. It's just like the human body, which has a very rigid structure but can bend and be pressed and can change in space.

ROY LICHTENSTEIN

Recorded December 1965 in New York City. The version edited for broadcasting by the BBC was re-edited for publication in *Some Kind of Reality*, Roy Lichtenstein interviewed by David Sylvester, London (Anthony D'Offay Gallery) 1997, and that version is reprinted here. The book also included a second, much shorter, interview recorded in April 1997 in New York City.

Roy Lichtenstein with sons David and Mitchell and their comic books, New York, 1964. Photograph by Dan Budnik.

ROY LICHTENSTEIN 1965

DAVID SYLVESTER *What do you think of as the main sources of your language?*

ROY LICHTENSTEIN Well, I think in some ways, really, Cubism, but of course cartooning itself and commercial art are obviously an influence. But I think the aesthetic influence on me is probably more Cubism than anything. I think even the cartoons themselves are influenced by Cubism, because the hard-edged character which is brought about by the printing creates a kind of Cubist look which perhaps wasn't intended.

The kinds of cartoons which you've borrowed from, which you've parodied, are of a fairly limited kind. You draw on those which are fairly straightforwardly realistic.

Not funny cartoons.

No. And I take it that this is a deliberate choice. Or is it just an instinctive preference you've never thought about?

Well, actually, you know, the first few cartoons I did were Mickey Mouse and Donald Duck. The first one, I think, was Mickey and Donald on a raft. Mickey Mouse had caught the back of his coat with his own fishing rod and said: 'I've caught a big one now', or something like that. I forget exactly how it went. [In fact they were fishing from a jetty and Donald said: 'Look Mickey, I've hooked a big one.']

What gave you the idea of doing it?

Well, this particular one was on a bubble-gum wrapper, and it was a kind of obvious joke. The first ones were very obvious jokes. But I kind of rejected the idea. There's a tendency to make the cartoons look interesting, and when the original work already looks interesting, or inventive, it takes away I think from – well, maybe this isn't really a

reason, but whatever the reason was, I seem to prefer rather straightforward cartoons.

What suddenly gave you the idea of using cartoon images in the first place?

I was sort of immersed in Abstract Expressionism – it was a kind of Abstract Expressionism with cartoons within the Expressionist image. It's too hard to picture, I think, and the paintings themselves weren't very successful. I've got rid of most of them, in fact all of them. They encompassed about six months. I did abstract paintings of sort of striped brush strokes and within these in a kind of scribbly way were images of Donald Duck and Mickey Mouse and Bugs Bunny. In doing these paintings I had, of course, the original strip cartoons to look at, and the idea of doing one without apparent alteration just occurred to me. I first discussed it and thought about it for a little bit, and I did one really almost half seriously to get an idea of what it might look like. And as I was painting this painting I kind of got interested in organising it as a painting and brought it to some kind of conclusion as an aesthetic statement, which I hadn't really intended to do to begin with. And then I really went back to my other way of painting, which was pretty abstract. Or tried to. But I had this cartoon painting in my studio, and it was a little too formidable. I couldn't keep my eyes off it, and it sort of prevented me from painting any other way, and then I decided this stuff was really serious. I had sort of decided that as I was working on it, but at first the change was a little bit too strong for me. Having been more or less schooled as an Abstract Expressionist, it was quite difficult psychologically to do anything else.

All the same, the love of the cartoons took you over quite quickly, if one thinks of your output between the beginning and end of 1961. Was the main attraction the kind of visual language or was it the kind of imagery?

Well, I think that it was the startling quality of the visual shorthand and the sense of cliché – the fact that an eye would be drawn a certain way and that one would learn how to draw this eye that way regardless of the consequences, these ideas being completely antithetical to the ones I felt had to do with art at the time. And I began really to get excited about this.

The cliché is a cliché if you don't know anything else, but, if you can alter this cliché slightly, to make it do something else in the painting, it still seems to retain its cliché quality to people looking at it. In painting, more than in some of the other arts, I think, one assumes that because it looks like a cartoon it's really just the same. Whereas in music, I think, if you alter a popular tune just slightly, the alteration would be immediately perceptible and it would look artistic. In painting you can alter the image of an eye or nose, a shadow or something from a complete cliché, without its ever being understood that anything is happening artistically.

In what direction do you try to alter the cliché?

Actually, in a number of ways. Sometimes I try to make it appear to be more of a cliché, to kind of emphasise the cliché aspect of it, but at the same time to get a sense of its size, position, brightness and so forth as an aesthetic element of the painting. And they can both be done at once, as you can certainly do a portrait of someone and also make it art.

What is the kind of thing that you might do in using clichés from cartoons in making a painting? I mean: what would be lacking in the cliché that you would want to give it?

There's a sense of order that is lacking. There is a kind of order in the cartoons, there's a sort of composition, but it's a kind of learned composition. It's a composition more to make it clear, to make it read and communicate, rather than a composition for the sake of unifying the elements. In other words, the normal aesthetic sensibility is usually lacking, and I think many people would think it was also lacking in my work. But this is a quality, of course, that I want to get into it.

But often the adjustments that you make are very small.

Yes, and I think that that's it. I try in a way to make a minimum amount of adjustment. Sometimes you get a very interesting image that would almost be good by itself except that this was not the artist's intention. I think that one needs more than pure intention to make a work of art: in other words, my intention to exhibit doesn't automatically make it a

work of art. But the original cartoonist has a job to do. He gets a story out and he's very good at his craft and puts it together and it's very interesting, but it isn't really inventive and it isn't really formed. I think it's inventive only in a mass way, that it has become inventive if you suddenly sit back and look at it and say: 'My God, look what's happened to this image. We take this for an eye and this for a shadow under a chin and look what it really looks like.' But this has gone on from generation to generation of illustrators, each one adding a little bit to the last, and it's become a kind of universal language. So I'm interested in what would normally be considered the worst aspects of commercial art. I think it's the tension between what seems to be so rigid and clichéd and the fact that art really can't be this way. I think it's maybe the same kind of thing that you find in Stella or in Noland where the image is very restricted. And I think that is what's interesting people these days: that before you start painting the painting, you know exactly what it's going to look like – this kind of an image, which is completely different from what we've been schooled in, where we just let ourselves interact with the elements as they happen. This highly restrictive quality in art is what I'm interested in. And the cliché – the fact that an eye, an eyebrow, a nose, is drawn a certain way – is really the same kind of restriction that adds a tension to the painting.

You were saying that sometimes you actually want to emphasise the cliché. Now this, I take it, would have to do not so much with its formal properties as with its meaning and its place in people's perceptions?

Yes, I think so.

But what is it that interests you about emphasising the cliché? You obviously enjoy the clichés of the romantic or adventure-style strip cartoon. You like calling attention to these clichés. You like pointing them up. You like in a sense making them more like themselves than they really are.

I have a feeling that in many ways I don't do as well as the original cartoons in this way. By the time the painting is put together, a lot of the impact of the original cartoon is really lost.

But is being interested in these clichés like people who care for Mozart and Beethoven also caring for Rogers and Hart and the Beatles? They wouldn't do so in a patronising way; indeed, a piece of popular music might mean a great deal to them because of its associations. Is this your attitude to the strip cartoons, or is it not that at all? Or is it partly that and partly something else?

I'm not sure that what I'm going to say is really true. I don't care whether they're good or bad or anything else. But they are subject matter, and I'm only using them and I am re-interpreting them. If I were working from three-dimensional things – trees and so forth or gas stations that actually existed – there would be no problem. The only thing I'm doing is that I'm not putting perspective into it, so that I seem to be doing the same thing that they're doing. In other words, they're making a flat image and I'm making a flat image, and mine is very much like theirs. But the real difference is the fact that there's really no perspective in my images, which I think is an element of the work.

I both like and dislike the cartoons. I enjoy them, they're probably amusing in some way, and I get a genuine kick out of them, though usually only a few frames will be really interesting to me. They're even strong in some ways. I think when they're very well drawn, certain sections – it may be partly accidental or maybe it's an innate ability on the part of the person that is doing the cartoon – really may be good. But by and large I think I look at them as being kind of hokey, just as I would look at those three-dimensional plastic photographs. That kind of material has been a silly thing for us to be spending time and technology on.

Insofar as they are silly, do you enjoy the absurdity of the activity of going to a great deal of trouble to blow these cartoons up and make them a little more beautiful than they are? And, by the way, admit that maybe they're less so? Is this an absurdity that appeals to you?

I think so. But I don't think of myself as really blowing them up and altering them. I get involved with them to the extent that I am no longer thinking in terms of the original, although I must admit, when I'm finished, there's a striking similarity between the two. But the whole fact

of using the cartoons is lost. I work on several of them for a month or so, and on the first day or two I'm really involved with the original image, and after that I'm working on the painting.

Partly because you begin, I believe, by making a drawing, and you paint from that drawing.

I make a drawing from the original cartoon, or rearranged from a group of cartoons. Or they might be made up: they range from being completely made up by me to being very close to the original. And then that drawing is projected on canvas. This is a rather recent development: I used to do them just fresh and from the cartoon itself. Everybody thought that I was projecting them up, so I did. But then I work on that drawing in pencil on the canvas for quite a while, and then I work on the painting, finishing it for quite a while too.

But once you've done the drawing, do you ever refer back to the original cartoon?

Rarely. Rarely.

By using a subject which is absurd, are you saying: 'I am using subject matter; I am not painting abstract pictures. All the same, the subject matter is absurd, so it doesn't really matter'?

No. I think I'm really interested in what kind of an image they have and what it really looks like as well as the formal aspect of it. Let it go at that. I'll just do it anyway. I'm interested in the kind of image in the same way that one would develop a classical form, an ideal head for instance. Some people don't really believe in this any more, but that was the idea, in a way, of classical work: ideal figures of people and godlike people. Well, the same thing has been developed in cartoons. It's not called classical, it's called a cliché. Well, I'm interested in my work's redeveloping these classical ways, except that it's not classical, it's like a cartoon.

I'm interested because of the impact it has when you look at it, not because it does anything formally. As a matter of fact, it's really contradictory to form, it's a restriction on form. I mean, you have to take

into account something else while you're forming this painting. The hair, the eyes, whatever it is, have to be symbols which – it's sort of funny to say this – are eternal in this way. In realising of course that they're not eternal. But they will have this power of being the way to draw something. I don't know how to express it beyond that, but if it didn't quite look like the kind of eye I wanted it to look like and the kind of mouth I wanted it to look like, I would be changing it; it would bother me a lot. It isn't purely a formal problem. I'm not sure exactly why I do this, but I think that it's to establish the hardest kind of archetype that I can. There's a sort of formidable appearance that the work has when this is achieved. I think it also doesn't become achieved unless it's in line formally; just by itself it doesn't work. In other words, the enlarged cartoon itself would not do anything; it would be a kind of joke. But I think it's when the formal and this aspect of it being the right kind of eye come about, you have something.

I think, really, that Picasso is involved in this. In spite of the fact that it seems as though he could do almost any kind of variation of any kind of eye or ear or head, there are certain ones that were very powerful and strong because of the kind of symbolism that he employed. And I don't know the meaning of this. It's what I think I'm up to, anyway.

When you're doing, for example, the girl lying on the pillow with the balloon caption saying: 'Good morning . . . darling', this girl is a certain modern ideal in exactly the same way as the classical head of Venus is also an ideal kind of beauty. The readers of those magazines would like to look like that; they believe in it as an image. Now, do you believe in it as an image, as well as not believe in it?

No, I don't really believe in it.

I mean, do you like girls who look like the girls you paint?

The kind I paint are really made of black lines and red dots; I see it that abstractly. It's very hard for me to fall for one of these creatures, because they're not really reality to me. However, that doesn't mean that I don't have a clichéd ideal, a fantasy ideal, of a woman that I would be interested in. But I think I have in mind what they should look like for other people.

What would you expect would be the reaction to seeing one of your cartoon paintings of somebody who was in the habit of reading these cartoons with complete seriousness, if there is anybody who does?

I have had actual experience in this way. When I was doing the paintings for the World Fair, I was doing them out of doors in front of my garage in Jersey, and people would pass by and make comments, and you got all kinds of comments on various levels. You would get children who would realise that this was rather funny for art, which was rather sophisticated. And you would get older people who thought I was doing a very good job of it, just like the cartoonist: it was wonderful art for this reason.

But as to your attitude towards these cliché goddesses, you say that it's not a particularly affectionate attitude?

Well, I don't know. I think it is and it isn't.

I mean obviously its ironical, but how ironical?

Let me put it this way. I can realise that, when I was a child and looked at the comic books, these women were really convincing. I really thought these were very beautiful women. Now I see the drawing in it and they don't look that way to me. I mean, you could really have a love affair with these women as a child, and now these don't mean that to me in the originals, in the comic books. I realise that some are drawn better, hit the cliché better, than others. As I said, I'm interested in kind of getting the archetype that will hit this cliché, but also be powerful as a drawing. It can easily be both. It has to fit a number of things. It has to be interesting and consistent in colour, and everything has to be up there all at the same time, and this has to do, on a very obvious level, what it's intended to do, to tell a simple story. I believe in the story in one sense and obviously don't believe in it in the other sense. It has to be right to make it all work as a visual thing. On the other hand, there's very little sense in a painting of a girl looking at a photograph of her gentleman friend and saying 'Good morning . . . darling'. At the same time, it sums up a lot of things. Everybody believes in it on one level and everybody talks like this, in spite of the fact that it looks funny when you read it.

1965

I'm interested that you've already read a story into this picture by talking about her looking like this at her gentleman friend, not at her husband.

I wish you hadn't brought that up.

This does suggest that you are interested in the literary qualities of these images.

I don't think I know why, but I am.

You don't think you know why.

No. I think I can make up reasons, as I've been making them up, but I'm not really sure they have anything to do with it. It's just that it has a certain kind of impact on me when all of this is right, even when the statement is a cliché. There are different kinds of statements that I put into these paintings. Some of them are very clichéd, something that could be said thousands of times and has been. But I've done one of a scientist which is just a very long sentence which has so many subordinate clauses in it that you have no idea what the man was saying to begin with, so that's in a way humorous for another reason. And it also takes up a block of space in the painting, which interests me too. This becomes kind of Pop poetry in a way. But usually the statement is succinct and clichéd and it's exactly like the drawing in that way. And I just like it when it falls in place that way. I don't really know why. And as you've seen, it's very different from the kind of work I was doing earlier. That was the opposite of the cliché, so it's been a kind of learning process to me. I think the idea isn't so much to mystify other people as to make an interesting problem for me to do. Maybe it's interesting because it's so different from what I've been schooled in.

It's an extension of something that's always been done a great deal in art, which is using subject matter that has hitherto been regarded as being taboo, or beneath the artist's dignity, and showing that he can make art out of this.

That's what realism is.

229

That's what realism is. And what about the paintings which are adaptations of fine art images, your Picassos and your Mondrians?

I kind of wish you'd explain them to me, because it really doesn't do the same thing. It takes something which is already art and apparently degrades it. It's like a five-and-dime-store Picasso or Mondrian. But at the same time it isn't supposed to be non-art. It's a way of saying that Picasso is really a cartoonist and Mondrian is too, maybe. I don't really know. I don't think I understand it, but I think that it's a way of making clichés that occur in Picasso more clichéd – a way of re-establishing them but also making them not a cliché. I think that it does just that.

Yes, and that of course brings us to the most recent work, the Abstract Expressionist brush strokes.

Yes, this is in line, pretty much, with the attitudes to Picasso and Mondrian.

Because those brush strokes are clichés, aren't they? They've become clichés of contemporary art. I suppose that Rauschenberg was the first person to comment on this when he made a very slashing dribbly Abstract Expressionist painting and then made a duplicate of it. That, I take it, was the first move in this direction.

Yes.

And you're really continuing this by doing these big slashing brush strokes but doing them in a way in which they've been very meticulously and carefully formed and shaped.

And of course I'm not sure that Kline didn't do this too in his own way. They look like brush strokes but they're not one brush stroke. I hear there were drawings for them. They are certainly reworked when you look at them, not spontaneous brush strokes. I think this is true of all of them really, that they were symbolising brush strokes, they were symbolising that art is art, but at the same time they were drawing a picture of a brush stroke. It has at first a degrading aspect, the fact that it takes something

which had a certain sensibility before and leaves that out, and puts it in again, in the same way that I would take Picassos which, when you really look at them, have very odd shapes, that are something like a triangle – only, I'll really make a triangle out of them to make it more of a cliché. But, at the same time, it is somewhat bent towards forming a work of art, so that it has this little twist to it also, so that it's re-establishing it as art but with more of a clichéd manner. I think I'm doing the same thing with the brush strokes, simplifying them and epitomising them but still trying to make an organisation out of them.

You've actually made them, it seems to me, look more violent in building them up in this meticulous way, you've made them more violent and aggressive and slashing than they ever are when they're made in a slashing way.

Well, I hope so.

The thing that impresses me about the biggest and perhaps the best of these recent paintings . . .

In America the biggest *is* the best.

. . . is that I see humour in it but I also see it as a very dramatic painting. And this, I take it, was also part of your intention.

Yes, I think that's always part of my intention.

In other words, it's another case of degrading the thing and then building it up again, is it? The Abstract Expressionist brushmark is meant to be a dramatic mark. You make a joke about it, but you make it dramatic again. In the same way as you do with the Picassos: you degrade Picasso but also try to take it back to art.

And I think that there's maybe the same element in the Picasso and the brush stroke that's in almost all subject matter that's violent, sentimental, romantic, highly emotionally charged. But the method of doing it is the very removed method of commercial art. And it's really not so much that

I use that method, but that it appears as though I've used it and as though the thing has been done by a committee of people rather than an artist at work.

In the Abstract Expressionist brush stroke paintings and especially in the biggest one, each dark and light in the stroke of the brush is brought out by being carefully drawn, meticulously done. And one of the reasons why the result seems peculiarly violent and aggressive is that the imagery of things like teeth and other jagged, tearing things that are seen in your carefully done image of the violent brush stroke are much more vivid there than they are in the original violent brush stroke. Were you conscious of making this sort of imagery of teeth and knives and other violent instruments?

No. I did notice that some of the edges of the brush strokes looked like explosions and things, but I really wasn't thinking of any other imagery except the obvious.

But you did want it to be violent and dramatic, through making the darks blacker and the lights more vivid and so on.

Yes. And its size. These would be very large brush strokes for anybody's painting. They're blown up and magnified even by comparison with brush-stroke paintings that were very large when they were done. I wasn't able to make anything that would look like a brush stroke, they all looked like something else, and it took me a while to develop the symbolism which would remind people enough of brush strokes and would be the kind of shape I could use in painting. I mean a brush stroke really doesn't look anything like these things: you'd have black lines around solid colours, and it just isn't anything like a brush stroke any more than a cartoon head is like a head. Or a photograph of a head. It was a question of developing some kind of cliché or some kind of archetypal brush-stroke appearance which would be convincing as a brush stroke, and which would be in line with elements I like to use and am familiar with using.

In some of your last abstract paintings before you started to do Pop Art I've noticed that there are passages where you've got what seems to be a trail left

by a very wide brush very charged with paint, with the paint put on heavily across the canvas. And it struck me that there it was as if those marks were not merely slashing brush strokes, but almost like illustrations of slashing brush strokes; they had a peculiarly concrete and material quality in the paint.

I think I was aware of that.

At that time?

Yes, not to the same degree as later, but I think I recognised that I was making brush strokes like brush strokes.

Without any humorous intention?

Yes.

And when you started to have the idea of doing these new brush-stroke paintings, you didn't think back at all to the last Abstract Expressionist things you yourself had done?

No. But I realised after I had done some that there was a similarity between the two. The kind of brush strokes in some of these is very much like the kind I was doing then. This was maybe more of a parody of myself than anyone. But I think that these brush-stroke paintings are really not so much a parody of anyone's paintings as an epitome or codifying of brush strokes. I think it's a sort of synthetic Abstract Expressionism. It's really in a way what Synthetic Cubism did to collage, in that it made a picture of a collage. And this was in some ways a picture of a brush stroke.

Yes, and in Synthetic Cubism there was plenty of play of that sort. Was this a painting of a piece of grained wood, was it a piece of grained wood, or was it a cut-out piece of paper imitating grained wood?

That element of play in Cubism: where the play became more literary, it led to Dada. I don't think that my work relates to Dada, though

probably everybody's painting is influenced by Dada, including Jackson Pollock's. But I think that the principal influence was Cubism and still is.

ALEX KATZ

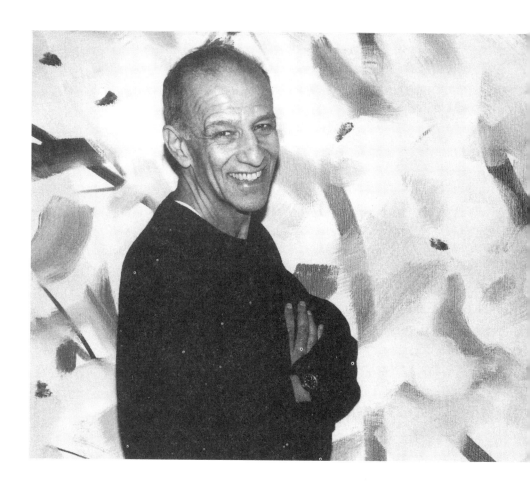

Recorded in two sessions in March 1997 at Palm Beach, Florida. Edited for publication in *Alex Katz: Twenty-Five Years of Painting*, ed. David Sylvester, London (Saatchi Gallery) 1997. That version is reprinted here.

Alex Katz, photograph by Vivien Bittencourt.

ALEX KATZ 1997

I

DAVID SYLVESTER *Does the all-overness in a lot of the big landscapes come from nature or from art?*

ALEX KATZ Oh, it's art, it's art, it's not nature. I think nature's just a vehicle for art.

And whose art? Pollock's?

Pollock's. And Baroque painting in general. But it's a Baroque idea with an image that I guess is something like Pollock. Most Baroque paintings don't have much of an image, they just have motion.

Your portrait groups aren't at all Baroque. They're generally static, classical.

When I did the first figure groups, *The Cocktail Party* and *Lawn Party*, I felt they didn't move enough. And that's one of the reasons I did the large flower paintings.

. . . which are certainly Baroque.

They have an image and they can't stop, you keep moving on them.

Like White Lilies. *It would be extremely interesting to see whether you could get that Baroque quality into figure paintings. It's difficult to do a Baroque figure-composition when you can't use figures in flight or sitting on clouds. So to do it you'd probably have to go into fantasy.*

No, that's something I'm not going to do. The subject matter is given and I'm not moving from it. I started with that when I was twenty.

So I take it that one of the reasons why you're attracted to doing the large

landscapes is that here you're able to use a Baroque rhythm?

Yes, that's one of the things that interests me. Painting another way. But it's been a new area. And it would seem exciting to go to a place that was kind of open and dangerous. And actually when you do a ten- or twenty-foot painting wet-in-wet, you're going where no one's been. Wet-in-wet painting is just the same technique you'd use on a small painting but on a huge scale, and it seems to suit my temperament. So it's like finding a part of yourself that you didn't know was there and working with it. When you start out you learn to do something, then you try something else, then you take a chance and try something else and it works, and soon you're doing things you never dreamed you could do. Then people ask you to do things and you do things, and you didn't know you had a talent for it, and it's a continual trip trying to find something that's interesting to do.

You were very emphatic when you said that the work would never go into fantasy.

Well, everything could be changed, but I'm pretty sure, always working from an optical base, you have an idea about what a painting should be, or an idea *of* a painting. And then it correlates with something I see and then I start out empirically and optically. And when I do that I get involved in the light: there's an unconscious procedure and it gets into something I wouldn't have thought of to start with. It moves around a bit and that's the part that's interesting. Because when you go in there you find things; weird things happen and some are all right and some aren't all right. But they wouldn't have happened if you just took the idea and did it, and that's part of it. I think with painting you have the opportunity to go inside yourself and find your unconscious intelligence or your non-verbal intelligence and your non-verbal sensibility and your non-verbal *being* in a sense. And you alternate between consciousness and unconsciousness and it can engage much more of you than if you just merely took an idea and executed it. You know it's very bright but you don't get as much into it. That's my feeling about it. So the thing I've found is that the subject matter is the outside light. This is the thing that got me inside myself and that's the thing I've been holding on to. And it's

just a matter of seeing how many variations I can do on it or where it could go.

It's the outside light?

Yes, then, when you paint perceptually and you're painting faster than you think, so to speak, you speed it up, and when you speed it up to that degree your unconscious takes over. The brush strokes are not conscious at all. I'll make a copy and it won't be as good, and I have to say, why did I do it this way? And it's very interesting. It's like the instincts of a child are kind of terrific in painting. It's trying to find that kind of instinctual intelligence which all people have while dealing with it on a more sophisticated level than a child.

It seems to me that in your paintings of the figures there's a fairly constant ratio between the acceptance of the given form and formalisation . . .

Well, I think that the formalisation is unconscious. You've done so much that it's your vocabulary. The way you put a sentence together.

The vocabulary is fairly constant, it seems to me, in your figure paintings.

Yes, but I think in the landscapes too, though. It's a much more simple vocabulary. It's all a matter of rhythms and strokes. The rhythms and strokes are contained in a certain area, all of them, they don't go outside of it much, my rhythms and strokes, if you break it down. And I think the rhythms and strokes of the heads in the portrait paintings are in a pattern too.

Well, I'll give you an example. In May *it seems to me it is a relatively literal transposition. It's like a Pollock in its all-overness, and you can see the identity of the brush strokes as flickering marks of great inherent vitality, but they still seem to relate fairly directly to the object that had been perceived. Is that unfair?*

No, it's okay.

Now, with Lake Light, *it seems to me that there's a greater transposition, a greater systemisation, a greater invention in the marks.*

I don't know, I don't know. No, I just think it went a little nuts. The painting got out of control a little bit. But the marks, I think, are all the same thing really. The grass marks on the front are the same as the marks on the water and on the other painting. The water marks are similar to the white marks in *May.*

So you do find that optical?

Oh yes, optical.

It's not a formula, not a schematisation, it's not a kind of equivalent?

No, no, it's optical. Well they are all kind of equivalents, they are just a different kind of painting, a different space. One's closer and the other's further away and I think that *Lake Light* was a much more difficult thing. It's catching light in the late afternoon. You have this great big blinding passage of light that you are dealing with and things around it. I'd worked on that for three or four summers, different paintings and this summer I did that one and that was the end of it, I finally got there. But it was a little out of control. But basically the strokes are all optical.

It's equally related to the optical?

The water becomes white and grey with black in it. With gestures and with light the difficulty factor makes things more interesting, so it's much more interesting to me now. I'm using moving figures. I'm doing several points of view at the same time and they look like they are from one but the figures are more active, so they have more motion in them. Like doing a smile, I did a whole series of smiles. And these are very fleeting fast things and in the landscapes I've done things like twilight in which you have a fifteen-minute interval to see it. And *Lake Light* is that kind of thing; it's a fifteen-minute interval you're looking at. The light is sliding across the lake and you have fifteen minutes to get that particular thing. These are really high-speed sensations and I find it very interesting.

You mean as with Monet and the haystacks?

No, his time is much slower than mine. He went back over them at the same time every day. It's more like a Matthew Brady photo, it's an image on top of an image. I'm working with a much more instantaneous light, it's more de Kooning or Sargent.

You mean you only have one go?

For the sketches, yes. Because it's changing so fast. What I do is after I do one I look at it, and wait and do another. I wait a day and then the next day I'll do it at the same time, eight-thirty, whatever it is and I'll paint another painting. And then I'll put it against the first painting and paint a third painting sometimes if I need it. Each one different and then you go through all of them or you try to figure out which one really is the one that would be the most interesting to blow up.

What is the usual size of the sketches?

Nine by twelve inches. This is basically because it's great for speed.

And what are they? Oil on paper or . . . ?

Oil on Masonite, with a gesso ground.

You'll never use watercolour or gouache?

No, watercolour's just too slow for me.

The final paintings are always done indoors, then?

Yes, not in front of the subject matter. The sketches and drawings, it's an indirect procedure to get to the big canvas and the colours are premixed the day before and on a lot of them I have to get specific brushes for specific strokes. And the brushes are laid out. When I have to do a branch I have a specific brush that will do the branch. And the strokes, it's a wet-in-wet procedure. So you paint, like in *May*, where the whole canvas is

painted white and then I have to have the perfect brush to make those long black lines. You're putting it into white paint so you have to put that stroke down exactly the way it's going to be. You can have a slight area where it can go this way or that way, but not too much. And you have to have a brush with the right amount of paint on it. And that's an eight-foot line you're making, so you have to have a lot of control.

I imagine you don't look at the sketch very much while you're doing the painting.

Not too much, I'm looking at the painting that has a drawing on it. But I do like, if I have one with a face, I may take the drawing up. I'll make a finished drawing of the people and I'll use that for reference. But on the big ones, in constructing an armature for a painting, then the marks become unconscious. I mean you put like it's soup, you know, 25 per cent of green marks, 30 per cent less, 15 per cent more. It's not like this mark will look good here, it's a much more generalised way of painting.

There is always, then, in your work an attempt to capture the optical?

Well, yes. In the very early fifties I used a lot of photos. It was nostalgia and I would paint them the same way. They looked optical but they're not. Optical, I would say, almost always; unconscious, I would say, always. It's a perceptual manner of painting that's the constant factor.

So although there's a very high degree of abstraction in your work, you do not invent at the expense of the optical?

Yes, people say painting's real and abstract. Everything in paint that's representational is false because it's not representational, it's paint. We speak different languages and have different syntax. The way I paint, realistic is out of abstract painting as opposed to abstract style. So I use a line, a form and a colour. So my contention is that my paintings are as realistic as Rembrandt's. Now, that's supposed to be realistic, but I don't see those dark things around it, I don't see those dark things anywhere. It was realistic painting in its time. It's no longer a realistic painting. Realism's a variable. For an artist, the highest thing an artist can do is to

make something that's real for his time, where he lives. But people don't see it as realistic, they see it as abstract. But for me it's realistic. I mean, do those Impressionist paintings actually look realistic? You open Pandora's Box when you start off with that. Then you say, well then what is realistic? Then I say, well, maybe my things are as realistic as the next guy's. Giacometti is very realistic, but for his time and place. It's not very realistic in my time and place. It has nothing to do with the quality of the art, it's the quality of the vision. And when paintings somehow are no longer realistic, they often become great, great art.

You never seem to have been tempted into that halfway house into which a lot of artists have retreated from both sides of the road – that halfway house between the optical and the abstract.

Thank you. When you say the paintings are abstract and figurative, that's exactly what I was driving at.

II

When you and I first met nearly forty years ago, it was in rather an Abstract Expressionist context, where socially you seemed very much accepted and at ease, but obviously you were totally contradicting the aesthetic mores that were accepted there. You didn't see painting as an act of self-discovery but a discovery of the world.

Well, it's both, for me. You discover yourself: as I said earlier, you discover parts of yourself. And you try to paint out of those things. No society was suitable actually for where I was. In the Abstract Expressionist society everything was sort of accepted. So, whatever you did it was anything goes. So it was okay because anything goes, but I think basically most of the early stuff was patronised. People would say, 'Hey, that's a nice painting', and that wasn't exactly my intention. When I started to make the figures on the flat grounds, then some people started disliking it. That was a real rupture with the crowd.

Which paintings were those?

The figures on flat grounds, like the *Paul Taylor* and *Ada with the White Dress*, and then I really had people who didn't like the paintings.

That must have been rather a release then, rather good?

Well, it was like the biggest kick in the whole painting thing. You'd been doing things for years and then all of a sudden you take a bigger risk and go out further, and you had no idea whether this idea you had in your head would make any sense to anybody, and then all of a sudden you engage people in a violent way and you realise you did and I was really on my way at that point.

Have there been painters around whose work was an encouragement or a help to yours?

No. I felt there were a lot of painters I was being influenced by but not encouraged by.

Who, for example? Fairfield Porter?

No, I liked Pollock a lot in the early days and I liked Rothko and Kline and I admired Fairfield's work too, that's later on. But I think painting has to come from the place that you live. It's a social act, and a painter works from other painters somehow.

Well, have you noticed that though there are great writers who have developed alone living in some village, there haven't been great painters who matured outside a city where there were other painters? Painters migrate to be together – in Florence, in Siena, in Rome, in Paris. It's extraordinary the degree to which it's a social activity.

Because you do things and people contradict you, and then you listen a bit and you might change a little bit, but I thought that I was very lucky to be born where I was, and grow up where I was, to go from the provincial American world into this worldly American world. It just happened when I got out of art school. I just stepped right into it. But it was all the people around you, talking, because you're in a provincial

world one day and then all of a sudden you're not in that world any more, you're trying to catch up and find out what it's about. And you met me at that time.

But you were also wanting to work in a European context when you tried to get that Fulbright grant in 1952?

Well, European paintings change as you see American painting. Because after I saw Pollock then I said, hey Tintoretto's really terrific. And Fragonard is wonderful. You know, after you see Pollock and de Kooning, Fragonard becomes terrific. You look at different things. You're involved in different painting through the modern painting. For me it was similar in poetry, I had a much better understanding of Byron after I'd read Kenneth Koch. And thinking about what de Kooning was involved in leads you to Rubens, and then I saw Rubens in the Louvre when I was around thirty-five or so, and I was very impressed with the energy of those Rubenses and of the Rubenses in Vienna. And I liked Veronese very much. It isn't Baroque but it is all-over, a great all-over painter. I realised to go into the big painting – the very large figurative painting – was an area no one was in, and you had to have things generalised to get a really strong picture. And I did the flowers after the first attempts, *The Cocktail Party* and *Lawn Party*, and they're areas I don't think anyone has been in much in the twentieth century. I had to look for references in the eighteenth century and earlier. When I saw the Veroneses they made a lot of sense for the all-over stuff and the Rubenses. So that was the start of the interest in Baroque painting. The interest in Tintoretto wasn't so much interest in Baroque, it was gestural. I was at the Berlin Museum and the favourite painting was the Tintoretto portrait, because there's just about no colour and just about no form and there's a real person there and everything is there with hardly any means. I think Tintoretto portraits are just absolutely extraordinary. There's a great one in the Met that looks like a dish rag. A great painting.

In evolving a figurative language in our time, what have been your great difficulties?

Well, there's two parts. One is areas of doubt. Through all the early

paintings the areas of doubt were in the use of flat colour. In the landscapes of the fifties they had to do with whether they were contemporary or not. And when I got to the flat figures it was whether they were anything or not. I had a lot of doubt. Then I had a lot of technical problems because I'm not trained to do what I was doing. I had to learn it. Particularly with the figure compositions there was nothing. There were no guides for me. I had to figure how to do it myself. So the pictures have a lot of energy but they're really rough. I had to work it out. And by the time I worked it out and got better – like *Thursday Night* is a lot better than *Lawn Party* – it's no longer that interesting. The difficulties were those. And the big heads were a big difficulty too, painting a realistic painting on that scale. Edwin Denby told me: 'I think you're going the wrong way.' But then he said also: 'I'm usually wrong when I advise artists.'

And where did he think you were going the wrong way?

I was doing heads in a smaller size, they had perfect balance for a while. The pictures were coming out great and I started to go into these larger heads where I didn't have perfect balance and the pictures were coming out real rough. So when I moved into those large heads I really didn't know how to do them. And so I would just paint them direct and then the proportions and scale weren't developed and then it took a couple of years to work out a way where I could have a grasp on it. I had to change my techniques.

What changes did you have to make?

Well, I had to go from direct painting to indirect painting. I used to paint right on the spot. Like most of the stuff in the mid fifties I'd just go out and paint a painting and the next day I'd do another one. That kind of painting. Very direct. Then when I did *The Red Smile* I did sketches, small sketches, and then I did a painting thirty by forty and then I did the big painting. So by the time I was painting the big painting I had some ideas what I was doing. But by the time I got into the seventies I was also doing very finished drawings, so I had more information, and I could do more complicated things. I started using preparation with drawings and I used

246

to draw on the canvas in the early sixties and then it was dirty, and so then I started to draw on paper and pounce it, by about '64, '65, and make cartoons. So basically I ended up working like an Old Master and I'd started out painting off the top of my head like Jackson Pollock. It was a big change. You just did it step by step. You know, something didn't work, you just tried to figure out how to get it to go. And you know, you learn. Because I remember I thought the early Monet paintings with the people in the gardens were just terrific. Then when I saw them analysed in terms of gesture and composition they were just art school. He never did anything. Just like you put people in the corners to turn the corners, they were really kind of rudimentary compositions and the people are totally static. And with Manet, who I think is the most interesting painter of that time, with two people it's nothing, it's just like a still life, the relationship between them. And then you start looking at Watteau and Rembrandt and Giotto, then you start thinking of developed relationships and gestures.

And if Giotto, what about Piero?

I liked Piero a lot in the early fifties and actually I kept trying to get a Fullbright to go to Italy to see his paintings. I love the *Baptism* in the National Gallery. The details in the background seem so brand new looking, like someone could have done it today. I like his casting of characters. I think his casting of Jesus Christ is one of the great things in Western art. He's like a producer casting someone to make that face. It's a sensational invention. But I haven't thought about Piero in years. A lot of the gestures are almost like *commedia dell'arte* gestures, really traditional gestures. They relate to the static quality in a gesture. Like Jacques Louis David's, which are very very clear, they are very decisive – clear in what they are supposed to be as gestures. I am very conscious of trying to make gestures very clear. If you make a standing person, it's supposed to relate to all of the standing figures in art, and you look for new gestures like someone's smoking a cigarette. When I saw the David with the three swords I thought of three guys with cigarette lighters and a woman with a cigarette. That's what it looked like to me. And you can see the transferal of the idea. And I think Piero is like David, making clear gestures that communicate.

I certainly see in your work a search for clarity of gesture and I also believe I see another search for something found in Piero and David among others, which is a search for ideal facial beauty. I think that, while your images of faces are very specific, tend to convey the feeling that they aren't invented but belong to particular people, they also seem to me to be intended to create a canon of ideal beauty, as Piero's do. I sense that very strongly in paintings such as The Red Band *and* Face of a Poet.

I don't know what the word ideal is, but it *is* a search for beauty and I think the paintings are involved with that. And I said it in the book I wrote that the Egyptian artist Tuthmose is the model for me. Because you live in the city where there is a value on elegance and beauty and that's like one of the things I'm involved with. I think some people find it hard to accept that as being art – elegance and beauty – they want to see social messages, suffering, inner expression, all of those things which I'm not interested in.

So if I see in your work a desire to create paragons of beauty, I'm not seeing something which is unconscious?

Well, no, it's conscious. The *Face of a Poet* is also like a big movie screen, it's like a glamorous Hollywood star. It's a complicated symbol, it has multiple readings. Well of course, it's that person who is beautiful. Anne Waldman is a poet, she is beautiful. She's also high-style bohemian and you see that too.

By the way, I do mean beauty, and also glamour; I don't mean sexiness.

It can be sensuous but not sexy. Once you have sexy you have problems with beauty and you have problems with glamour.

And maybe it was the greatness of the Hollywood still photographers of the 1930s that they didn't go for sexiness?

No. It was more for glamour and beauty.

Why is it that you've done so little with the nude?

248

Well, I have done nudes; I haven't shown many of them. I haven't done a lot, though. And one of the reasons is, I think, that you don't deal with them in a civilised form, clothed, you deal with them in a less styled form. And the other thing is I always wanted to do nudes with a non-traditional concept and I've done a couple but they haven't been seen. But mostly it has to do with that it's a more generalised time-frame. Because I want to get out there in the exact minute I live in, in terms of the artefacts and so on. (The landscapes are in a more generalised time-frame.)

It is true that on the beach a girl with a bikini is much more of her time than a topless girl.

A topless girl could be of any time.

Being as steeped in European art as you are, you've never actually felt tempted to work in Europe, have you?

No. No, I haven't. As they say about New York, it's a great place to visit but I wouldn't want to live there. No, I never wanted to work outside New York. I like working in New York. I could conceive of painting in Los Angeles. I was in Paris, I guess, for three weeks. That's a long period for me and I didn't feel like doing any artwork and I didn't miss it. It just didn't seem interesting to me. If I was forced to live there I guess I could do it, but it isn't a place I would want to go to paint.

Is this because of the spiritual and social climate of New York being very sympathetic or is it also very much, or even more, that incredible light of New York which does seem to be very much related to the kind of light in your paintings?

I don't know whether it's the light. I think it's the subject matter that turns me on. The people in New York turn me on, the way they wear clothes, etc., their gestures and their clothes, it's specific and I like that. And I like working in Maine because the light is so beautiful, it's completely different to European light. And you have a kind of social freedom in Maine that I wouldn't have in Europe. Maine is sort of really live and let live. It's very uncivilised, it's beer cans all over the place,

people do whatever they want to do. It's not at all socialised.

We talked about light. Do you always paint by daylight or do you paint by nightlight as well?

Well, my paintings are of all different lights and, since the process is empirical, I have to paint at night to paint a night painting, but when I paint the large paintings they're just from sketches and I do that at daylight.

And the portraits?

Well, the same thing. If it's a nightlight I'll paint the sketches at night, but the finished paintings are always by day.

And if you get to the end of the day and the light is going, you wait till tomorrow; you won't put on the electric light?

Definitely not. I will not put on the electric light unless it's a totally freak situation.

And you always have worked by daylight?

Yes, I've always had studios with daylight.

And do you like to have the paintings exhibited by daylight?

Daylight's the best place for them, yes. Daylight's ideal for my paintings.

ROBERT MORRIS

Recorded March 1967 in New York City. The version edited for broadcasting by the BBC remains unpublished. A version edited from the transcript for publication in *Robert Morris* by Michael Compton and David Sylvester, London (Tate Gallery) 1971, is reprinted here with minor revisions.

Robert Morris in *Box for Standing*, 1961.

ROBERT MORRIS 1967

DAVID SYLVESTER *With work such as you're doing, I think it would be supposed* a priori *that that sort of work would give a feeling of otherness and distance and coolness in relation to the person looking at it. Now, I have found with almost all the pieces that the kinds of feelings and muscular sensations that I have in front of them are the sorts that one has in looking at humanist sculpture and painting of the figure – that is to say, a very pronounced sense of one's own body and feelings about extensions of one's own body, the scale of it, all kinds of sensations of this sort referring back to one's body, such as one feels and is meant to feel in front of, say, a Michelangelo. I wonder whether one is meant to feel that in front of your work.*

ROBERT MORRIS I don't know. This is the first time I've ever heard it articulated like this.

Do you feel it at all when you're looking at them?

Well, I feel some relation to my body, naturally. I think the sense of scale that a piece has is always a relation between your body and the object that's external to it. I mean, that is where the scale comes in, it seems to me; you relate it to yourself. And so I'm very aware that these pieces create this kind of situation in which one is aware of one's body at the same time that one is aware of the piece, because I think that is the term that gives it its meaning or gives it its measure in some sense.

For example, I was looking at one of them today, a bit unlike most of the others, this very long flat platform, as it were, about three feet above the ground. And I felt as I looked at it: 'Now I know what flatness really is.' The reason I felt this flatness was that, as I looked at the piece, I felt as if I was lying on it so that I could feel this flatness, as it were, pressed against my body. Now, when you look at them, do you have these sorts of sensations? What is your measure in making them?

Well, I think it's just very intuitive. I can't say. I think the body is involved in the kinds of things that you were talking about in reacting to the pieces.

What makes you feel that one of them works?

Sometimes it's not always apparent to me whether it does or not. It takes a while for me to know. And again sometimes I don't know until I've seen it in different spaces. For example, that piece that was in the back room at Castelli's before the long piece. I've only seen it in rather confined spaces or spaces that I thought were too small for it, and so far I haven't liked it very much, but I don't know whether it works or not. I haven't really looked that long enough. I don't always know if pieces work or not and sometimes I have to wait until I've seen them under different circumstances. I feel that that long one does.

What is it that's working for you about it?

Well, it's easier to say what isn't working about something.

But I mean, is it just a matter of harmonious proportion? Do you find yourself looking at a harmoniously proportioned object you've made and saying, 'Yes, that's beautiful'?

No, I don't think so.

I wouldn't have thought so.

In some cases, you know, you have a more or less specific problem. Sometimes something becomes a problem in the situation. Something's gotten in the way, or something has become a constant too long in the work, or you're too familiar with something, and it obtrudes, or you're aware of it too much and so you want to deal with this. And sometimes I make a piece to deal with this problem and it will be more or less specific in what it does, and then I can say whether it works or not in these terms. But in more general terms, you know, when you're not dealing with something in the work that is specific and that has come up again and

again, then it's much harder for me to say what it is I'm feeling when I make the judgement that it works. In fact, I don't even like that terminology, whether it 'works' or not. It seems to set up a kind of scale or something – or a switch, like it's either on or it's off. And I don't really think about the work that way at all. Sometimes I respond more than at others. But I don't think I often respond in these terms, whether it works or not.

Then what would be the terminology you would like?

Well, for me it's more specific, you know. I've made a piece that permutes. I've done one thing or another and I don't know of anything to replace. I feel that when you say a thing works or doesn't work, it doesn't give you much latitude to talk or to deal with the piece. We can talk about how that big fibreglass piece of 1967, twelve feet square and forty-four inches high, worked in the space because it was compressed maybe. The space was compressed and the piece seemed to function well, and you could see it and it set up certain kinds of responses. But here we're talking about a specific situation. And I think maybe that's more the case, you know: if you say something works at all, it's in terms of something.

Are you saying that what you're interested in doing is in making shapes which in combination have certain possibilities that you don't know about and that those possibilities are interesting and within them something might be found that – well, you've admitted yourself in the end you have to use the word – works?

Yes, yes, I think it's a relationship to a situation.

But are you interested, in the permutable pieces, in creating units which have the widest possible number of permutations, so that as many different possible situations will be created, some of which may work?

Well, there are probably shapes that I could have used that would offer more combinations.

And you didn't?

And I didn't. And say, had I made forms that could have been discrete units in space – most of the units are continuous, you know, they join to each other – I suppose you'd have more combinations there. But I wasn't looking for a situation that would get me a great number of possibilities. I think that it just developed gradually. And in one respect it developed out of the very practical, mundane matter of having to deal with sculpture that's large, because you'd have to make a research to get it through the door. And after I'd done that a few times I realised that you don't always have to put these sections together the way you planned, and that if you vary some of the elements – say, you keep the cross-section and vary the axis – then you get a continuing element that is going to change depending upon what's on either side of it. And so I think the development was gradual and the situation sort of presented itself to me that I might make a series of forms that would have no definite shapes, but rather a set of possible shapes. And I wanted to explore that possibility, and I did, and I'm sure that it can be taken further or you can do different things depending upon the shape and the kind of variables you build into it. But that's about as far as it goes. I wanted to see what I could do. Actually, I started with these wedge-shaped forms and had no idea that I was going to do anything more with them than make wedge-shaped forms, and it was only after they were in the factory that I began to add more and more parts.

When somebody buys one of these permutable pieces, would you wish him to permute the piece according to your instructions as to the possibilities?

Well, that would be up to him, I think. I haven't thought about it. I want to see them in these different positions. I have, and some I prefer more than others. I think there are probably some I haven't yet tried. There are a few that other people have pointed out to me. So that I am still involved with seeing them in these different configurations and I would just assume that, if they had them, then they might change them around too. I would certainly specify which configurations I would consider to be part of a piece. I think there are others that I don't find very acceptable but are possible.

Do you work by sort of doodling round an idea, maybe on paper? Or do you

1967

see the things clearly in your head beforehand, do you actually visualise these sculptures?

I do to some extent. I think that I can visualise the shape pretty easily, sometimes through a drawing, sometimes through a model. What I can never visualise is the specific scale of the piece.

The scale you can't visualise?

No. No, I can't. I can't know what that'll be until the piece is right there sitting in front of me.

But you've got to have the piece manufactured before you see it?

Yes.

And do you sometimes get the scale wrong?

Yes.

And have to have it remade?

Well, I just reject it.

You don't make the same forms on a different scale?

I've never done that. No.

Do these ideas for pieces come to you unbidden, so that you spontaneously visualise something? Or do you find that by thinking about a certain problem solutions arise?

Well, I think that's more like it. You do have these, as I said, sometimes problematic and specific focuses, sometimes a certain form that you keep manipulating and moving around and seeing what it's combinations are. You noticed those drawings I had in the back. They're kind of very fine charts on which I've taken certain cross-sections – round, square,

257

diagonal, quarter-round, half-round – and used those with a certain number of floor plans. In some cases the floor plans are equal to the cross-sections. And you shuffle those together and you get a lot of possibilities, and I might want to make one or two of those.

How did you get involved in making very simple abstract sculptures as against what one might call the neo-Dada early works? Was it a decision or was it simply that you found yourself quite spontaneously evolving that way?

Well, in the beginning I was doing both things at the same time. I was making objects that were involved with some kind of process or literary idea of history or state that an object might have other than just that visual one. And at the same time I was making these plywood forms. And they seemed to go along together for a while. Then I just lost interest, I guess you have to say, in the things that dealt with information.

In that kind of work there are often – in the tradition of Duchamp and Johns – paradoxes, jokes, etc., etc. Are there paradoxes in these, what one might call, abstract works?

I don't think of them having that quality. So far as the material that I work with is concerned, it doesn't seem to arrange itself in those terms. No.

Are these works asking questions about what is sculpture? Or are they simply the sculptures that you want to make?

No, I don't think they're dealing at all with that idea of a limit, questioning sculpture.

Do you think that some of the other artists doing minimal sculpture are concerned with such questions?

I doubt it. I think they're all pretty convinced that what they're making is art. They may not call it sculpture.

You don't think there's a matter of a kind of assertion: 'this too can be art'?

Well, I think that we've gone through about fifty years of that kind of thing now and I think artists are aware of the latitude of attitude that has entered into making art; that's not very central any more. Art, I think, has to be defined as anything that's used as art; it's a conventional definition. And that's the way it's accepted, and so I think artists are aware of this, and that kind of protest art or questioning art is not relevant any more. It used to be more complex; it was, maybe, at one point.

Until quite recently perhaps.

Possibly, yes.

Such concerns have been attributed to artists doing the kind of thing that you're doing.

Probably, yes. They have been, yes.

I wouldn't have thought that it was true of you, and you don't think it's true of anybody else?

Well, I don't really know; I can't say. Certainly, people when I first started showing – people who were quite articulate and conversant with even things similar to mine – were saying it doesn't look like art. But I don't think that I was involved in that kind of issue.

I get the feeling, and I don't know what the mechanics are which give me this feeling, that your work is not so much concerned with making objects that are absorbing to look at as such, but rather that you want to make something which makes one very conscious of one's relation to that thing you have made – in other words, that you're concerned with the relation between the spectator and the object rather than with the object itself as a self-sufficient entity, which I think, say, Brancusi was. Do you think that that is so?

Well, I can only say that I think that the work is less introverted than something like Brancusi. It seems more open and more extroverted, in some way makes one more aware maybe of oneself. But for me it doesn't go to the point of being environment. You know, it's like these polarities.

I just don't think that there's the right kind of language to use: that it's either an object or it's an environment – that, if you slip out of the compact introverted focus, then you're in an environment. I can't accept that either.

I hasten to say in my own defence that I didn't use that word 'environment'.

I know you didn't, and I'm not saying that you're implying it either. But I just find that very hard to talk about. I don't quite know what terms to use.

Is it a confrontation?

No, no more than any art.

What am I looking at when I look at one of your works? Simply a large object made of geometric shapes? Is this what I'm looking at?

Well, that's certainly one of the things. I think this whole question of whether it's art or not has been asked because I'm not sure that what I'm doing, what a few other people are doing, has any real legitimate connection to past art. I mean, it's still used as art, it's still focused on as art, it's still meant as art. But it seems to me that there's a kind of order involved in this art that is not an art order. It's an order of made things that is pretty basic to how things have been made for a very very long time. It's those kind of things in the art maybe that make it seem less like art than art was before. I think as an image it doesn't refer to past art but to manufactured objects: it doesn't try and imitate manufactured objects, but it's more like some of the aspects of manufactured objects or made things. The clearest example I suppose you could cite would be the kind of ordering and object quality that you get in maybe bricks and in the way bricks are used – you know, the cubic form and the right-angled grid. It's a kind of unit in a syntax that has been in the culture since the Stone Age, I suppose, and it's still very basic to industrial-type manufacturing – standardisation and repetition and repeatability, the wholeness of a part that can be extended. I think it's this kind of thing that much of the art is tied to and not to the past order of art. So that's why it seems

discontinuous. And I think that a great deal of the order that I'm speaking about has already been explored in painting.

In, for example, Stella?

In Stella's work, yes. The idea of the grid, the symmetry, the non-hierarchic – this kind of ordering has been indicated by painting. But this work that I'm involved in carries it into the object, and this is the kind of object that we see around us here. I mean, that box over there, the window, the way such things are made. Some of the allusions that this art has are to the way things are made – to a kind of forming that's in the culture, I think.

If somebody comes along as I do and tells you that in front of the work he feels the kind of feelings that one may feel in front of humanist art, of figure sculpture, do you find this disconcerting?

No. I don't quite know what to make of it, though. I'm interested to know more specifically maybe the kinds of responses that would be parallel in the two cases.

Well, one is very conscious of oneself standing there. One feels very conscious of every nerve in one's body from top to toe, one feels sensation in one's muscles and one's shoulder blades, not perhaps in one's hands; above all in one's body rather than in one's limbs. One feels oneself very intensely and one feels one's scale in relation to that of the work. And one feels too as if one's scale were changing, sometimes becoming larger, sometimes becoming smaller. Exactly as one might feel with certain classical sculpture.

I do feel that kind of thing with early classic sculpture, I suppose. That's where I feel it strongest. Maybe it was the most immediate kind of experience I had when I started to study.

As a matter of fact, I can think of a specific work which for me produces very similar sensations to your work – the west pediment of the Temple of Zeus at Olympia.

Well, I think there's a kind of full volumetric quality you get in both things. That's quite true.

When you talk about responding to early classical sculpture, do you mean the Parthenon as well as Olympia?

Olympia, not the Parthenon. It seems simpler, clearer, less concerned with over-refinement.

Which pediment do you prefer?

The one with the Apollo figure in it pointing, whichever one that is.

The west. What is it that you like about it?

Well, I like the immediacy and the fullness of it. It seems to state itself very fully as stone, as rounded forms. It doesn't seem to me to get to that point where even classic sculpture gets where it's attempting to transcend its medium in some way. I don't feel that so much about that early classic work. That's part of it, but I don't really know. I just have a very strong response to it.

So you're making art?

Definitely.

About scale, how does this work for you when you're planning a piece?

I take a chance and make it a certain size, and I won't know if that'll be right until I actually look at it. There's no way I can calculate that. I can't imagine it like I can very clearly imagine a shape or even a surface with a colour, but I cannot imagine scale. And so I guess – that's all. There are certain limits within which I work in terms of scale: I don't want the thing to be enormously big, I don't want it to be oppressive and overwhelm you. Generally I don't make it over the size of the body in terms of height, so it won't bear down on you. I don't make it so that you can walk into it, like a piece of architecture. I don't make it small enough

that you can hold it and it becomes, I feel, too intimate. So there are limits, there is a range within which I work. But other than just having those limits, I guess.

As an epigraph to an article you wrote, you quoted from an interview with Tony Smith: 'Why didn't you make it larger so that it would loom over the observer?'; 'I was not making a monument'; 'Then why didn't you make it smaller so that the observer could see over the top?'; 'I was not making an object'. The piece in question was his six-foot steel cube. Smith was thinking along the same lines as you. He wanted to make a cube that was the height of a man.

I guess so, yes.

In what ways do you feel that your approach is like and unlike Tony Smith's?

Well, I feel that that cube is maybe for me the piece that I feel closest to in my own work because it does share that kind of calculation of scale. I don't feel terribly related to most of the other work that's larger and that one can walk through or that's higher than one or that twists around in space and sets up some relationships within itself in a way that my work does not. I chose that cube because I feel related to that and I like that very much.

Why don't you want the parts in your work to be varied?

Well, I don't want the situation where there is composition. I want the piece to have a wholeness which symmetry does better than asymmetry for me. That's why. It's more immediate. It's more direct.

Traditionally symmetry in sculpture is linked with frontality. Now, with your work it's quite precisely not.

No.

On the contrary, because it is not a symmetry in one plane, but a symmetry

in four planes, so to speak, it actually means that the work has no front, no back.

That's right, yes. Sometimes it has an inside and an outside, though.

What happens then, of course, because the middle is usually empty and shows the floor, is that there's a very acute relationship between the outside shape and the inside shape – between the inside of the form that is on the far side and the outside of the form that is on the near side.

Yes, it does that. And there's another thing it does in these pieces that I really am just seeing for the first time, since there was no space where I could set them up before. With some of the larger configurations of that permuting piece with eight sort of wedge shapes. I found in photographing them that the only photograph that I wanted to take really was one from almost directly above. That seemed to me the only one that read most clearly as a shape, because, from the side, if you're any distance at all away from the piece, you can't see the inside. So you see an outside wall which is big enough and has a certain kind of configuration involving some of those curves – at least in the way it's set up now – so that you're not really sure of what the shape is. I keep walking around it as though I can never convince myself of what that shape really is, until I get up and I look over and see the floor and there on a smaller scale is the floor plan very clearly presented. So that I think that the experience of the outside being away from it is very different from going up close and looking down into the piece, and this is something new for me. I hadn't thought about that before.

That piece is something like a bear-pit. You get a wall at the outside which, as it were, keeps you away. Then, inside, the thing is coming down with concave shapes which almost give you a sensation of falling. Right? As if it was something you could slide down. But you're kept away from this by the wall which is keeping you away and which comes up to somewhere around the middle of your chest. So that you at the same time feel threatened by the height of the wall, which is a barrier to getting at the thing, and, on the other hand, feel threatened by the possibility of sliding down those sides if you did get near it. I don't know whether thoughts of this kind come

to you in inventing these sculptures.

No, those particular thoughts don't. I don't think of them, say, in terms of any kind of threat or don't think of them in those psychological terms. But I do think of them as having this difference between what one sees away from them and what one sees closer. I didn't anticipate it would be as strong as it was, separate, one from the other. Given that the body has to move around the piece to see it all, it's all very much a kind of a constant thing I've known for a long time about pieces of this size, that you see it and you know it. You see a shape – these kinds of shapes with the kind of symmetry they have – you see it, you believe you know it, but you never see what you know, because you always see the distortion and it seems that you know in the plan view. I know that ashtray in plan view somehow, I know it that way, I believe it that way, but I don't see it that way. This round table: I'm convinced of its roundness, that every part of this shape can be described by the end of the radius; and yet, from every position except when directly overhead, I'm going to see it as an ellipse. And I think this thing happens in this work, in a lot of work. It is something that one has to work with if you're going to use symmetrical shapes. And when you force a big shape, when you expand a big shape, then maybe it becomes intensified, this difference, in some way.

What would that intensification mean?

Well, I think one of the things it means is that one keeps moving around in looking at the piece, that you're constantly seeing something different. Perhaps that's what it means, that you are more aware that it's always different from each position, that you're always seeing something different each time you move. Whereas this table is small enough that I don't have to really remark on the event that it's an ellipse. Maybe that's it. Some of these pieces, they cause you to feel very concrete about what you're seeing at the moment and from whatever position you're seeing it.

Wouldn't this possibly be the missing term between the elements in that dichotomy that you objected to before, between the contemplation of a compact object and the idea of the sculpture as environment? Wouldn't what you're talking about be the nature of this relation between the

object and the spectator?

Yes, maybe it does get into that area. I think it does, yes.

When you talk about the experience, you make its interest sound much more a matter of intellectual curiosity than it is in front of the work.

Well, possibly because just in speaking of it, it makes it seem that way.

How far do you feel that the basis of the effectiveness of the work is rational? Obviously, when one talks about art, one cannot speak of that which is most important about it.

Yes.

At the same time, an artist may feel that what is important about his work is rationally based or he may feel that it's irrationally based, and a lot of abstract artists have persuaded themselves, rightly or wrongly, that their work was rationally based.

Well, I don't think the kinds of things we've talked about, such as this difference in seeing and the fact that one knows what it is, are terribly central to the work. Or that what you can say in these terms is, as you've pointed out, really that way when you're there in front of the piece. It's something that I've only thought about after I've made a great deal of work. It isn't anything that I find is useful in programmes in any way. And so the degree to which one can be rational about work is, it seems to me, as I said before, only in those incidental ways where you find something becoming problematic. But, so far as just making work and your whole involvement with it goes, it's not programmatic for me, not rational.

You are saying that what really matters about the work is irrational and can't be accounted for?

I guess finally I'd have to say that, yes, because nothing I can say about it seems satisfactory.

1967

You're one of those artists working today who have a great admiration for Barnett Newman. Newman sees his work as having some kind of metaphysical meaning. Do you see yours as having a metaphysical meaning?

I don't think so. No, I don't think so. I think it has implications of one sort or another, but I don't think of it in the terms Barnett Newman uses when he talks about his work as having the kind of transcendental qualities he attributes to it.

What is it you've got from Newman?

Oh, there's a lot of things in the work, I think. A certain sense of rigour and yet openness at the same time. A set of limits and yet no compulsive adherence to these; they don't seem to restrict his range. A real sense of immediacy, the greatest sense of immediacy of any painting that I have experienced. The least allusive painting, the least metaphysical painting for me, the most direct. And his scale and his imagery, I think, are important to a lot of people, including myself.

Your works are untitled, with a few exceptions. Even the neo-Dada pieces are more often than not untitled. Is the reason for this that you don't want to pin down, or think you can pin down in any way, what the work might be about – that you feel this really must be allowed to look after itself?

No, I don't think that's it at all. I think that the reason I don't title them is that I don't think the work is about allusions. And I think titles always are. And I think the work is very much about *that* thing there in the space, quite literally. And titles seem to me always to have some allusion to what the thing isn't, and that's why I avoid titles.

Do you ever, in fact, find that ideas for works might be set off quite obliquely by actual things that you've seen in reality?

Well, I think that's probably true. I'm impressed by a lot of things I see: in industry, for example. And certainly, the more you have things made, the more you go into fabrication, the more feedback you get from the processes and the materials and methods that you see in these factories.

And that suggests things to you. So that you're constantly responding to all these shapes you see around you, and that has an effect, and it goes into the work.

Inasmuch as there are *stimuli they are man-made objects?*

Yes. Yes.

Never natural objects?

No. No. I don't feel any response to natural objects. I mean as far as making art goes. Not that I don't like nature, especially the West. But I don't think it gets into the work very much.

You talked before about a scale which is in a sense a human scale, because it's neither intimate, something one could handle, nor is it monumental, something which looms up over one. But one also tends to feel, as with a lot of good sculpture, that it seems to be larger than it is. One has this illusion, though, while also being very strongly aware of its real size as a function of human scale. Do you see it as seeming larger than it is?

I don't know if I am too aware of that. That may have to do with the fact that I handle the work so much. I know precisely where it is and I'm so concerned with all of the difficulties of placing it and getting it level, I tend to be pretty assured all the time of its limits. But I'm constantly thinking about the room and how much space it has. So it may be that that is a visual possibility that I've eliminated for myself, because of all of the concerns I have to have about its getting there and being in a space.

I take it that you do not want the relationship between the spectator and the works to be dramatic?

No, not especially so.

Do you want it not to be?

Not especially so. Because that's kind of a term where, if you say you do,

well then it's one thing; if you say you don't, well then all right, then is it going to be boring? I don't want it to be specially dramatic. I don't want it to have a kind of boring passivity either. Generally it's a term that I would prefer not to have to deal with.

Do you want the spectator always to retain an awareness that he is looking at something?

Rather than what?

Rather than to lose himself in its impact.

I don't know. I'm always aware of that thing there in front of me. It's not a matter of being lost. I'm very much aware, myself, of the specific thing there. And I find it hard to imagine a situation where people would somehow lose the edge of the thing or not be aware of where it left off and the space began.

I mean emotionally rather than visually.

Well, I think sometimes I feel just the kind of presence of these things without really looking at them, if that's what you mean. I can do that too. I can be in the same room and not be especially attuned to them, and I like that situation too, I guess. They don't have to demand my attention always. That's a kind of relation I had not thought about much until this point, but it's one which I have because I'm round the pieces a lot. I find that I like that situation with the work. I don't have to attend to it, and yet it's there. That may not be the same as what you're saying.

I don't think it is quite the same. I'm not quite sure what I do mean. A thing which I often feel in looking at the work is that in its relation to my scale it suggests the possibility of certain extensions of my own limbs: for example, I feel that it's horizontal dimensions often relate to my reach, the possible extent of my reach. Does this mean anything to you?

No, I can't say that it does. But all of these things that you touched on, I think are very much in the work – the whole idea of the body being in

some sense a measure of the work. But specifically that particular thing, no. Or even other more or less anthropomorphic identifications, no. But the fact of the body, fact of the work reflecting back to the body, its scale, and that in turn reflecting the scale of the work to the person is very much, I think, a feature of seeing it, experiencing it. But this is not in terms of any specific anthropomorphic kinds of equivalents in the work for the body in any way.

It certainly excludes anything anthropomorphic in the sense of any reference to bodily form, except, I suppose, at an unconscious level. So far as one's conscious apprehension of it is concerned, there's nothing anthropomorphic about it. But there is precisely this reflecting back that you talk about. It's exactly a phrase which I've used for myself in looking at the work: 'somehow this is reflecting my scale back'. But what is happening? What is happening?

I don't know – you tell *me*. It's something that's very hard to talk about. I can't talk about it.

I'm sure it's what the work is really about. And I'm sure it's what gives the work its value. This feeling that one's body is intensely related to a form utterly unlike it – a manufactured looking form, totally regular in shape, totally symmetrical, assembled, abstract, which seem in some mysterious way to reflect oneself. And it is surely because it is so different that any reflection it might have is very poignant. But what is it that can make such a reflection occur?

I don't know.

But you would wish it to occur?

Well, I think it's one of the terms that seems to be in the work, this kind of reflection. We've talked about some of the things that make it occur, I guess, the particular scale and orientation of the piece, height and even maybe some of the particular morphology of the thing. But other than that I don't know what I would say.

Since nothing is more important to all this than scale, it interests me very

much that you said before that you can visualise the shapes clearly and you can't visualise the scale beforehand. How often do you have to reject a piece because the scale turns out to be wrong?

Well, certainly not more than half the time.

It's as much as that?

Less, probably. There may be other things wrong with the work that I don't like and that cause me to reject it, but so far as the scale goes I think maybe less than half the time.

What makes you feel the scale is wrong? Can you rationalise it at all?

No. And sometimes it really isn't even the scale that's wrong, it's the room that's wrong. In fact when I really think about it I don't know if there are any pieces that I've rejected because the scale was wrong, but that other things seemed unsatisfactory about them. I've never thought about it. I just hate to take the arrogant position that I've never been wrong about scale but I really can't think of pieces now that I've rejected because the scale was wrong.

CARL ANDRE

Recorded August 2000 in London. Edited for publication here.

CARL ANDRE 2000

DAVID SYLVESTER *You've said quite a lot at different times about experiences that have had a crucial effect on your work, like visiting Stonehenge and canoeing in New Hampshire and working on the Pennsylvania Railway as a brakeman. And those experiences you've talked about tend to have happened out of doors. Do you find that significant?*

CARL ANDRE Well, it's very strange, because I am not an outdoorsman, so those great experiences were unusual for me. I'm not a Richard Long, quite the opposite. I've said that in a way Richard Long, whose work I tremendously admire, has taken the modernist sensibility and taken it into nature, whereas I feel I've taken the neolithic experience, if you will, and brought it into the gallery. We deal with the same challenge, but I'm the converse to Richard Long.

Can you think, then, of particular indoor experiences that have had the same kind of crucial effect upon your work as Stonehenge?

Going into the Pantheon in Rome for the first time. Every time I have repeated that experience it has happened again. It's such a strange building, because, with the great oculus in the ceiling, the outer world is constantly pouring into the space.

What other architectural experiences have been crucial?

For years I had a recurring dream that I was in the bottom of a great granite quarry as part of a procession. Now Quincy, Massachusetts, does have great abandoned granite quarries, but I couldn't remember any circumstances in which I would have been in a procession in a granite quarry. And then it came to me that it must have been my christening when I was a baby in arms. It was done at the Bethany Congregational Church, which was in an imitation English vertical Gothic style. It had beautiful arches, hammer-beam arches, over it and stone walls, and I'm sure that that was my first out-of-the-house experience – being taken to

275

church and being with people before a baptismal font. Once I said to myself that must have been the origin, I never had that dream again. I don't know whether this has any validity, but I believe that a great part of dreaming is from experiences we had before we acquired language, so that we have a vivid remnant or fossil of an experience in the mind but can't name it, and so it keeps on coming back. Several times I've had dreams and when I could name what they were truly about, I never had that dream again.

Did you feel any relation between that dream and certain forms that you've made or put together?

Not really, but as a very small child I was always around building sites, because my uncle and my grandfather had been Swedish contractors and bricklayers, and they socialised with the Swedish carpenters and bricklayers, those were their pals. During workdays I remember going around with my uncle to his various construction sites and walking around houses being built, gas stations being built, things like that, and also on building sites when there was no work going on after working hours and playing in situations like that. So I did not have a childhood of the white-collar class at all. That's probably the reason that conceptualism doesn't appeal to me in any way, because my father's work and my male relatives' work and their friends' work was not paperwork. My father did plans for ships' plumbing, but it was a material relationship, it was not a linguistic relationship. As you know, I have been writing poetry a lot longer than I have consciously been doing sculpture. I suppose that's why for me, as I said the other day, if you can put it in a fortune cookie it can't be art.

I find that certain works of yours can make me acutely aware of the process of their assembly, whereas a sculpture by Judd or Sol Lewitt keeps the attention focused on the finished fact. Would you agree?

Well, that's true, because they have their work fabricated by others. I have my parts fabricated by others, but I always put together my works myself, at least initially. I think a test of my work is whether my pleasure in putting it together, which is very real, is conveyed by the work itself. I

think all great works of art convey the ecstatic pleasure of their creators. I think a lot of people don't catch that sense of my pleasure in doing the work. But kids do. Little kids – under the age of six, certainly before they can read and write – know the pleasure of putting blocks together. They do it all the time, and they can sense the pleasure that was had in making the work come into being. I'm not the only artist who has agreed to this, that when I'm working well and putting a work together in a just way, there comes a moment when, after you've warmed up in it, you just feel at one with the task, there's no difference between you and the blocks and moving them around, or the place and whatever, and that's a great feeling.

That feeling of excitement that you have in putting it together comes over so strongly to me that it tempts me to ask you if, when you are putting oblong blocks of wood together, you sometimes feel as if you are putting living bodies together.

Never, no. I love joining with human bodies, but that's a different experience. With wood, of course, the wood never really dies, because the cell structure is always changing as to humidity and heat. So in one sense the wood remains alive, perhaps because it's changing its dimension. But no, to me it's grander than that, because I'm relating to the cosmos, the material cosmos. I feel much more related through assembling a work to the universe of matter: that's what I join to, not another body. That sounds rather grandiose.

No, it doesn't sound grandiose.

Well, of course, in a certain sense I am becoming a force in nature. As the stream runs through a mountain and wears down a groove, I'm assembling things as they have never been assembled before.

When I look at your wood pieces I never think of all the furniture that's ever been made; I think of trees.

Well, I'm very happy about that, yes. There was the famous *Primary Structures* show in 1966 at the Jewish Museum in New York; it's still the

only Minimal art show that's ever been in a museum in America. And Kenneth Snelsen, who is a brilliant sculptor, said about the show that there were almost no structures in it, and particularly not mine. That was *Lever*, the row of one hundred and thirty-seven firebricks, and he said that cannot be a structure because the parts are not rigidly joined together and the basis of structure is joining parts rigidly together. I said that's absolutely right. So I don't make structures, but the wooden pieces tend to be the most structural looking of my works.

You once said to me that if anything is worth doing it's worth doing again and again and again.

I have the same attitude towards restaurants; there are about half a dozen restaurants in New York that I will go to. Everyone accuses me of having a very narrow range as an artist and I do indeed, and I feel my range becoming narrower. I feel the years have honed me to a sharper and sharper edge with my work and I find that this narrowing, this sharpening, this honing, is a gratifying experience. There are foxes and there are hedgehogs, as you know from Archilochus, the Greek poet, who told us about how the fox knows many things, the hedgehog knows one thing very well. When I met Frank Stella in 1958, he was very much a fox pretending to be a hedgehog, and I was very much a hedgehog with a delusion that I was a fox. It took me quite a while to realise that I was a hedgehog and no fox at all.

You are a hedgehog, but I would still say that the difference between your wood pieces and your metal pieces is as big as the difference between the wood pieces and the polished pieces – whether metal or marble – of that prototypal hedgehog, Brancusi, and that, because of that substantial contrast, your range is not all that narrow.

Yes, well that has a great deal to do with the range of the possibilities of the materials themselves, which is what my work is really about. I didn't really know that when I began; I just carried on the fascination of the materials that I had inherited from my father. And one thing that is certainly true about my work, it's very conservative because I have retained in the work the experience of materials that have largely

disappeared from the world, such as copper – as in copper pans and kettles – and I like that. And actually I think materials are richer in properties than colours are. Colour is only one of the properties of matter, whereas there are so many other properties that one can display and develop and bring out. I've never in my life made a mark on a canvas that I could believe in. When I started doing art seriously in 1951, at Phillips Academy, Andover, it was the first time I was ever in a studio, the first time I ever used oil paint. I painted away – there was no other option at that time. When I learned about Clement Greenberg praising flat painting, I was tremendously amused, as I had never been able to do anything but a flat painting. You have to have some gift for painting to make paintings that aren't flat. My making a mark on a canvas has never convinced me. Moving a brick from one side of a room to another, that convinces me. I know I've done something when I've done that.

By the way, about the bricks: I talked before about Brancusi's polished marble sculptures; I didn't mention his limestone sculptures. And I see your bricks as the equivalent of those, even though the bricks are cast forms, like the metal tiles. So I see them as occupying an analogous place in your work to the limestone carvings in Brancusi's.

I would say that. Yes, like the sand-lime bricks which I used to make the original *Equivalents* first shown in New York in 1966. [*Equivalent VIII* in the Tate is a firebrick reconstruction.] Sand-lime bricks are an artificial limestone made by mixing sand and lime in moulds and subjecting that to high-pressure, superheated steam. That fuses the lime and the sand into an artificial limestone, very much like the limestone that Brancusi used, except, of course, it is man-made.

There's a work of yours which I find particularly moving, which is called Fall. *I don't know how many other pieces of yours there are in metal which are set both against the wall and on the floor and make an L-shape.*

Certainly, that's the only large one. I never did another one that is fabricated by taking metal plates and bending them. And that is certainly the only large sculpture I've ever done that was directly inspired by a painting, and it was a painting I loved very much in the Museum of Fine

Arts in Boston. It's a very large oil sketch by Manet for *The Execution of Maximilian*. The final version of the painting was not allowed to be shown while Louis Napoleon was in power because it was about killing European royalty in Mexico. It was cut up in pieces after Manet's death. The surviving oil sketch by Manet is very large, and Maximilian and his companions are very close to the soldiers shooting, so you have the rifles and the muskets of the soldiers making an angle, the horizontal muskets, the vertical bodies of the firing squad. Then you have the vertical bodies of Maximilian and his henchmen, who are being executed, tied to posts. Then you have the ground. *Fall* was my L-shaped completion of the soldiers and the rifles and Maximilian and the ground. I began to be deeply moved by that when I was about five or six years old. There was another beautiful oil sketch that I liked very much, by Daumier. It's a sketch of a man climbing a rope in a studio, done almost like a Futurist work. Daumier is an artist I love, a wonderful sculptor – those little busts that he made so that he could continue his caricatures from one week to the next.

I think it was Balzac who said that Daumier was a true son of Michelangelo, and that's very true. Daumier is a painter who was essentially a sculptor.

It's so much like Michelangelo's fresco paintings, they're really quite similar. I've never thought of that.

It's very haptic, and I think that is probably what Balzac meant.

Yes, absolutely.

There's a question which is in a way a cheating question, in that I am really asking you to do my job.

Good.

It seems that certain critics see your work as not so much aesthetic as ideological, as being primarily the embodiment of some ethical or social message. For me, your work is as physical in effect as Brancusi's. I cannot see you in any way as a conceptual artist.

That I agree to entirely.

But the physical impact of your work is easy to understand, when the work has a palpably imposing presence, as it does in Pyramus and Thisbe *or 25* Cedar Scatter, *but it happens just as powerfully in floor pieces of metal squares like the* 44 Roaring 40s *or the* 144 Tin Squares. *Now, I know that an art as reductive as Newman's can be physically overwhelming, but Newman's is an art which stands up and confronts you. These pieces of yours are so modest they almost disappear into the floor, and I am left totally mystified why they can take me over as they do.*

Well, for one thing I do employ a dimension or a position that had not commonly been used in this century for art – that is, the horizontal plane. When I first showed work in New York, people would come into the gallery, look around, see there was nothing on the walls and say, 'I'll come back after it's installed.' Of course, when you told them, 'You're standing in the middle of the work', they would look down and leap up and run out even faster. I was just lucky.

It was a great period, the sixties. The amount of originality which you on the one hand and Oldenburg on the other brought to sculpture was fabulous.

But there were a lot of people doing that. Smithson and Judd and Morris and Flavin. A diagonal Flavin in a room is about as powerful as a work of art can get. I think there is a plain, obvious simple reason that no one seems to be willing to admit. Everybody says, what is it about the sixties that made this possible? It wasn't anything about the sixties, it was about the thirties, the forties and the fifties. We are the sum of our pasts, not the sum of our presents. And all of us were raised before television. I think that's such a key point. Because we were raised before television, before organised games for children. It's true that we always went out and organised our own games and we learned our games from the slightly older children. You learned how to be responsible and kids learned about *justice* from playing games which they were inventing and composing and making the rules for. I don't know if Britain is oppressed with it, but in the US adults now want to organise all their children's activities, allegedly to protect them, and I suppose that's right. We were feral children, we

ran everywhere over our neighbourhood and in the swamps and so-called islands and mounds that were around it. Melissa Kretschmer, my wonderful friend and brilliant artist, had the same kind of childhood in Pacific Palisades. They used to run through the Will Rogers State Park all day long, and nobody worried about paedophiles or such things at that time. Occasionally there would be a great tragedy and some little child would be destroyed by some deranged person, but it was very very rare and nobody went into riots about it. It was a different era, a much freer era in many many ways, certainly free of television. And there was not nearly so much conformity. We live in an age of much greater conformity now than even the derided fifties. I always felt in the fifties, if you paid your dues, your tuppence to appearances, you could do anything you wanted to. William Burroughs said that, of course. He was very proud of his banker's drag. He could dress up in a three-piece suit and go to a club with anyone and outclub them all. Now you must be sincere, you must show your inner self to everyone, and your appearance must be absolutely consistent with your inner reality, and that's an impossibility. You lose your internal reality if your external appearance is the same. We were a product of our time including the Second World War. In the United States we didn't have any bombing, we didn't have any of that domestic hardship that Britain had with death, destruction, shortage. But we did have a great sense of uniting for a national purpose. That's an enormous experience to go through as a young child.

You know what Oldenburg said about everything he did having been made up when he was a little kid.

That's his great line, I love that. You ask, 'Claes, where did all those great ideas come from?' and he says, 'I made it all up when I was a kid'. And of course Henry Moore said the work of art is to recover the vividness of our earliest experiences. I feel I haven't learned anything since the age of five. My work has nothing to do with language, but the most important work a human child does is acquire language. That is one of our most complex accomplishments. Calculus is nothing as compared to acquiring a language. And almost every human being does it, and at certain ages when the wiring is fresh and still malleable in the brain they do it quite well and they love to do it. A three-year-old child can make up a sentence

that nobody has ever heard before. It's good to keep that in mind, I think.

Speaking of the sixties, what personal contact did you have with other Minimalist sculptors?

None. I did not see works by Judd and Morris until I was in a show with them at the Tibor de Nagy Gallery which opened in January 1965. I had more or less stopped making work seriously. I first started to make sculpture in 1958, just as I happened to meet Frank Stella. Then I had two years of intense making of sculpture. I couldn't do multiple timber pieces because I could only scavenge individual timbers in the street. To get sets of timbers you had to go to a mill and I had no money for that. Only a few people saw what I was doing. Between 1960 and 1964 I worked on the Pennsylvania Railroad because I had to support myself. I worked on the railroad, and that's where I got my advanced degree in sculpture. Some people in 1964, after Judd and Morris and those people began to show, came looking for me, because they said, 'You're a Minimalist, didn't you know you were a Minimalist?' And Henry Geldzahler and Frank Stella put me in the show called *Shape and Structure* in January 1965. It was really the first time I saw Morris and Judd. Actually I had seen some works of Morris because Hollis Frampton had taken photographs of them. Those photographs were very interesting because they were of things that I had thought about doing and decided: Well, that guy's doing that stuff, fine! That's something I don't have to do. I admired tremendously the work of David Smith, the welding, but I knew I never wanted to do any work like that. That didn't diminish my admiration. It's wonderful when whole great avenues are blocked off for you by giants because you have to find your own little corner. Then I got a chance to start working again, and there was an ambience. You can't do things before their time, people just can't see them except for a very few. Frank saw them and said that I could carve in his studio when he wasn't there. There would be scraps of canvas around and some paint and I would daub on the canvas, and this infuriated Frank. He said, 'Carl, if you do that again I'm going to cut off your hands', and Frank being Mediterranean, you're never sure what's going to happen. Although he had a very even temperament, he had his work to do. I said, 'Frank, couldn't I be a good painter?', and he said 'No'. I said 'Why?' 'Because

you're a good sculptor now.' And it was true. I'd never truly painted because of a lack of conviction and gift; conviction comes from gift. Frank was a great, great model, because he was becoming a fully mature, a fully masterful, artist. When I saw that, I realised the job he had in front of him. He demanded that other people had to do that too, and he wouldn't handle any bullshit. What Frank forced me to do was to separate the linguistic from the haptic, visual, spatial areas of the brain. They're different areas. They really are. That's why I repeat myself: 'If you can put it in a fortune cookie it isn't art.' The visual arts are about a material intervention in the world that creates a relationship, an erotic relationship with others. Art is an erotic relationship with the material world which can be shared with others. I've said for many many years that all art is erotic, even the worst of it. Just imagine what that tells us about the human psyche. Another thing that people don't understand is that my work is done entirely out of the need and the delight in pleasure. I think that in our civilisation, our culture, certainly in the United States, which I know far better than Britain, there is a crisis, a collapse of the civilisation. The difference between savagery and civilisation is the management of pleasure. That's really what all art is about, all great art. Tragedy is deeply about the management of pleasure, the whole violation/purgation aspect of tragedy that Nietzsche wrote about. Almost every tragedy is some desperate mismanagement of pleasure.

Oedipus *is a rather good example.*

It's a perfect example. For instance, the Nancy Reagan campaign against drugs, 'Just Say No', to America's children. That is not the management of pleasure. Denial is not, because immediately you have the return of the repressed in a form far worse than that which has been repressed. There's a deep hypocrisy at the core of American life, as there is in the life of every puritanical person: they're obsessed with what they deny, and that rots the soul. I also think that the association of reproduction, for instance, with evil and sin is one of the most corrupting associations that there can possibly be. We cannot accept the carnality and joy of our own personal creation, of the creation of ourselves.

What role in this drama is played by conceptual art?

Well, I think conceptual art arises, to a great extent, from the legalisation of society; things are forbidden rather than managed. Conceptual art is the final conquest of art by the bourgeoisie because the bourgeoisie have always conquered by turning everything into words. Remember in the *ancien régime* in France you had the nobles of the sword and the nobles of the robe. Well, it was not Robespierre, it was the nobles of the robe who defeated the nobles of the sword with words, with laws and writs, with lawsuits, with edicts, with rhetoric and all such. For me the final triumphant capitalisation of art is conceptual art, because it's nothing but a piece of paper, and the bourgeoisie rule through paper. I remember in the army a great old grizzled master-sergeant. We were just bullshitting one day and he said to me: 'Andre, you talk like a man with a paper asshole.' You don't often hear Homeric epithets but that one is: 'Andre, you talk like a man with a paper asshole.'

RICHARD SERRA

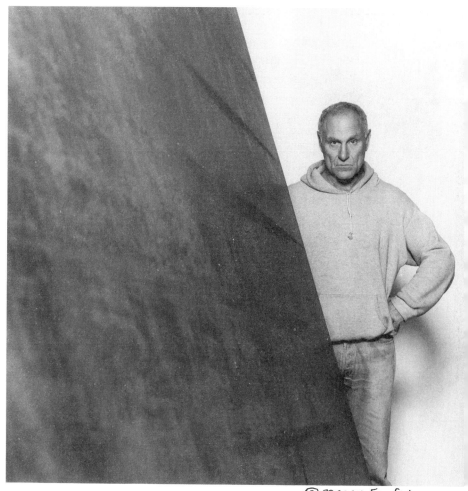

A tripartite interview about the artist's series of *Torqued Ellipses* at different stages in its realisation. The first two sections were recorded in April and September 1997 in New York City, the third in April 1999 at Bilbao. The first two were edited for publication in *Richard Serra: Sculpture 1985–1998*, Los Angeles (Museum of Contemporary Art) 1998, the third in *Modern Painters*, Autumn 1999, and those versions are reprinted here.

An earlier interview, with Nicholas Serota as co-interviewer, was recorded May 1992 in London and edited for publication in *Richard Serra: Weight and Measure 1992*, London (Tate Gallery) 1992.

Richard Serra at Pace Gallery, New York, 1989. Photograph by Nancy Lee Katz.

RICHARD SERRA 1997–99

I

DAVID SYLVESTER *The structures which I went to see the other day – out of doors, not indoors, as you mean them to be seen – are something totally new in sculpture. It would be very helpful if you were to give a physical description of them.*

RICHARD SERRA What they are are vessels that you walk into. There is one opening. And the vessel is made from a piece of steel that has been bent under a tremendous amount of compression to form a continuous skin so that this, as it encircles an elliptical form, continuously either leans out or leans in. When you stand inside the vessel, the shape on the floor would be similar to a Borromini ellipse. We'll just talk about one piece in particular.

The space overhead would be the Borromini ellipse open to the sky. This means that the vessel or skin surrounding the shape, in order to form the ellipse as it rotates upward, has to bend continuously on its curvature, either inward or outward. So there's never a vertical line in the sculpture in terms of its surrounding topology. If these things are anything, they're probably topological deformations.

They're not conical, in that the radius doesn't change, as it either elevates or elongates. So, it's not the same as a lampshade or a flower pot. You have to think of an ellipse on the ground, not changing its form whatsoever, rotating as it evolves upward, either at a 55-degree angle to itself or at a right angle to itself. Or one of them is at a 70-degree angle to itself. So the form has a torque in it, so to speak. And because the form has a torque in it, it's either constantly leaning over your head or away from your arm's length. So that the piece either falls away from you or the concavity reaches up over you. On the outside, the exact reverse occurs. It either looks like a plane that's moving away from you, like a cone shape falling back, or it looks like the underside of the bow or stern of a ship, as it moves in two directions, like a reverse curve, two directions at the same time.

289

The thing that's interesting about these pieces is that that particular form, an ellipse that rotates the skin of the surface, has never come up in the history of architecture or in the history of pottery. There's probably a reason why it has never come up in the history of vessel-making. Vessels are usually made with a coil or a wheel. So it couldn't have come up, because you have the central curve. You'd have to twist the form while it was rotating. It didn't come up in architecture because, if you take a form that remains the same, whose radius doesn't change, it has very little compression strength, so you really couldn't put a heavy load on top of it. It would collapse as if your foot was on a can, so to speak – it would twist down on itself.

So there is probably no immediate apparent use for someone to think about making it. At one point after we had made it, we were so convinced that it was an invention that we took it to a trademark and patent office. And they said that, although they thought it was an invention, and could have a trademark, it would be useless to patent it, because if someone did apply it in technology for the transference of liquids or gases – and they thought that that's how it would be used most immediately in its application – that we wouldn't be able to sue them because the model is probably something that a pipefitter could have done unwittingly.

One of the things that I find interesting about these pieces is that people who have seen them immediately say, once they have seen them: 'This I could not have imagined, but, once I see it, it's totally understandable. Isn't it strange that this thing didn't come up before?' So, it's like one of those forms which have waited to happen.

What we have been able to do in pieces I have made with our own little bending machine has always been cones. And then, when we got to pieces like *Intersection*, they started to imply a more contained volume. If you're making cones that are inverted, the plane either leans towards you or away from you. But it's in pieces. We wanted to see if we could make a *continuous* form that leaned towards you or away from you, and we didn't know how to do it. And we thought about it for about a year. And I was in Italy, and I saw Borromini's San Carlo. And there's an ellipse that moves directly upward. So it's just an ellipse, and the walls that surround it are geometrically regular. But I walked in and looked at it, and I thought: what if I could turn this form on itself? That seemed to be like a real plausible possibility. But we didn't know how to do it. First my

assistant Allen Glatter and I tried to make the form ourselves, and we couldn't make it. We came close, but we couldn't make it.

You couldn't make it even in lead?

No, no. We couldn't make it with the bender we were using. And we phoned Frank Gehry's office and just talked to an engineer out there, Rick Smith, who had come out of the aerospace industry and was running Frank Gehry's CATIA programme. The CATIA were invented by the French to build the Mirage jet. So you see them on every TV ad. They make like a continuous line drawing in volume of any given shape and they can make the crossline to it. So it's like a linear read-out of a volumetric shape, and you see it in advertisements for automobiles, aeroplanes, tyres or whatever. It's a three-dimensional schematic way of rendering something in space. They also could make them so you can enter into them. Anyway, Rick Smith's a real genius at figuring out these things, and I asked him whether, if we had an ellipse on the floor as an open space and an ellipse at a right angle to it above you, could we create a skin that surrounded as one piece? And he said, theoretically yes, you can do any of that. But I don't have time for you right now, because I'm working with Gehry on Bilbao. Get back to me.

So, Allen and I said: Oh, screw this guy; we'll figure out how to do it ourselves. And we came up – Allen, for the most part, came up – with this wheel that was at a right angle to itself. We cut out an ellipse, put a dowel between it, put an ellipse at a right angle to the dowel above, like a wheel – only, where the wheels were at right angles to themselves. Lay down a piece of lead on the floor. Now, if you had a normal wheel and rolled it up on a piece of lead, it would just roll parallel to the lead, and would make a roll. Because think of a broken bicycle. A wheel, at a right angle to itself, when you roll it up, will track a form that, when it surrounds and envelops the wheel, will be the skin, if you then cut it off at the top or the bottom, of the surrounding form of the vessel we were trying to make.

And that is what the computer would have given us, if wc had given them the coordinates of these two twenty by thirty ellipses at right angles to themselves. We made a drawing from the skin, sent it back to him, and asked him if we were close to what he could have come up with. And he asked us what computer we were using. We said we had made a model of

it; we weren't using a computer; we literally had made a wheel. And he said, 'You made a wheel?' And we explained to him what we had done, and then he immediately got interested in the problem and said he could help us. From there, Allen and I, after he had laid out the bending procedure for Rick Smith, went all around the world to see if we could get these filled. We went to Germany, we went to Korea; it took about two-and-a-half, almost three years, to find somebody who could build them. We kept sending out the programme to different steel mills. The Koreans could build them, but they didn't have wide enough plate. They only make plate twelve feet, but these have to come out of a sixteen-foot plate, because the shape of the curve, when cut, gets reduced. So the height of these pieces is only thirteen feet right now. So I'm working within the maximum dimension you can get out of them vertically. And I didn't want to make them lower.

I always work here at the place called General Dynamics that builds all the American subs. They wouldn't touch the problem. They thought the tolerances and the invention was something that they didn't want to get into; they thought it was not something they could handle. The best quality work I've ever had made in my life – and that's why I build most of my pieces there – is in Germany. I've been working in those German steel mills for twenty years. They looked at it and said they didn't want to do it: they didn't have the Rick Smith machine. They understood what the machine was. They wanted to make it hot over a form, which would have been out of the park, just too, too expensive to do – ten times as expensive as what we're making now.

The people here in Maryland, Beth Ship, a rolling mill and shipyard, when we first went there with our programme on how they ought to bend the plate, didn't believe that they needed to bend it the way we were telling them. They thought what the form really was was just one cone on a plate inverted and another cone going in the other direction. And we said: 'No, you have to follow the programme. If you don't follow the programme of its bending, you won't bend the piece correctly.' And the first day we were there we had a forty-foot plate, two-and-a-half inches thick, sixteen feet wide in the press, and they cracked it right in half – sounded like lightning. After that, it took about a year to get the project back on – eight months, say. The second piece they built, they cracked the second plate. The first piece took a year to build, but then the learning

curve got quicker, and they finished the second and third – I think you've seen three – and we're into the fourth now. The fourth is a jump in the work, in that we now are making one ellipse at a 70-degree angle to itself, contained within another ellipse at a 70-degree angle to itself. So you'll be able to walk within the interior of the first ellipse, and then pass into the interior of the contained ellipse inside. And that's the one we're working on now. That takes five sections. All these others have only taken two.

Is the geometry anything like that of certain shells?

No, it's not. Shells are all, for the most part, cones. There's not a shell that I know that actually turns, that rotates as an ellipse in its vertical dimension. What I think you're thinking of are nautical or Fibonacci spirals. This is not that. When you think about these pieces, or if someone tells you what they are, you might instantly refer them back to something like shells. But when you're in them, they are not that. Because what's happening is that the volume as it moves upward is staying exactly the same. It's just turning as it moves. As the plane rotates, as the volume that you're watching rotates, it doesn't decrease in its conical dimension; it stays regular. And that's something hard to imagine until you've seen it. It's not a space I've ever been in. It's not a space that anyone's ever been in.

And from the outside, it's very, very difficult to tell that the space is going to be exactly what it is in the inside. The outside reads almost like a topological form you can imagine coming out of some kind of skin surface. It could be rubber. It probably could have come up from an elbow to an arm in Bertoldo di Giovanni or something; it could have been part of the skin of how someone dealt with an outside volumetric plane: it could have come up in the history of figurative sculpture. But only because a volume was moving into another; and it's very different, because you could never enter into that space. Having said that, I don't really know the figurative sculpture I could put my finger on that actually does that. But somehow I think that with so many people working with volumes, maybe it did come up. But I don't really know what it would be, because I haven't seen it.

You said in 1980: 'As my work evolves, it changes from a literal possibility of

collapse to a disorientation of your perceptions, in relationship to a plane,
line, edge, which lean off the vertical.' Is this an extension of that tendency?

Yes, these pieces are completely destabilising inside. Because your visual
coordinates to the left and right are totally challenged. The only way to
try to get a semblance of where you are is to look up. And when you look
up, you realise the plane you're standing on is not the one you're looking
out of. In fact, it moves at an angle to it – either a right angle or a 55 or a
70. And then, in order to understand how that happens, you have to start
following the interior wall of the vessel. And when you do that, it
becomes very destabilising, because it's not a cyclodrome, it's not any
space you've ever been in before. And it's not anything that you can relate
synaptically to.

Well, that's very interesting, because I gave my head the most terrible bump
when walking inside. Suddenly, the wall was nowhere where I thought it was
and I went crash into it with my head.

You walked right into it?

Yes, walked right into it. The effect of the pieces from the inside was, not
surprisingly, totally different from the effect from the outside. Walking
around the outside, what struck me was their sheer beauty, the sheer beauty
of the edge, the sheer beauty of the curved plane, and the beauty was more
striking than the strangeness. When I walked inside, it was extremely
vertiginous, violently vertiginous. How does the destabilising work when
you're inside? Presumably, it surprises even you.

Yes, I think it works on my stomach. And I don't know exactly how the
haptic response occurs, but I think it's probably first felt from the eye to
the stomach.

It made me feel all the time as if I were off balance. It was disorientating, to
use that word you used back in 1980.

The one that's at a right angle to itself, as the ellipse rotates is, I think, the
most disorientating. The thing about qualifying them as beautiful – I can

take it or leave it. It's not the way I see them. It's hard when you're involved with a problem, making something, unless you're really concerned about its image, then you don't relate to it in terms of some sort of qualification. I'm really involved with trying to make them lean more or less. And there are a lot of variables that go into how far they lean, and what the different radii are between the width and the length of the axes of the ellipse. And those are all decisions, I think, that probably end up having to do with the aesthetic choices that we make. But I don't make the choices, I think, on what I think the feedback will be qualitatively.

No, I'm sure you don't. And I think that artists generally don't think about whether the thing is going to be beautiful. I think the artist is rather like a cat crossing the floor to get its food and thinking of what it wants, not thinking of how it looks. But in moving towards what it wants, it looks beautiful to others. And I think a lot of art is like that. The artist is not thinking at all if the thing is going to be beautiful; he's thinking of dealing with making something that he wants to make. It's only others who perceive beauty in it.

Yes, I can go with that. I think you have a need to follow some instinct you have in form-making, and using one form leads to the other, and you have a need to follow your curiosity about what you don't know. And I think you start probing at areas that you don't know. And you find yourself wanting to make something that you haven't seen before. There wouldn't be much point in making something you already knew.

No, it is exactly the curiosity. And I imagine that this series must have been one of the things that you have felt most curious about. I mean, you are really working in unknown territory.

And we've been on them four years. And at one point, after about two-and-a-half years, particularly when the first one broke . . . first, we couldn't find a place to work, and we thought we would never be able to make them. And architects were telling me to make them in concrete and I thought maybe they would just end up being models, that they really wouldn't be able to be realised. And I think that there is something about the willingness to sustain a thought and the effort it takes to sustain a

295

thought. And maybe the sheer wilfulness or obstinacy that it takes to sustain a thought oftentimes is discernible in the resultant work. Not that the work is an expression of the thought, but that some things, even when the expression disappears, seem to be of more critical substance because of the decisions that were made and excluded, than other things that seemed lesser. Some things seem trivial, some things don't, and it's almost discernible in given works of art, that you can read the thought that went into it, often because it has evaporated from the form. (The other kind of thing that we see a lot of still is heavy-handed Expressionism trying to *pass* for thought and form.) I do think sustained effort has a lot to do with the manifestation of form. And it doesn't matter if the form is minuscule or large. It has nothing to do with it. It's almost the qualification of the invention and sustaining of thought that becomes relevant in the form.

Is that what you like about Giacometti?

Well, I think it's what I like about works that we can say have more substance – and we can qualify them that way – than works which we find more trivial. I mean, I think one kind of admires some sort of critical distance in being able to reduce some problem to a point where an invention occurs. And one can go there and have the experience that the language has changed because the thought that went into it allowed the invention to occur. And that to me isn't any historical imperative, it's something that goes on in terms of people's inquisitiveness, whether it's in poetry or science or art or music or whatever. Some things are just more profound because they're more thoughtful. It's pretty obvious. I don't think *less* thought ever made anything better.

I do think there's something else to it. I think that at certain points you open a kind of feedback to yourself in relation to either a problem or an experience or a sensation in the experience or in the problem that in and of itself is interesting, and you feel a compulsion to follow it. And I think those are things you have to see through.

I also think that there's something about these pieces that have to do, on a very simple level, with walking and looking. And being *inside* of a contained space where, if any content is going to be revealed at all, you have to pay attention to every part of the surface that's surrounding you.

And the work in its deformation asks you exactly to do that. There's no way of not doing that. As soon as you walk into these pieces, you become part of the dialogue of their physical existence, by having to try to discern what is going on here. It doesn't really help having more information when you see them.

I have to tell you that I was with a person and we walked into one and the person said to me when we walked out: 'Oh, I understand there was an ellipse on the floor and an ellipse up overhead at a right angle to it. Well, if I took a cross-section, what would that be?' And I said: 'Well, just rotate it. You can see that. I don't have to tell you that.' The problem with thinking in those terms is that that's not the way you *experience* the piece; that's someone trying to *diagram* the piece after they've had a geometric read-out given to them. But your experience of the piece is utterly other than that.

For myself, absolutely.

To make a whole iconography of the internal structure of the work, so that they can diagram it in their head to understand it and want to follow the rotations of the planes as they move upward at every cross-section of the tree, is absolutely useless. We can do it. We can make a nice drawing of it. And the computer print-out does it all the time. But it doesn't tell you anything about the experience of the continuousness of the surrounding vessel, because that's not how you respond to it.

You've been rather emphasising the experience of the thing from inside, but it's also amazing to walk round them.

I think when you walk around them, you never have a sense of the whole, because the pieces are leaning towards you or leaning away from you and you can't within the centre of them try to contain the continuousness of their surface. You have to physically walk around thirty feet. You have to anticipate memory, reflect upon what was moving towards you, what was moving away from you. So to follow the continuousness of the curved volume as it either protrudes or leans away from you is an impossibility from the outside. From the inside, that becomes the dialogue of the nature of the shape that surrounds you. You cannot help but follow it. So

I find the inside, in terms of the understanding of the work, more revealing.

It is interesting. I think I can say that when I was outside, I tended to go on moving around them. Once one was inside, one stayed still.

Well, maybe after you bumped your head. Did you stay still in the centre? Or at one end of the long axis, or a short end of the axis?

At different points, but mostly against the wall. But at different points in each one I would stop and look. But when one was outside, I think one tended to go on circling.

And, if you had started by not walking around the outside, but just went into the inside, I don't think that you would be able to discern what the outside is doing from the inside. I don't believe it.

No, I think that's true.

Nor the reverse of that. The reverse of that is also true. From the outside, you can't discern what's going on inside.

Has that got precedents in works of yours when there's an outside and an inside?

All of the vertical open structures that I've made. Certainly.

I was looking at a piece of yours the other day called Balance, *made in 1970. This is a piece which is a simple plane, a flat plane, about eight foot by five. One corner is in the ground, another corner up in the wall. Now, as I looked at it from various points, the plane always seemed to take on a curvature. There was a young woman from the gallery in the room with me, and to make sure I wasn't hallucinating, I asked her whether she was having the same experience, and she said she certainly was. So that at different points, looking at it, the plane always seemed to become curved – either slightly curved or quite a lot curved, down towards the bottom end. The illusion of the curve changed at different points in the room as you looked at it, but*

there's no doubt that it had the effect on the two people who were looking at it of appearing to be curved.

Well, the outermost surface of any form is where you read the drawing, and, if you're looking at a plane that's moving away from you and you follow its axis vertically and horizontally simultaneously, it could be that the reading of the cross-axis has a certain kind of parallax to your vision, starts to bend away from you. So it looks as if there's pressure from the back, bending the form like a shell. But I think in any form, basically what's always interested me is that the drawing always occurs, in most sculptures, where the surface meets the space – that the outermost form is where the drawing occurs. And that's certainly true in someone from Rodin to Brancusi to Matisse. Probably not so true of Giacometti. Because these people are all involved with volume; Giacometti's involved with more the intersection of the space through the plane.

In these pieces, the definition of their drawing is really about the volume as it cuts the round of the space. That's why I said that it's more interesting to see them inside than outside. Because, if you see them inside, you always have to relate their outside edge to a vertical plane. In so doing, you can see the way that the form is either leaning out or in, as opposed to a vertical. Where if you have them outside, like in an open field, there's no vertical to read their fullness against. And I think in a contained space, they work better; there's more resounding scale in a contained space. They just have to have a vertical plane near them, I think: wall; doesn't matter where; right angle would be better; doesn't even have to be close. But that's only for the outside reading. And I think that it does change their scale. One of the things that's always interesting when you build in large sheds or steel mills, if the work starts to have a scale in a large shed – if it starts to resound physically within the containment of those spaces – you usually have a notion that it's going to work equally well in more compressed spaces. Because those sheds down there in Maryland are vast.

The three works that I've seen, what's their height?

Thirteen feet and twelve feet.

RICHARD SERRA

What would be ideally for you the height of the enclosed space in which you'd like to see them?

Well, we're going to show them at Dia. I think the space there up to the rafters is probably fifteen or sixteen feet. To tell you the truth, I'm not even so concerned about the space overhead, I'm more concerned about the contained space that they're in. It would be better probably to show these pieces one at a time. But that becomes an exorbitant economic question. So we'll probably show them two at a time.

They seemed to me to look right when I saw three of them together. If I had not been told that you had raised the question whether they should not be shown one at a time, the thought would never have occurred to me that the intended work didn't consist of those three pieces which I saw together that day.

Well, there are thirty models downstairs, and we've got the fourth piece in the works right now. And this plant in Maryland may close down. But this Rick Smith machine, there are four of them in existence. And I've just recently learned that there's another one in existence in northern England which I may be able to use. We're going to send them our information next week. So, even if we have to stop the problem here, and I hope not, we might be able to open another front of work in Europe. Because I want to stay with these. I mean, if you say these three looked like they ought to be together, maybe after you see six or seven, you'll say oh, those seven ought to be together, and then we can make more distinctions. But I don't think you can really get into the qualifications between them until you see the whole series played out. And that may take several years.

Well, they seem so rich. So much of what you've done is site-specific. How do you see the actual use of these pieces, the models for which already exist?

None of the cone shapes I've made were built for particular places. And I think in trying to continue that series, I got involved with the problem of how to make a surrounded shape within a vessel rotate, keeping a similar radius. So the form is really not dependent on its place. And in that sense,

these pieces are not site-specific. Nor do they need be. On the other hand, I would like to, if possible, place all of them once and only once, so we could at least accommodate them to what I think would be a situation where they would have a possibility of being seen the way I want them to be seen. Whether that'll be possible or not, I don't know. And if they have to eventually end up somewhere, the first time out I would like to have as much say in that as I can, and I'll probably insist on it. I *will* insist on it. But that doesn't mean they're being made for the site they're going to. Not at all. But nor were any of the cone pieces. The cones have probably been going on for about, I don't know, seven or eight years. Maybe ten.

But you've never previously produced a series of variations on an idea like this.

Well, one of the things that's interesting about these is that they're not predicated on a module. Each one is being specifically invented. So they're all different. Where, if you take *Intersection* or *Olssen* or *Call Me Ishmael*, they're really permutations on a module, inverted for the most part. These are not that. These are specific forms, each one individually invented to do something different than the others, even though the problem of the rotating ellipse is a constant. We could do it different ways, where we could change the sizes of the ellipse. We could also overlap them so that they don't have a central point. But all of those things seem to be like mannerisms. Right now, the simple rotation of the ellipse with different angles of overlap seems to be fruitful. And putting one inside the other seems to be something that we can only anticipate, because we haven't seen it yet. I haven't had a series like this in a long time.

I think just the sheer effort to build these things has a lot to do, finally, with what they've become. It sounds strange, but I think it's true.

What you were saying before about curiosity is of course true, more or less, of all artists who are any good. But with you in particular I suspect that what your work has been about above all has been curiosity, about your asking: what would happen if . . . ?

Yes, I used to say that out loud: what would happen if . . . ? And I think

that's one way to start a problem. But there are other ways of just simply working out of your work, when you're already working. And for me I think that's the case. Work comes out of your work, but you have to be working in order for the work to come out of it. I can't think my way through a problem; I have to work my way through a problem. And that's why I'm interested in building things, because often what happens in the process of sustaining the effort to build something is that you could not have foreseen what you thought the conclusion of what your intention would be. And the physical fact of things counts for a lot more to me than the thought that doesn't take a physical manifestation. Because oftentimes I could not have foreseen what the conclusion of the manifestation would be, if it wasn't translated into a material substance. And it's hard to deny the physical experience of the substance when it's not something you could have imagined. So it counts for a lot.

I do think what we said earlier is true: that the thought that goes into works of art is usually discernible in the object that exists, or the sculpture that exists, or the painting that exists, or the manifestation of whatever form that exists. And I think that's where one enters into the *dialogue* with works of art. On one level. I mean, for me, that's always been the most interesting level. But I can understand how other people respond in different ways and enter works very, very differently. It doesn't interest me that much.

You said in an early interview – it was in 1973 – and I think you're saying it again now: 'What I decided is that what I'm doing in my work right now has nothing to do with the specific intentions.' And the interviewer said: 'What on earth do you mean?' And you said: 'If I define a work and sum it up within the boundary of a definition, given my intentions, that seems to be a limitation on me and an imposition on other people of how to think about the work. Finally, it has absolutely nothing to do with my activity or art. I think the significance of the work is in its effort, not its intentions. And that effort is a state of mind, an activity, an interaction with the world.'

Yes, I think that's right. I still believe that. I believe that.

1997–99

||

When we talked about the Torqued Ellipses *after I'd seen them at the shipyard, you were absolutely convinced that they needed to be seen indoors because they needed a vertical wall nearby. And now that I've seen three of them indoors, at the Dia Center, I know how right you were. Can you conceive that any of the* Torqued Ellipses *you're going to do in the future might be outdoor pieces or do you feel that with that language you're always going to need the thing to be contained by vertical walls?*

I think in the Dia show it cuts two ways. The vertical wall helps you read the exteriors of the volumes, to read the angle of the lean. On the other hand, the cross-bracing of the trusses of the ceiling interferes with the reading of the top ellipse. If you have them outdoors, usually what happens is that the sky acts as a lid, so the volume is contained within the piece and easily discernible and you read the revolution of the ellipse as it turns. At Dia that's much more difficult to do. If there's anything that's problematic there, it's the busyness of the wood, and probably the reading between the coloration of the wood and the coloration of the two sand-blasted pieces, because they tend to meld into each other, which further disrupts the reading of the top ellipse. The other problem with Dia is that the space could have been a little wider, because in the first piece to the left as you go in, the piece at a right angle to itself, there's one side opposite the cut that reads like the prow of a ship, and it's very difficult to get away from that piece that's actually been hovering over your head – to get away from that side of the volume – and that interferes with its reading also. It would have been better, probably, if the space had been a little wider, and if the ceiling had been uncluttered. Having said that, I didn't see that these pieces could work well outside in a contained space, a courtyard where there was a wall, a space where they could hold their volume as a substance almost, not being interfered with by the architecture.

Maybe the courtyard is the ideal situation.

I would have to see the courtyard, to see the context. I don't have some general idea about where they would possibly work to their maximum.

303

I know that if you put them out in an open field, like when they were on the pier at the shipyard, then they tend to diminish in terms of their relation to the vertical plane and they tend to get diminished in scale. I think one of the interesting things about the three at Dia is that the language becomes more accessible from one to the other. I think it would be interesting to be able to keep the group together, though that's probably not going to be possible. I think what's interesting about the show is that the accessibility of the language allows one to begin to engage with the problems of the pieces and that the complexity of the third piece, with its further ellipse inside the ellipse, then builds on the engagement. One can then go back and understand how the pieces are moving, and what one's feeling about their space is in relation to how one walks them. I think they all have a different kind of content in terms of your experience moving in, through and around them. I would say that the one at the right angle has more to do with the continuousness of its ribbon or belt as it spins around, the one at the 55-degree angle is more about the substance of holding its volume almost in a static way, and the ellipse inside the ellipse has multiple readings. There's one reading where, if you just follow the floor of the corridor, so to speak, between the two walls, and then you step into the inner ellipse, there's actually a shift, or a perceptual shift, or an illusionistic shift, by which the floor seems to slant downward, visibly on a different plane than the space you've been walking in. So there are ways in which this piece has probably affected your inner ear, your balance, inside the inner ellipse which isn't the same as with the first two.

I must say that I felt, when going into the first two, that the floor, as you go in, slopes away, not to the same degree as in the double ellipse, but that it definitely slopes away.

Yes, I think that does happen in all of them.

I'm discouraged when I hear you say that maybe the three won't stay together. I feel, and a lot of other people who've seen them feel, that those three should be kept together permanently.

Yes, but that's outside my hands. And I'm not going to make it a

condition. If there's a possibility for that to occur, I would certainly like it to occur, and I would make any kind of adjustment I could to make that occur.

Actually, when we talked several months ago, you said that you might show them separately at Dia. What finally made you decide to put the three together?

I was interested in my own history of how the language evolved in going from piece to piece, and I was interested in the evolution of how you know them. The language becomes attainable when you see three of them. I think also that if I'd shown them one at a time they'd have become like precious objects. And I wanted it to be clear that these aren't to be seen as precious objects but to be experienced in different ways. These are a series I've been working on, and I'm sure that there's at least five or six or seven more to be done, and I just want to watch the language unfold. I didn't want to make them overly precious; I didn't want to signify one as being better than the other. I mean, it might have been impossible to show them one at a time, given the constraints of finance, but in the final analysis, I don't think it would have been a good idea. To tell you the truth, I'm also interested, because the space is rectilinear and not a square, that, unless you line them up to one, two, three in a row, they're going to fall into some triangulated configuration, and the triangulated configuration makes for a tubular kind of space between the three which one can acknowledge as one walks them. And so you have the leaning in the angles from the outside, and the expansion and contraction of the pieces from the outside in relation to each other, which sets up another field of understanding which would have been lost if you'd shown them one at a time.

And which in a way has the same kind of feeling, while it does something different, from being inside the pieces. The experience of seeing the related outsides has something of the same quality as being inside one of them. But, actually, when we talked before, I'd seen three singles, I hadn't yet seen a double. And, of course, what you're showing now is two of those single pieces plus a double. I had the impression that from the start you thought that, if there was going to be a group, it was going to include the double.

I always knew, if I completed it in time, that the double would be included. The other single that you saw didn't have the same breadth. It was actually diminutive in scale, it was, I think, eighteen by twenty, and the lean was probably, oh, two feet or less, and it had more of a cylindrical form. I liked the piece but it didn't work as well in terms of the evolution of the language as the other three.

Will you ever show it?

I'll show it, absolutely. But I didn't want to show it in this group. I wanted to show the maximum variability, and I think that's pretty well stated in these three.

I know you used models to establish the positions and orientation of the three pieces for the Dia showing. Were they the original working models?

We also made life-sized templates in the space at Dia and moved them around, and we also drew them out on the floor and several times changed their positionings. There was a lot of anxiety about whether three would be too much, actually. We thought that two would suffice and then there was a dialogue that went on for almost a month whether we should show three or two.

It so often happens, when things take a long time to decide, that in the end the thing looks so inevitable that it never occurs to one that it took a long time to get there.

I'm not interested in exposing the effort. That's not . . .

No, of course not, but sometimes when things look so right it doesn't occur to one that it's needed an enormous amount of experiment.

And the other thing, I think, is, because these pieces were so difficult to bring along in their fabrication, I don't want to confuse that with their relevance. Sometimes you think that, because there's more effort the thing is more meaningful, and that's not always the case, and you can't confuse the two, or you ought not to.

1997–99

When you brought the three pieces together, did you make any changes in the colour of or markings on the surfaces?

Only in the piece at a right angle to itself, and I did something there that I'm usually very very reluctant to do. These pieces were so difficult in their making that the piece at a right angle to itself had to be line-heated to bring it together and, when you line-heat, you put water on and you get very big scarrings on the plate. And the scarrings interfered with the reading of the internal spin. Even when they were outside and weathered and they rusted, the line-heating marks were still there. And I really had a need to bring the surface to a continuum so you could read the torque, and we oiled the last one. I have been reluctant to do that in most of my pieces, but here it was a trade-off.

And you did that before they came to Dia or . . . ?

No, no. I oiled the one at Dia maybe a week before the opening. I salted it down. I thought I could bring the surface to a point where the line-heating wouldn't be such an obstruction to perceiving the piece. And, you know, in terms of being true to the organisation of the process that goes into the work, if the manufacture interferes with the perception and just putting oil on the piece could make it more easy to read, then I thought that was a better thing to do, although I was very very reluctant to do it until a week before.

Why were you reluctant?

I just don't like to interfere with the material. I don't like to add anything to the material, I've hardly ever done that. I think the material has its own kind of oxidation, evolution, in and of itself, and I hardly ever intercede with something else, I hardly ever add something to the material. Usually never. I've never painted a material.

It's almost a moral principle, the way you talk about it.

Well, I'm not interested in truth to material, and it's not some axiom. It's just the way that I think about material. I mean you can really keep a

piece of wood from breathing by coating it with paint, and it's something that I've always steered clear of. It's preference. It's not a moral principle for me, it's preference. I think it has something to do with understanding the nature of what you're doing in terms of the correctness of how you understand it, the correctness of what it is. I don't want to interfere with the material, to make it purport to be something other than what it is.

I'd love to know what for you are the key differences between the single ellipses and the double one. One of the obvious differences is that, when you've gone around and into the single ones, and you've then traversed an open space, you enter the double and you get the big surprise of coming bang up against a wall; it's quite a terrifying moment when you're in through the entrance and there's a wall. And then there's the other very obvious difference that in the double one you've got a corridor you walk along, a very enclosed passage which hems you in physically as well as psychologically. But what do you feel about the significance as against the immediate impact of the double one?

I think the double one has a lot to do with memory and anticipation. The double one has more to do with being lost in space. After a point, you don't know exactly where you're being led to and, even when you arrive at its core, you don't know quite how you got there, or where you're going to go when you exit. So there's a whole disjunctive narrative that goes on in the double one. You're dislocated in time much more. The single ones may implicate you in their volume: as they move, you move, and as you try to understand them, you move and they move. So they ask you to walk their field in a circular motion to understand them. With the double one, you're really involved in a much more psychological space in relation to its movement and your movement, and there's a certain feeling of relief when you walk to the centre, because, when you first enter you have no idea what you're going to be led into and where you're going to arrive, and I think that there's certainly anticipation, and there's a certain memory about where you've been, so you have to kind of give yourself over to the notion of the journey. I think the double one has a much richer and more complex potential for knowing, and what that knowing is depends on each person's willingness to experience their own history, by knowing different places, spaces, times, locations or whatever.

308

And I think that there's more of a disjunction in time in the double. The time of the two singles is not continuous with your time, but the time of the double is very discontinuous with your time.

Do you find, when you go into them, that you have an instinct to go clockwise or counter-clockwise, and that you usually pursue the same course? Especially with the double?

It's interesting, because I haven't thought of it that way. The first two weeks, I've walked counter-clockwise, and the second two weeks I've walked clockwise, and then one day I decided just to walk contiguously, and not enter the centre, to see what it would be like to walk contiguously. But I think that I started walking them naturally counter-clockwise. And I don't know if that's meaningful or not.

I found myself walking counter-clockwise almost every time, and had to make a deliberate effort to go clockwise.

Yes, I'm the same, but I don't know why that is, and I'm sure it's not true for everybody. The piece doesn't ask you to do that in any way.

About the way you move into a piece from the previous piece: if you go from the one on the left to the one on the right and then on to the one at the back, you tend to enter by going counter-clockwise round the outside, so that maybe, once you go in, you just automatically continue in the same direction.

That's possible. That makes a lot of sense, actually. Let me tell you something else. The experience is very different if you walk into them clockwise or counter-clockwise. You have a different experience, and I can't quite specify what that difference is. It's a different experience in kind.

Is it conceivable technically – I mean it's something you might not want to do aesthetically – but is it conceivable technically that you could do a triple ellipse?

309

RICHARD SERRA

Oh for sure, absolutely.

And is it something you'd be a priori *tempted to do?*

No, not at the moment. That's not how I'm thinking these are going to
evolve. There's several more doubles I want to make. I have never before
worked on a series where I was so convinced about the necessity of
continuing. But I don't think I'm interested in a triple. I'm not interested
in having them be labyrinths of that sort. All the axes of the inner and
outer share the same centre. You could shift centres, you could rotate
centres, you could tilt the axes. I haven't done that yet. There's
possibilities of making them more complex by changing the problem. But
I don't think I'm going to make it more complex by putting another one
inside another one.

*Did you realise, when you were making the pieces, or before you were
making the pieces, that you were going to get an illusion of perpetual
movement, with the walls moving around you all of the time, rather like a
room going round you when you're drunk?*

No, not until I sat on the floor of the plant, after the first two halves of
the first one came together. And when that happened, I was as startled as
anybody in the plant. But no, I had not realised that. There was no way I
could have known that. While working on an experimental form, I don't
care about the aesthetics of the work; that seems to come after the fact.

You would agree that the ellipses seem to be in perpetual movement?

I think they implicate you in their movement. They have a torque, and
when you walk into them, in order to understand their torque, you move,
and as you move they move, so you're always trying to play catch-up with
them.

*They're moving in several directions. Oddly enough, I've never tried going
down on my knees half way down to look at a wall from a different height, so
the distance of my head from the ground has always been steady. But these
things are moving up and down, moving in several dimensions; they're*

stretching, like you might stretch your limbs, or your skin across your chest, or your muscles. Or they're stretching upwards. The movements are going on in several dimensions.

Well, they're all generated by diagonal lines. And I think what's implicit in the structure of them as you read them is that they're being generated by line, not by plane. I think the way they differentiate themselves from architecture is that most architecture is generated by plane; these are generated by line. And because the line, as it moves diagonally, particularly in the one that's at a right angle to itself, has no vertical section, everything is continuously leaning in or out. It makes it very very hard to grasp exactly where the materiality of the plane is as it moves from leaning away from you to leaning over your head. Philip Johnson came in, and he's probably around ninety-one, and, as he was walking around, he was putting his finger close to the wall of the plate to try to adjust his movement to how it was moving in and out, and he was doing it with a great deal of pleasure.

There was something I noticed and I don't know whether this is due to the colour of the piece, but I found that, when I was going around the outside of the double ellipse, I stayed much closer to it than when I was going round the single ones. I don't know whether that's because of the blackness of the double one.

No, it's because of the radicality of the lean on the first one. The first one's leaning five feet. The second one is probably leaning, I think, two feet eight inches. I think the lean on the 70-degree one is less, so your ability to walk up to it is easier, because it's not either going to lean away from you or over you. With the other ones you tend to walk away from the overhang, or not so close to the lean. The 70-degree angle has probably the least lean. One of the qualities I like about the double is that, because it hasn't been sandblasted, the mill scale has been allowed to stay on, so that it has a silver-greyish sheen to it, which makes it much more leaden and heavier. I like the weight of it better.

It looks distinctly heavier.

Because of the materiality, because of the light, the way it reflects the light. It's interesting because the double ellipse kind of pulls the show together, it gives the show another affirmation.

It's very interesting how much the placing together of the pieces was part of the creative act. It seems to me that it wasn't just a matter of installing an exhibition but of the creation of a work.

I think one of the things that's true about having three pieces in the room is that the room tends to disappear. You don't sense the walls, the space, the length, and what happens is that you're in the room with the space of the pieces, and the pieces seem to suck the room right into them. So the sense of the room and the pieces seem spatially to be one and the same. I mean, basically, what you're looking at there is concrete, steel and trusses overhead, and there's very little room to the room, other than the space of the room. And the space of the room is different than the space when you go outside of the room; it has a different physical feel to it. There's more of a material substance to the space in the room that's discernible.

When you say that I'm reminded that you once said to me that you thought that perhaps Corbusier's church at Ronchamp was the one work of architecture with which the Ellipses had a certain affinity.

Well, that's like a pretentious statement on my part.

It doesn't seem so to me; I find the experience very like that of Ronchamp.

Maybe in my dreams. I was very very moved by Ronchamp. And the aspect of the light in Ronchamp, and the physicality of the space in Ronchamp, evoke feelings that very few places and spaces do; maybe Hagia Sophia. But there's very few spaces and places like that, and, if there's any kind of even parallel reading in any slight way of that kind of presence of space, or acknowledgement of space or articulation of space or substance of space, I'd be happy. Ronchamp's space isn't being torqued, but it's being made. The space itself has turned into a substance.

Exactly. And I think there are certain small Romanesque churches where

space turns into a substance.

I did a tour of Romanesque churches, actually, in France, about four years ago.

And don't you find that this phenomenon happens more often with small churches than with the cathedrals?

Yes, because with the cathedrals, the space dissipates out; there's no ability to hold the volume of the space. Holding the volume of the space has a lot to do with your body size, and the verticality and horizontality of the space you're in, and, if it's too big, or too punctuated, it'll just dissipate out. There are small Romanesque churches where the compression of the space can be felt immediately.

I'm going to ask a question to which I think I know the answer beforehand, but I'm still going to ask it. When you're making these pieces, are you so focused on the problem of making them that you have no time to think at all of what their emotional impact might be, of what their 'affective content' might be?

No, I think what happens is that it becomes like a residue of the problem, but as soon as you make one you see the potential to articulate the problem in terms of what you want them to convey, and then you adjust the axis, the major and minor, whether you want it to be longer or shorter, which then affects the overhang, and then you can control more or less to a degree how you want them to move, how you want the compression of the space to be felt. And there are things that you can adjust to, but initially there's no way of knowing that. And then you just work the problems out of the problems, you see which are useful ideas and which are ideas that are extraneous, and if you want to produce works that both hold and torque the volume and don't dissipate out, the more you build, the more knowledge you have to make adjustments in what you need to do. But I had no way of programming that to begin with, and didn't even think about it. If you ask whether the pieces were predicated on evoking some kind of feeling: no, not at all. After the first one was built, I understood that the torquing was affecting me in a

particular way, and I thought that I could control to a degree what I wanted it to do, how I wanted the volume to move, but not until I made the first one.

Right. But when you had made the first one, and thought that you could control it, were you controlling it in terms of the physical reaction that a spectator, including yourself, might have, or did you think at all of the emotional impact – in the way that Newman certainly thought of emotional impact?

No, I think I thought about its complexity. I thought the more complex, probably, the better, and that they can function in different ways. And I was interested in how you could either put the focus on both the volume as a substance and material and the torque that moved, the rate of the torque, or the compression of the space, so that the one at a right angle to itself has a greater revolving spin to it, speed to it, and it's much more about the continuousness of its driven surface than the one at the 55-degree angle, which feels like an X on the interior, which is much more subtle in the way that the volume holds the field and then slowly turns. And the double, which is at the 70-degree, has a very very different relation to its spin. It's much more cylindrical.

You continue to talk in physical terms. You're not talking in terms of emotional impact. You're not talking in terms of wanting the spectator to feel awe or a sense of release or a sense of joy or sadness.

You know, I'm not interested in some sort of Skinner box behavioural programmatic way of having people react. That's like throwing fish to the audience – it's the basis of a lot of theatre, but that doesn't interest me at all. On the other hand, I do know that there are ways that pieces can release you and not be oppressive, and there are ways that pieces can be made claustrophobic and threatening. And so, to a degree, you try to make the pieces accessible, and you try to have the pieces point to the possibility for a complex experience, without being heavy-handed about it. But you don't really know. I can only go on my experience of the steel, and I've been around it all my life, so I think I probably have a greater tolerance for things that startle other people than most.

You've said that your time spent in Kyoto was something that marked you particularly. I would like to suggest that, and I know it's true to some extent throughout your work, but possibly more with this work than in anything else you've done, that you're paying your debt to Kyoto. That's to say, I think there is an Eastern aesthetic by which the organisation of forms is not evident from the outside. When you enter the work, and you become part of it, and you move about in it, and the relationships constantly change according to your movement in it, and the thing is always changing, and you discover the organisation through your movement inside it, in time, that seems to me to be a specifically Eastern aesthetic, and I think it's one that's relevant to the Torqued Ellipses.

I think the time of Zen gardens is more protracted. It's a longer time, and it's more continuous with your physical walking. The thing about the *Torqued Ellipses* is that their time and your time are not the same. I'm not quite sure how to explain this, but the time that you become involved with in the movement of these pieces isn't the same as your normal walking time. It's faster than your normal walking time, where in Kyoto it's slower. Kyoto forces you to pay attention to the entire field, as the field changes as you move. These pieces agitate you to a degree, to try to move in relation to their movement, so it's very very different. It's an accelerated time these pieces have, and it's a dislocated time, because it's not the kind of time I've ever been involved with in any other enclosure. And in that sense there's a shift between your understanding of what your normal time is and the time that you experience these pieces in. And I'm not trying to sound too esoteric, but it does happen. It's like a dislocated jump-cut, in time. It brackets another space. It's not linear; it's not narrative. But this always happens with art. It gives time a kind of qualification whereas other things don't.

III

This is the third time we've recorded something about the Torqued Ellipses. *The first was when there were three, still at the shipyard. The second was when two of those three and the initial* Double Torqued Ellipse *were shown together at Dia in New York City. And now we're in the Guggenheim*

315

Museum in Bilbao at an exhibition of five single Ellipses *and three* Doubles
*– eight of the ten made up till now. I want to go through them with you in
the sequence in which they were made, but would like to begin with a general
question. Long before I saw any of them on their full scale, I saw a group of
sketch-models in your studio in New York; to what extent do the ten pieces
you've realised relate to those initial sketch-models?*

The models allowed me to work out the *Torqued Ellipses* in terms of
all their basic coordinates, like major to minor axis, height, balance,
openings, whatever. They give a useful indication of layout and shape but
obviously no indication of what the temporal experience of the large-
scale work will be.

*And how many of the pieces that you've made have a close relationship to
the models and how many are different from any of the models?*

Altogether there are about sixty models. There is a model for each piece
I've built, plus those that remain experiments. The bend, the lean, the
overhang of the plates, the equilibrium, where the opening needs to be,
that's all worked out *fairly* precisely in models usually at a scale of one
inch to one foot. The engineers translate the models into digital
information.

And how many of those models were made before you started to make any *of
the pieces on their own scale?*

Forty-four. After the Los Angeles exhibition I made five more; three of
the pieces based on that group are here. I work most of my pieces out in
models. I recently made thirty-two models for a sculpture where for the
first time I used torqued plates in a vertical structure. Four sixty-foot
plates are torqued in elevation to conform around a parallelogram which
is rotated 35 degrees from top to bottom and which gets smaller as it rises
in elevation. It has taken nine months to resolve all the problems that
came up, and the only way I could resolve them was with models.

So there has been a feedback into the models in realising the big ones?

Yes, that's a continuous exchange. I need to see each sculpture in full scale to understand its effect. That enables me to decide how to continue the series and what to change in the next group of models. There's a big difference between a plate twelve feet high and one that's fourteen feet high, and there's a big difference between a section that leans two feet and one that leans six feet. Look at *Torqued Ellipse IV*, the work that's going to MOMA, an ellipse that is relatively low, less than twelve feet, and compare it to the most recent piece, *Torqued Ellipse VI*, which is over fourteen feet high. Two feet make a tremendous difference. *IV* has a much more horizontal torque and turn, *VI* is much more volumetric, pneumatic; it seems to palpitate from the inside out, expanding the outer surface. One of the things that is essential for the variation within this series is that the relationship of major to minor axis differs from piece to piece: that means the shape of the rotating ellipse is different in each sculpture. Because the pieces are not based on a modular elliptical plan the read-out is never similar, never a permutation or inversion. Each sculpture has a particular individual character in that it offers a different solution for the dislocation of space.

Yes, there's no duplication at all in their character. Now, at the moment we're in Torqued Ellipse I. *When I saw this at Dia, it was the piece whose interior, as you went round it, presented the greatest variation, and I find all that variation is present here, in a much taller space with very different lighting. On the other hand, the illusion of the floor sloping, tilting, is nothing like as strong here as it was at Dia.*

The reason for the illusion of a sloping floor at Dia was that the cross-bracing of the wooden roof structure was very close to the top of the *Ellipses*. The low roof seemed to compress them and tended to compact the space and to put more focus on the ground. When you read an ellipse your eye follows the perimeter of the shape, even a drawing of an ellipse on a piece of paper creates an illusion. This illusion is much stronger when you follow the elliptical curvature of a *Torqued Ellipse* on the ground. You're entering into the *Ellipse* from a stable, known, rectilinear space, which adds to the destabilising effect; also, any illusion of a sloping floor is reinforced if a low ceiling compresses the space downward. Here that doesn't occur as much, because the ceiling's very high and open.

Do you find too that the greater height here above the tops of the pieces tends to make them look taller?

Yes, that's something that I could not have imagined. I would have thought that big pieces in small spaces would have looked bigger than big pieces in big, high spaces, but, as it ends up, the higher the space, the larger the works look. The *Ellipses* soar here where at Dia they seemed to be more contained. They look less heavy here and more sensuous, not as earthbound. There is a difference in the gravitational bearing of the work because of the scale of the room.

What about the difference that at Dia you had daylight throughout the gallery whereas here you've got a mixture of daylight and electric light?

I don't think the difference in lighting is mainly responsible for the difference in perception. What is more important is that the three pieces at Dia were placed so that you couldn't get back from two of them more than five feet. Dia is a room whereas Bilbao is a hall. The light did contribute to the feeling of compression. It was funnelled through skylights and the shafts of light made for a more cavernous container. I did not want any electric light. The space here is very open, you can sense the circulation, you can stand back and away from each work. Once you walked through the door at Dia, you could not get out of the spaces of the sculptures, you were always within their spatial field. There's more fluidity but also more disjunction in the surrounding space here, particularly because the installation clusters three *Torqued Ellipses* in the front and five in the back and you have *Snake* in between. The works had to be located on the floor so as to straddle the support beams below ground, which means that their placement was determined by the structural limitations of the load-bearing capacity of the gallery. So I couldn't possibly achieve the density of the arrangement at Dia or the more even distribution of the installation at the Geffen in Los Angeles. Also here you have curves answering curves, not curves in contrast to straight walls. The *Ellipses* don't look as hard here and the ceiling detracts from the delineation of the top edge. Your eye tends to bounce from the curves of the sculpture to the curves of the architecture.

1997–99

In our first interview, when I'd only seen pieces out of doors, you were very emphatic that they had to go indoors. The reason you gave was the importance of having a vertical in relation to which to see the leaning walls.

I still think that they work better in relationship to straight vertical walls than to curvilinear walls and ceilings. The curvilinear architecture and its busy baroqueness detract from the exterior volumes of the sculptures. In the ellipses you have the outside of the outside, and then you have the inside of the outside on the outside, and then you have the inside of the inside, and then again you have the outside of the inside on the inside. These pieces continuously ask you to pay attention to their surface as it moves from what you would think is an interior form to an exterior form. In some way they become topologically continuous. That continuity breaks if you start relating them to the rhythms of curvilinear walls and ceilings. Also, the curvilinearity of this room is a little soft, a little like cheesecake. If anything, the precision of the *Torqued Ellipses* points to the shoddiness of the drawing in the architecture. The detailing of the sheet-rock is shabby.

We're now in Torqued Ellipse II. *I felt at Dia that this piece was tremendously static, tremendously independent of you, didn't impinge upon you, the spectator, the way that* Torqued Ellipse I *did, and that it had this wonderful kind of indifference to your presence. Here it's a very good example of how the increase in the space above a piece makes it look taller: it is even grander than it was at Dia, and more imposing and more self-subsistent.*

There's another reason why this *Ellipse* is static. It differs from all the others in one poignant and particular aspect. The opening into all the other sculptures occurs at the tangent where the top ellipse overlaps the bottom ellipse; in that case one side of the opening leans towards you while the other leans away. Here, in this *Ellipse*, the opening occurs on the *major* axis and both sides of the opening appear parallel, which means that as you enter into the space of the sculpture, you're not entering into its torque. You immediately see and sense the entire volume and only after you have walked it do you notice its torque and rotation, which is very subtle, whereas in all the other *ellipses* you are immediately

pulled into their movement as soon as you enter.

Now we're in the third of the Dia pieces, Double Torqued Ellipse I.

The work came together so precisely during the bending process that we didn't have to flame-heat to perfect the curvature. The heat treatment leaves torch marks, diagonal lines on the surface, and the steel has to be sandblasted to obliterate the line scarring. If you didn't sandblast, the scarring would interfere with the reading of the rotation of the ellipse. Since we did not need to sandblast this piece the mill scale is still on, which accounts for its grey, leaden, heavy look. I prefer the mill scale to a sandblasted surface. The steel looks heavier, it reinforces the volume. When we shipped the Dia *Double* from LA to Bilbao we wrapped the plates in order to protect the surface and to maintain the grey leaden colour. However, on the high seas water spilled into the hold, and on to the inside of the plates where the wrapping had ripped. That's why floods of oxidation cascade down its interior walls and give it a range of colours different from any other sculpture in the exhibition. The colour changes from ambers to oranges, to greys and blacks. I have never seen this combination of colours before, from vegetable marrow to burned wood to fall mud. It's not the colour of painting, it's more like alchemy. The interior looks like it has been burnt. Usually I don't pay that much attention to the colour of the steel, since I know that Cor-Ten oxidises over a period of six or seven years, and during that time the surface colour changes continually. The steel slowly turns dark, dark brown, then dark amber, and finally almost blackens, and that's the colour that will remain when the surface seals itself. So I don't concern myself with the evolution of the process. It's just that I happen to like the particular state that this sculpture is in at this moment. It's totally subjective in that it relates to experiences I've had in the past, and brings up a host of metaphorical associations. The steel weathered in a way that makes the sculpture richer than it was before. That is not always the case. There were pieces at the Geffen which were so striated with different colour combinations that it distracted from the experience of their volume and their torque.

The character of the piece is now, for me, radically different from what it was

at Dia. Because of the much hotter colour, the interior is much more earthy and less ethereal.

I think that's right. And more grounded. And it allows for a bigger range of reactions. Not only do you experience its volume as moving and turning as you turn, but you also get involved with the particularities of the surface oxidation. This is, as I said, the only piece where I was concerned with its colour even though I know that it won't stay the way it is, that it is going to change again.

And the beauty of this is it that it happened by chance, that it happened beyond your control?

Yes, it had nothing to do with me.

And you prefer it the way it is now?

I prefer it to the way it was before.

If you had not preferred it, would you have done anything with chemicals to change it?

No. There's a piece here, the very last piece I made, which hardly oxidised. After it was sandblasted it was immediately shipped from Germany to Bilbao and wasn't exposed to the weather for any length of time. It's yellow-orange now, a colour which puts me off, but there's nothing I'm going to do about it. It will change in time.

We're now in Double Torqued Ellipse II *and it seems to me that this is the one of the three* Doubles *in which the drama goes on in the corridor rather than in the interior ring.*

The corridor is extremely tight, it narrows to only twenty-eight inches just before you enter the inner ellipse. You have to measure your steps and break stride. The counter-step tends to throw you off balance.

Given the precarious nature of the walk through the corridor, have you any

preference as to whether people go round it clockwise or counter-clockwise?

The passage is equally narrow on both sides of the opening into the inner ellipse, so it shouldn't really matter whether one walks in one direction or the other. I feel that it is less destabilising to walk the passage clockwise. But that might just be my preference, although I think it's a natural impulse to walk to the right.

I'll go and try that later.

This *Double* is the most claustrophobic and the most psychological of all of them. It tends towards Surrealism in the sense of its heightened anticipation. It's lower and has a very tight stretch to it. It is more compressed but at the same time turns quicker, and its torque is faster than in all the other *Doubles*. It's the most unsettling and unknowable of the three *Doubles*. Walking through its corridor is irritating, it makes you feel uneasy, and entering the inner ellipse does not give you any relief. You're contained in a space that doesn't reveal itself readily, you still feel like you're caught up in the drama of how it is unfolding. You can't assimilate this *Double*. You never get rid of your vertigo. It's the most unstable.

Of the Doubles *or of any of them?*

I think of any of them. It's almost overly affective. It's geared to pricking you into reacting. It's the easiest piece from which to get an immediate charge. As a result the process of perception is not as protracted as it is in other *Ellipses*. *Double Torqued Ellipse II* represents an extreme. After the first *Double*, I wanted to get to the boundaries of where I could go in the opposite direction. The *Double* that follows *II* is a rebound in that it is very static. Before I made the third *Double* I made *Torqued Ellipse V*, which is a big drum, because I was curious to see a large cylindrical static space. The second *Double*, in dictating how you move, is most like a Skinner box: cause and effect. But there are people who prefer this *Double* to all of the others and it is definitely one of the works that I think about a lot.

I certainly agree with you that this is the most claustrophobic, the most impinging of the pieces – it really squeezes in on you – but I don't share your criticism of it as being excessively emotive and also I don't agree that it's the most vertiginous; I'll tell which I think is that when we get to it. But what I'd like to do is to break the chronological sequence and go to Double Torqued Ellipse III *because I think that the contrast is so telling. It does indeed look as if this third* Double *is a deliberate antithesis to the second.*

The third *Double* is very static. It feels very archaic. It's very vertical: in fact, its content lies more in its verticality than in its torquing. When you're in this piece you almost sense that you're in the bottom of a shaft. Its quality is that of light moving upwards. If I had to name another artist whom it has any relationship to, it would be Barnett Newman. That might be presumptuous on my part but I do think that this *Double* has a quality that I find in Newman's paintings in that its perception has to do with centring oneself in relation to a vertical entity. The space of its interior passage is very generous: it measures between three and five feet, and two people can walk through side by side very easily.

About its stability: when you walk round the corridor, there always seems to be space to spare, and you somehow know all the way that there are going to be no dramatic surprises which will change that.

There's more release in this piece. It's not about anticipation. You are more at ease in this piece.

Absolutely. 'At ease' is right.

This is the most generous of the pieces, I think.

It's the most serene of the pieces.

I have a great fondness for its space. I like to come back to it.

When we were talking before about Torqued Ellipse II, *I was saying how its self-subsistence gives it an air of indifference to our presence. It sort of asserts itself against us, is like a* noli me tangere, *and makes us feel uneasy. This*

323

present piece also has an impressive self-subsistence, but it presents us with a very serene place to be in. It makes me feel very much at ease to be contained in it, as with a fifteenth-century Indian Muslim tomb.

Without being architecture, this sculpture relates to architectural containers I've been in, particularly in Greece, in Mycenae. It starts to call back something of Mycenae.

Do you mean the Treasury of Atreus, the Tomb of Agamemnon?

Not sure. I don't recall a specific tomb or place, but once this piece was up I recognised an experience that I'd had in Greece: I don't mean classical, I mean ancient, Greece.

Can you say anything about the proportions that explains the way the piece works?

Longitude and latitude differ only by approximately two feet, so the ellipse tends to read as more circular and the walls don't shift in and out as much as it rotates in elevation. You don't follow the rhythm of the plane as it bends around. The volume, the void, is the active driving force moving upward. The torque is almost ineffectual, the volume takes over and drives the weight of the piece upward. This piece has an incredible lift and vertical thrust to it. You immediately raise your head and look up when you walk in. The opening reinforces the notion of the upward movement in that the edges of the plate are almost vertical and parallel.

Now we're in Torqued Ellipse IV, *the one that's going to the Museum of Modern Art. This is the most open of all the series, the most spread.*

This *Ellipse* has the greatest difference between longitude and latitude, which gives it a tremendous torque. It's the most horizontal, and the most satisfying from both the inside and the outside. It has a bigger range of inflection than any of the other pieces and a more noticeable stretch. Its walls seem to be made of a malleable material, of something other than steel. Due to its large spread its shape looks truncated. It is actually lower than any of the other pieces. You could compare the driving force

that forms its skin to your fist pushing into a malleable surface and shaping it by the turn of your elbow. The feeling you get as you walk through it is that it's moving laterally away from you. Your perception is propelled by the movement of your hips, not by your trunk. Number *IV* has more athleticism to it than the other pieces.

It stretches you, it stretches your body. There are other Ellipses *where an illusory movement of the walls is analogous to the movement of muscles in the body, but this one is unique in the way it creates a very definite pull in both directions, a stretching of your length.*

Your gesture is different in this piece. You take larger strides as you walk its length.

Well, it has the quality of a stadium. It's as if it is open to the skies, and it gives you a great feeling of release. It's like being out of doors.

That's right.

And now we're in Torqued Ellipse V.

This piece was the first that was fabricated in Germany. It was made in relation to the very open and sinuous qualities of *Torqued Ellipse IV* and it was followed by the very static *Double Torqued Ellipse III*.

I'll tell you what's it's like for me, this piece: it's like a great barn. It has a sense of enormous size, but of a huge indoor space as against the feeling of a stadium in Torqued Ellipse IV.

This is a big container. It doesn't have the classical quality or the vertical thrust of the *Double* that followed it, even though it's very high. It has a boxy volume. It's the most volumetric of the series. But it doesn't have the nuances of the other pieces nor the richness of the raw metaphors. It's very static and blocky.

Well, that's why I say it's like a barn, and that's what I like about it, that it's a building, not a piece of architecture. It has no pretensions, it's

325

just a wonderfully large generous space.

This is the most flat-footed of all of them.

But that's its charm.

It's the least evocative in terms of metaphor. It's big, blocky, volumetric, and as you walk into it you are confronted by the substance of this almost cylindrical contained space. I like the substance of its volume, but I don't like its lack of potential for thinking about other things; it remains too static for me. The resolution of number *V* for me is the last *Double*, where I used what I learned in this piece to make a space that would not only hold the volume but simultaneously create a vertical lift.

But I don't think you should underrate it, because, while the Double *has more refinement, this has got a wonderful primitive generosity.*

I think *V* works very well in the context of this installation. Since I had to group the pieces according to the substructure of this gallery, I had to overcome a hollow in the installation because there is a section of the floor that does not have sufficient load-bearing capacity. I decided to place the biggest volume next to the area that had to be left empty hoping that it would hold that space. In placing number *V*, I was mainly concerned with its relation to the architecture of the room as a container in a container.

We're now in the final piece here, Torqued Ellipse VI, *and this is the piece that for me is easily the most vertiginous.*

This is one of the three pieces in the series that I prefer, along with *Torqued Ellipse I* and *IV*. It's very different from *I* in that the torquing isn't the issue, the containment of the space is the issue. In that way it's comparable to *II*, although in *II* the opening is on an axis, whereas here it's on a tangent, but, since the rotated ellipse is very round, that hardly matters.

When we were talking about Torqued Ellipse V, *you said something about*

326

feeling 'confronted' by the substance of an almost cylindrical space. And when you used that expression I disagreed with you in my mind because I don't think the thing does confront you; I think it contains you. You do often get with these sculptures a feeling of confrontation with a sloping wall or a curved wall, but for me there's not a sense of confrontation, either in Torqued Ellipse V *or in* Torqued Ellipse VI. *There's a sense of containment, the thing is all around you, you're as aware of what's behind you as you are of what's in front of you.*

VI doesn't have the generosity of the longitudinal openness of *IV*; on the other hand, it has a large moving volume, and it has a six-foot overhang. In the combination of torquing and volume it is more successful than any other single *Ellipse*. The particular rotation moves the volume upward and torques the field at the same time. This piece is like a bellows. You sense that the air in the inside is pushing the skin out and that the outside curvature is being driven by the torquing on the inside. It's the least diagrammatic. Within four feet you find that the piece has shifted from a shape that appears vertical and truncated to a shape that seems to be falling away and opening. This piece has the most satisfying external movement of any of the pieces for me other than number *IV*, and it has the most satisfying interior volume. Number *VI* comes closest to what I've been driving at in the singles.

JEFF KOONS

A bipartite interview recorded February 2000 and November 2000 in New York City. The first part was edited for publication in *Jeff Koons: Easyfun-Ethereal*, the catalogue of the retrospective exhibition at the Guggenheim Museum, Berlin, October 2000, and that version is reprinted here. The second part has been edited for publication here for the first time.

Jeff Koons, 2000. Photograph by Reinhold Kaufhold.

JEFF KOONS 2000

I

DAVID SYLVESTER *When you were first working on the* Celebration *series [1994–present], there was sometimes quite a team of assistants. How many assistants did you have on your recent series of paintings, which are a part of* Easyfun *[1999]?*

JEFF KOONS I had one person on the colour table at all times, mixing colours as we went along. And then I had three people painting, and at times, with myself, four, and even another assistant stepping in.

With the Celebration *paintings, you'd often explain where you were with a piece by telling me what you were telling the assistants about the changes that you wanted. And I was always struck by the precision of it, by the way you were able to define exactly what you wanted and exactly what you did not want and why.*

You know, art, to me, is communication. I try to communicate to the assistants, and of course the assistants who are with me now have worked with me over a long period of time, and they know what I'm looking for. To communicate ideas, verbally or visually, you have to repeat. So I'm not afraid to continue to let everybody know what I'm looking for. I hope that the work, when it presents itself, continues to state what its ideas are.

With these three new paintings [from the Easyfun *series], were all the ideas ready before you made any of them?*

There was an image that I saw, which was of a cutout. Like if you go to an amusement park or a fair, there might be a board that's painted – maybe it's an astronaut – and you put your head through a cutout in the plywood, and then you're the astronaut. Anyway, this image I saw was of a workhorse, and I really liked it. So I kept it for a long time, because I love two-dimensional sculpture, and I knew that I wanted to make a

painting with this idea of a cutout. This was the first of the three, and I called it *Cut-Out*. Then, I guess, the second one that I started to develop was *Hair*, and the last one was *Loopy*. They all have their own texture, and they're kind of dealing with different aspects of abstraction.

Did you find the cutout of the horse in a photograph or in a Disney image, say, or on a cereal packet or anything?

The idea came from a photograph in a newspaper. The image is slightly manipulated. I wanted to pick up aspects of the workhorse, so I put in these little iron things and threw in a flower in the hat – things like that. My painting is really, for me, about my background. I was trying to show that I come from a provincial background. Eventually, over a period of time, the provincial always wins. When I've made other bodies of work in the past, or images, I've worked with things that are sometimes labelled as kitsch; but I've never had an interest in kitsch *per se*. I always try to give the viewers self-confidence, a foundation within themselves. For me, my work is about the viewer more than anything else. My work, I think, is a support system for people to feel good about themselves and to have confidence in themselves – to enjoy life, to have their life be as enriching as possible, to make them feel secure. I mean, what I really try to do is to give people a confidence in their own past history, whatever that may be, so that they can have enough self-respect to move on, to achieve whatever they want. There's Mount Rushmore in the back of *Cut-Out*, that's kind of saying, 'If you want to grow up to be President . . .' And the cereal exploding with milk behind: that's just optimism. You can put your head through a cutout and for the moment become whatever you want to be. Mount Rushmore in the sky, I painted the sky there. I looked at images from *Winnie the Pooh* and different colourful images like that, again, to give a very optimistic feel to it.

It has great elation. And it's nice that instead of a head coming through the hole, there are a lot of Cheerios.

The texture of them is such that sometimes you look and they could even be bagels. I wanted this painting in particular to have this texture, like a cutout. A cutout would not have a perfectly defined surface. It's

something that would be done rapidly, because it's just used at an amusement park or a fairground. Nobody's going to labour on it too long. So I don't know if they're Cheerios; they could be bagels. I mean, the texture gives it just this little bit of abstraction.

And in Hair, *where did the hair come from?*

The hair came from an ad in a magazine – a coupon-type ad. It was originally of a blonde. Trying to create more of an image of Everywoman, I changed it from blonde into this kind of brownish colour with blonde and red highlights and brunette aspects. The cookies came from, again, those coupon-type advertisements in the newspapers. The background came from a box for an inflatable toy, that sort of image where people are in a pool, with young children playing with an inflatable toy. For me, that painting's about sexuality. When I look at it, I always have to go to my mouth and feel like I'm pulling a hair out of it.

The chocolate-chip cookies are a very erotic image or an alternative to a very erotic image.

I've always loved the *Venus of Willendorf*, and I think *Hair* has that aspect of fullness.

And the whipped cream and cherry in Loopy?

Loopy is a collage of a rabbit along with whipped cream and a cherry. I also added a face made out of cereal. But it was more like a spatial abstraction that I got involved with. Then I have these whiteouts that are kind of John Baldessari-type circles. But, because of their placement within the collage, some are overlapped by the cereal and some are right on top of the image.

Did the cereal remind you of the basketballs in the Equilibrium *series [1985]?*

Yes. I mean, as far as it's floating in space there. And even the whiteouts reminded me of them too. But I wanted to make this painting a very

aggressive, visual painting. I love Pop art, and I really want to play with aspects of Pop. So much of the world is advertising, and because of that, individuals feel that they have to present themselves as a package. The work gives them a sense that they really feel they are packaged, like this cherry.

Childhood's important to me, and it's when I first came into contact with art. This happened when I was around four or five. One of the greatest pleasures I remember is looking at a cereal box. It's a kind of sexual experience at that age because of the milk. You've been weaned off your mother, and you're eating cereal with milk, and visually you can't get tired of the box. I mean, you sit there, and you look at the front, and you look at the back. Then maybe the next day you pull out that box again, and you're just still amazed by it; you never tire of the amazement. You know, all of life is like that or can be like that. It's just about being able to find amazement in things. I think it's easy for people to feel connected to that situation of not tiring of looking at something over and over again, and not feeling any sense of boredom, but feeling interest. Life is amazing, and visual experience is amazing.

It's very interesting how certain artists of our time have dealt with childhood in some ways more precisely than it's ever been done before. Magritte constantly reminds us of various childhood activities and games. Johns's work seems to me to be about a lonely childhood, about a child alone in the schoolroom. It seems to be about a very sad childhood. Your work seems to be about happiness and excitement in childhood. Did you in reality have a happy childhood?

I think other people could have had a much more painful childhood than myself. I have fond memories of my childhood, and I think of those years as supporting. I know that I deal with that experience within my work.

I have a son, and art is such a wonderful experience to be able to watch occur in young children. My work has continued to go in this direction. It's about being able to create a work that helps liberate people from judgement. First of all, the art has to make them feel that it isn't making any judgement on them. Then, it has to free them to have the confidence to understand that judgement being placed on them in life is irrelevant; there's no place for it. So sometimes when I'm with my son and he's

making a drawing, he'll pick up a dark purple marker to put in an area. And in my own mind I'll think, 'If only he would use the orange, it would be so much nicer.' But then he'll use that dark purple, and it's beautiful. Just because of this confidence and this sense of self, it can't be wrong. I try to give my son this self-confidence that he can't do anything wrong. I mean, if he's making a mark and put something down and then tears it up and says, 'That's not right,' I'll say, 'Well, why is it not right?' 'Well, it's not right.' 'Well, you now, you're in control of this. And if you take your arm and you do this, it's right.'

So when I made my sculpture *Play-Doh* [1994–present], I was very consciously trying to make a work that's about no judgement. You know, the viewer can't judge it, and it can't be wrong. It's just this mound of Play-Doh. You know, the intentions were good in doing it. I tried to give myself all the freedom of piling it up.

The preoccupation with experiences of childhood goes back a long way in your work. But do you think it's been altered by closely watching, as you have, your son playing? Are you conscious of how watching Ludwig play has affected your work?

Absolutely. The education that I've gotten back from him is like tenfold. I mean, it's like an avalanche or a tidal wave. I've always been aware of art's discriminative powers, and I've always been really opposed to it. It's just helped me simplify my method of being able to deal with that, and to try to go against this discriminative power of art.

I was very excited to see the Easyfun *series we've been talking about because over quite a long period I've been seeing the* Celebration *paintings and loving them, and the* Celebration *sculptures even more. They've seemed to me to get better and better; in your continuing to work on them, there was nothing neurotic or obsessional about it, but you were actually making those paintings and sculptures better. It's been gratifying to see how, in these three new paintings, you've gone off on another tack. But what's going to happen, or what has been happening, to the* Celebration *works? I know you have had difficulties with the sculptures.*

What happened with *Celebration* is that originally it wasn't going to be a

huge body of work. And for a variety of reasons, it developed into a larger body of work that was going to be exhibited at the Guggenheim in New York. So the project demanded more work and time than a normal gallery exhibition. But we ran into financial problems. It's not that I didn't do my work, or that I was being too obsessive about my work. At the end of the day, the problem came down to increased costs for fabrication that were beyond our control. David, I believe in art morally. When I make an artwork, I try to use craft as a way, hopefully, to give the viewer a sense of trust. I never want anybody to look at a painting, or to look at a sculpture, and to lose trust in it somewhere. Now, let's say it's a sculpture. Typically, the attitude is that you pay attention to the front of a sculpture, and at the back, where somebody doesn't see it; well, you can get away with not doing so much. I would never want anybody to walk around and look at the back and feel that something was missing, that less support was there.

It's a shame the work was not able to be realised for the show that was originally planned. But I really love the *Celebration* work, and I'm happy that the pieces have started coming out, so that the public is able to see them.

Peter Schjeldahl has said that if there was an artist today whose work should be in every public place, it was you.

That's kind.

I'd like to see that happening with the Celebration *sculptures.*

I enjoy seeing them come into this world, and I look forward to seeing the public respond to them. Because, as I was saying earlier, it's really what they carry away about themselves that is the work. One version of my *Puppy* [1992] is in front of the Guggenheim Museum in Bilbao. Its location is the high end of where public sculpture may be. Another *Puppy* is going to be at Rockefeller Center later this year. This is an incredible location. At one point, there was even talk of it ending up in an entertainment complex in Arizona with a sporting arena for a hockey team and huge theatres for films and shops. When I first realised that this was going to be the home of *Puppy*, I thought, 'Mmm . . . I don't know.'

Maybe I always thought a city would get it for its park or something. Even though *Puppy* is not going to end up in the entertainment complex, I really just came to the realisation that every place that public sculpture goes is really similar today to a mall, or it's a commercial environment.

My own art is about aspects of entertainment. I believe that one of the increased interests in art today is not just economics but that the form of entertainment that art's providing is more passive than other competing things. The passivity of television is something that art is kind of fulfilling. Because even though we speak about the Internet as a kind of public entertainment, the Internet is not passive. There's a lot of layering. To get the information you want, or if you want to communicate, you have to keep going; you have to keep doing. Whereas art is a more passive type of experience physically. Mentally, it's maybe not passive, but physically it is.

Your work often makes me think of the Baroque, and you've said the same thing yourself.

I have always loved the Baroque, because I love the negotiations in the Baroque: the symmetrical against the asymmetrical, the aspect of eternity through spiritual life or biologically through procreation.

The Baroque does give one confidence and comfort in existence, does it not?

I think so. But the Baroque for me has always placed the viewers in a state open to intervention. It gives them enough confidence and security to do that.

When we were in the studio earlier, there were the plasters of some of the Celebration *sculptures, and I felt I was walking from one Bernini fountain to another. Also, you showed me the* Play-Doh *painting [1995–present], which you've started working on again, and that is an utterly Baroque work. The weight of those volumes yet at the same time the éclat, the explosive vitality, this combination of solidity and upward movement is very Baroque.*

With *Play-Doh* and the other *Celebration* paintings, I started with photographs that I shot from little setups, almost like a form of still life,

and then from that I made a projection on to the canvas and put the basic proportions there, and whatever else I could still pick up from the photograph. Then the paintings went through this process of being stylised into a kind of superrealism through a kind of paint-by-numbers method. It's not that we were laying numbers down there, but specific shapes, so that there was no blending, so that it was all hard edge against hard edge. But you have to continue to be able to create ways to make breakdowns – to have something go from light to dark – so that it doesn't become Op Art in style, and so that it works in kind of a highly superrealistic way. I mean, that's my goal. But they still have a colouring-book-type quality. They're bright, and they're very Pop. They maintain an innocence about them.

Going to sculpture, tell me about that recent small piece called Split-Rocker *[2000].*

It comes from a polyethylene rocking horse. I like the title, *Split-Rocker*, because you think of maybe a rock star having a split personality or a person with a schizophrenic quality. But it's really an innocent image that at the same time is menacing. My son happened to have this rocking horse, and when I was working on *Shelter* [1996–97], the painting, I thought I needed something for scale in the background, so I used that. Then I remembered another rocker that I had found, which was a dinosaur. So I would lay in bed, and I'd think it would be great just to cut them down the centre and put them together, and then put the bar back through the handle. So I finally did it [in *Split-Rocker*, a sculpture from the *Easyfun* series]. Because of the nature of their forms, the horse has an eye looking out to the right and the dinosaur's eye is looking straight forward. So there are references to Picasso. I love two-dimensional sculpture, such as Picasso's wooden pieces and Roy Lichtenstein's sculpture. But for *Split-Rocker*, what I was really interested in was the split, where there actually isn't any form, that interface where the overlap occurs. The space between the two is really what I was interested in. Though the piece has a sweetness, it also has a Minotaur-type quality to it, or a Frankenstein-type quality.

So along with the allusion to the rocking horse, and along with a certain

comic quality, it has at the same time a menace, even a horror.

I think that's in a lot of my work, David, even though pieces sometimes can seem so optimistic. Like *Balloon Dog*. It's a very optimistic piece; it's like a balloon that a clown would maybe twist for you at a birthday party. But at the same time it's a Trojan horse. There are other things here that are inside: maybe the sexuality of the piece.

Or even like the sculpture of *Play-Doh*. It has this external aspect about it, but it's actually a sculpture with twenty-five separate sections that lay on top of each other. The inside of the sculpture, to me, is as important as the outside, because it's like the subconscious of the piece, the internal reality of the piece.

You talked a lot about your work giving comfort and reassurance. But the force with which it does so is surely dependent on its always containing a dark side: the id, if you like. As well as being affirmative, it is also disturbing and shocking.

I never consciously sit down and try to create a work that is optimistic and that at the same time has a dark side. I just follow my intuition. If I am feeling a little down or something, my images probably present themselves as happier or more upbeat. But I'm not doing it on a conscious level. I think that I'm doing it on a truthful level. I hope that my work has the truthfulness of Disney. I mean, in Disney you have complete optimism, but at the same time you have the Wicked Witch with the apple. I don't tend to be pulled towards the idea of making a menacing work, but if I ever was pulled to that, I'm sure that it would also have this other aspect connected.

With my early work, I was always making an effort to remove the sexuality. Like with my first inflatables – say, the rabbit and the flower [*Inflatable Flower and Bunny*, 1979] – I felt that I just wanted to keep removing my own sexuality, this more subjective aspect of my work. That's where I got pulled to things like vacuum cleaners and basketballs, these kind of ready-made objects. But sexuality is such a tool, and I try to use it in an objective way. A communal sexuality, not just mine.

The vacuum cleaners are very sexual.

They have kind of a male-female aspect. They're anthropomorphic. They're like lungs, breathing machines. I went and did the *Equilibrium* series because I wanted to do work that, again, was distanced more from my sexuality. From a consumerist standpoint, I wanted the work to be more related to male consumerism, whereas vacuum cleaners are more geared towards female consumers. So I did the *Equilibrium* pieces, which are all in browns and oranges and have a sense of the weight of bronze. The basketball hovering in the tank [*One Ball Total Equilibrium Tank* (1985)] is like a foetus in the womb, it's an ultimate state of being.

After doing my *Equilibrium* show, the next work I did was the *Luxury and Degradation* series [1986]. It was the first time I'd worked with stainless steel. I liked its proletarian quality, pots and pans are made out of it. I was walking down the street and saw this ceramic train filled with Jim Beam and I thought: 'This would be a great ready-made.' So I cast it and went back to the company and had it filled with bourbon and sealed with the tax stamp [*Jim Beam–J. B. Turner Train*]. Because, for me, the bourbon was the soul and the tax-stamp seal was like the interface to the soul. It was about creating something that you'd desire. I wanted to create work that people would be attracted to. There was a wide range of works: I made casts of a pail with liquid measurement [*Pail*], a little bar tool kit with swizzle sticks and stuff [*Travel Bar*], and a Baccarat crystal set [*Baccarat Crystal Set*]. In the 1960s, people would travel with their liquor with them. The higher you went economically, the more luxurious the objects they used to carry it became. The *Jim Beam–J. B. Turner Train* was like the middle class. I also found all these liquor ads that were targeted to drinking audiences at different income levels: at like a $10,000 income level, which is the lowest level, targeting people for beer and cheap liquor, up to the highest, at $45,000 and up, targeting people for Frangelico. So I had these images made into paintings. It's very clear in these liquor advertisements that the more money you make, the more abstraction that's laid on you. In this series, I was telling people not to give up their economic power – that this pursuit of luxury was a form of degradation and not to get debased by it but to maintain their economic power. I was really telling people to try to protect themselves from debasement.

After *Luxury and Degradation*, Ileana Sonnabend asked a group of artists – there were four of us – to make an exhibition at her gallery, so I

did a body of work called *Statuary* [1986], and to me, it was a panoramic view of society. On one end, I had Bob Hope, and on the other end, I had Louis XIV. But I was really trying to show the history of art since the French Revolution. Also it was saying that if you put art in the hands of the masses – which Bob Hope was a symbol of – it'll become reflective of mass ego and eventually just become decorative. On the other end of the panoramic view, if you put art in the hands of a monarch, it'll reflect the monarch's ego and also eventually just become decorative.

Rabbit, made the same year, was art as fantasy; maybe you could say it was Surrealist, but I thought of it as art as fantasy. The same year, I made *Two Kids*, which was art as morality, and *Doctor's Delight*, which was art as sexuality, and *Mermaid Troll*, which was art as mythology.

Then I did *Banality* [1988–89] for Ileana. That was in wood and porcelain and was a collage of dislocated images. In *Banality*, I was trying to tell people to have a sense of security in their own past, to embrace their own past. This was the most direct way that I started to speak about people not letting art be a segregator. I felt the bourgeoisie would embrace these images because all advertising at the time was really using a lot of dislocated images. If you think of a Newport commercial – with someone carrying a watermelon on their head and smiling or maybe playing a trombone – people should embrace this, and just kind of accept this within themselves.

After that, I made *Made in Heaven* [1989–91], and *Made in Heaven* was really about coming to appreciate the Baroque and the Rococo. I love Fragonard and Boucher. I also love Manet very much. I just wanted to make a body of work that was extremely romantic and in the Baroque and Rococo traditions. I never planned to make work that was going to be shocking. Masaccio's *Expulsion from Eden* was a very important painting to me as a basis for my *Made in Heaven* work. I believe very strongly that what I was doing was desexualising the sexual aspect, which was explicit, and sexualising things that are normally not sexualised, like the flowers and the animals.

Then I made *Puppy*. *Puppy*, for me, is a very Baroque work, where I have a certain order and control in creating the piece, but, at the same time, eventually I have to give up all control. It's a very spiritual and joyous piece.

341

You want the work to be joyous in impact. But it's also disturbing and ambivalent.

Look at the *Rabbit*. It has a carrot to its mouth. What is that? Is it a masturbator? Is it a politician making a proclamation? Is it the Playboy Bunny?

It's all of them.

Yes, it's all of them.

And the work is about that.

Well, I think that great work – and I hope that my work does this – is chameleon. That it's chameleon for whatever cultures come after it. If it's going to sustain itself or be beneficial to people, it has to be able to adapt somehow and have meaning for them. I've tried to put things of interest in my work for *this* cultural climate, *this* society, but I hope that somehow I can hit into archetypes that continue to have meaning to people. I think that the meanings change, but there's something at the core of the archetype that remains very important to the survival of humankind.

I think that your work can be seen by some as essentially aesthetic rather than as essentially conceptual.

David, actually, I see my work as the opposite. I see it as essentially conceptual. I think that I use aesthetics as a tool, but I think of it as a psychological tool. My work is dealing with the psychology of myself and the audience. 'Aesthetics' on its own: I see that as a great discriminator among people, that it makes people feel unworthy to experience art. They think that art is above them. But there are basic aesthetics that I use to communicate.

I received such support in my interest in art from when I was just a child. The first things I did were from the newspaper. Every weekend there would be a section called 'Cappy Dick', which was a little black-and-white cartoon. What you had to do was to cut that out of the newspaper, glue it on to another piece of paper, and extend the drawing

and colour it. I would enter every weekend. I never won first prize – which was a set of encyclopedias – but I'd always win a second or third prize, every week. And I loved doing that. I was always supported in doing that.

Eventually, I took art lessons. My first teacher was about eighty years old, and she was a wonderful woman. I'd go to her basement – I was about seven years old – and we would draw vases of flowers, in charcoal and pastel. Every afternoon, at the end of our session – about a six-hour session – she would take my drawing and say, 'Okay'. And she would redraw it. She'd take the eraser and say, 'See the curve on that rose petal?' And she'd erase mine and draw it. 'And do you see this colour here? What happens there?' And she would teach by showing me how to create these illusions.

My father was an interior decorator and had a furniture store, and so I was brought up with an understanding of how colour and different objects and things coming together could affect your emotions. My father loved the French provincial a lot, and in his showroom he would have different rooms: one would be a bedroom, another a dining room, another a kitchen. I would go back two weeks later and everything would have changed. Instead of being this French provincial bedroom, now it'd be a modern bedroom. This led to an understanding of how one's emotions are affected by these changes of colour, texture, design. This was the beginning of my aesthetic understanding. So my father was very important to my ending up being an artist. My mother was also very influential and supportive. Her father was a city treasurer in York, Pennsylvania, where I came from, and he was involved in politics. I got more of a political sense from my mother's side. Aesthetic from my father, political from my mother.

How did they react when you went into Wall Street?

From the time that I was a child, after school I would go door to door selling things. I would sell gift-wrapping paper and bows and ribbons, or chocolates. I'd use mail order to buy twenty packages of something for a dollar a package, and then I'd sell it for two dollars. I always enjoyed that. I always liked the idea that I could make some money on my own, and my parents were always very supportive of it. I would take my money – I

had a very large road-racing set up in the attic of our home, and I'd always keep increasing it in size. I also enjoyed the interaction with people. I'd present the product, and people would buy it, and it was nice. I felt it was a way of meeting people's needs. One of the reasons that I want to make artworks is to meet people's needs and to give support to them.

So I was always good in sales. When I came to New York, I worked at the Museum of Modern Art at their membership-information desk. I realised that nobody was selling memberships, so I just decided, you know, people could upgrade their memberships, and we could bring in more money for the museum, and, actually, the people would get more benefits. If they paid only fifteen dollars more, they'd get like fifty dollars worth of books. So I started increasing membership by telling people they could upgrade. Eventually I started bringing in around a patron a week – just by talking to people when they'd come through the door. A couple of people I made patrons said, 'You should come and work for me.'

The work on Wall Street was really just sales. There were people who were specialists and just analysed markets. I was never an analyst; I was a salesperson. I got licensed and registered to sell commodities and stocks and bonds, and that's what I did. The reason I did this was to make enough money to be able to make my artwork. I had no limit to the income that I could make. Making my vacuum-cleaner pieces cost about $3,000 each, and in the 1980s it was the only way that I could make enough money. I continued until I reached an emotional level where I could not think about anything else other than my work. I was with Smith Barney at the time, and I'd be on the phone, and – instead of prospecting to bring in a new client, or trying to have a client invest more money – I'd just be on the phone with Dr Richard P. Feynman, Nobel Prize winner, talking to him about equilibrium, asking him how to make a permanent equilibrium. I think that when you reach that point where you can't do anything else other than your work, you just have to go for it. I was fortunate enough that, when that really occurred to me, there was enough interest in my work that I was able to just do my work and receive support from the art world.

I feel salespeople are on the front line of culture. Society changes so much, and sales has changed a lot. I mean, there used to be a time when a salesman would go door to door; in America, the knock on the door

meant the Hoover man was there. One of the reasons I did my vacuum-cleaner pieces was the door-to-door salesman. Even in *Celebration*, a painting like *Pink Bow* [1995–97] makes you think about a birthday or a gift, but it's also about my own history of door-to-door selling. This is what I would buy and sell to people. And candies. Now, I haven't painted candies, but there's a lot of food in the work. I think food relates back to more of these archetypal things, the bare essentials we need to survive. Each of the *Easyfun* paintings has an aspect of food, whether it's whipped cream, or it's a cookie, or it's Cheerios or milk. And in the *Celebration* paintings, I have cake, I have popcorn, I have bread with egg, I have an eggshell.

Your ambition is to nourish.

I feel incredibly strong when I make my artwork, and so art for me is about increasing my own perimeters in life. And hopefully my work gives viewers a sense of the possibilities for their own futures as much as it does for mine.

II

Before resuming this interview ten months later, I think there's a need to explain the relationship between the two instalments. When we recorded the first, it was in order to include it in the catalogue of an exhibition at one of the Guggenheim museums, but without knowing what that exhibition was to be. It turned out, when it opened last month in Berlin, to consist of a series of seven paintings, each measuring 3 metres by 4.3 metres, and entitled Easyfun-Ethereal. *Stylistically, these pictures were developments of the three* Easyfun *paintings we'd talked about at the beginning of the interview, but were much bigger, more complex, and a great deal more intense. We're going to talk about them now for publication in catalogues of their future showings. I'd like to begin by asking how and when the initial idea for the series appeared.*

I was asked by the Guggenheim if I was interested in a commission for the Deutsche Guggenheim Berlin and I told them that I was. I wanted to continue to make paintings in the *Easyfun* series. In the past I've worked

on series where the parameters of that body of work would be defined in one exhibition, but I knew that with *Easyfun* I wanted to continue it.

And when did the idea come of doing these paintings on that particular scale?

That was decided by the size of the space in Berlin. And when I sat down to make the work, I started with seven white books, the type you open up with rings in them: binders. I took certain images that for some reason I felt were important to me and I just started by placing one image in each book. Then I'd go to my other source material and I would look, and if something had any association to any of those images, I would place it in that book. I ended up with books that were quite full. Of course, some information that was in there was irrelevant. So, when I started to study each individual book, I would just start pulling out sheets or moving one sheet from one book over to another one. I just let the dialogue within these books start to develop. For me, it's a very intuitive type process, one of just responding to what my intuition tells me: that this and that, for some reason, make sense together.

For how many weeks or months were you sorting out the material for the seven paintings?

Well, I always look at everything. If I'm walking down the street I'll stop and I'll look at a window. Last week I had to spend a half-hour in a pet shop and I had a fantastic time just waiting there looking at the packaging of the pet food. So I'm always trying to look, and I learned a lot about how gradation is used in package design, and why I think it's used. I'm always collecting source material. Some of these things I've had for a long time; some for years; some for a few weeks; and even some things from the day before. It's just putting together what is important. And some sources which I felt were really important to me and that maybe I've had sitting on my desk never made it there. But yet they're there, not directly as an image but maybe as a motivation or a direction.

Did the paintings come together as computer collages one by one, or did you work out all seven provisionally?

346

I began one by one. Then, as I would go along, I would start focusing more attention on one particular painting, collaging it together and then jumping to another one, and as soon as I would start to understand the vocabulary of that painting, the direction to go, then I would jump to another and pull it together. But I worked on all seven at one time.

How many of them were worked out provisionally before you actually started painting them on the canvases?

I don't really think that one was 100 per cent worked out before I started painting. But I would have enough worked out in areas where I knew that I wasn't going to go into them and change anything; of if there was a certain area where I knew I was going to put snowflakes, maybe three, maybe four, I would keep a space open. *Grotto*, even though it was one that I started in the very beginning, and put a lot of energy into, and really focused on a lot, was the last one I completed, and throughout the process I kept the centre open to the very end.

How are the computer collages transferred to the canvases?

After I have an image on a computer file that I like, we make a digital slide. And then the slide is projected and we draw out the image on the canvas.

I started seeing you work on the series about six weeks before its completion. I'd see you in one room working out the images on the computer while in the big room at the back there were the seven canvases with assistants painting them and these were at various stages in their progress. Did you make changes on the computer as a result of how things were shaping up in the back studio?

No. Because I have a vision of what I would like to have happen. So starting a painting before the collage was completed was just to assure that I could get the paintings finished on time. Because the whole series was done in really a very short period of time – I think in a total of about two and a half months. So as soon as I would realise – let's say for a painting like *Lips* – that I could commit to a certain background, I would

347

start mixing the colours for that. Even though no paint was being applied, all the paints were being mixed in advance. So the actual execution was very rapid.

Viewing the painted surface, the surface quality was something that I'd already envisaged. Now, when you're working on a painting, a surface can present itself somewhat to you, but it wasn't something that directed me for completion of an image. I knew the surface I wanted: the whole idea of the *Ethereal* paintings was to have a little bit of a blur, the sense of a photograph, not having edges defined so sharply – a little bit of a sense of a snapshot, something you may take with your own camera.

I remember your often saying you wanted to get rid of any cartoon quality.

My ambition with the works developed into wanting them to be everything. But there are some images that are a little cartoonish. I mean, I have a big eye in *Sandwiches*, or I have a moustache that is a cutout. But I wanted the presentation of them to have quite an adult feel. In *Celebration*, the images tend to be very youthful, but my intention with *Easyfun-Ethereal* was that this was an adult vision.

And you wanted the realisation to be as real, as physical, as substantial, as possible?

That's correct.

And you were enriching the colour with nuances all the time to that end?

I wanted them to come off as mature. And when I say 'mature', it's that I think the vision is kind of mature – an acceptance of everything. Not maybe the freshness of seeing something for the first time: *Celebration* tried to have the excitement of seeing maybe a pony for the first time. But where something can't be so defined, perceptions and definitions always have a slightly different edge, and I wanted that to be in the work. The whole time while making the works, a type of metaphor that I would think about a lot was that, when we wanted to put someone in space, to get the weight of that payload up there, the concept of the booster rocket was developed. And it was amazing, because, with the idea of the booster

rocket having one level, then a second level, then a third level, it was about letting go, throwing this away. And the objective isn't to take everything with you, but to get into orbit. And I felt that I was just letting everything go.

How many people did you have painting the canvases in the end?

We went up to forty-seven at the end. There were a lot of people mixing colour. And we had two different shifts, so the studio was going twenty-four hours a day, seven days a week, always with half the staff there working to complete the paintings. Of course I brought in people who were very able to execute them.

I was impressed by the atmosphere in the studio of attentiveness and concentration of your assistants. It was extraordinary that, with all these different people working on them, and although you never touched the canvases yourself – until, finally, in Berlin, you did some painting on Grotto *– it was as if every square centimetre of each of those canvases was under your total control.*

I started working with fabricators many years ago; I started in bronze. Prior to working with a bronze fabricator, I always made everything myself, and I was always a painter; I started taking drawing lessons when I was about seven years old. I mean, physically, I could execute these paintings, and they would look identical to the paintings that are there now. But I wouldn't have even been able to finish one painting in this time frame. So the thing is to be able to bring in a staff. And I've worked with my main staff now for about five years, so they already know what I want. And they know my vocabulary and they understand that there's no room for interpretation. When I give a source, and give a printout, or set up a system, this is how it has to be followed. And when new people come in, they're watching the new people, and I'm watching too. And so it really just comes from always being there. So I was probably getting an average of maybe four-and-a-half hours of sleep; I was putting in seventeen-hour days during the project.

You wanted everything to look as if it was done by the same hand?

349

Absolutely. If somebody isn't executing in a manner that's appropriate for the painting, they're pulled off. There isn't a detail that I'm not looking at. I stay with the paintings all the way through, and my staff always knows that I care more than anyone else.

It was an extraordinary experience to watch this happening, and to see the way in which all these different hands could be working together, towards the realisation of one person's vision. You know that in the factories of both Raphael in the sixteenth century and Rubens in the seventeenth they absolutely wanted the handling of the paint to be uniform. They wanted all those assistants – it didn't always happen but they wanted it – to be producing exactly the same texture in the result, so that the whole thing looked as if it was done by one hand.

Within the work, there's no place for an assistant to make their own interpretation. They're not there to interpret something. They're there just to follow what the guideline is that's been given to them: what the image is; and the system to execute it. And, now, if a certain person's working for me, and they have an ability . . . Let's say that they are great with backgrounds: I want them to be able to do as many backgrounds as possible. I always try to have the correct person to do that area of a painting which can benefit from their ability. You know, David, in my work as a whole, I'm interested in trying to get as much enjoyment and fulfilment out of life as possible. And interaction with people is very important to me. I mean, I don't want to be isolated in a studio alone. I like to be able to spend a lot of time working and I like to have people around me. My work deals with what it means to be alive, and relationships with other people, and I get fulfilment out of working closely with people.

Through the development of the *Celebration* works, we already knew how to break down an image into its component colours, where to blend, how to control shapes; we already had this system intact. We were already using a colouring table for the people who were executing the paintings. The colour was already being prepared – and maps for where everything was to go. This, again, is controlled. When a painter gets up there, it's not just: okay, I see that we would start with a light colour here, and we'll go dark, and this value will change here, and a hue here. It removes that

sense of interpretation, and all the colours are approved before coming off the colouring table. Sometimes you still have to go back, and you have to change colours, because maybe a colour will look one way but when it dries it'll darken and change. It's set up, and drawings are made, for where that'll go. But it's really set up so that there's no interpretation: there should be sensitivity, but not interpretation. Because I want them to be sensitive to the image. It's really just about looking, and just executing what's there, and being sensitive to that. I mean, pulling out what is there but not putting anything that isn't there. That goes back a little bit to earlier working with the ready-mades, where I didn't want to change an imperfection or a perfection within it, but I'm freer from that than I used to be. But the only way that I can work in this method, unless I'm going to execute everything myself, is to have everything laid out precisely beforehand.

One difference in Raphael and Rubens is that they did a good deal of the painting themselves. Why do you prefer not to do part of the actual painting?

It's nothing that I feel that I have to adhere to. I mean, sometimes I will. I painted on *Pot Rack*; I painted on *Cut-Out*. On *Lips* I did some of the little circles at the very end. It just has to do with following. I mean, somebody's got to be watching. When you have forty-seven people doing something, I have to be watching all the process. Also, my vocabulary isn't just the execution of it; it's also a continued conception of where I want my work to go in another area. So it has to do more with the reality of being able to be in a position where I can continue to grow as much as possible as an artist, instead of being tied down in the execution of the work.

So is your position something like that of the orchestral conductor who really hasn't got the time to pick up the fiddle and play a few bars?

Yes. Nor the real desire. I think that's very close. I mean, it's a pleasant thought to be able to sit down, and say, okay, I'm just going to execute this. But that's all I'd be able to do. When people are working on a canvas, they're too close to it. I'm not doing that. I'm seeing it from a distance, and things are more obvious when you have that distance.

351

Which was the first of the compositions to be started in the execution of the canvases?

I think it was probably *Lips*. Now, the order in which they're in the catalogue has to do with the order of the books, the way I laid them on the table. And I feel that the paintings do have almost two poles – that on one side you would have *Lips* and on the other you would have *Grotto*. I put them on the table in that order.

What were the sources of the imagery in Lips?

It comes from a wide range of things. From a box of frozen corn where I would cut out the individual pieces of corn and make into a spiral, which is an homage to Man Ray; and taking an ad of a woman from a fashion magazine and just dropping out everything other than her hair; and lips from a fashion magazine; and a photograph that was in a real-estate magazine advertising a parcel of land. But I think *Lips* is, in particular, about the Western European avant-garde and the American avant-garde of the twentieth century, and how it's impacted on me and the rest of contemporary culture.

Do you remember which was the next image that you started painting?

I started to spend a lot of time, I think, on *Sandwiches*, which doesn't mean that it was necessarily the next book that was there. I had an advertisement for a detergent product, and it had a sense of a sunrise, and I really struggled with it. I introduced the sandwiches right away, but finally I just eliminated the background and freed myself. I knew that, at some point, I wanted to put a car in there, and I wanted the painting to be a direct reference to Pop, so I put a '63 Impala Chevy there; it happens to be a low-rider. But, you know, I wanted to keep stating that. It's like a very Pop painting. Some of the paintings have the human form in them, or references to the form, whether it's lips or hair, but in *Sandwiches* there really isn't anything like that. There's maybe a cartoon moustache, not like a real moustache.

It's a bit like a moustache in a work by Arp.

Yes.

Were you conscious of that?

Well, I was thinking of Jasper Johns and Duchamp. But it's also that these two sandwiches seem to have like a male-female type identity and a flirtation going on between them. And then it has an ice-cream turkey that's in between them. I think the painting has references to heaven.

And what was next?

I think it was *Legs*. It was first titled *Legs*, and then I changed it to *Niagara*. I knew that I wanted to work with legs, and I had them on grass, but, as I was developing that piece, I was also working on *Blue Poles*, which was coming along rapidly. In a lot of these paintings I also used my own private snapshots made when I'm travelling or I see something of interest. I incorporated them into several of the paintings. I think that I wanted to have a sense of intimacy in the paintings, something connected closely to me. So at the bottom of *Niagara*, the grass is from a photograph taken at the Villa Borghese, even though it's not recognisable. Another thing I like about *Niagara* is the big scoop of ice cream, which can also have the feel of a meteor. I also used photographs I'd taken in *Blue Poles* – for the sliding board and the steel roller coaster. The photographs show blue poles and I always like to title things literally. But right away I enjoyed the connection with Pollock's *Blue Poles*. At the same time, for me, *Blue Poles* is about the children who are there – the protagonists in their costumes on a stage. One is like a lobster, which is a reference to Dalí. And their faces are cut out and circled by cereal.

But there's a sense, to me, of discontent or disillusionment that's there, even though, in the background, you have this amusement-park type activity – loopty-loop – and you have these stacks of pancakes, and packaging for morning foods is directed very optimistically: people think about the day ahead of them, so I believe that people think about pancakes as an optimistic image. But when I was working on it, I really couldn't find pancakes that were working properly. And, finally, after really trying very hard, I was able to get the pancakes to work. And they're the same set of pancakes duplicated over. So it's a kind of a reference to

353

Warhol also: the duplication of the Campbell's Soup, and the Coca-Cola, over and over. But I realised that the reason pancakes were so important to me was that it was a reference back to my Frangelico paintings. And the reference to the syrup, and the colour of the pancakes: they weren't stacks of pancakes, they were stacks of Bourbon. It's like you're sitting at a bar, and you just see the alcohol bottles stacked up there, which go along with the disillusionment, which is a reference to Pollock.

And what came after Blue Poles?

Mountains, which was one of the collages I left open, because I knew there was a certain type of cutout that I wanted to do – taking certain clothes that would be on a woman's body and to drop out the body. I wanted to work with a certain type of abstraction there. And I left that for a while, because I continued to think about it, but I actually put it together quite rapidly, as far as actually building the image. At the very beginning, the first image I put in there was the ice-cream-type sandwich, bitten out of. And a Pop Tart and an apple, all connected. Those images were in there right away. But as far as the actual form – the cutout of bikini-like panties – I did that very, very rapidly. I pulled that part of the image together in an hour or something, one afternoon, with the background. But I think that *Mountains*, to me, is about the history of sex. That's what I think of when I look at it. They do all these sexual studies: how the mind can pick up on the smallest measurements of the human body – whether someone's hip goes a couple of millimetres this way, or the length a couple of millimetres that way. So I thought I'd try it out and test it in *Mountains*. I saw an image of a woman in a pair of bikini-type panties, and I thought it was such a beautiful image, I just dropped out the rest of the body and had it hovering in the centre. And there's a scene of an ocean in the background, and the idea of human life developing out in the sea. The apple is a reference to Adam and Eve, the Garden of Eden. But there are also rocks lying on the beach, which I think gives a reference to sexual symbols, phallic and vaginal. But it also looks to me as if they could be faeces washed up on the beach.

It's a sort of post-Freudian Birth of Venus, *isn't it?*

That's a beautiful description. I like, very much, mixing food and hair and sexuality together. And I think that has to do with birth – of an opening.

You know, when things come fast, there's always something nice about that. Because the type of abstraction that I was playing with there was very nice. When I look at *Mountains* I also think of Carl Andre. There's a certain minimalism in that piece.

I liked its evocation – I don't know whether it was conscious or not – of a certain group of Magritte paintings of early 1927 – with the sea and the beach.

In *Lips* I was very conscious of Magritte, because in the folds of the hair, I would darken the hair slightly more and in some areas I'd lighten it a little bit, as I wanted the aspect of day and night, where you'd have the street scene, and it would be night, and yet you'd have the daytime sky. So there I was definitely making a direct reference to Magritte.

Hair With Cheese: *when did that appear?*

Laying across the table, it was, I guess, the second one. Even though *Lips* ended up being the one that I started painting right away, it doesn't mean that the last one on the table was the last one started, but just how the books were lined up. Actually, *Hair With Cheese* was one that we started pretty early on; I waited till the very end to decide whether I was going to put a fourth snowflake in there or not. When I look at *Hair With Cheese* I think of Salvador Dalí. And also the background there: I was looking at different grottoes and this was a waterfall that was on the path to a grotto that I also went to.

A photograph you took?

Yes.

And then I think the last one you were working on – which you were still working on in Berlin – was Grotto.

Yes. About *Grotto*. One time I was asked by a magazine in France to give my definition of happiness. I said that to me happiness is a full box of cereal and a full carton of milk. To me there's something sexual about that and hopefully it's captured in *Grotto*.

What was also important to me in making the paintings was about being able to work with the vocabulary of twentieth-century art and not feel that this was a vocabulary which is controlled by egos. If it's something which is important to society and culture, it should be a vocabulary which can be touched, articulated and used and spoken. And I tried to do that with the work. So that's why, in having an essence of Magritte there, I didn't feel like: Oh, I'm trying to make a Magritte painting. Not at all. But I was trying to be able to speak and work with his vocabulary, to try to articulate and use those sounds. Within, hopefully, a larger speech – something vast, which I was interested in. Because it's not just the Magritte vocabulary; it's also incorporating the Pollock vocabulary. *Grotto* is like Duchamp, like *Etant donnés*, with the sense of looking in through a doorway when looking through the vortex-like spiral. Also, Duchamp's very much in *Sandwiches*. And I can see Lichtenstein, I can see Rosenquist, I can see Dalí. I was trying to have the work be as vast as possible.

I always want my art to increase my parameters. I feel that this series has freed me a little bit. I was speaking earlier about these different levels of booster rockets, and I feel that I have let go of things – of whatever type of baggage that I felt that I was carrying – and to feel that I can just be more open to the world around me, through the process of making the paintings. More open to art, and just to the rest of the world. And to people. The work loves a viewer, it looks forward to somebody standing in front of it. I think that, if the paintings are in a room and the lights go out, I think they go out too; I think they leave too. And they only come back when a viewer comes back into the room. There are other works that I've made that I don't feel are like that: I don't think *Balloon Dog*'s like that; it stays in that room and it's always on. At any moment it's there, reflecting. I think these are different.

A lot of the references in them that you've talked about are to Pop artists.

Yes. What I've always loved about the Pop vocabulary is its generosity to

the viewer. And I say 'generosity to the viewer' because people, every day, are confronted by images, and confronted by products that are packaged. And it puts the individual under great stress to feel packaged themselves – enough to look back at that image. And so I always desire, within the paintings, to be able to give a viewer a sense of themselves being packaged, to whatever level they're looking for. Just to instil a sense of self-confidence, self-worth. That's my interest in Pop.

BIOGRAPHICAL NOTES
Jonathan Shirland

DAVID SMITH Smith's potent objects, often radically abstract and uncannily anthropomorphic at the same time, set new definitions for the concerns of modernist sculpture. Formally trained as a painter, Smith insisted he 'belonged with the painters' of the New York School: he painted all his life, fusing the disciplines in his coloured sculptures. Born in 1906 in Decatur, Indiana, after attending Ohio University he worked as a riveter at the Studebaker plant in Southbend, Indiana. In 1926, in New York, he met his future wife Dorothy Dehner, a modern dancer and member of the Art Students' League: he studied at the ASL until 1932, under the Czech Cubist Jan Matulka. In 1930 Smith met the Russian émigré painter John Graham, who showed him pictures of metal sculptures by Picasso and González, and he started to produce constructions of wood, wire and coral alongside Surrealist paintings, whose organic forms evoke Picasso and Miró. He made his first freestanding sculptures in the Virgin Islands in 1931. In 1933 he made welded sculptures at his farm in Bolton Landing, and a series of welded, painted heads such as *Saw Head,* the first of their kind in America. He was then assigned to the Technical Division of the Civil Works Administration, before visiting England, Greece, France and Russia for a year. On his return, he began his Medals of Dishonor series, exhibited in 1940: explicitly anti-war, anti-fascist images, whose insect-like figures and stylised landscapes were inspired by the Sumerian Cylinder Seals and medals that he had seen in the British Museum. In 1940 he moved permanently to Bolton Landing and studied welding at a wartime government school before working at the American Locomotive Company, assembling tanks and trains. In 1944 he produced *Home of the Welder.* In 1950 he was awarded a Guggenheim Fellowship. He then produced pictorial landscapes such as *Hudson River Landscape* (1951), and looming upright figures like *The Hero* (1952) before beginning the major Tanktotem, Agricolas and Sentinels series, and setting his sculptures in the fields around his house, as captured in Ilya Bolotowsky's 1954 film. In the 1960s he worked on series including Zigs and Cubis. His mature works, notable for their delicacy and intimacy as much as for their size and power, exemplified and re-worked the concerns of Abstract Expressionism. He died in 1965.

LOUISE NEVELSON achieved international recognition in the mid-1950s for her monochromatically painted wood assemblages. The fusing of the real and imaginary with geometric and Cubist foundations was central to her work. Born Louise Berliawski in Kiev, Russia, in 1899, she moved to America in 1905. Her family settled in Rockland, Maine, and their history in the building and lumber trades and her memories of Maine forests inspired her later use of found pieces of wood. She married Charles Nevelson at nineteen, before moving to New York to study painting and drama. Here she developed an interest in philosophy and comparative religion, attended the Art Students' League from 1928 to 1931 and then separated from her husband and travelled to Munich to study with Hans Hofmann. She returned to New York in 1932 and, after working as a film extra, assisted Diego Rivera with his murals for the New Workers' School and began a long-lasting study of modern dance with Ellen Kearns. In 1937 she worked for the WPA and in 1941 had her first one-person show at the Nierendorf Gallery. In the same year she began to use found objects in her assemblages, and *Sun Game* (1942) was a landmark in her shift to wood. After visiting Mexico in 1950, the wood assemblages became free-standing 'buildings' encrusted with decorations inspired by her impressions of the ruins of Mayan sculpture. Her 'total environments' date from the mid-1950s; often installed in groups, the assemblages produced the effect of an enigmatic environmental shrine, as at the 1955 *Ancient Games and Ancient Places* show. She also worked on terracotta and marble sculptures and printmaking. Works such as *Royal Tide IV* of 1960 were arranged in large sets of boxes occupying a wall taller than the viewer, and sprayed upon completion in white, black or gold paint, unifying the sculptures. In the 1960s she also worked on large metal sculptures such as *Environment IV*, part of her 'Atmosphere and Environment' series. In 1965 she presented the wall, *Homage to 6,000,000 II*, to the Israel Museum in Jerusalem and a gold wall, *An American Tribute to the British People*, to the Tate Gallery, London – spectacular relief monuments that attested to her combination of formal elegance and ritualistic power.

ADOLPH GOTTLIEB was a prominent Abstract Expressionist who distilled fundamental relationships out of a complex visual vocabulary, moving towards ever greater economy, which enabled him to achieve a

striking monumentality. Born in New York in 1903, he studied at the Art Students' League with John Sloan, who introduced him to Cubism. In 1921 he stayed in Paris, then travelled around Europe, returning to New York in 1923: his early work, such as *Sun Deck,* was influenced by the soft representational manner of Milton Avery. He soon helped to form 'The Ten' group, facilitating work on the Federal Arts Projects as an easel painter, while his friendship with John Graham fostered his interest in Surrealism, psychoanalysis and primitive art. In 1937 he moved with his wife to Arizona, where the landscape inspired a series of still lifes of cactuses. In New York in 1939, he embarked on beach still lifes indebted to 'Magic Realism', arranging shells and coral in three-dimensional boxes against irrational spaces. These developed into his 'Pictographs', composed of checkerboard compartments that evoked a sense of mythic narrative while stressing the flatness of the picture surface. The first, *The Eyes of Oedipus,* already displayed his essential dialectical tension between line and symbol-as-form, and adapted Surrealist techniques to fill up the compartments without predetermination. He and Rothko worked closely together in the early 1940s on the idea of myth, which provided a new vocabulary of de-contextualised symbols that evoked a Jungian 'Collective Unconscious'. After 1950, the grids developed into thick black lines, reaching their apogee in *Blue at Noon* of 1955. His 'Unstill lifes' of 1952–56 liberated his forms further, leading to his 'Imaginary landscapes' organised around a horizontal horizon line, such as *Frozen Sounds Number 1.* When he introduced a pairing of divergent forms, he arrived at his 'Bursts'. *Burst* of 1957 was a milestone in its monumental simplicity, with the earlier rigid formats dissolved into fluid space. The Bursts are concerned with a polarity between two distinct visual effects, normally a clearly delineated disc and a ragged lower mass, repeatedly described as 'solar' and 'terrestrial'. The works stand as a psychological manifestation of colour and form, with a sense of almost theatrical confrontation. From the Bursts onwards, he painted on a large scale, and even worked on a number of architectural projects.

BARNETT NEWMAN. An outstanding metaphysical painter and an articulate intellectual, Newman became an unofficial spokesman for the emerging avant garde in the 1940s, before contributing his own pictures, which sought to resurrect the concept of the Sublime while avoiding an

associative use of symbols. Born in New York in 1905 to Polish Jewish immigrants, he studied at the Art Students' League in 1922, and at City College of New York until 1927, where he read philosophy. Until the Depression he worked in the family clothing company, and despite meeting Avery and Rothko in 1931 he produced no works of note in the 1930s – indeed he destroyed everything he made before 1940 – but he developed his concept of truly abstract art in his writings, inspired by Worringer, including polemical manifestos such as 'On the need for political action by men of culture', and he even stood for Mayor of New York in 1933, paralleling Dadaist stunts. He began a study of botany in 1939 and began painting seriously again in 1944. His works began to coalesce into his mature format in *Genetic Moment* and *Euclydian Abyss* of 1946, which revealed a concern with themes of germination and creation, exhibiting plant, sperm and seed forms, with biomorphic shapes recalling Gorky, Rothko and Pollock. In 1948 came the groundbreaking *Onement I*. Here he rejected his earlier biology versus geometry symbolism in favour of a more absolute pictorial statement. The luminous red vertical that bisected the darker field which he came to call a 'zip' wiped out the problem of composition, acting as a visual analogue for his writings. He saw it as a channel of spiritual significance as well as a field between two other fields, rather than a compositional dividing line. The mystical sense was reinforced by the evocative title, a habit he maintained, adapting phrasings from Greek, Christian and Kabbalistic sources. Sometimes the zip broadened into a plane (*Ulysses*, 1952), located itself at the edge (*Eve*, 1950), became a pair (*Here 1*, 1950) or was used as a marker of intervals or stresses across panoramic colour fields (*Vir Heroicus Sublimis*, 1950–51). He painted little between 1956 and 1957, and then suffered a heart attack before beginning his controversial series, *The Stations of the Cross*, fourteen paintings that occupied him until 1966. During the final phase of his career he produced several large steel sculptures that echoed his use of a single line in space, including *Broken Obelisk*. He died in 1970, his work having become a catalyst for the development of colour-field painting, minimalism and Op Art.

WILLEM DE KOONING. Arguably the most potent painterly force of the second half of the twentieth century, de Kooning was famously described by Thomas Hess as having a 'Michelangelesque conscience' because of his

devouring necessity to create 'impossible' new masterpieces. His mature works thrive on violence, energy and ambiguity but these qualities are used to generate, not destroy, aesthetic order. He became notorious for his inability to 'finish' a painting, but a perpetual struggle for resolution is a central and conscious dynamic. Born in Rotterdam in 1904, he enjoyed a long academic training, discernible in his painstaking approach to drawing and celebration of Rembrandt and Titian, and the de Stijl group. In 1916 he was apprenticed to a commercial art and decorating firm, but studied at night at the Rotterdam Academy of Fine Arts. He arrived in America in 1926 as a stowaway on the SS *Shelley* and worked as a house painter in New Jersey before moving to New York, where he supported himself through sign-painting and carpentry before joining the Federal Arts Project in 1935. A friend of John Graham, Stuart Davis and Arshile Gorky (with whom he shared a studio), he was energetically experimenting, producing works influenced by Gorky and Picasso. By his first one-man show in 1948 he was producing powerful black-on-white abstractions that bore reference to Pollock, but he continued to paint his seated women of the 1930s, and added a further syntactic level by incorporating letters and numbers, and sometimes fragments of newspapers that he had used to slow the drying process. *Excavation* (1950), with its flattened anatomical 'chunks' and overpowering all-over composition, stands as the culmination of this period. Immediately after, he began work on *Woman I*, part of his most famous and controversial series, exhibited in 1953, which divided Clement Greenberg and Harold Rosenberg, the two important American critics of the avant garde. De Kooning defended the works as engagements with the classical tradition of painting the female nude and continued to pursue his monumental imagery of women in the 1960s, but in a more 'friendly and pastoral' manner. In the later 1950s he emphasised painterly gestures, enriched his colour and made his brushwork more muscular. The women gave way to abstract urban landscapes, capturing the frenzied energy of New York, as in *Gotham News* (1955). By 1960 his technique in the landscapes had developed into huge, dynamic but lyrical brush strokes, as in *Merritt Parkway* (1959). He continued to paint brilliantly into the 1980s before being incapacitated by Alzheimer's disease.

FRANZ KLINE brought new splendour to the monumentality of the

black and white image in the 1950s. Kline was born on 23 May 1910 to Anglo-German parents in Wilkes-Barre, Pennsylvania: his father committed suicide when he was three, and in 1920 his mother married the chief of a railway round-house – memories of railways, coal mining and the Appalachian landscape remained powerful in his imagination. After studying at Boston University, he travelled to England in 1935 where he became fascinated by the English graphic tradition. In 1938 he settled in New York, and began work on oils influenced by the realism of the Ashcan School, and on murals for the Bleecker Street Tavern. Throughout the 1940s Kline painted portraits and worked on recurrent themes based on childhood memories, including empty rocking chairs, seated women and trains. His first significant abstract works date from 1945–47, such as *The Dancer* (1946), encouraged by an awareness of de Kooning, Motherwell and Tomlin. Visiting de Kooning's studio in 1948, he enlarged some of his small drawings on a Bell-Opticon projector, inspiring a radical change in style. Abandoning formal representation he started using housepainters' brushes, working in monumental formats on large pieces of canvas tacked to the studio wall. His first solo exhibition in 1950 at the Charles Egan Gallery displayed stark simple forms in black and white, often in commercial enamel, with abrupt gestures, unconcerned with finish. (Many critics assumed they were influenced by Oriental calligraphy, a connection Kline denied.) The following year he exhibited with Pollock, De Kooning, Gottlieb and Still in Paris, showing dramatic works such as *Wanamaker Block*. In the late 1950s he re-introduced colour – which caused as much controversy as its earlier absence and which added to the dynamism of images like *Shenandoah Wall*, 1961. Kline died on 13 May 1962, from a rheumatic heart condition.

ROBERT MOTHERWELL. Articulate and intellectual, Motherwell was a leading spokesman for Modernism in America. His works embraced a wide lexicon of abstract imagery, exploring the expressive possibilities of signmaking, mediating between the gestural and field-painting elements of Abstract Expressionism. Born in 1915 in Virginia, he studied philosophy at Stanford University from 1932–37, writing on psychoanalytic theory in his undergraduate dissertation. Following a European tour he entered Harvard's Graduate School of Philosophy, then

lived in France, before returning to the Art History department at Colombia University where he studied under Meyer Schapiro, who introduced him to prominent European émigré artists. Friendship with Duchamp, Ernst, Tanguy and Breton encouraged him to experiment with Surrealist automatist writing processes. In 1942 he met Pollock and Krasner and the next year, at Peggy Guggenheim's urging, he produced his first collages. His early collage, *Pancho Villa, Dead or Alive* (inspired by the trip to Mexico with Matta in 1941), already engaged with his recurrent themes of life, death, violence and revolution. He produced his first nearly totally black paintings and in 1945 was founding editor of *Documents of Modern Art*, which provided translations of major primary texts about the history of European Modernism. In 1948 he founded the 'Subjects of the Artist' school in Greenwich Village with Still and Rothko before starting his own school of Fine Art, which lasted until 1950. At the same time he began his famous 'Elegy to the Spanish Republic' series, producing *Granada* in 1949. He worked on his second major series, the 'Je t'aime' works , from 1953–57, the final years of his second marriage: in 1958 he began the *Iberia* series and married Helen Frankenthaler. His writings set a serious intellectual tone for the Action Painting movement, and painting remained a vehicle for the elaboration of philosophical idealism for the rest of his life.

PHILIP GUSTON. Because of his luxurious virtuosity and comprehensive vocabulary, Guston maintained a consistent dialogue in his work between subject and abstract structure. Born Philip Goldstein in Montreal on 27 June 1913 to Russian Jewish émigrés, he took a correspondence course with the Cleveland School of Cartooning, and in 1927 met Jackson Pollock at Manual Arts High School: both were expelled for contributing to a satirical broadside. Guston worked as a movie extra, and won a scholarship to the Otis Art Institute, but left after three months. Friendship with Reuben Kadish introduced him to the Mexican muralist movement, and in 1934 he worked on a mural in the former emperor Maximilian's palace in Morelia, Mexico, before creating murals for the PWA projects in Los Angeles. In 1936, in New York, he met Gorky, de Kooning and Davis through his work for the WPA/FAP, and exposure to Diller, via the projects, intensified his interest in creating tension between surface and depth. He created murals for the 1939 New

York World Fair and the Queensbridge Housing Project on Long Island before resigning to concentrate on oil painting. In 1941 he produced *Martial Memory*, and in 1945 won first prize at the Carnegie International exhibition for *Sentinel Moment*. He continued his series of children in works such as *If This Be Not I* and *Porch II*, where the figures are flatter and abstract architectural backgrounds are brought up to the picture plane. In 1947–48 came *Tormentors*, the first of three transitional works in his shift to abstraction. After a year in Italy and Spain, he completed *Review*, where figures vanished altogether. Then in 1950, he became active in 8th Street Club meetings in New York, and completed *Red Painting*, where landscape is eliminated as well, replaced with a pattern of rectangular coloured shapes. In 1951 he taught at New York University and executed *White Painting*, his first fully abstract and gestural work. His work of the early 1950s earned the title 'Abstract Impressionism', but as the decade developed his intense re-working got the paintings to the point where, 'the air of the arbitrary vanished and the paint fell into positions that seemed destined'. In 1955 he joined the Sidney Janis Gallery, and had a major retrospective in 1962 at the Guggenheim Museum. Although considered the lyric poet of the Abstract Expressionists, after 1967 he returned to figure painting, via the influence of Pop Art, generating controversy with cartoon-like images of Ku Klux Klansmen, a subject he first painted in the 1930s. He died in 1980.

HELEN FRANKENTHALER. A prominent Abstract Expressionist and major force in the development of colour-field painting, Frankenthaler is best known for her pioneering stain-painting technique. Her diluted pigment, floated and puddled on absorbent grounds, was more serene and diaphanous than that of her contemporaries. She was born in New York in 1928, studied painting at Dalton School and Bennington College, taking graduate classes at Columbia. Among her various teachers were Tamayo and Hofmann. Well travelled, with a keen knowledge of old and modern masters, in 1950 she became a close friend of Clement Greenberg, who assisted her entrance into Abstract Expressionist circles and remained an ardent supporter. Her work is a heady marriage of ideas, imagery and facture, but her relating of forms and pictorial unity is rooted in Cubism. Her early abstract style took inspiration from Hofmann and Gorky, and from the experience of watching Pollock work:

but she had the sagacity not simply to imitate his drip technique, but to develop from it by pouring and running thin paint on to canvases on the floor, allowing it to soak into the unprimed surface. This 'soak-stain' technique became her signature style, first successfully implemented in *Mountains and Sea* (1952), evocative of the Nova Scotia landscape. After Morris Louis and Kenneth Noland saw it in her studio in 1953, it proved an inspiration for their subsequent colour-field experiments. *Eden* (1956) is typical of Frankenthaler's large-format works with its governing image of a landscape arcadia, whilst *Las Mayas* (1958), with its references to Goya, typifies the homage pictures that occur throughout her career. She married Robert Motherwell in 1958 and in 1960 started to make lithographs and woodcuts, and later worked on ceramics and sculptures. *Arden* (1961) signalled a change towards greater restraint and serenity. In 1962 Frankenthaler turned from oil to acrylic paint, allowing her to achieve more richly saturated colour and a harder edge to her canvases. Her decorative surface qualities, reminiscent of late Monet, gained her and several imitators the title of 'Abstract Impressionists' in the mid-1950s, and her work has continued to bring greater artistic validity to lyrical decorative beauty. Morris Louis, in 1953, described Frankenthaler as 'a bridge between Pollock and all possibilities'.

JOHN CAGE. One of the most innovative twentieth-century composers, and a controversial proponent of the avant garde, in place of self-expression, Cage proposed an art born of chance and indeterminacy, in which every effort was made to efface the personality of the artist. As he put it in his lectures, Cage saw the function of art as 'purposeless play' that was nevertheless an affirmation of life, letting it act of its own accord. Born in Los Angeles in 1912, the son of a well-known inventor and electrical engineer, Cage was an intellectual star, but dropped out of college to travel round Europe, studying architecture, art and music. From 1933, he devoted himself to music, his teachers including Arnold Schoenberg. In 1938 he invented the 'prepared piano', transforming it into a percussive orchestra by inserting objects between the string, and he created rhythmic structure based on duration, rather than classical harmony, with a mathematical relation of parts. In New York from 1942, he became friends with many artists including Ernst, Motherwell and later Duchamp. He began to focus on opening listeners' ears to the

sounds that surrounded them every day, a shift influenced by Zen
Buddhism, and from 1950 began to use chance as a means of getting
beyond the ego, plotting rhythmic structures based on movements along
large charts, as in *Sixteen Dances,* for Merce Cunningham. A hostile
musical establishment accused Cage of irresponsibility, but he found
allies in the pianist David Tudor, the composer Morton Feldman, and his
student Christian Wolff, who introduced Cage to the *I-Ching* or *Book of
Changes.* Its sixty-four hexagrams for obtaining oracles via tossing coins
or sticks was an approach Cage adopted in his *Music of Changes.* At Black
Mountain College his students included Rauschenberg, whose white
paintings inspired his notorious 1952 silent piece *4'33".* In the same year
Cage organised the first 'Happening' at the College. In 1960 he started to
use contact microphones to amplify various sounds, incorporating
feedback, and exploring the possibilities of magnetic tape in his
Imaginary Landscapes. In 1963 he gave a performance of Satie's *Vexations,*
repeated 840 times over 18 hours; and in 1964 the New York
Philharmonic played his *Atlas Eclipticalis with winter music;* by its end
only a third of the audience remained. From the late 1950s his exquisitely
hand-written scores began to be exhibited, and in the 1970s he worked on
engravings and drawings that recalled the calligraphy of Zen painting. He
died in 1992.

ROBERT RAUSCHENBERG. A defining force in modern art for half a
century, Rauschenberg was a forerunner of many art movements that
followed Abstract Expressionism, a persistent innovator in painting,
assemblage, printmaking, performance and technology-based art. Born in
Port Arthur, Texas, of German, Dutch and Cherokee Indian descent, he
had a haphazard education. He enlisted in the Navy in 1942 and served as
a mental hospital nurse before his discharge in 1945. After attending the
Académie Julian in Paris, from 1948 he studied at Black Mountain
College: alongside an antagonistic but important relationship with his
teacher Josef Albers, he met the composer John Cage, choreographer
Merce Cunningham, and Jasper Johns, influential collaborators in the
1950s and '60s. His innovative work already revealed enduring themes:
sequences through time, grid formats, mirrorings, contrapuntal shifts
and an awareness of the material qualities of various mediums. His white
paintings of 1951 such as *Mother of God,* black paintings of 1951–53, and

early elemental sculptures all display Abstract Expressionist predilections. Travelling in Europe in 1952–53 he produced small portable collages indebted to Dada and Surrealism, and in his subsequent 'Red Paintings' he included text and images in his abstract compositions; out of their complex surfaces came the 'Combines' begun in 1954, incorporating objects and images from everyday life, often alongside bawdy visual puns. He included animal forms, like a rooster in *Odalisk* (1955–58), and an angora goat in a rubber tyre in the famous *Monogram* (1955–59) and used commercial elements such as Coca-Cola bottles (in *Curfew* and *Coca Cola Plan*), setting a precedent for Pop Art. Early 1960s works such as *Allegory* exhibit a more abstract use of paint, and in 1962 he turned from combines to enlarged photographs silk-screened on to the canvas, and then partially obliterated by paint. For a long time he worked with the Merce Cunningham Company and created and performed his own innovative dance pieces, and he was also involved with the radical Judson Dance Theater group. He linked performance with visual art in works such as *First Time Painting* (1961), made in front of a live audience during a predetermined period whose ending was marked by the ringing of an alarm clock built into the canvas. In the mid-1960s he extended his range further in a variety of experiments concerning the use of advanced technology in the arts and has continued to be a tireless art activist.

JASPER JOHNS. With Rauschenberg, Johns is considered responsible for instigating the move from Abstract Expressionism to Pop Art and Minimalism in the late 1950s: both artists explored a powerful middle ground between abstraction and representation. Born in Augusta, Georgia, in 1930, Johns briefly studied at the University of Southern Carolina before moving to New York in 1949. He worked at a commercial art college before being drafted into the army, stationed in Sendai, Japan, during the Korean war. In 1953, he met Rauschenberg and they earned money designing shop windows, including Tiffany's. The following year he destroyed all his works, apart from four in the hands of others, including the Dada-influenced collage, *Construction with Toy Piano*. In 1954 he also met John Cage and Merce Cunningham, for whom he designed sets and costumes. The following year he painted his first flag, a faithful copy of the American flag, distinguishable only through heavily textured brushwork: this became his central motif, at once

laboriously realistic and patently artificial. As with his use of other standardised signs, including maps, numbers and targets, he used the flag as a means of pre-existing compositional structure – leaving him free to concentrate on other aspects of his works – and as a means of limiting his own contribution. This exploration continued in *Target with Plaster Casts* and *Target with Four Faces* (both 1955), and in the Number paintings, which also took on images perversely not 'looked at' because of their familiarity. When his works were shown at the Leo Castelli Gallery in 1958, he gained fame as an icon of a new avant garde, but feeling a pawn in the art world's power politics, he temporarily abandoned his famous imagery in favour of the semantic paradoxes and riotous compositions of *False Start* and *Jubilee*. In 1958 came his first sculptures of flashlights and lightbulbs, playing on the ambiguity between hand-made and ready-made objects, carried to an extreme in *Painted Bronze* (1960), two ale cans cast in bronze and repainted to look like 'real' objects. Between 1961 and 1964 he increasingly used hanging or attached objects. In *Disappearance I* and *II* (1960, 1961), he explored the idea of layers of space created by folded canvas, while in *White Flag* and *Gray Numbers* the images almost vanish into the monochromatic fields. In his later work Johns continued to strike a remarkable balance between the conceptual and the visual: he wanted his creations to stand as an objective correlative to the experience of seeing and looking in everyday life, and as an exploration of the relationship between vision, perception and understanding.

CY TWOMBLY. In works that culturally belong to both America and Europe, Twombly has combined figuration, abstraction and writing to create a dense and idiosyncratic symbolic language. Rather than turning to contemporary popular culture, he linked personal experience to classical mythology and epic narratives at a time when such allusions were considered outdated. Born in Lexington, Virginia, in 1929, and trained initially in Boston, he developed an interest in Dada and Surrealism, making collages inspired by Schwitters before moving to New York in 1950 to study at the Art Students' League. Exposure to the emerging New York School purged figurative aspects from his work, encouraging a simplified form of abstraction. He met Rauschenberg in 1951, and enrolled at Black Mountain College, studying under Ben Shahn and Robert Motherwell, and

producing his first significant oil paintings such as *Didim*. He became fascinated with tribal art, using the painterly language of the early 1950s to invoke primitivism, reversing the normal evolution of the New York School. After travelling in France, Spain, North Africa and Italy, he and Rauschenberg had a joint exhibition before being drafted into the army. His first mature works of the late 1950s fused graffiti-like motifs reminiscent of Klee with Surrealist automatism and calligraphic elements within Abstract Expressionism. Works such as *Free Wheeler* and *Arcadia* chart his growing use of letters in 'anti-compositional' order where words, marks and doodles begin to coalesce into a complex visual vocabulary. In 1957 Twombly moved to Southern Italy, and this furthered his use of classical sources: from 1962 he produced a cycle of works based on subjects from history such as *Leda and the Swan*. Erotic and corporeal symbols became more prominent, whilst a greater lyricism developed in his 'Blackboard paintings' from 1966 to the early 1970s. His later sculptures exhibit a similar blend of emotional expansiveness and intellectual sophistication. In 1978 he worked on the monumental historical ensemble *Fifty Years in Iliam*, a ten-part cycle inspired by Homer's *Iliad*; since then Twombly has continued to draw on literature and myth, deploying cryptic pictorial metaphors that situate individual experience within the grand narratives of Western tradition, as in the *Gaeta* canvases and the monumental *Four Seasons,* concluded in 1994.

FRANK STELLA. An archetypal hard-edge Minimalist whose search for 'non-relational' art led to paintings possessing an almost architectural presence. He preached that a picture was 'a flat surface with paint on it – nothing more', yet invested his abstract works with a range of urgent energies, generating pictures at once arrestingly direct and slowly compelling. Born in Malden, Massachusetts, in 1936, Stella studied history and painting at Princeton from 1954–58. After seeing Jasper John's Flags at the Leo Castelli Gallery in 1958 he seized on John's use of commonplace images and translated them into more fully abstract terms. Painterliness was increasingly eliminated, and the horizontal stripe module was given exclusive control over the picture space, as in the blazing yellow *Astoria* (1958), a visual example of his important 1959 lecture at the Pratt Institute in which he stressed the need to 'do something' about relational painting, proposing the use of symmetry,

regulated pattern and paint application using house painters' techniques. His 1959 'Black Paintings' mapped out a path towards Minimalism, and in 1960 he started using commercial aluminum paint, while works such as *Six Mile Bottom* introduced indentations and notches taken out of the canvas, generating greater agreement between striped surface and framing edge. His next series, the 'Copper Paintings', opened out into U-, T-, and L-shaped canvases that echoed the contours of the painted pattern. In 1963–64, he produced a group of polygonal canvases each named after an artist friend, taking his structural logic even further as the canvas frame was reiterated concentrically. He also engaged with the pictorial problems of the square in the early 1960s, and re-introduced colour-chart sequences, vertiginous mazes creating vibrant optical effects; in some, he played off grisaille and coloured squares, as in *Jasper's Dilemma*, a reference to Johns's oscillation between monochromatic greys and coloration. In 1964, he worked on X-shaped canvases; the pressure between radial energy and inflexible geometry is potent in works such as *Marrakech* (1964). He also introduced wedge-shaped canvases, clustering these together, as in *Black Adder* (1965). Stella's emblematic clarity, anti-relational compositions, exploration of commercial pigment, and impersonal handling were themes shared and developed by colour-field abstraction, Op Art and Pop Art in the 1960s, but his greatest influence was upon the emergence of Minimalist sculpture.

CLAES OLDENBURG's sculptures, revolutionary in their glorification of detumescent presence, are connected to Pop Art and classic Surrealist objects in their engagement with the aesthetic potential of the everyday. Best known as the creator of 'soft' sculptures, giant objects and imaginary projects for colossal monuments, he took standardised objects and made them behave contrary to their nature, converting a variety of unlikely objects into metaphors for the body that traded on conventionalised gender binaries, and working with contradictions between desire and repulsion. He was born in Stockholm in 1929 and spent his early years travelling between Oslo and New York, as his father was Swedish vice-consul. His family settled in Chicago and Oldenburg graduated from Yale in 1950, then in 1952 went to the Art Institute of Chicago. In New York in 1956, he worked at the Cooper Union Museum and met artists engaged in environmental and theatrical fields, united in their reaction

against Abstract Expressionism, including Jim Dine, Allen Kaprow and Red Grooms. Oldenburg participated in their 'Happenings' and contributed costumes and props. In 1959 he produced hundreds of sketches of his surroundings, leading to his first significant sculptures made primarily of cardboard and newspaper – capitalism's bulimic waste products. In 1960 he exhibited *The Street*, a total environment at the Judson Gallery, in a show which also saw the first appearance of the 'Ray Gun', a recurrent personal motif. In 1961 came his major environmental work *The Store*, and his famous 'soft' sculptures were started in 1962. Made of sewn canvas, stuffed with cloth and foam rubber, and painted with Liquitex, these outsized works centred on themes of food, the home, mechanical objects and the car. He built up a repertoire of objects – typewriters, plugs, vacuum cleaners, cigarette butts, and various processed foodstuffs – executed in 'hard', 'soft' and 'ghost' versions (painted canvas models). In 1963 he made *Bedroom Ensemble*, a subtly distorted re-creation of a kitsch motel room, and in 1965 began drawings for his colossal monuments that sought to replace established landmarks with enormous commonplace objects, including lipsticks and clothes pins. In the 1970s he concentrated on large public sculptural collaborations with his second wife Coosje van Bruggen. Oldenburg's soft sculptures undermined the traditional hardness of the art form and altered conceptions of what sculpture is, anticipating the 'Process Art' of the late 1960s.

ROY LICHTENSTEIN proved one of the most consistent and pure practitioners of Pop Art ideas, with a rare capacity for self-renewal. He was born in New York in 1923, and trained under Reginald Marsh at the Art Students' League in 1939, and at Ohio State College from 1940–43. After three years in the army he taught in the College until 1951: his early work examined subjects from American history in a Cubist-influenced figurative style. He then moved to Cleveland, taking on engineering drawing jobs, and on returning to New York in 1957 he executed non-figurative and gestural Abstract Expressionist works, soon incorporating loosely handled cartoon images. In 1961 the cartoon imagery took over, and he produced six big paintings (including *Look Mickey I've Hooked a Big One*), which enlarged frames from comic strips and advertisements, a move that helped determine the course of much art of the 1960s. For the

next three years, his works drew on advertising, everyday objects and comic strip imagery of romance, warfare and science fiction, faithfully reproducing the Ben Day dots of cheap printing processes while subtly altering the images' composition. In 1964 he worked on a series of cartoon-based girls' heads, land and moonscapes that were a play on Optical art, and on felt banners, before producing his 'Brushstroke' paintings of 1965–66, openly ironic of Abstract Expressionism. Lichtenstein continued to engage parodically with a wide range of modern styles, subjecting famous works to the idioms of popular imagery. In 1967 he did paintings of canvas-backs and stretchers. Playing upon the distinctions drawn between 'high' and 'low' culture, Lichtenstein produced a new kind of figuration based on the brazen hardness of modern consumerism imagery, and a potent and ironic reaction to Action Painting. In comparison to the New York School, his paintings at first seemed static, impersonal and flat, but appreciation of the nuances of form and texture in his work has grown steadily and pictures such as *Whaam!* (purchased by the Tate Gallery in 1966) are now among the most popular works of modern art in the world.

ALEX KATZ played a major role in the emergence of New Perceptual Realism, and was among the first of the New York School to work on specific representation, reducing gestural brushwork and appropriating the monumental size of Abstract Expressionism and colour-field abstraction to figurative painting. Born in Brooklyn in 1927, he enlisted in the navy before attending Cooper Union Art School from 1946–49 where he became familiar with Cubist figuration. At Skowhegan School of Art in Maine, Henry Poor urged him to paint outdoors, and in 1951 he saw works by Pollock, prompting his all-over pictures of trees and works based on photographs, used as pretexts for simplifying and blurring figures. He started to engage with the problem of reconciling clearly defined subjects with the declaration of flatness that diverged from the flux and dynamism of the New York School, leading to a period of critical dismissal. Specific representation without sentimentality became his goal, paving the way for the New Perceptual Realism of the 1960s. *Irving and Lucy* of 1958 signalled an enlargement in size and scale; in 1959 he started painting double portraits such as *Robert Rauschenberg* and began the 'flat sculptures' – freestanding painted cut-out figures, made first of wood

and later metal – and in 1960 he designed sets and costumes for the choreographer Paul Taylor, leading to six further collaborations up to the 1980s. He then began painting large-scale heads, producing the striking ten-foot-long *The Red Smile* (1963), depicting a cropped profile of his wife Ada counterposed by a flat red ground, and played with scale further in the giant close-ups of flowers from 1966–67. From 1962 his familiar subjects – wife, son and artist friends – appear sleeker and more stylish, leading to the bright, urbane grandness of *Lawn Party* (outside his home in Maine) and *The Cocktail Party* (in his New York studio) of 1965. His work of the 1970s continued to record visual appearances at the same time as transforming them into symbols of modern America, as in *Face of a Poet* (1972), two huge profiles of Anne Waldman, and the 1976 marquette for Times Square of twenty-three female heads extending 147 feet along the RKO general building. In the 1980s and 1990s he executed a number of large landscapes such as *Lake Light* (1992). In 1996 the Colby College Museum devoted an entire wing permanently to Katz's work, and a year later he received the Queen's Museum's Lifetime Achievement award.

ROBERT MORRIS. Identified as a leader of Mixed Media, Minimalism, Anti-Form and Process Art movements, Morris has worked in a range of media, but remains most closely associated with his Minimalist sculptures of the 1960s. Born in Kansas City in 1931, he studied engineering before moving to California, producing theatrical improvisations, dance performances and paintings. His early canvases adopted a gestural style indebted to Abstract Expressionism. He moved to New York in 1961, enrolling at Hunter College to study art history and producing his first important sculptures: small ironic works indebted to Duchamp and the Fluxus Group, such as *Box with the sound of its own making*, which contained a three-hour tape loop of noises produced during the box's construction. He joined the Judson Dance Theater in 1960, and his *Column* was first shown as part of a Living Theater performance in which it topples over halfway through the seven-minute piece; Morris originally intended to be inside the hollow form. In 1962 he executed *I-Box*, which also fused the gestalt (a simple and immediately recognisable form with which Morris tried to characterise Minimalism) with performance. *Two Columns* (1961) was a pivotal work, moving away

from dance works and theatricality towards simple abstract geometric objects, as in the *L-Beams*. In these large plain forms Morris challenged viewers' conceptions of form by highlighting differences in the conditions of perception. The contingencies of setting and of seeing dominate, and relate to Morris's interest in the ideas of phenomenology, especially the writings of Merleau-Ponty. Between 1966 and 1970 Morris developed a theoretical rationale in articles, influenced in part by the architect and sculptor Tony Smith. Mainly published in *ArtForum*, these became virtual manifestos for Minimalism. In the *L-Beams*, and the related mirror cubes, he tried to take 'the relationships out of the work and make them a function of space, light, and the viewer's field of vision'. He engaged further with these issues in the 'Permutations', shown at the Leo Castelli Gallery in March 1967. By 1968 he was making his 'anti-form' works composed of a variety of base materials such as earth, which challenged assumptions that form is prior to substance, and the equation of sculpture with finished end-products. He also became more directly involved in art politics as co-chairman of the Art Strikes Committee and the organiser of the Peripatetic Artists' Guild.

CARL ANDRE. A prominent member of the Minimalist movement whose works have been at the centre of several controversies because of the ordinariness of materials and limited interventions of the artist. Assertively anti-illusionistic, he broke away from the vertical format and anthropomorphic associations of sculpture. Unlike other Minimalists, he used natural materials and located work out of doors: on a visit to England in 1954, Stonehenge and Avebury alerted him to the aura of locations and the importance of the rootedness of monuments, but he has still remained engaged with modernity and the city context. Andre was born in 1935 in Quincy, near Boston, known for its shipyards and granite quarries: his grandfather was a mason, and his father a woodworker and engineer. After visits to Europe and a spell in the army, he moved to New York, meeting Frank Stella in 1958. It was in Stella's studio, while the 'Black Paintings' were being made, that Andre produced his first sculptures of blocks of carved wood, having to scavenge his materials. He devised the 'Element' series in 1960 but could not afford to make them until later, although he did produce his first horizontal sculpture, *Steel Piece*, in 1961. To earn money he worked as a brakeman

on the Pennsylvania Railroad, informing his preference for industrial materials organised in horizontal rows or grids. In 1966 he moved to commercially fabricated materials disposed in specific space. *Lever* was his first site-specific work, a linear arrangement of 137 identical firebricks, exhibited at the *Primary Structures* exhibition at the Jewish Museum, New York. Its stark simplicity was both adventurous and controversial. The *Equivalents* (composed of two superimposed sand-lime bricks of equal height) were inspired by canoeing in New Hampshire and a desire to make sculpture 'as flat as water'. He turned next to metal squares, meant to be walked on by viewers. He exhibited at major Minimalist shows in Europe in the late 1960s and worked on his 'field poems', arranging letters in 'intuitive patterns'. In 1975 he produced *144 Tin Squares*, and later *25 Cedar Scatter,* twenty-five identical timbers strewn upon the floor with no central point, encouraging the viewer to wander between them. The arrangement varied from one installation to the next. *Pyramus and Thisbe* (1990) comprised two distinct spatial sections of ten identical timbers in adjoining rooms. Like the lovers who were forbidden to meet, the blocks are united by the very wall that separates them.

RICHARD SERRA. Using space and gravity as integral components, Serra's powerful industrial-poetic sculptures are assertively experienced by the body as well as the eye and mind, especially as they often have the disorientating effect of seeming to teeter on the verge of collapse. Born in San Francisco in 1939, of Spanish and Russian-Jewish descent, Serra worked in steel factories to pay for his education. He studied literature at the University of California and painting at Yale, then spent time in Paris and Florence, where his interest turned to sculpture. Alongside a series of films investigating the performance of simple tasks, including *Hands Tied* of 1968, he produced many works connected to 'process art', centred upon the manipulation of lead poured, rolled or thrown into the corners of rooms, such as *Splash Piece.* These works were founded upon Serra's 'Verb List' – transitive verbs making up a programme of performance-based tasks. Other works explored precarious balancing, weight and gravity, as in the massive lead *One Ton Prop (House of Cards)* of 1969. In 1970, after seeing the Zen gardens in Kyoto, Japan, Serra found a new spatial temporality and a heightened appreciation of bodily perception.

His works became open fields that drew the viewer into their space, such as *Circuit I* and *II* (1972–86) where four steel plates were arranged in an empty room into a X shape open at the centre. The gigantic scale of his work led to production in public spaces, such as *Shift* of 1970–72, six cement sections embedded in a snowy slope in Canada. His works increasingly seemed to move as the viewer walked around them, such as *St John's Rotary Arc* of 1980, a long piece of metal bent into a smooth curve which oscillates between convexity and concavity as one travels its length. In the 1980s he produced a number of controversial, site-specific works including *Tilted Arc* of 1981, installed in the Federal Plaza, New York, the subject of highly publicised legal proceedings before being removed. Later the arcs were subject to doubling: *Olssen* (1986), *Intersection* (1992). From their destabilising conical shapes whose radii differ from top to bottom, the *Torqued Ellipses* developed, as Serra pursued space that leans in and out simultaneously. Inspired by a visit in the early 1990s to Borromini's church in San Carlo, Rome, and fabricated at the Beth Ship steel mill, Maryland, the *Ellipses* surround the viewer with twisted space that seems to circulate and shift in response to the body's movements, and mark a new departure by using material as the 'skin' of a void.

JEFF KOONS. The most famous artist and aggressive self-publicist of the 1980s, Koons has polarised critical opinion. Blurring the boundaries between art, mass entertainment and advertising 'to communicate with as wide an audience as possible', he is considered an heir to Warhol, Dalí and the spirit of 1960s' Pop Art. The tensions between commodity culture, the aesthetics of display and art's claims to eternal values remain a key dynamic. His lovingly grotesque reconstructions of kitsch force the viewer to confront the petrified realities of modern capitalism. He was born in Pennsylvania in 1955, and studied at the Maryland College of Art and Art Institute of Chicago before selling memberships at MOMA in 1977. Five prosperous years as a Wall Street commodities broker financed his first works, including vacuum cleaners encased and fluorescently illuminated as part of his 'The New' series. His first one-man show in 1985 included the 'Equilibrium' series of basketballs suspended in water. The 'Luxury and Degradation' series in 1986 concentrated on seductive alcohol advertising, and at the same time he embarked on his project of

flagrant self-publicisation in a variety of art magazine advertisements. The 'Statuary' series followed, including *Rabbit*, the notorious stainless steel reproduction of an inflatable toy. The 'Banality' works of 1988, comprising souvenir-like porcelain objects, including *Bear and Policeman* and *Michael Jackson with Bubbles*, was followed by his most controversial series, 'Made in Heaven' of 1989–92, which fused pornography with celestial and biblical references in mural-sized photographs and glass statues of Koons and of the Italian porn-star, his wife, Ilona Staller (La Cicciolina). As representations of a 'contemporary Adam and Eve', the series sought the boundaries of censorship, and continued Koon's blurring of art and life, high and low culture, religion, sex and consumerism. He also draws on grand Baroque heritage, fusing it with modern kitsch, as in *Puppy* (1992), a forty-foot sculpture made of thousands of flowering plants, first placed outside an early eighteenth-century castle. From 1994 he worked on the large-scale multi-media project *Celebration* for the Guggenheim Museum, financed by a consortium of American and European dealers. Koons confounds critics by denying any ironic element in his work and asserting its religious connotations over and above his engagement with perverse forms of commodity fetishism.

ACKNOWLEDGEMENTS

We are grateful to all the artists or their estates for granting permission to publish these interviews. Individual thanks are due to Helen Frankenthaler, Jasper Johns, Jeff Koons, Robert Morris, Robert Rauschenberg, Frank Serra, Cy Twombly. In New York we would also like to thank the Artists Rights Society (Robert Morris); the Leo Castelli Gallery (Jasper Johns); VAGA (Robert Rauschenberg); the John Cage Trust; the Adolph and Esther Gottlieb Foundation; the Barnett Newman Foundation; the Estate of Roy Lichtenstein; the Estate of Philip Guston, Courtesy McKee Gallery; the Sonnabend Gallery (Jeff Koons); Pace Wildenstein (Alex Katz, Louise Nevelson, Claes Oldenburg); the Paula Cooper Gallery (Carl Andre); Edward Taylor Nayhem (Franz Kline); Knoedler & Company (David Smith and Frank Stella).

We are also grateful for permission to reproduce portraits of the artists, while respecting the wishes of Carl Andre not to be represented by a personal image. In particular we would like to thank Dan Budnik, who worked closely with David Sylvester at the time of the early interviews and has kindly provided contemporary photographs of Philip Guston 1964, Jasper Johns 1964, Roy Lichtenstein 1964, Louise Nevelson 1958, David Smith 1962, Robert Motherwell 1964, Claes Oldenburg 1965, Robert Rauschenberg 1964, Frank Stella 1967: all images (some of which were originally in colour) are © Dan Budnik/Woodfin Camp & Associates. Thanks and acknowledgements are also due for the following images: John Cage 1966 © Herve Gloaguen, by courtesy of the John Cage Trust; Helen Frankenthaler 1968 © Alexander Liebermann/Getty Special Collections; Adolph Gottlieb c.1960 © Adolph and Esther Gottlieb Foundation; Alex Katz © Vivien Bittencourt, courtesy of Pace Wildenstein; Franz Kline 1954 © Hans Namuth Ltd; Jeff Koons 2000 © Berliner Verlag/Kaufhold; Robert Morris 1961, courtesy of Leo Castelli Gallery; Barnett Newman © Ugo Mulas Estate, All rights reserved; Cy Twombly 1994 © W. Patrick Hinely, Work/Play/The Menil Collection; Richard Serra 1989 © Nancy Lee Katz. We would be grateful for further information in the few instances where it has not proved possible to identify the photographer or copyright holder.

INDEX

INDEX